C000111198

A THEORY OF

■ ■ ■

HOWARD RISATTI

A THEORY OF CRAFT
FUNCTION AND AESTHETIC
EXPRESSION

■ ■ ■

FOREWORD BY KENNETH R. TRAPP

THE UNIVERSITY OF NORTH CAROLINA PRESS

Chapel Hill

© 2007 The University of North Carolina Press
All rights reserved
Manufactured in the United States of America
Set in Scala and Citizen types
by Tseng Information Systems, Inc.

Library of Congress Cataloging-in-Publication Data
Risatti, Howard Anthony, 1943–
A theory of craft : function and aesthetic expression /
Howard Risatti ; foreword by Kenneth R. Trapp.
p. cm.
Includes bibliographical references and index.
ISBN 978-0-8078-3135-9 (cloth : alk. paper)
ISBN 978-1-4696-0090-1 (pbk.)
1. Decorative arts—Philosophy. 2. Design—Philosophy. I. Title.
NK1110.R57 2007
745.01—dc22 2007011952

cloth 11 10 09 08 07 5 4 3 2 1
paper 17 16 15 14 13 5 4 3 2 1

For Kenneth Trapp,

for my nieces and nephews,

Ashlyn, Megan, Dylan, and Teddy

and, above all,

for Christina

CONTENTS

■ ■ ■

PART IV

Aesthetic Objects and Aesthetic Images 207

ILLUSTRATIONS

■ ■ ■

FOREWORD

■ ■ ■

Considering the lowly status craft holds vis-à-vis other visual arts, arguing that craft is art is a courageous undertaking. In *A Theory of Craft*, Howard Risatti presents a thoughtful and careful argument that this is, in fact, the case, that craft is art. He has been developing the arguments presented in this book for over two decades. As his thoughts about craft took form and became clearer, the author struggled to find the appropriate organizational structure to address such thorny dichotomous issues as "function versus nonfunction," "craft versus design," "the artist as intellectual versus the craftsperson as object maker," and "artistic content versus physical object." As the reader will see, each chapter is written to address a particular issue, with chapter building on chapter, to the conclusion that craft is art. Drawing liberally on his scholarly background in artistic theory, in particular as it pertains to Modern Art, aesthetic theory, and other philosophical discourse, as well as casting an acute eye to contemporary culture, Risatti challenges many of the long-held stereotypes about craft that hinder a true understanding of the art form. His conclusions challenge us to reevaluate our ideas not only about craft but also about what actually constitutes a work of art.

KENNETH R. TRAPP
Former Curator-in-Charge of the Renwick Gallery
of The Smithsonian American Art Museum

PREFACE

■ ■ ■

The task I have undertaken in this book is to answer the question "What is a craft object?" This question is prompted by two factors that I believe especially relevant to contemporary society even though they began to take shape already in the early years of the last century. The first is the altered relationship (perhaps strained would be more accurate) that developed, and continues to develop, between craft and fine art both in critical theory and in practice. Because the craft field lacks a critical theory that is specifically its own, when critical judgments are made about craft objects they tend to revolve around the fine art notion that functional things cannot be beautiful and therefore they cannot be art. The other factor is the relationship between craft and design. This relationship is important because the design profession, which rose to prominence in the wake of industrialized machine production, has transformed craft's fundamental relationship to function by taking over production of most of the functional objects of daily use. The result is a situation unique to the modern world, but one that has been mostly ignored by arguments that pit craft against fine art.

It is in view of both of these factors that the question "What is a craft object?" becomes so relevant and urgent. For without understanding, in the fullest sense, what a craft object is, the craft field will remain unable to define the limits of its activities, especially vis-à-vis fine art and design, and hence it will be unable to articulate a serious role for itself in the contemporary world. In the face of the great prestige accorded fine art and design in our society, craft will eventually disappear as a recognizable field of activity, being absorbed by either fine art or design. The unfortunate consequence of this is that the unique approach to understanding the world that I believe the craft object can offer will be lost. For these reasons a comparison is undertaken in this book not only between craft and fine art, but also between craft and the modern profession of design.

As the reader will quickly see, this book is broadly divided into two sections. The first section, Parts 1 and 2, approaches the question of what a craft object is by looking at traditional craft objects as physical entities, as actual material things that exist in space. It does this by

examining them in terms of function and their material identity and then by comparing them to apparently related functional things such as tools and machines. After doing this, a comparison is made between the traditional craft object and the fine art object. From this it should be clear to the reader that the main thrust of this first section is devoted to describing the physical characteristics of craft and related objects, including works of fine art. This is done to better understand how the physical aspects of craft objects not only differ from those of fine art, but also reflect craft's unique origins in function. Also discussed in this section are manual skill, workmanship, and craftsmanship as they relate to craft as a practice centered on the manipulation of physical material by the skilled, knowing hand.

The second section of this book, Parts 3 and 4, marks a shift from discussion of physical characteristics to the more subjective realm of meaning. This begins in Part 3 with an analysis of the relationship between craft and the modern profession of design. Here the symbolic importance of making as a process shaping our worldview is considered. The main theme in Part 4, which gets to the crux of the aesthetic argument that underlies the craft versus fine art debate, is the relationship between physical function and aesthetic expression as both a theoretical-philosophical concept and a practical aspect of objects. Questions such as "Does physical function really preclude expression, as many modern aestheticians and critics believe?" and "Can an object be both physically functional and aesthetically expressive at the same time?" are explored. To do this the nature of "the aesthetic" in relation to beauty and the work of art are examined as both abstract and historical concepts.

Ultimately, the intention of this book, regardless of how comparisons of craft to fine art may stir debate, is not to argue for or against one in favor of the other, that one is better than the other. It is an attempt to show the importance of craft in the development and expression of human values.

Thus, the importance of this enterprise in these politically contested times of multi-culturalism, nationalism, and religious fundamentalism, times in which all values (even artistic values) are said to be relative, to be cultural constructions in the service of power, domination, and greed, is to show how the craft object is a fundamental expression of human values and human achievement that transcends temporal and spatial boundaries as well as social, political, and religious beliefs. To quote a statement by Florence Dibell Bartlett that adorns the en-

trance to the International Museum of Folk Art in Santa Fe: "The art of the craftsman is a bond between the peoples of the world." As she suggests, all the world's peoples are bound together by the creation of craft objects, something that began with the dawn of human time. In this way craft objects offer a meaningful example of our shared heritage as human beings, a shared heritage that in many ways outweighs our superficial differences. Appreciation of this can only happen, however, if we come to know and understand what the craft object truly is.

My interest in craft and related issues was nurtured, in part, from my years as a graduate student. At that time I didn't know that one wasn't supposed to study crafts or the "decorative arts," that they were somehow inferior, not quite art. In studying art of the ancient world with Ann Perkins, for example, no high art/low art distinctions were made between Greek sculpture and Greek pottery—what was good was simply good. Ann Morgan, my dissertation adviser, not only offered a model of what an adviser should be; she also emphasized careful looking as part of critical thinking and critical writing, something that has challenged me ever since. For this I am grateful.

I also have benefited from discussions with my colleagues at Virginia Commonwealth University, especially those in the Department of Craft/Material Studies; also, as chair of that department I was able to actually see objects being made in the various craft studios, experiences that gave me an added appreciation for skill and the "thinking hand" involved in craft. Appreciation for providing me the opportunity to think and talk seriously about craft also goes to the art history, craft, and fine art students who took my graduate seminars on craft theory. Thanks also to ceramic artist-writers Steven Glass and Adam Welch as well as to Kenneth R. Trapp, former Curator-in-Charge of the Renwick Gallery. Not only have I benefited greatly from our continuing conversation about craft that began over thirty years ago when we were graduate students, but Ken's passion for craft and the decorative arts, his scholarship, and his early reading of the manuscript have been enormously helpful. I must say the same for Donald Schrader; he and I had intense conversations about craft almost daily over several summers while I was working on this book, and he has continued to be an enormous scholarly resource. Thanks also to Donald Palmer for generously putting his own book project on hold to read my manuscript; his remarks on my philosophical "musing" were extremely thoughtful, though, needless to say,

he is not responsible for any false steps I may have taken in that area. Others who deserve my sincere gratitude include William Simeone Sr., who with patience and care began reading drafts of the manuscript early on, giving me valuable advice along the way on content, clarity of style, and logic of organization; and Janet Koplos and Glenn Brown, two of the field's most knowledgeable experts, who took time away from their own important scholarly work to twice read the manuscript, each time posing challenging questions and offering serious advice on its improvement; and Eric Schramm for final editing of the manuscript and Paula Wald and Charles Grench of the University of North Carolina Press for their help and generous support of this project.

For advice and help with images, thanks go to James Farmer, my art history colleague at VCU, and to John Jessiman, Cub Creek Foundation for the Ceramic Arts; Jill Bloomer of the Cooper-Hewitt; Robyn Kennedy, Richard Sorensen, and Leslie Green of the Renwick Gallery; Peter Lau; Jason Hackett; Ree Schonlau of Jun Kaneko Studio; Lyssa Stapleton of Cotsen Management Corporation; Lou Stancari of the Smithsonian National Museum of the American Indian; Jon M. Williams of the Hagely Museum and Library; Rebecca Akan of the Image Library, Metropolitan Museum of Art; and all the artists who graciously loaned me images of their work. I hope they aren't disappointed with what I have written.

And finally, I must thank my wife, Christina, for cheerfully letting me use her as a sounding board for my ideas about craft and art. Never once do I remember her saying "basta, basta"—enough, enough!!

A THEORY OF CRAFT

■ ■ ■

INTRODUCTION

To see or hear is nothing.
To recognize (or not recognize) is everything.
ANDRÉ BRETON
Le Surréalisme et la peinture *(1928)*

■ ■ ■

In the last three decades there has been much discussion about the relationship between craft and fine art. In many ways this discussion was anticipated by "The New Ceramic Presence," an article written by Rose Slivka that appeared in *Craft Horizon* in 1961. In this article Slivka attempts to relate what she identifies as a "new ceramic presence" to modern industrial culture and to the new trends occurring in contemporary painting. She argues that "the painter-potter avoids immediate functional association . . . and so, the value of use becomes a secondary or even arbitrary attribute." To the inevitable question that this position implies ("Is it craft?"), Slivka replies that it is indeed craft unless "all links with the idea of function have been severed, [then] it leaves the field of craft."[1]

Slivka's article came at the beginning of a wider debate about the status of craft vis-à-vis fine art. To some extent this debate was spurred on in subsequent decades by the astronomically high prices that fine art, but especially painting, was commanding at auction.[2] As British ceramist Greyson

1. Slivka, "New Ceramic Presence," 36. Rosemary Hill locates the same attitude in England around 1973 with the publication of *Crafts* magazine by the Crafts Advisory Committee; see her "2001 Peter Dormer Lecture," especially 45–47.

2. Examples of auction prices include Jasper Johns's *Out the Window*, which fetched $3.63 million in 1986; two years later his *False Start* sold $15.5 million. In 1987 Van Gogh's *Irises* sold for what seemed a staggering $49 million, while eleven years later his *Portrait of the Artist Without a Beard* (1889) sold for $71.5 million. These prices were shat-

Perry, winner of the prestigious 2003 Turner Prize awarded by the Tate Gallery in London, noted, "Pottery is older than painting, with just as venerable a history, but if you look at the big prices in auction houses . . . paintings get the big sums."[3]

However, it is not just the "go-go" eighties or the "new technology bubble" of the nineties or even the renewed affluence of the last few years that explain fine art's high prices. Its prestige is also a factor. In no small part this prestige can be linked to the tradition of critical discourse surrounding contemporary fine art that has appeared in newspapers, journals, and magazines for well over a century. Moreover, this critical discourse reflects the intellectualization of painting and sculpture and even architecture as the fine arts and is based on a tradition of aesthetic theory that began with the ancient Greeks and was revived in the eighteenth century with philosophers such as Alexander Baumgarten, Edmund Burke, and Immanuel Kant, among others. What this theoretical and critical discourse has done is provide an intellectual framework within which to ground fine art, to transform it, as it were, from a mere object of trade or handwork into a conceptually and intellectually centered activity.

By contrast, historically the field of craft has not undergone a similar "intellectualization," nor has it had the same kind of critical and theoretical support, either from within or without, that has characterized the fine arts. This remains largely the case even though there are craft critics who have taken a more theoretical/intellectual approach to the field. Nonetheless, as art and craft critic Janet Koplos has pointed out in a talk to a professional ceramics organization, "Crafts critics tend to be nontheoretical; they're usually either historically oriented or they give sensory, experiential emphasis to their writing. I don't know whether that's a cause or an effect of the fact that the crafts field, in general, is also nontheoretical." Koplos went on to say that "the big question . . .

tered by Picasso's *Boy With a Pipe*, which sold for $104.1 million in 2004 and Klimt's *Adele Bloch-Bauer I*, which went for $135 million in June 2006. For more on this and auction prices see Risatti, "Crafts and Fine Art," 62–70; Allen, "Rule No. 1"; Melikian, "Contemporary Art"; and Rubinstein, "Klimt Portrait."

3. For Perry's remarks see "Refuge for Artists." Critic John Perreault asks the art world, "Why is it important to distinguish craft from other art objects?" He goes on to answer his own question: "Because prices and careers need to be protected, categories must hold." See his "Craft Is Not Sculpture," 33.

is whether it matters if crafts benefit from emulating [fine] art's intellectual structure." Her answer is that it doesn't matter and that "lusting after equality with [fine] art has, in fact, been destructive to crafts." Ultimately, she encourages craft's people to be "distinctly yourself, especially where it means being unlike mainstream fine arts."[4]

In a recent issue of *Ceramics Monthly*, craft critic Matthew Kangas also discussed the problem of the intellectual standing of the craft field. Kangas quotes fine art critic Donald Kuspit, who praises Garth Clark's curatorial efforts to "overturn the deeply rooted negative attitude that ceramics is inherently trivial." Kangas also quotes craft critic John Perreault, who faults the craft field for ignoring its own history. Even more damning, it seems to me, is the experience of fine art critic Peter Schjeldahl who, in reviewing a 1987 exhibition of Adrian Saxe's ceramics, somehow felt he was "encroaching on a field where suspicion of intellect is a given, anti-intellectualism being a shadow of certain positive values embodied in most modern craft movements." Echoing these observations, Kangas ends his "Comment" with a plea "for the American ceramics movement to attain the same intellectual maturity demanded by painters and sculptors."[5] And finally, there is the plea from craft critic Glenn Brown, who, in speaking of contemporary installations, argued that "the failure to develop a body of theory that is faithful to the craft tradition yet effectively asserts the contemporary relevance of craft practice has left craft consciousness vulnerable to pejorative stereotyping. Worse yet, the craft world has permitted itself to be bastardized, represented as alienated from some of the very characteristics—multiplicity, dispersion, interaction, and temporalness—that have defined its tradition."[6]

Despite such pleas for a more intellectual approach to the field, writing about craft is still largely devoted to practical issues such as materials and techniques. Lack of a critical and theoretical framework within which to ground the field helps explain its generally low prestige (aesthetically and otherwise) and, consequently, its inability to overturn what

4. Her address was to the "Texas Clay 2 Symposium" in San Marcos, Texas, February 12–14, 1993. For a reprint see Koplos, "What Is This Thing Called Craft?" 12–13.

5. While Kangas is addressing ceramics specifically, I believe Schjeldahl's comments apply to the craft field generally. See Kangas, "Comment," 110, 110–112, and 112, respectively.

6. Brown, "Ceramic Installation," 18.

Kuspit sees as "a fixed hierarchy of the arts [that still] lingers," a hierarchy in which fine art rests at the top.[7] It also helps explain the slight regard given contemporary craft objects in the marketplace. Considering this, Slivka's article can be viewed as an early attempt to remedy this situation, to cast craft activity in a new light. Unfortunately, by taking a vast leap over unchartered theoretical territory, her claim that the "painter-potter avoids immediate functional association" seems to suggest that the craft field should ensconce itself within the already existing critical and theoretical discourse surrounding the fine arts; it unintentionally, I believe, reinforces what Perreault sees as a fear of pots, a "fear that the utilitarian and the aesthetic could be once again truly united."[8] I think the gap left by the uncharted theoretical territory in craft needs to be filled before the kind of craft objects that have implied or metaphorical function, rather than actual function, will be accepted as replete with meaning.

Responses to the low prestige and poor market value of craft have led to claims that there is little or no difference between craft and fine art; therefore, there should be no distinction, no separation between the two fields. Such claims are made mostly by people in the craft field who tend to affiliate themselves with sculpture rather than by fine artists. In 1999, Paula Owen, a painter and a long-time craft advocate who also writes and directs the Southwest School of Art and Craft in San Antonio, curated an exhibition titled "Abstract Craft." In the exhibition brochure she writes that "the artists and objects in this exhibition argue . . . against fixed definitions or separate categories of art and craft." Having stated this, she goes on to postulate a specifically craft sensibility, something that supports rather than denies a separation between the two fields.[9]

While Owens may be right about a "craft sensibility," it seems to me what advocates like her, Perreault, and others are actually calling for is aesthetic parity between craft and fine art.[10] But however desirable aesthetic parity may be, framing the issue around the elimination of

7. Kuspit as quoted by Kangas, "Comment," 110.

8. Slivka, "New Ceramics Presence," 36, and Perreault as quoted by Kangas in "Comment," 112.

9. Owen, "Abstract Craft." For more of her views see her "Labels, Lingo, and Legacy."

10. I think it significant that Perreault's "Craft Is Not Sculpture" was published in the art magazine *Sculpture* and not a magazine devoted exclusively to craft.

craft and fine art as separate categories is a questionable strategy. At a practical level it faces several problems, including established habits of thinking about the two fields that make this "no separation" argument difficult to accept. For one thing, viewers often identify objects as craft by their materials. An object made in what is now regarded as a traditional craft material (say clay/ceramic) is automatically regarded by many people as a craft object (see Figure 1).[11] Such a conclusion is unfounded simply from a historical perspective. Large-scale figurative sculpture has been made of clay/ceramic at least since Etruscan times (see Figure 2). Yet habits of thought are difficult to overcome. If sculptural objects in clay/ceramic can't readily cross over into the realm of fine art sculpture, even given the historical precedents, then sculptural works in uniquely craft material such as glass and fiber have even less of a chance of resisting being automatically relegated to the category of craft.

The problem of defining craft by material aside, there is a more significant issue that the "no separation" argument ignores. This has to do with the identity of craft and fine art, both as objects and as concepts. What, from a theoretical point of view, is a craft object? Do craft objects share the same theoretical basis as fine art objects? Are the fields of craft and fine art, in some real and meaningful way, actually the same? Without knowing the answers to such questions, how can one relate craft to fine art, much less make the claim they should be viewed as members of the same class of objects? The "no separation" argument remains unsatisfactory for both craft and fine art because it ignores these questions; it implies that either it is unnecessary to understand formally and conceptually exactly what is referred to when speaking of craft and fine art, or, on the other hand, that formally and conceptually craft and fine art are exactly the same enterprises.

As to the first point (that understanding is not necessary), I believe it a gravely mistaken notion because understanding, and hence recognition, is essential to identity and meaning. This is something that the German hermeneutical philosopher Hans-Georg Gadamer has argued. As art critic Klaus Davi notes in an interview, Gadamer's concept of games and game playing leads to a reevaluation of the concept of mimesis; that is to say, to the concept of representation. For Gadamer,

11. For more on the work of Allan Rosenbaum, see Risatti, "Eccentric Abstractions."

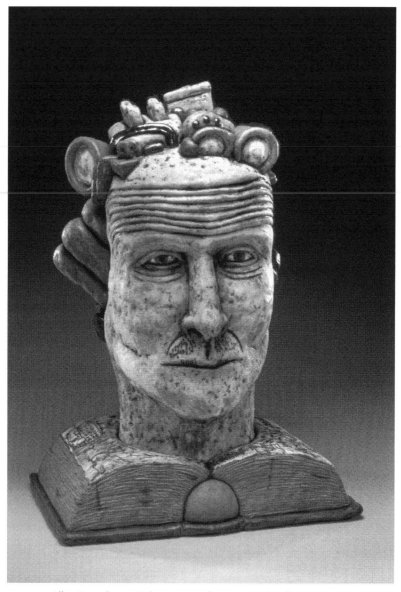

FIGURE 1. Allan Rosenbaum, *Tale*, 2002, earthenware, stain, glaze
(28″ high × 19″ wide × 15″ deep). Photograph courtesy of the artist.

This over life-size head is part of a widespread contemporary movement utilizing clay
and sophisticated ceramic hand-building and glazing techniques to make figurative
sculpture. While influenced by Funk Art of Northern California and Chicago, Rosen-
baum eschews the scatological and overtly political that typifies that work in favor of
deeply psychological overtones. Nonetheless, many people would consider this work
craft because of its material.

FIGURE 2. *Apollo of Veii*, Portonaccio Temple, Veii, Italy, ca. 510–500 B.C., painted terracotta (ca. 5′ 11″). Museo Nazionale di Villa Giulia, Rome, Italy. Photograph: Scala/Art Resource, N.Y.

This is one of many life-size sculptures in painted ceramic to come down to us from antiquity. Other examples include the more than 7,000 life-size painted terracotta figures of horses and soldiers of the Imperial Bodyguard from the tomb of Shihuangdi, first emperor of the Qin Dynasty, 221–206 B.C., Lintong, near Xi'an, Shaanxi, China.

mimesis involves much more than simply realism or naturalism, what in the Aristotelian sense would be the unities of time, space, and action. Gadamer's concept of mimesis has to do with how "imitation is grounded within a knowledge of cognitive meaning." Gadamer argues that every work, whether abstract or realistic, is a "representation" of its time, of the historical moment in which it is made. In this sense, the concept of mimesis, as Gadamer says, "implies the concept of recognition. With a work of art, some element is 'recognized as something' [only] when its essence has been grasped."[12]

Gadamer's concept of mimesis is instructive for our discussion of craft because it strikes at the core of how we go beyond simply looking at things we casually encounter in the world, to actually seeing them in the sense of recognizing and comprehending them. When we say in English, "Take a *look* at this. Do you *see* what I mean?" we are making such a distinction. While Gadamer's argument is quite nuanced, his point becomes clear from a simple example. Say we are at an airport to pick up someone and passengers are leaving the gate. Though we look at them, we pay little attention, except to subconsciously note that the plane must have just arrived. Then we look at someone we recognize and say hello. We recognize this person because we know him to be a neighbor from down the street. Soon we also recognize the person we have come to meet, an old friend we have known for many years, and we embrace. In both instances it is clear that recognition involves more than just looking, that recognition only comes from knowing. This is Gadamer's point. Moreover, the deeper the level of knowing, the more profound the level of recognition, which is one reason why the response to a person who does something completely out of character is to say, "I don't recognize you anymore." A side of their character has been revealed that was unknown to us. And in fact, the word "recognition" actually means to "re-know."[13]

My point is twofold. One is that we must find a way to go beyond simply looking at craft objects as things that have function or are made

12. See Davi, "Hans-Georg Gadamer," 78.

13. Something of the original sense of the word comes back to us when we encounter someone like TV celebrities. Upon seeing them on the street we have the feeling of knowing them because of our familiarity with their TV roles. However, off-camera, in real life, they may be completely unlike the roles they portray, making it clear that what we recognize are not real persons, but simply physical features.

of certain materials (e.g., clay, glass, wood, fiber, or metal); and two, we must begin to see and recognize them in the sense of comprehending them by grasping their essence. However, comprehension, in the sense of understanding and meaning about which we are speaking, always occurs within structured limits or boundaries, what Gadamer calls "games." In this sense, games refer to any structured set or system of conventions or rules; these could be the rules or conventions that the artist or writer manipulates and the viewer or reader recognizes (say those of portraiture or the sonnet) just as easily as the rules of ordinary, everyday games like football or boxing. Only when one knows the rules of the football game or boxing match does one recognize that it is not a free-for-all or an argument that has gotten out of hand. Unlike the uninitiated, because we know the rules, we don't call the authorities but watch in a certain way, paying attention to salient aspects of the contest, always within the formal structure created by the rules.[14]

That meaning is necessarily grounded within a system of "conventions" or rules pertains equally to the conceptual aspects of things (what something is) as well as to their perceptual/formal aspects (how they look)—what is often characterized by the polarities "form and content" and "theory and praxis." Such bi-polar separations, however, misconstrue the interdependent nature of this relationship. Knowing and understanding/comprehending (as opposed to simply looking or hearing) are not only intimately related formally and conceptually, they are co-dependent and are essential to any system of communication, including art. As Gadamer writes, "Only if we 'recognize' what is represented [in a picture] are we able to 'read' a picture; in fact, that is what ultimately makes it a picture." He goes on to conclude that "seeing means articulating."[15]

14. Literary critic Jonathan Culler notes that a poem "has meaning only with respect to a system of conventions which the reader has assimilated." Without these conventions, a poem may seem no more than an inept attempt at prose. He also notes that "to speak of the structure of a sentence is necessarily to imply an internalized grammar that gives it that structure." See Culler quoted in Tompkins, *Reader-Response Criticism*, xvii–xviii. George Kubler makes a similar point in relation to visual art when he argues that "every meaning requires a support, or vehicle, or a holder. These [supports] are the bearers of meaning, and without them no meaning would cross from me to you, or from you to me, or indeed from any part of nature to any other part." See his *Shape of Time*, vii.

15. Gadamer, *Truth and Method*, 91.

The importance of this for the discussion of craft and fine art that follows is that recognition and comprehension of both craft and fine art require an understanding of them at an essential, elemental level. To recognize them in the same way we recognize a neighbor from down the street whom we only know well enough to say hello while walking the dog after work is to know them in formal appearance alone; it is like encountering a celebrity walking down the street. To know at the level Gadamer is talking about is to know at a more profound and deeper level.

Only from understanding at such a level can meaning itself be given to form by a maker and apprehended by a viewer. In all visual art the very possibility of meaning itself is dependent upon knowing and understanding the conceptual ground upon which the formal object rests. In this sense, to recognize the nature of some*thing* (such as a craft object) requires understanding and knowledge of the thing itself—how it is made, what it is for, and how it fits into the continuum of its historical tradition.[16]

I can't stress enough that this applies equally to fine art as to craft. If one had no idea what a picture or a sculpture is, how could one make such a thing and how would one respond to it? This may seem a foolish question, but the history of Modern Art suggests otherwise, for it is exactly the problem confronted by "jurors" when they first saw Marcel Duchamp's *Fountain* (Figure 3), a simple store-bought urinal he submitted as a work of sculpture to the Society of Independent Artists exhibition in New York in 1917. Because it did not posses enough of the salient, characteristic features that would have allowed it to be recognized and understood *as* sculpture, the organizers of the exhibition rejected it even though they said there was to be no jurying process for the exhibition. In the eyes of the organizers it was not a question of *Fountain* being a "bad" sculpture; it simply wasn't a sculpture at all.[17]

Any level of understanding/comprehension of craft and fine art in the sense in which we are speaking can only come from a deep knowl-

16. For these reasons, I think Perreault's definition of craft as "handmade" using "traditional craft materials," "processes," and "craft formats such as vessels, clothing, jewelry, and furniture" would be more useful if grounded within a theoretical framework. See Perreault's "Craft Is Not Sculpture," 34.

17. For more on the history and reception of *Fountain*, see Camfield, *Marcel Duchamp*.

FIGURE 3. Marcel Duchamp, *Fountain*, 1917, replica 1964, porcelain (unconfirmed size: 360 × 480 × 610 mm). Purchased with assistance from the Friends of the Tate Gallery 1999, Tate Gallery, London, Great Britain. Photograph courtesy of Tate Gallery, London/Art Resource, N.Y., © 2007 Artists Rights Society (ARS), N.Y./ADAGP, Paris/Succession Marcel Duchamp.

The original, now lost, was an ordinary urinal Duchamp purchased from a plumbing store and signed R. Mutt, before entering it into the inaugural exhibition of the American Society of Independent Artists in New York in April 1917. Interestingly, Duchamp was on the society's board of directors and was head of the exhibition's hanging committee at the time he submitted *Fountain* under R. Mutt's name to the exhibition. During the installation of the exhibition, *Fountain* drew such heated criticism that it was withdrawn and Duchamp and several other members resigned in protest.

edge of them as both formal and conceptual enterprises. That is why the assumption implied in the "no separation" argument, that craft and fine art are exactly the same, can only be demonstrated by examining craft, both internally as a practice and externally in relation to fine art. Only in this way can one discover whether craft is the same as fine art or a practice unique unto itself.

PART I

PRACTICAL-FUNCTIONAL ARTS AND THE UNIQUENESS OF CRAFT

QUESTIONS ABOUT TERMINOLOGY

■ ■ ■

When using the word "craft," it is necessary to clarify what is being referred to because of a great deal of confusion about the term. In his influential book *The Principles of Art*, first published in 1938 and still in print in 2007, R. G. Collingwood uses the term "craft" qualitatively; in his view, if a work is inventive, creative, it is art; if not, he concludes it must be a work of craft. Following his logic, the term "craft" ends up defining what can be called failed attempts at art or simply repetitive, rote work. Why not, I think one can rightly ask, oppose art to non-art instead of art to craft? Why should craft be made to stand for all those objects in the world that are not art? Isn't this a simplistic way of looking at things? Moreover, and here is where the long-standing prejudice against craft comes out, Collingwood apparently assumes any activity that involves the making of functional objects (his example is of a table) is simply the executing of a pre-conceived plan or design and therefore cannot possibly be a creative activity, hence it cannot be art.[1]

Collingwood doesn't distinguish between craft as a class of objects and craft as a process of making. Furthermore, his definition of craft as preconception and art proper as a matter of creative imagination, in which the artist, unlike

1. See Collingwood, "Art and Craft," 15–16. For similar views, see Martland, "Art and Craft: The Distinction," 231–38, especially 233; Bayles and Orland, *Art and Fear*, 98ff.; and Allen, "Mounce and Collingwood on Art and Craft," 173–76. For a critique of Collingwood, see Mounce, "Art and Craft," 231–40.

the craftsman, doesn't know in advance what the outcome will be, is so coarse as to suggest that artists like Rembrandt and Ingres only realized they were painting a portrait when they had finished. This simply is incorrect. Artists not only make plans in advance in the form of drawings and sketches, they also work from preconceptions such as the concept portrait, landscape, still life, what Gadamer calls a structured system of conventions or rules. Neither Rembrandt nor Ingres invented the tradition of portraiture; it was long established by the time they began to paint. Considering this, surely using the term "craft" is not the best way to distinguish between journeyman work, whether in portraiture or furniture making, and genuinely creative work that springs from the artistic imagination.

In the usage proposed here, the word "craft" refers to specific objects such as vases, pots, chairs, tables, chests, covers, etc.; it also refers to the profession concerned with the creation of these objects among whose practitioners I would include ceramists, glassblowers, furniture makers, metal workers, weavers, etc. When referring to the skilled activities with which and through which these objects are made, the term "craftsmanship" is used. This is a way to separate craft objects from the skills employed to make them while at the same time reinforcing the connection between craft and the skilled hand inherent in craftsmanship.

Making distinctions about how objects are made is important because the process of making is closely tied to an object's meaning. Today more than ever, maintaining such distinctions must be done because of industrial production. Before the Industrial Revolution the activities of making were always carried out by the skilled hand. The words "craft" and "craftsmanship" not only referred to the quality of making, but they also assumed the skilled hand was the source of this quality. This is no longer the case; today the skilled hand is not the sole producer of objects so that when the terms "craft" and "craftsmanship" are used, they often have a somewhat different, less precise meaning than in the past. Though they may still retain their qualitative dimension by referring to the "well-made-ness" of things, often they refer to things that are made by machines and therefore have nothing at all to do with the skilled hand.

Even if well-made and of extremely high quality, objects made by machines (or even partly by machines and then assembled by the unskilled hand) and those made by the skilled hand differ because different conceptual attitudes are involved in the process of making. To articulate

these differences I suggest "well-made" be used as a generic term to refer to the quality of making as found in things generally, regardless of the making process involved; "machine-made" to refer specifically to mechanical production; and "well-worked" and "well-crafted" reserved for hand-made things. This allows for greater precision as long as care is given not to assume all hand-made things, regardless of how well-made or well-worked, are craft objects. Skilled activities of the hand alone are not sufficient to define something as a craft object.

How then are we to define a craft object? Where do we begin if fine art aesthetic theory doesn't help us understand craft? It is my contention that craft must be approached on its own terms; this can be done by looking to those objects that have traditionally defined the field and then examine them for their inherent features. This is a way to uncover what I believe is a shared conceptual framework that exists across the individual areas of craft production.

Traditionally, the production of craft objects as well as the discourse that has surrounded them has tended to focus on practical matters rather than on theoretical or critical issues. Focus has been on materials and the difficulties of bringing the object, as a material entity, into existence. For this reason discussion of materials and technical matters including tools, formulas, temperatures, finishes, and techniques have dominated craft discussions rather than abstract, theoretical concepts or artistic/aesthetic issues.

Concern with material is so important to craft that the field is categorized and identified by it. For example, major areas of craft, as well as specific craft objects, are identified by materials such as ceramics, glass, fibers, metals, and wood. Tea pots, pitchers, and bowls, all considered craft objects, would be identified as belonging to the realm of ceramics if made of clay; these same objects as well as vases, tumblers, and goblets, if made of molten silica, would be considered part of the realm of glass. In a similar way rugs, blankets, baskets, quilts, and clothing, even felt hats, would be categorized under the term "fiber," a term that encompasses a wide variety of natural and man-made materials including rayon and nylon.

All these different objects are subsumed under the same word, "craft," but are also referred to and identified by their material. Crafts are also named by technical processes such as weaving, quilting, and turning. And though one may intend to identify the very same objects as mentioned in the above paragraph, when referring to them as weav-

ing, quilting, or turning, different implications are given to the word "craft" as emphasis is shifted away from material and placed on technique and process. In the case of such terminology, process takes precedence over material since a great variety of different materials including cloth, metal, plastic, natural and man-made fibers, wood, and even clay can be woven, quilted, or turned. A term such as "smithing" (whether it be gold, silver, or blacksmithing) links together material (metal) and specific processes involving heating and hammering so that process and material are given relatively equal importance.

Similar to this are terms such as "wood working," "glass blowing," and "furniture making." All imply action, technical process, and specific materials to one extent or another. However, "wood working" denotes a specific material, wood, rather than a specific working technique. Only secondarily does it imply working processes such as bending, turning, joining, or carving to produce things as varied as bowls, spindles, balusters, or bureaus. Glass blowing, too, is a verb form, but it denotes both a specific material and a specific way of working that material. "Furniture making," on the other hand, refers to the making of specific types of objects without specifying either working methods or material. Furniture, after all, can be made of wood or, as in the case of much Modern and Postmodern furniture, leather, woven fabric, various laminates, metal, glass, plastic, etc.

This categorization of the craft field according to material, working methods, and techniques, and even by the type of object produced (furniture), reflects a long heritage, one that goes back to the medieval guild system, perhaps even as far back as the ancient Roman system of *collegia*. It continues today in college and university art departments, and even museums where areas of collecting are usually designated by material. That this heritage still survives gives some sense of the importance that materials and the technical skills and technical knowledge needed to work them have for the craft field. To draw or paint an image that resembles a bowl is a very different enterprise from making an actual bowl.

Clearly, materials and technique go to the very heart of craft. In fact, the requirements demanded of a craft practitioner lie at the very root of the word "craft." According to the *Oxford English Dictionary*, the word "craft" is of Teutonic origin, where its original meaning had to do with strength, force, power, virtue. In Old English it additionally came to

mean skill or skilled occupation, an ability in planning or performing, ingenuity in construction, or dexterity. In this usage the word "craft" emphasizes the kind of technical knowledge and technical skill required to make an actual object come into being. Skill of this kind was so useful and so extraordinary that in the Middle Ages the word "craft" also became associated with magic and the occult, as in the word "witchcraft," a vestige of which remains in our use of "crafty" for a shrewd or even underhanded person.

Any complexity in terminology in the field of craft, as well as the origins of the word "craft" itself, reflects the very real need of practitioners of craft to focus on the mastery of specific materials and techniques. The importance and even monetary value of this mastery was recognized early on by the medieval trade guilds that generally organized themselves by material; they guarded as "trade secrets" techniques for working material and they limited entrance into the trades by controlling apprenticeships.[2] Such guild practices still survive in the form of modern trade unions like those for carpenters and bricklayers, plumbers and electricians. Some of these practices also continue in the field of craft because without mastery of material and technique it would be impossible to participate, in any real sense, in the activities that traditionally comprise the field.

Internal divisions in the craft field caused by the need to focus on material and technique makes the existence of a shared framework between areas difficult to discern and comprehend. It also seems to undermine the prospect of a cohesive concept of craft and the existence of any common theoretical ground necessary for critical understanding. I believe these differences disappear as soon as one begins to look at craft from the point of view of function. When this is done, the relationship between material, technique, and form becomes clear and meaningful, because practical physical function, what in the past would have been called "applied function," is that element that has been common to crafts objects for millennia, regardless of the material or process of their

2. According to *The Compact Edition of the Oxford English Dictionary*, the word "guild" is probably of Teutonic root and connected to *geld* (money). "The trade guilds, which in England came into prominence in the 14th century, were associations of persons exercising the same craft, formed for the purpose of protecting and promoting their common interest."

making. All the craft objects I have identified above have, at their core, practical physical function; it is practical physical function that unites what otherwise would be distinct areas of activity.

This premise challenges many contemporary views about craft. For example, the inclusion of contemporary nonvessel sculptural objects would be called into question, as would the inclusion of traditional figurines, jewelry, and tapestry. However, for those who adamantly reject the premise based on the exclusion of contemporary nonvessel sculptural forms, I reiterate the questions posed at the outset. How are we to distinguish such work from fine art sculpture? Is it the material, such as ceramic, that makes the difference? Or is it the fact such work demands technical skill? If either of these is the case, why are they referred to as sculptural forms? As for figurines, is it simply size that distinguished them from fine art sculpture? Not only do such approaches completely avoid any intellectual/theoretical engagement with the work in favor of a simple litmus test based on material or skill or size, but they still leave functional objects unaccounted for both as objects and as ideas.

As to the question of jewelry, of which a fuller discussion occurs later in the text, I believe it occupies a position tangential to craft. This is not to say jewelry, or tapestry and figurines for that matter, cannot be works of art. Quite the contrary; as my argument in part 4 will show, I believe in a much less restrictive view of art than that commonly defined by the notion of "the fine arts." My view is one in which most any man-made object can be a work of art. All that is required is for it to possess sufficient aesthetic qualities so that upon viewing it a competent viewer will have an aesthetic experience. Instead, what I am suggesting is that even though jewelry also has a close relationship to the body, as do craft objects, it is not the same kind of relationship, especially in terms of function. The making of craft objects (objects I characterize below as based on the functions of containing, covering, and supporting) involves a conceptual approach to the body that is categorically different from that of jewelry. However, I do think that jewelry's close relationship to the body is one of the reasons why it traditionally has been associated with craft and not sculpture.[3] Another reason why jewelry is associated with craft is that it demands a level of technical skill that today is typically reflected in craft, but not necessarily in fine art practice. As to the ques-

3. For a diagram showing jewelry and tapestry's relationship to craft proper see Figure 28, below.

tion of tapestry, how are we to distinguish it from fine art images, say paintings or photographs? Again, is it material and the demands of technique that link it to craft? If so, are these enough to overcome its emphasis upon image making as opposed to functional object making? I don't think so.

To return to the issue of practical physical function, I have chosen this term purposely to avoid the more common term "applied" (as in "applied art"), because I want to imply a different meaning and because the latter is one with which many craft people take issue. Not only does "applied" seem to stress craft's connection to trade work, to the manual as opposed to the mental, but also to indifferent machine production. The term "applied art" seems to have originated in nineteenth-century England in reference to the practice of applying artistic/aesthetic elements to machine-made functional objects.[4] The impetus behind this movement, common throughout the industrialized world, did not stem from an interest in the artistic/aesthetic as such, but from commerce, from a desire to make indifferently designed and fabricated objects more saleable. It was a market-driven attitude based on the belief that the artistic/aesthetic and the means of design and manufacture are distinct, not integrally related operations. So, in order to make objects more appealing to consumers, what were thought to be artistic/aesthetic qualities were superficially applied to otherwise purely commercial objects of often dubious quality; surfaces were enhanced with decorations in the belief that, regardless of how poorly designed or manufactured the object, people would find them attractive and buy them.

To a great extent the rejection of ornament and decoration in the twentieth century was a reaction to the belief that aesthetic qualities could simply be "pasted" onto an object, that aesthetic qualities are not, in some important way, essential to the object as material and as form.[5] One suspects that today, even though applied function is an important part of the craft tradition, any reference to "applied" is rejected because it still has overtones of the nineteenth-century idea of "applied art." But

4. For more on this see William Morris's 1889 essay "Arts and Crafts Today," 61–70, and Walter Crane's 1892 essay "Importance of the Applied Arts," 178–83.

5. Examples of this rejection include Loos's *Ornament und Verbrechen* (Ornament and Crime), originally published in 1908, and his *Die Form ohne Ornament* (Form without Ornament), originally published as an exhibition catalogue by the Deutsche Werkbund in 1924.

the fact that the idea of function itself is being dismissed by people in the craft field, or at the very least suppressed, has less to do with nineteenth-century ideas of applied art than with the modern theoretical/aesthetic idea that for something to be art it must be nonfunctional. Slivka's essay "The New Ceramic Presence" is an attempt to deal with this situation by broaching the idea of metaphorical function. While metaphorical function is an important concept that reflects the new, post-World War II ceramics, something that will be discussed at the end of this study, many people still feel uneasy about function, metaphorical or not. To garner the same prestige for craft as accorded fine art, they have come to regard function as, at the very least, incidental to craft or, at worst, detrimental.

Unfortunately, by suppressing its functional dimension and tacitly accepting the nonfunctional as a requisite for the aesthetic dimension, craft has allowed the aesthetic terms by which it is judged to be those articulated around fine art. Seeking theoretical and critical support for craft in fine art theory has created an unreasonable, if not impossible, situation for craft, because meaning (in the sense of "to signify," "to have import or significance") as the basis of any theory or critical position about an object must be grounded in that object. As the issue of applied art in the nineteenth century has shown, it cannot be imposed upon an object or borrowed from another class of objects. Dismissing craft's functional dimension from discussion is to dismiss what I see as the normative ground upon which craft originated. It risks leaving the field without something unique from which to shape a theoretical and critical discourse for understanding the craft object.

I also suspect that this lack of a critical ground is one reason why in the late Modern and Postmodern periods craft has been tempted to imitate the forms and methods of fine art (that is, to try to become sculpture or painting or, at least, pass itself off as those art forms). As a result, the search for an aesthetic theory that could provide a critical framework for understanding craft's unique perspective on the world is abandoned, something most apparent when ceramists working in the craft field begin referring to their work as sculpture. This may be expedient in the short term, but ultimately it means the disappearance of craft as a distinct field of artistic activity, which, I think, would be unfortunate.

The concept of practical function avoids any adversarial relationship with fine art and sidesteps preconceived notions about what craft is or should be and forces one to explore the subtle but complex relationship

that exists in craft between function and other elements such as material, technique, workmanship, craftsmanship, and their relationship to conventions of meaning/signification and artistic expression. As I hope to show, in craft these elements form a unique relationship that underlies all activities within the field, a relationship that certainly does not exist in the same way in fine art. Far from undermining the value of craft, practical function can help us understand a constellation of features unique to both the traditional and the contemporary Studio Craft object.

PURPOSE, USE, AND FUNCTION

■ ■ ■

In trying to identify, know, and eventually understand craft objects, it is helpful to begin by examining man-made things generally. One can approach them from any number of categories, including their usefulness and their desirableness. George Kubler, in *The Shape of Time*, argues against use, saying that "if we depart from use alone, all useless things are overlooked, but if we take the desirableness of things as our point of departure, then useful objects are properly seen as things we value more or less dearly."[1] His approach has advantages as long as we don't conflate use and usefulness with desire and as long as we are careful to distinguish between desire and actual need; for while need fosters desire, desire itself may not always depend on actual need; there are many things that we desire but do not need. Another point to keep in mind is that usefulness and function are not necessarily the same; the use to which something may be put may have nothing to do with the functional reason why it was made.

Many man-made things are desired because of an actual need, while others are not. As examples we can take prostheses (artificial limbs) and military weapons of all kinds. Desire in the case of prostheses springs from a genuine need to overcome physical impairment; desire in cases of cosmetic prostheses may come from a wish to appear normal, which is important though not quite the same as correcting a physical impairment. And in the case of weapons,

1. Kubler, *The Shape of Time*, 1.

some people desire them even though they have no actual need; apparently they just like weapons. Society, on the other hand, does not actually desire weapons (or so it is hoped), but having a need for security military weapons are seen as a way to fulfill this need, though this is something peace treaties and mutual understanding pacts may also do. Other man-made things that are desired but do not spring from need in any practical, physical sense are toys and even many works of art. Thus, the connection between need and desire is not always as clear as Kubler suggests.

Rather than focusing on the desirableness of things as a point of departure, I want to approach them in terms of purpose. I am defining purpose in the general sense of an end or aim to be achieved. All man-made objects—simply because they are man-made—must have a purpose for someone to spend time and energy to make them. Whether the purpose was to give pleasure or to make someone whole or to protect someone from enemies or to amuse and entertain does not change this fact. However, the purpose to be achieved, just as in the case of national security, is not to be confused with the instrumental means of achieving it. As I have said, security may be achieved by different instruments including weapons of war, peace treaties, and mutual understanding pacts; these are the instruments that actually function to fulfill, to achieve the purpose of national security. It is in this sense that man-made objects are the actual instruments that function to achieve whatever purpose or end it was that initiated their making.

An advantage of approaching objects from the point of view of purpose is that purpose forces us to examine use and usefulness in relation to function; I am defining function as that which an object actually does, by virtue of the intention of its maker, in order to fulfill a purpose. When we understand purpose in this way it becomes clear that the use to which a man-made thing may be put need not necessarily correspond to either the purpose or the function for which it was made; using a chair as a prop to keep open a door is neither its function nor a fulfillment of its purpose. Making a distinction between use and function in this way is important for craft when one considers that craft objects are often rather indiscriminately characterized simply as objects of use; in this sense use is seen as reflecting craft's purpose. But this position raises questions, not the least of which has to do with craft's relationship to other so-called useful, utilitarian, functional, or applied things—two obvious examples being tools and machines. Are tools and machines

craft objects or are they something else? If they are something else, how and in what way are they so? Furthermore, can the giving of pleasure by an object of pure desire be considered doing something in the same sense that tools and machines do something? Or asked another way, can fine art objects be said to be useful, functional, and applied since it is said they give pleasure? If so, does this mean that craft and fine art are the same category of objects? If not, does it necessarily mean they stand in opposition? These are a few of the questions we must consider, and to begin sorting them out, terms like "applied" (as in applied object), "use" (as in object of use), and "function" (as in functional object) need to be carefully examined. I should say at this point that I think craft objects belong to a large group of objects, all of which have an applied function; but I also think craft objects can be distinguished as a separate class within this large group by the nature of their functions. I hope my reasons for thinking this will become clear as we sort through the above list of terms.

According to *The Oxford English Dictionary*, "applied" means "put to practical use; practical, as distinguished from *abstract* or *theoretical*." Thus in the strict sense—and this is the sense in which I would like to employ the term—one could say that applied objects are those whose purpose is to fulfill practical as opposed to theoretical, abstract, or imaginary aims; they are the actual objects, instruments, if you like, made to carry out or perform some practical, physical function. Thus applied function differs from purpose in that once purpose has been recognized or conceptualized as an end or aim, an actual physical object must be made that is capable of performing/carrying out a specific physical "operation" to realize that purpose; this "operation" shall be designated the object's function.

In this scenario, purpose initiates function and function initiates object, object being the physical solution to the problem posed by purpose.[2] For example, while the purpose that initiated the making of a canteen and a sheep-skin coat may be the same (survival, one in the desert and the other in winter cold), their applied functions (the way they instrumentally solve these problems) are different—one is by carrying water,

2. While we may not always know an object's original purpose or its function, as in many old tools that are no longer necessary, we don't actually have to. From their general form we can surmise, as does Kant, that they are tools and as such are applied objects. For Kant's views see his *Analytic of the Beautiful*, 45.

the other by keeping the body warm. Similarly, while the purpose that initiated the making of carpentry tools is the same, to aid in construction, their specific applied functions differ—some are made for cutting, others for hammering, sawing, chiseling, or planing. Purpose is the aim that instigated the making of an object; applied function is the specific practical "operation" intended to fulfill that purpose or aim; and an applied object is the actual thing, the instrument that functions to carry out the "operation."[3]

Having said this, let us now turn our attention to the question of use and function, especially as regards the idea of "useful objects." Not only does reference to useful suggest the opposition "useful versus non-useful," it isn't helpful in understanding the nature of man-made objects because, as I have said, use need not correspond to intended function. Most if not all objects can have a use or, more accurately, be made usable by being put to use. A sledge hammer can pound and it can be used as a paperweight or a lever. A handsaw can cut a board and be used as a straight-edge or to make music. A chair can be sat in and used to prop open a door. These uses make them useful objects, but since they are unrelated to the intended purpose and function for which these objects were made, knowing these uses doesn't necessarily reveal much about these objects, nor does it always help identify them as things—after all, even an object found in nature like a stone can become a "use object" simply by being put to use. Furthermore, the use to which something may be put may change, but its originating function always remains constant. For these reasons, we must not think of "use objects" or "useful objects" or "things of use" as synonymous with applied objects. Applied objects are objects with an intentional applied function; they are objects intended to fulfill the purpose that initiated their making.

The word "applied," as in applied object, is more appropriate and revealing than "use" because "applied" implies intention, a response to a specific purpose. In this sense, to identify an object as an applied object

3. It may seem a conceit to separate purpose from need. If, for example, I need to cut a piece of bread and I use a knife, it seems that the purpose of the knife is to cut bread. But if I cut bread with a sword or even a saw, does this make their purpose the cutting of bread? Also, what about things I don't need, such as toys or basketballs? They have a purpose, but not a need. It makes more sense, at least for our study, to think of people as having needs and desires (the need to cut bread and the desire for entertainment or physical exercise that is fun) so that objects are made whose purpose is to fulfill these needs and desires.

is to say it is an object made with an intention to fulfill a purpose; it is an intentional object. On the other hand, the terms "use" or "useful objects" only denote something as usable for some end. That stones can be *used* as hammers or as pillows or as scrapers does not change the fact that they do not have an origin in purpose; strictly speaking, they possess neither intention nor purpose nor function. Only that for which a thing is intentionally made can properly be considered its function and thus part of its true purpose for being brought into the world.

What this means is that, as opposed to use or usefulness, practical physical function is something inherent to and never imposed on an applied object. It is built into it by its maker and exists at the very core of the object as a physical entity, a formed piece of matter. This is why an empty chair or empty pot still exhibit their intended function. It is also why how some*thing* is used, even a man-made thing, doesn't necessarily reveal much about it. Though a ceramic pot may be used to hammer tacks and a figurine may be used as a deadly weapon, such uses do not define these objects. That's why we may identify a specific figurine as a murder weapon but we can't identify every figurine as a murder weapon nor every murder weapon as a figurine.

With applied objects, because their function always has its root in the purpose that initiated their being made, function always reflects and is reflected in the applied object's physical make-up, in its physical distribution of matter. With use, because it is *any* activity or operation of which some*thing* happens to be capable of being put, it can even be imposed on an applied object regardless of the applied object's originating purpose (see Figure 4). As a result, use isn't a determinant of an object's physical form the way function *always* is.

While we will have more to say about the connections between physical form and function, for now we can conclude that applied objects are objects bound by the idea of a purpose *and* by the intentional act of *form giving*. Form giving is a willful act through which a thing is actually made as a specific physical form embodying a specific physical function. With objects of nature, since it is merely a happenstance that some have a physical shape that is useful, matching a preexistent shape to an existing need or function is to recognize their usefulness; it is an act of "shape-matching." (An act of *shape matching* also can be said to occur when man-made objects are used for something other than their intended function.) *Form giving*, on the other hand, is the creating of a specific form to fulfill a specific function; it is applying a form to a function.

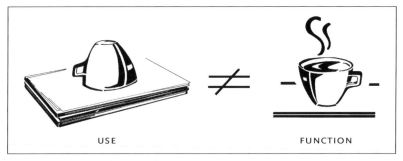

USE FUNCTION

FIGURE 4. Examples of use and function.
Use does not equal function because the use to which objects can be put needn't correspond to their intended function. As this example shows, a cup's use as a paperweight, being unrelated to its function as a container, doesn't reveal much about its purpose or about it as a physical entity the way function does. About all this example of use tells us is that a cup is heavier than a piece of paper, something true of an almost unlimited number of objects.

For these reasons it holds that while all applied objects are necessarily objects of use, all objects of use are not necessarily applied objects.

Since applied objects have function as an essential part of their physical form as made objects, function remains long after radical changes have occurred to the social and cultural institutions that originally brought them into being. In this sense function exists as something independent of social and historical contexts, an observation apparent to anyone who has seen an ancient Chinese urn or a piece of Louis XV furniture. Despite being produced for exalted personages whose cultural milieu is socially, historically, and temporally far removed from our own and despite the vicissitudes of time that may have eroded their specific cultural significance, their applied function is still quite apparent.

A final point should be noted about these objects. Besides being applied objects, they also are recognized as extremely sophisticated examples of craft, which is to conclude that craft objects traditionally have been included among objects having an applied functional base. This means craft objects can be understood as belonging to that larger class of objects that we have been referring to as applied objects because they also are instigated by purpose and formed by applied function. However, the relationship between applied objects generally and crafts objects specifically is complex and needs to be explored in some detail in order to understand how craft objects are a separate class within the larger category of applied object.

TAXONOMY OF CRAFT BASED ON APPLIED FUNCTION

■ ■ ■

Though craft objects, by virtue of their applied function, belong to that larger group of objects I am calling applied objects, this does not mean all applied objects are craft objects. Craft objects have unique features that define them as a separate class of applied objects. This is not always apparent, as we can see by referring back to our earlier list of craft terminology, which includes such commonly used terms as "ceramics," "glass," "fiber," "smithing," "woodworking," "furniture making," "weaving," "quilting," and "jewelry." The difficulty these terms present, certainly for grasping whatever common relationship the activities of craft may share, is that some (such as "ceramics" and "glass") focus on material; some (such as "weaving" and "quilting") refer to technique; and some (such as "smithing") suggest, if only vaguely, material and technique; while a term like "furniture making" designates certain specific types of objects (such as beds, tables, and chairs). They sometimes overlap without, however, actually defining the basic nature of craft. What they do provide, however, is twofold: one is a preliminary list of objects and activities to be considered as composing that field called craft; the other is some sense of the importance that material and technique and even form have for the craft field. As I have already argued, the field long ago organized itself around these features, and while I believe function the most important, these other features cannot be dismissed out of hand. So, before arguing for function, I want to show how these other features are not sufficient for our purpose of understanding and classifying craft objects.

One way of establishing a classification system, what is called a taxonomy, out of the diverse objects that compose the field is to group individual objects into "sets" around salient features they have in common. If this is done, relationships between sets can be explored for those features that can then be used to define a larger grouping called a class, in this case the class "craft."

A taxonomic system based on material would be one corresponding to the five major media areas in craft. Such a material-type classification would yield sets of objects grouped around the traditional categories of ceramic, glass, wood, natural fibers, and metal. Examples of sets within a "materials-based" taxonomy would be as follows:

Ceramics	Glass	Wood	Fibers	Metal
pots	glasses	bowls	sweaters	chairs
bowls	bowls	chairs	shirts	bowls
bottles	bottles	trays	quilts	trays
vases	vases	bureaus	pants	vases
mugs	mugs	mugs	rugs	mugs
teapots	teapots	beds	Afghans	teapots
coffeepots	coffeepots			coffeepots
plates	plates	plates	blankets	plates
platters	platters	platters		platters
casseroles	goblets	cabinets	baskets	baskets
pans	phials	tables		pans
flower pots		chests		

From the historical perspective of craft these are logical groupings. However, they are not very helpful because they tell us little about these objects as objects. This is why so many objects can be placed in more than one set; even sculptures and other non-applied objects can be included in several of these categories.

A process or technique-based classification would be another historically important way to organize craft objects, but it would have the same shortcomings because it would also allow objects to be in multiple sets, as can be seen from the following examples:

Turning	Blowing	Throwing	Weaving
bowls	glass bowls	clay bowls	rugs
bottles	glass bottles	clay bottles	scarves

vases	glass vases	clay vases	baskets
spindles	glass mugs	clay mugs	sweaters
balustrades	glass dishes	clay dishes	
handles/pulls	goblets		

A form or morphological classification likewise has historical precedents and would group objects into sets according to their two- and three-dimensional form; a three-dimensional classification could include cuboid shapes (such as boxes and chests) and spheroid shapes (such as pots, bowls, and baskets) while a two-dimensional classification could include sets of "flat" shapes that are rectangular (such as quilts, textiles, and blankets) and sets of "flat" shapes that are circular or ovoid (such as dishes, plates, and rugs). Examples of sets within a "three-dimensional form-based" taxonomy would be as follows:

Cuboid Forms	Spheroid Forms
boxes	pots
drawers	vases
chests	bowls
bureaus	baskets
caskets	goblets

Examples of sets within a "two-dimensional form-based" taxonomy:

Rectangular Forms	Circular Forms	Ovoid Forms
textiles	dishes	dishes
quilts	plates	rugs
blankets	rugs	
trays	trays	trays
scarves	shawls	

All are, to some extent, valid because they are derived from commonly employed materials, processes, or obvious formal features that historically have been employed to identify craft objects. None, however, provides a taxonomy that groups objects based on unique characteristics. That is why objects can overlap several sets at the same time (a square box could be woven of wood strips, reeds, or wool, or it could be carved from a single block of stone or made of joined planks of wood; similarly, a spheroid vase could be thrown, blown, turned, or hand built).

Other taxonomic sets that could be created from these same objects include a "topographical" taxonomy based on surface description; a simple "phenotypical description" based on the general external properties; and a "typological" taxonomy based on object type (e.g., furniture or vessels). None of these will do either because all approach the object from the point of view of appearance. But appearance alone does not direct us beneath the surface, as it were, to gain a deeper understanding of the object. To gain such an understanding we need to connect the object's purpose for being made to its function and to the processes and materials employed to make it capable of carrying out its function. A taxonomy of applied function encourages us to compare the function of craft objects to that of other objects within the applied object category (for example, tools) so we can more fully understand craft objects and the concept of function as it relates to them. And, understanding more fully function in craft objects is essential to our main concern—craft's possible status as art—because fine art aesthetic theory has made function a central issue in denying an object the status of art.

Approaching craft from the concept of applied function also helps us solve the problem that form, material, and technique, as separate yet historically essential features of craft, pose for the field. Function forces us to understand them, not as discrete components, but as a constellation of interrelated elements residing at the core of the craft object. Thus, rather than approaching the field simply as a group of unrelated activities producing objects of widely divergent forms and materials worked through various diverse techniques, a taxonomy based on applied function provides a basic, unified approach to the field. From the vantage point of function, craft objects come together into coherent groupings/sets showing craft to be a field of shared concepts, rather than a loose grouping of objects without common ground or shared norms bound together solely by historical tradition.

One example of a set based on function would be containers. A partial list of such objects—which actually compose a large portion of the class called craft—is shown below:

Containers
bowls
jugs
vases
pots/pans

cups/mugs
glasses
pitchers
bottles
baskets
bags/satchels
boxes
case furniture
trunks/caskets/coffins

While some are round and others square, some of wood and others of glass, and some thrown while others woven, all share the same applied function: that of containing. So, while the materials, techniques, processes, and skills employed to make them vary greatly, the concept of containing unites all of them.

In addition, there are two other function-based sets: one can be called "covers" and the other "supports." The set called "covers" are objects that cover the human body. The set called "supports" includes objects whose function is to support the human body. A partial list of objects composing these sets would look something like this:

Covers	Supports
clothing	beds
quilts	chairs
scarves	stools/benches
blankets	tables/desks
shawls	sofas

These three sets seem to include most, if not all, of the basic and essential objects generally thought to compose the field of craft. It may be possible to add other sets. A fourth might be shelters, which would include architecture. H. W. Janson writes in his famous textbook *The History of Art* that "architecture is, almost by definition, an applied Art."[1] The reason I mention this is that even though applied art and applied objects are related by the idea of applied function, they are not the same. By accepting the proposition that craft is part of that larger group called applied objects, admission into the group is limited to objects (to things

1. Janson, *History of Art*, 16.

that can be picked up and moved about and also are of a size that doesn't dwarf the human body). While architecture clearly is an applied art, it can hardly be thought of as an object, certainly not in any normal sense of the word. The requirement of objecthood also excludes from the field of craft applied arts such as graphic design, interior design, illustration, and typography. In view of this, while shelters may be thought of as a set that has some connection to the sets that constitute the class craft, they are not objects because of their large size and immobility, and therefore, strictly speaking, cannot be considered part of craft.[2]

Without the rule of function to connect them, each of our sets would be divisible into a number of subset groupings suggested by traditional craft terminology, as has already been discussed.[3] Focusing on applied function avoids this even though some things could be moved from one set to another. For instance, one might argue that mittens are containers since they "contain" the hands or that a tent is a container since it is small, mobile, and contains people. Though one could look at things this way, it would seem rather odd. Ordinarily, "contain" is used in reference to things or substances whose material distribution would drastically alter if not held together physically. To say that one's hands are "contained" by mittens is to imply they would otherwise somehow scatter or change shape. By the same token, it seems more proper to say "tents shelter, not contain people" since people generally can come and

2. Interestingly, in French, Italian, and German, the word for furniture is "mobile" (movable), presumably because furniture, in its objecthood, is movable; architecture, by contrast, is immobile, stationary.

3. For instance, subsets can be defined by the unique demands of technique and material. The set called "containers" can be divided into subsets (a) according to material (ceramic, glass, wood, etc.); (b) according to technique or process (turning, weaving, blowing, etc.); and (c) according to type or shape (box, bowl, vase, dresser, basket, etc.). The same is often done to the set called "covers"; it can be subdivided into similar subsets (a) according to technique or process (weaving, felting, knitting, etc.); (b) according to type or shape (clothes, blanket, quilt, shoes, hat, etc.; clothes can be further subdivided into shirt, dress, pants, etc.); and (c) according to material (leather, plastic, cloth; cloth can be further divided into specific materials such as wool, cotton, synthetics, etc.). And the set called support can likewise be subdivided: (a) according to type (some kinds of furniture—beds, chairs, tables, couches); (b) according to material (wood, cloth, steel, glass, etc.; such materials can be further divided according to specific kind of wood or cloth or steel, etc.); and (c) according to process (turning, joining, carving, bending, etc.).

go as they wish. (Nevertheless, it would perhaps not be totally imprecise to say "jails contain prisoners" and that "grammar-school classrooms contain students," something with which many an eight-year old would agree on a warm spring afternoon.)

Sometimes the peculiar way things are used (as opposed to their intended purpose) might also suggest shifting from one category to another. A large container could be used as a shelter, something all too commonly seen among the homeless in American cities today. Nonetheless, it would be a rather sorry social circumstance if cardboard boxes became socially accepted shelters. On the other hand, one could speak of a warehouse as a kind of container for goods, though again not in the generally accepted sense of a container as an object or in the sense of keeping material from dispersing, though a grain silo might be an interesting exception if it were small enough to be an object rather than a building.

Finally, there are also things that are not covered by these three sets. Jewelry, tapestries, stained glass, mosaics, and ceramic tile are some of them. Even though they are generally spoken of as part of the craft field, they don't fit very comfortably in any of these sets as I have defined them because they are neither containers nor covers nor supports; and generally, they also don't possess a sense of objecthood. By sense of objecthood I mean a sense of thingness, of self-sufficiency. Because of this, what to do with them is a more significant question than whether or not to shift an item from one set to another. One could make another craft category for them, but it wouldn't be commensurate with our previous three. For one thing, the previous categories all adhere to the rule of applied function; for another, they all meet the requirement of objecthood. The solution would be another category to be called adornment or decoration. It would not be a strictly craft category, but one that existed somewhere between craft and fine art (see Figure 28). I say this because craft objects as well as works of fine art, architecture, and any number of other objects all can be decorated; even tools, machines, and weapons can be decorated. Buildings traditionally have been decorated with moldings, cornices, and patterns and designs, both inside and out. Works of fine art also have been decorated with moldings and frames as in the early Northern Renaissance in Europe—here I am thinking of the abundance of Gothic architectural flourishes that pass for frames in Flemish paintings. Perhaps more important, there is Pattern & Decoration, a 1970s style of painting that was composed, as its name implies,

of patterns and decorative elements; as the case of these works demonstrates, even a painting itself can be composed of decoration (not just used as decoration). Surely this would not make these paintings craft objects any more than it would make decorated buildings craft objects.

Granted, it could be argued that I am not making a strong enough distinction between decorating and being decorated, between that which does the decorating and that which is decorated. But isn't there a tendency in good decoration for that which does the decorating to lose itself in the thing it decorates, to become one with it, something that did not occur in much nineteenth-century applied art? Furthermore, isn't this why decoration usually lacks a sense of objecthood as in the patterns and designs on walls and floors? "Objecthood," as I am using the term, refers to an object's quality of self-sufficiency, something that goes beyond simple physicality. Since a wall could be decorated in paint, ceramic tile, or metal with the exact same pattern, what would be the difference between them? And, could either claim a sense of objecthood through independence and self-sufficiency? I would answer no to both questions. In their basic effect there would be no substantial difference between them; moreover, each would lack a sense of self-sufficiency because each would become part of the wall it decorates. Since all three of these forms of decoration can be very moving aesthetically, this is not a value judgment; it is simply an attempt to understand what they are, which is a different issue altogether.

Another important way decoration differs from craft objects is that it does not have a physical function. Certainly ceramic tile may have a physical function as floor or wall covering, just as would a coat of paint. However, such a physical function is not dependent on whatever decorative elements they may have; both could be completely devoid of any decoration whatsoever and still function perfectly well in their capacity as floor or wall coverings. For this reason they should be understood simply as surface treatments; being elaborately adorned with decorative patterns and designs cannot change this and make them craft objects; adornments can't give them a sense of objectness or physical function. They would best be characterized as building decorating materials more than anything else. Much the same can be said of mosaic tile unless it is used in the manner of Roman and Byzantine mosaics; then it is more properly considered a picture and treated similar to fine art painting. As to stained glass, it can be thought of as having physical function since a

window is basically an opening in a wall for light and the glass a climate barrier against wind and weather. In this capacity, however, it would lack objectness being part of a building and, therefore, could not belong to the realm of craft objects. Even more important is the fact that what is unique and definitive about stained glass is its staining. However, the "staining" (the image or decoration in the glass, whether actually "stained" or painted on with transparent enamel pigments) does not have an applied function any more than does the image in a mosaic or the pattern in a ceramic-tile decoration. Though illuminated by sunlight, a stained glass image, if a picture, would belong to the realm of fine art; if an abstract pattern and design, it would probably belong to the realm of decoration as part of a building.

Many of these same observations apply equally to tapestries which are basically covers and can be used on beds or hung on walls to protect the body against cold. Their imagery, which is their defining characteristic, however, has nothing to do with their applied function as covers; when hung on walls as pictures they are rightly judged as belonging to the realm of fine art pictures—this is why they are regularly collected and exhibited in fine art museums, as are Roman and Byzantine mosaics and medieval or Tiffany stained glass windows.[4] When tapestries are treated as covers, their designs or images would be decorations or adornments on a craft object.

This brings us back to the question of jewelry. While it has traditionally been considered part of craft, as opposed to decoration or adornment, simply defending it as craft because of tradition or convention isn't reason enough; more substantial reasons need to be mustered. After all, it is also conventional to claim that craft cannot be art. As I have said, I believe one reason jewelry has long been connected to craft has to do in part with the fact that making it requires a good deal of technical and manual skill, something typical of crafts and, in the past, also of fine art.

4. In this regard it is worth noting that tapestries were generally modeled on paintings and their cartoons were made by painters and then turned over to weaving workshops to execute. According to Fleming and Honour, by the late Baroque period under the guidance of Charles Le Brun in France, tapestries were "rendered with an attention to detail, chiaroscuro and modelling which could hardly be bettered in oil paint." They go on to say that by the eighteenth century "tapestries came to be regarded as a very expensive alternative to oil painting." See Fleming and Honour, "Gobelins Tapestry Factory," 334–35.

Because of these technical and manual demands, jewelers traditionally belonged to goldsmith guilds beginning in the late middle ages. However, this is only a partial explanation since painters and sculptors also belonged to guilds—painters belonged to woodworkers guilds because they painted on wooden panels and sculptors belonged to metalsmith guilds because they worked in metal. By the modern period, while the technical and manual skill demands of jewelry and also of crafts generally remain quite high, such demands basically disappeared from fine art. This change, which will be discussed in detail in Part 4, has made jewelry seem closer to craft than it actually is.

Another reason jewelry has a closer connection to craft than fine art is that both jewelry and craft have a strong connection to the body. As I will argue later in detail, craft objects relate in their purpose and in their function to the body, similar to the way jewelry does. However, there is a substantial difference. Besides possessing a sense of objecthood, craft objects are formed around physical purpose and physical function, motives absent from jewelry. Yes, jewelry does have purpose, but its purpose typically is related to status and wealth; sometimes it has an apotropaic function—to protect by warding off evil, as with amulets or a lucky rabbit's foot. However important, these are social, not physical functions. Furthermore, as I have already said, jewelry doesn't possess a sense of objecthood. Again, what I mean is that even though it is something physical and can be held and carried about, it can't stand alone as something independent and self-sufficient. By definition, it always rests on the body as an adornment of the body and therefore is dependent upon the body as its support. Considering this, it is entirely reasonable to argue that the word "jewelry" is a very specific term, one used to designate a very specific type of decoration, decoration intended to enhance the human body. This is not to argue that there is a categorical difference between jewelry and other types of decoration. What would the difference be between pearls and elaborate gold filigree decorating the human body, say as a necklace, and decorating a chalice or reliquary or bookbinding? It would seem there isn't one since the purpose in all cases is to enhance the "thing" being decorated. Granted, jewelry is sometimes displayed off the body, say on a stand; but this is not its intended setting, only a method of storage or display. Moreover, even if it were an intentional display strategy, one would still have to imagine it on the body for it to be understood properly, which is why jewelry stands are shaped like the human body.

A more significant objection to classifying jewelry as decoration/ adornment may be raised with some contemporary jewelry. Occasionally contemporary jewelry departs radically from tradition by being made oversize for display on a wall or floor. As radical departures from convention as such cases are, they prove the rule because they are actually treating jewelry not as jewelry, but as sculpture. Their disturbing effect comes from the way they reject (perhaps flaunt would be more accurate) jewelry's normal mode of being; they undercut jewelry's expected connection to the body by size and by intentionally suggesting a sense of objectness and self-sufficiency in the manner of sculpture. Such works, by their very differences from what is traditionally understood as jewelry, point up the traits that have defined jewelry for millennia.

For these reasons it makes more sense to classify jewelry as an adornment or decoration. After all, in the way they actually operate, there is little difference between jewelry, tattooing, scarification, and body painting—none has a sense of objecthood and none can stand apart from the body. Like jewelry, adornments and decorations always need a support, which is why most objects, even craft objects, can be adorned and decorated. Even things like fibula, pins, and tie clasps, which function physically as fasteners, can be adorned or decorated with designs and jewels (however, in these cases, we should not confuse the decoration with the object being decorated). In some societies a person's teeth are adorned with jewels, typically a diamond on a front tooth.

Considering this, as a category, jewelry is more logically located with other "things" that are obvious adornments than with craft objects. Such a departure from convention may disturb some, but it is entirely consistent with the argument that I am trying to make. Furthermore, as I will demonstrate throughout this study, there is really very little logic to the craft conventions that have come down to us over the years. My purpose here is to suggest some logical ways to understand craft based not on convention, but on the objects themselves.

To reiterate, because jewelry is so radically different from craft objects as I have so far identified them, a separate category called "adornment" or "decoration" needs to be established. Besides jewelry, such a category would include tattoos, scarification, body painting, and patterns and designs in fabrics, on roofs, and in tiles and window glass and the patterns and designs found on buildings and on things of all kinds, including craft objects. When seen in this light, the category "adorn-

ment" or "decoration" would be one located somewhere between craft and fine art, but would not be the same as either. Making such a separate category is not to imply "things" like jewelry are unimportant or that they cannot be art; rather it is to say they are different from craft objects proper.

DIFFERENT APPLIED FUNCTIONS
TOOLS AND CRAFT OBJECTS

■ ■ ■

So far the common properties I have attributed to the class craft are objecthood and applied function. This is well and good except objecthood and applied function are features common to a great variety of man-made things, including tools and even some simple machines, not just craft objects. Perhaps this is another reason why the term "applied," as in applied art or even applied object, is resisted by many craftspeople. It not only suggests that aesthetic qualities can simply be applied to objects, but in its imprecision it lumps together craft objects with all variety of other functional things; the suggestion being that all functional, applied objects are essentially the same, that function is function and there is no need to distinguish between different types of function. This helps explain why the term "craft" has traditionally been used to refer to things with applied function like cutlery—knives, forks, ladles, spoons, spatulas. But, tradition aside, should cutlery be considered craft just because it too is functional? Is there a strong enough connection via function between it and tools and craft objects that is compelling enough to include them all in the same class?

What I wish to do here is twofold: first, to show that tools and craft objects function very differently and therefore not all functional objects are the same even though all are related as applied objects; second, to show how the functions carried out by craft objects are unique to them and not a feature of other applied objects. Doing this is an important prelude to better understanding function as a concept central to

the origins and identity of craft objects; it also provides background for the discussion in Part 3 of design and the machine-production of functional objects.

To answer the above questions I would like to begin by examining more closely the terms "practical use" and "applied function." When generically referring to the realm of the "practical as opposed to the abstract," terms like "use" and "function" lump all practical, functional objects together, thereby erasing subtle differences in kinds of uses and types of functions. Teasing out these differences will show how craft objects, dinner flatware, tools, and machines, as functional objects, both relate and differ from each other in subtle but substantial ways.

Merriam-Webster's Collegiate Dictionary defines a tool as "something (as an instrument or apparatus) used in performing an operation . . . a means to an end." In *The Oxford English Dictionary* a tool is defined more specifically as an instrument of manual operation, "usually, one held in and operated directly by the hand." Following this, a host of things like hammers, knives, axes, hatchets, adzes, sickles, chisels, awls, files, rasps, saws, hoes, and shovels would be identified as tools. Their applied function generally entails adding, subtracting, or refiguring material—more specifically, cutting, piercing, tearing, pounding, grinding, spreading, and so on. Cutting tools would include those that sever material, such as knives, razors, axes, hatchets, chisels, sickles, hoes, shovels, and planes. Piercing tools would be those that are forced into material without necessarily cutting it, such as picks, plows, and needles. Tearing tools (as opposed to cutting or severing material) include all manner of scrapers and, perhaps, saws. Pounding tools include hammers, adzes, clubs, sledges, and maces. Grinding tools work by friction and abrasion and include all sanders, grinding stones, and wheels, and, perhaps, rasps and files. Spreading tools tend to add material and include things such as brushes and various kinds of trowels and putty or palette knives.

Considering these applied functions, we can say a tool is something used directly by the hand with an intention to make some*thing* by doing something to material. Because tools are used to make other things, they can be classified as objects having practical function, but they cannot be considered self-contained or self-reliant things that exist in and of themselves; they are not ends in and of themselves. As Arthur C. Danto reminds us, Heidegger astutely "observes that tools form systems, so that any given tool is defined with respect to the remaining

tools in a systematic totality . . . a totality of tools. Thus the hammer refers to the nail and the nail to the board and the board to the saw and the saw the adze—and these to the whetstone." In other words, the nail could only have been invented as part of a larger system from which it gets its "meaning."[1] A tool is always instrumental, a means to another end. As such, a tool is a thing normally used in the process of bringing an independent, self-contained thing into being. Tools carry out tasks and thus belong to that group within applied objects that can be said to "work." In this sense, the purpose of the chisel, plane, file, hammer, saw, and all other such tools is to bring self-contained things, things that are ends in and of themselves, into being.[2]

Furthermore, as an instrument that works, a tool is a kinetically dependent object; it always requires someone or something to activate it, to bring it into operation. It needs someone to make it "work." Once this activation stops, once energy has ceased being put into the tool, it stops functioning, though it retains its "tooling" potential, its ability to "work." What this means is that, in its fullness as a functioning instrument, a tool is as much energy in action as it is an object in motion. When a tool is functioning, when it is being put to "work," energy and object come together as motion geared to practical, instrumental purpose.

From this we can conclude that a tool is some*thing* with a "tooling" potential and that a thing becomes a tool in the process of being put into action, of being put to "work." This definition helps us better understand tools, but since most if not all things have a "tooling" potential of some sort (that is to say, most things can be put to work), how can tools be identified as specific things separate from other things in the world? For instance, not only a stone, but also a cup can be used to hammer a tack. When a cup is used in this way, one probably loses one's morning coffee, but does the cup also lose its identity and temporarily become a hammer? Or does it retain its identity and become some*thing* being

1. Danto points this out in his "Art and Artifact in Africa," 106. Unfortunately, Danto seems to include craft objects along with tools as system dependent, with which I don't agree.

2. While this process may not always be direct (e.g., a tool may be used to make another tool), ultimately, tools are created to be used in a process or processes to make things that are self-sufficient, self-reliant, and self-sustained. In this context, it is significant that while tools are normally used to make craft objects, craft objects are not normally used to make tools.

used *as* a hammer? And what about a stone? Is it still a stone if it is used to hammer or is it now a stone hammer?

I think to understand what some*thing* is one needs to understand how it came into being. As I have already argued, use alone seldom accurately indicates what something is (see Figure 4). If someone were to use his or her head as a battering ram, it would hardly be an indication of what a human being is. In the same way, that a stone is used as a hammer tells us little about what a stone actually is as a thing among other things in the world (except, perhaps, that it is hard).

Thus, the fact that something is put to "work" by being used *as* a tool does not make it a tool. We know that early humans used many different things they found in their environment *as* tools simply by exploiting their "tooling" potential. Those that worked better came to be preferred, but they were still not tools in the strict sense of the word. Use of found objects is probably the first stage in the evolution to tools proper and can be called the "object-matching stage," that stage when a specific need was more or less matched to an existent object. At a certain point people must have become dissatisfied with having to search for natural things with a latent "tooling" potential, so they began enhancing the "tooling" potential of found objects by reshaping or adapting them. By chipping the cutting edge to sharpen it or rounding the grasping section to be more firmly held, found objects were adapted to better suit a specific task. At some point people moved beyond this "adaptive stage" and actually began making things so that they functioned even better for a specified task.

In this latter instance, "tooling" potential was transformed from a feature latent or hidden within a found object to a feature made visible by being physically manifested in an object. It is at this stage, the "formed-object stage," when "tooling" potential was no longer a matter of serendipity, but part of the "thingness" of the thing, that the first genuine tool can be said to have been made.[3] In this way genuine tools can be said to have come into existence through a sequence of events in which the search for found shape to match a specific need eventually became a

3. In many modern tools the identity of the tool is invisible because it is no longer to be found in its "thingly" character. For instance, a modern cutting tool need not have a specific shape, just a cutting potential; a welding torch, a laser cutter, a knife, and a saw look completely different as objects, but in their potential they are the same even though the former two subtract while the latter two sever or tear material.

search for material that could be suitably transformed into a functional form capable of fulfilling that need.[4]

The implication of this, of moving from "object-matching" to "object-forming," regardless of how many intervening steps occurred, is of consequence in and of itself because going from looking for usable form to looking for usable material to be formed marked a profound change in both object and attitude. In terms of attitude, looking for material that was still divorced from a usable form meant looking for raw material; this clearly involved a greater degree of abstract engagement than did looking directly for a usable object. In terms of object, at the "formed-object stage," the object now possesses actual formed form; this is in marked contrast to both the "object-matching stage" and the "adaptive stage," stages in which the object possesses only mere or informal form. Formed form always stands in opposition to informal or randomly shaped material because formed form is the result of a conscious organization of material by a maker. As such, formed form always betrays intentionality in its making and therefore can be said to be ontological while informal or random form cannot.

Consequently, that some*thing* is capable of being used *as* a tool because it has latent "tooling" potential is not enough to qualify it as a genuine tool. Not only do genuine tools stand ready at hand to have their "tooling" potential activated, to be put "to work," as it were, through the input of kinetic energy, but with genuine tools, "tooling" potential is visibly manifested within the tool itself because it is intentionally made as part of its "thingness" as a physical entity. For these reasons, a cup used as a tool to hammer a tack retains its identity as a cup just as a stone used in the same way remains a mere stone. Even though it is

4. In relation to this scenario, Frank R. Wilson writes that "tools did not become complicated in their structure, nor were they kept and transported for long periods by their users, until quite recently [in prehistoric terms]." Wilson goes on to write that "it is a virtual certainty that complex social structure—and language—developed gradually in association with the spread of more highly established tool design, manufacture, and use." See *The Hand*, 30, and also 172–73, where he notes that only humans make polylithic tools (complex tools that are bound together rather than dependent solely on gravity as are tools used by animals). Also, Christopher Wills says the oldest hafted ax (polylith ax) is ca. 37,00–45,000 years old from New Guinea. This suggests a confluence of tools with the oldest cave art from France and North Italy and the development of fully modern humans; see *Runaway Brain*, 104–5.

used *as if* it were a tool, a stone still cannot be said to have purpose or function.

From these observations it can be concluded that the way something is used may not necessarily reveal anything significant about its identity as an object. A stone used as a doorstop tells us something about its weight relative to a door; but, since a chair or a statue can also be used as a doorstop, this use alone doesn't reveal much about the stone or the chair or the statue. Only when use coincides with intention does use become one with function; only then does use become a meaningful indicator. When the stone is re-formed to make manifest a "tooling" function as its "thingness," it becomes a stone hammer. Because of this, we can say that, *though all tools have a "tooling" potential, all things with a "tooling" potential are not necessarily tools.*

The point of this discussion is to make clear that, though tools relate to craft objects in manifesting instrumentality as applied function in their "thingness," they still are not the same. Tools are system dependent, requiring the input of kinetic energy; this energy, associated with motion as tools "work" to carry out their tasks, is consumed in the "tooling" process. For this reason, tools can't be considered self-contained, self-reliant entities nor ends in themselves. Craft objects, however, don't "work." In their applied function they "operate" without the input of energy from an outside agent. In fact, one could argue that they "operate" in a way that is the opposite of tools because they preserve energy; craft objects keep energy constant by resisting transference or dissipation of energy through kinetic or other means.[5] Containers contain by resisting the force of gravity to level their contents; something similar happens in supports as they support the body. Covers function to achieve constancy by resisting the dissipation or addition of energy. In this important sense, craft objects are self-contained, self-reliant objects that function without need for kinetic energy, the energy upon which tools are dependent. So, unlike tools which are always concerned with using and directing energy in motion in order to make things, craft objects are typically concerned with preservation and stasis.

This leads us back to the question of cutlery. Though they are func-

5. In his essay "The Thing," Heidegger says the jug's void "holds by keeping and retaining what it took in." Though he is referring to something material, craft objects "keep and hold" in the more precise sense of resisting the dispersal/dissipation of energy. See Heidegger, "The Thing," 171.

tional objects traditionally associated with the field of craft, in light of the above discussion, they cannot actually be considered craft objects in the strict sense in which I have defined craft. Cutlery may require a high degree of skill to make, but not all things that are the product of the skilled hand are craft objects. Cutlery, as system dependent, are not ends in themselves, but are instruments used to do something to some other material. And as instruments, they require input of energy to activate them, to make them "work." From this it seems reasonable to conclude that despite their traditional association with the craft field, cutlery are not strictly craft objects but are more akin to tools intended to be operated at table.[6] Their association with craft, as is the case with many other hand-made things, comes in part from tradition and from the technical and manual skill required to make them. This is why their makers historically belonged to guilds. Cutlery also has a long association with craft objects in another way; they are used at table with containers like tureens, bowls, and plates. Neither this nor the fact that something is made by hand by however highly skilled a person makes it a craft object. Associations and level of skill in making must not be confused with the object made.

6. "Feeding Desire: Design and the Tools of the Table, 1500–2005" is an exhibition organized in May 2006 by the Cooper-Hewitt National Design Museum in New York City. It specifically identifies flatware as tools and proposes to explore dining from the Renaissance to the present and to address, among other issues, "flatware as social commentary."

COMPARING MACHINES, TOOLS, AND CRAFT OBJECTS

■ ■ ■

The word "machine" usually conjures visions of large factories and complex engines like those that power today's automobiles. Hence, it would seem machines have little connection to craft objects or even to tools. Machines, however, need not be complex nor large, certainly not in principle. They can be relatively simple, small, and objectlike, just like crafts and tools. And, since they are made to serve practical, applied functions, as are craft objects and tools, taking a closer look at them helps gain a greater understanding of how craft objects differ in the nature of their applied functions from other members of the group. Moreover, to understand the special relationship that craft objects have to the human hand and body it is necessary to examine tools and machines in order to show they have a different relationship, not only to each other, but to craft objects as well. This is another way to demonstrate how unique craft objects are as applied objects. And finally, in understanding something about the machine we come to understand how the handmade craft object stands against it, how the craft object stands in support of the individual's unique existence in the world, something that will be discussed in detail in Part 3 in relation to design and modern industrial production.

Like tools, machines are dependent upon kinetic energy and are "used in the performance of an operation." In this sense they seem to be the same kind of things—machines being just more complicated tools. There are, however, essential differences between them that have nothing to do with simplicity or complexity. A machine is defined as

"any system formed and connected to alter, transmit, and direct applied forces to accomplish a specific objective." Here the key words are "alter" and "transmit." Unlike tools, which do not alter a force but use it directly, a machine alters the direction and/or magnitude of a force in such a way as to produce mechanical advantage. Simple machines, as John Harris already noted in his 1704 publication *Lexicon Technicum, or An Universal English Dictionary of Arts and Sciences*, are commonly reckoned to be "the Balance, Leaver, Pulley, Wheel, Wedge, and Screw."[1] Because they exploit such basic principles, these simple machines are recognizable and are still in use today. Compound machines are those whose efficiency depends on the combined action of two or more parts. Common examples would be pendulum clocks and an automobile drive train. In the latter example, downward motion of the engine pistons is transformed into the circular motion of the crankshaft and drive shaft; this circular motion continues to the wheels, where its direction is changed once again by gears known as the differential.

Mechanical advantage is the identifying feature of machines, even the most common and simplest of them, such as the lever. A lever can be employed to lift very heavy weights. Pivoting on a fulcrum, it changes the direction, distance, and speed of the kinetic energy put into the handle end such that the lifting end of, say, a crowbar not only moves in a direction opposite to the handle, but also moves more slowly but with greater force, or, on occasion, more quickly with less force. Depending on the position of the fulcrum, a force on the handle of the lever of 10 pounds traveling downward for 50 inches may be transformed at the lifting end into an upward force of 200 pounds traveling over 5 inches — distance and speed are transformed as the lever is put to work. In a bicycle with gears, an example of a more complex machine, energy is transferred from the legs of the pedaler to the rear wheel, producing mechanical advantage through a series of gears. Not only does the force pushing downward on the pedals (something the rider may increase by standing on the pedals instead of sitting on the seat) get transformed into forward motion; on steep inclines pedaling force may be geared down for more power and on modest declines geared up for greater speed; in the former case, more pedaling is required to travel a certain distance, while in the latter case, less pedaling is required to travel the same distance. Not only does the downward direction of the pedaling

1. See Harris as quoted in *The Oxford English Dictionary* under "machine."

not correspond to the forward motion of the bicycle, neither does the speed of the pedaling; it is faster with more pedaling on an incline and slower with less pedaling on a decline.

The great advantages of machines is that they save labor and reduce the cost of goods produced, thereby increasing the material standard of living for the vast majority of people in industrialized countries. I think it fair to say that in the last two centuries mechanical advantage harnessed in the form of industrial production has transformed the modern Western world into a virtual land of plenty. The quantity and even the quality of material goods possessed by the average person today would have been unimaginable to earlier generations, even to the very wealthy. Despite this, there is also a negative side to machines, something inherent to their very nature, that should be taken into account. Again our bicycle affords an important example. As it increases a person's locomotion through mechanical advantage, it transforms the rider into a source of energy; the rider now becomes a power source for a machine. This is why Marx argued that machines and all means for the development of production "mutilate the labourer into a fragment . . . degrade him to the level of an appendage of a machine, destroying every remnant of charm in his work and turn it into a hated toil."[2]

While there is much truth to what Marx says, what interests me is the way machines reverse the traditional relationship between a maker and his or her tools. As philosopher Vilém Flusser notes, tools work as a function of man, but man works as a function of machines.[3] In this reversal much is to be learned about the role of the hand in craftsmanship and, ultimately, in the creation of craft objects. This is why I think it is important to compare tools and machines; it is a comparison having a direct bearing on the origin and meaning of the handmade object of craftsmanship.

When we examine tools, it becomes apparent that they are not machines even though both may perform the same applied functions and both are instruments involved in actions as means to ends. The categorical difference between them has to do with the way they use energy. This difference is more important to their identity than applied function because it goes directly to how they connect to the human hand and body and, consequently, to the handmade craft object. Unlike machines,

2. See Marx, *Capital*, 1:708–9.
3. Vilém Flusser, *Towards a Philosophy of Photography*, 17.

tools don't alter the direction, speed, or the magnitude of a force, nor do they involve mechanical advantage; regardless of whether energy comes from hand or arm, tools simply carry it in the same direction as the material being worked. This is apparent to anyone who has used a hammer or chisel or sickle. Unlike our lever, a hammer strikes the nail in the same direction and with the same speed and energy put into it by the hand or arm.

Another significant feature of tools is that they act as extensions of the hands and arms and reflect their motions. In this they relate closely to craft objects and to the concept of the hand and handwork that the word "craft" as a skill has traditionally implied. As shall be discussed in a later chapter, tools (in their "tooling" function) and craft objects (in the way they are made and function) are conditioned, controlled, and limited by the hand. In contrast, machines, by their very nature, tend to ignore the human hand and the human body or, as in the example of our bicycle, they reduce it to a source of power. This is why in recent usage the word "machine" tends to be "applied especially to an apparatus so devised that the results of its operation is not dependent on the strength or manipulative skill of the workman." In other words, workmanship and craftsmanship, as manual, technical skills, are either reduced or eliminated entirely from machine operation.

In contrast to machines, tools are manually operated; in this case "manually" means "of or pertaining to the hand or hands; done or performed with the hands." And in the way they operate, tools enhance the ability of limbs, hands, fingers to work material.[4] As bodily exten-

4. Dinner flatware, especially forks and knives, also extend the hand/fingers, though they are somewhat unusual tools. This is attested to by the fact that a two-pronged version of the fork seemed to have been used by the ancient Romans, but its use disappeared after the fall of the western empire. In the Middle Ages it was reintroduced into southern Europe via Venice from Byzantium, where it apparently was used for eating sweetened fruit. Today such forks are called sucket forks and the sweetened fruit sucket or succade, a term evidently related to "zucchero," the Italian word for sugar. As dinnerware or cutlery, knives and forks did not make their widespread appearance until sometime in the sixteenth century; in Italy use of the fork seems to have spread along with the eating of pasta. That the use of cutlery is not ubiquitous is evident from the fact many Asians use chopsticks in their stead. For more information on the fork, especially its admonition by the clergy as a sign of luxury, see Robb, *Midnight in Sicily*, especially 72ff., where he quotes Pasquale Marchese's *L'invenzione della forchetta* (The Invention of the Fork), published by So-

sions, they afford more efficiency and durability than unaided fingers, hands, and limbs. Stone or obsidian or metal scrapers, for example, imitate fingernails but are more efficient; for cutting or ripping, knives and swords are more efficient than hands; a shaped stone outfitted with a handle (a hammer or a mace) is a more efficient pounding implement than a fist; likewise, abrasive material for rubbing or polishing also reproduces the effects of wear caused by years of contact with human skin, but is more durable, practical, and faster.

Because tools are manually operated, they never reduce the body to a mere source of power as do machines. However, not relying on a *mechanically advantaged* device interposed between hand and material means that tools demand manipulative skill of the user. The quality of their performance is directly dependent on the ability of the hands and arms to control the tool. In this they require a kinesthetic sensibility, kinesthetic being "sensation of bodily position, presence, or movement." Tools involve motion and are designed around the hand and body as kinesthetically sensitive; it is not *raw* power (the kind measured in horsepower), but proficient, controlled power ever sensitive to "tooling" potential, process, and the material being worked; it is the kind of power that requires finesse and expertise in determining the outcome of the "tooling" process. To a lesser extent this is also true of hand power tools; as mechanized hand tools they still require a degree of manual skill in their operation, something that disappears with full automation processes. Their close connection to simple tools is probably why they are referred to as tools and not machines.

The kind of expertise and skill required by hand tools is often seen as the source of what are usually referred to in common language as "well-crafted" objects, something understandable since expertise and skill are so essential to the making of such objects.[5] This is another reason that further explains why expertise and object often are conflated with the result that any skillfully made object comes to be referred to in the vernacular as a craft object.

veria Mannelli in 1989. Also see Rebora, *Culture of the Fork*, 14–18, where he relates the spread of the fork to the spread of pasta, and Petroski, *Evolution of Useful Things*, especially 3–21.

5. This observation parallels Collingwood's implied contention that skill is related to craft (to non-art, mindless reproduction), while art is inventive and not dependent on skill, which, he argues, is secondary to art. See his "Art and Craft," 15–19.

By their very nature, tools have more in common with craft objects than with machines, even the simplest of machines. This holds even though both tools and machines are system dependent means to ends, means that require energy input to function while containers, covers, and supports are self-contained, self-reliant entities that hold and preserve. Nonetheless, in the way tools respect the human body through their kinesthetic properties, the way they are sensitive to the body by being made to fit the hand and extend the body's motion, they reinforce the concept of the hand and handwork that forms the basis of traditional craft. At one time machines also were limited by water, wind, animal, or human power before the invention of other power sources in the late eighteenth century. This made them seem similar and even sympathetic to tools and traditional craft objects. What has happened subsequent to the modern invention of external motive/energy sources, something evident in the unlimited production of machine-made objects in the nineteenth and twentieth centuries, should make it abundantly clear that machines actually stand in opposition to tools and craft objects. The more powerful machines become, the less kinesthetically sensitive they are to both the body and the material being worked so that the body must conform to them in much the same way material is overcome and mastered by the machine.

Rather than championing the skilled maker and celebrating the potential that comes from a union of hand and mind, in the modern industrial world the machine stands over and against the body; it tends to either replace the body or reduce it to serving its needs, undermining the desire to make and stripping the object produced of any individuality or personal meaning as the product of a human act. It is against this machine attitude that the handmade craft object stands as a statement supporting the individual's unique existence in the world. This is not to condemn machines outright, for our world would be much worse without them; rather, it is a cautious reminder of how the machine has removed the process of making as a significant factor from the identity of objects and thereby has changed our view of the world and the things in it. This is something about which more will be said when the differences between craft and design are discussed in Part 3.

PURPOSE AND PHYSIOLOGICAL NECESSITY IN CRAFT

■ ■ ■

Having divided craft objects into sets by looking at purpose and the concept of applied function, it is now time to see what other basic features they share as a class of objects. This means returning to the question of purpose to probe deeper into purpose's roots, to ask what it is that drives purpose in craft objects and necessitates their making in the first place.

Today most of us live in a world virtually filled with stuff and it is not always readily apparent why such stuff was made—purpose is not transparent in the object itself. One explanation for the growth of advertising in developed industrial societies like ours is that advertising tries to convince people that many unnecessary products are, in fact, necessary. It does this by creating imaginary need in order to entreat people to buy. For example, is it really necessary (as opposed to just convenient) to have a TV in every room and a cell phone that can take pictures? Is it absolutely necessary that one keep abreast of the latest clothes fashions when last year's are still fine? Of course not. But since the purpose and aim of advertising is to sell products, it is not a question of need but of commerce. This is why, in a very real sense, advertising operates by creating desire; desire acts as a substitute for both absent need and needless function. In this environment in which the connection between applied function and purpose is no longer clear, objects of pure desire, like pet rocks, or objects of simple amusement, as epitomized by the Hula Hoop, co-exist equally with more practical and necessary objects such as furniture, clothing, vessels, and tools and machines. In the kingdom of com-

merce, differences between desire, value, function, usefulness, and necessity are intentionally blurred so that little distinction is now made between them; all seem equally purposeful and important in justifying an object's being made and consumed.[1]

When it comes to craft objects, however, the impetus behind purpose is clear and transparent; it is physiological necessity. Physiological necessity is too important a factor for our understanding of craft objects and our own place in the world for them to be confused with the myriad of unnecessary objects of pure commerce that surround us in our daily existence. It is also why our understanding of purpose in crafts should not be seen solely from the perspective of intended function; if it is, only a small part of the object's significance is revealed. When understood in the fullest sense of physiological necessity, then the fundamental *raison d'être* of craft, as a class, emerges. Or to put it another way, understanding what drives purpose in craft is as important to an understanding of craft as is applied function. Together they illuminate the larger significance of craft as an expression of human culture.

What do I mean by physiological necessity and what are its implications for crafts? Objects such as chairs and beds support the human body; blankets and clothes cover the body; and baskets and vessels of all types carry and store food and water for the body. These, the basic functions of craft objects, all spring from the same purpose, that of fulfilling the body's physiological needs. In one important way or another, by containing, covering, and supporting, craft objects help in our struggle for survival in an otherwise indifferent, if not hostile, world. Purpose in craft is singularly driven by this; it is craft's overriding reason for being made. And while this purpose and these needs may be simple and straightforward, their implications are not.

To begin with, as a complex living organism, the human body's physiological needs are biologically driven; they are not arbitrary, something based on whim or caprice; nor are they invented by advertising or some other social mechanism designed to convince us to consume. They arise from absolute biological necessity and we have no choice in the matter, for without their continual satisfaction we simply cannot

1. It is in response to this situation that a large body of Marxist, post-structuralist, feminist, and psychoanalytical critical theory has developed in recent years. For an examination of this material in relation to media, desire, and our sense of reality see Risatti, *Postmodern Perspectives.*

survive. It is in this important sense that purpose in craft objects can be said to spring directly from our confrontation, as a species, with nature; it is grounded in physiological necessity and in our struggle for survival. This means purpose in craft objects has a primordial dimension that goes beyond culture; it also means that craft objects, individually and as a class, must be seen as a continuing reflection in the present of this ancient and timeless struggle that mankind has waged with nature for survival.

Clearly with the creation of craft objects, chances of human survival increased dramatically as a modicum of security was won from nature. But why early humans created craft objects rather than adapting other strategies of survival remains a mystery. Perhaps they were more vulnerable than their animal counterparts—they did not have fur or a protective hide, were not very fleet afoot, lacked claws and great physical strength. Whether or not this forced them to confront natural elements in new and bolder ways is probably the ultimate evolutionary question; it may be that those humanoids who did not adopt strategies simply did not survive and we are those that did. This remains a puzzle geneticists and paleoanthropologists are still attempting to unravel.[2] What concerns us is that craft objects were made and that, as a class, they share an origin and purpose in satisfying the body's physiological needs. But satisfying such needs is not unique to human beings; all organisms must do so. This means our confrontation with nature is not just timeless because it is something we must still do today; it is also universal because it is something we share with all other life on the planet. However, what is unique is the making of craft objects; they are a uniquely human response to these needs, a response that humans share with each other and no other creatures on the earth.

The physiological basis for this confrontation with nature helps explain why craft objects are not localized geographically or historically. It helps explain why they appear at the edge of human time in the Middle East, in Asia, in Africa, in Europe, in the South Pacific, and in the Americas. Wherever human beings have lived for any length of time, craft objects or their remnants are to be found. They are virtually ubiquitous across the earth from the dawn of human time to the present. It is this

2. For a review of some of the current research on the development of homo sapiens see Wills, *Runaway Brain*, and Wilson, *The Hand*.

that makes them essential markers to paleoanthropologists of human habitation.

Their widespread presence also suggests that purpose founded in physiological necessity is probably an essential, even innate human trait. Occurring in places that are so isolated from each other means contact from one group to another was highly improbable. Consequently, diffusion theory—the theory that ideas or things diffuse outward from a single discovery point—cannot explain the presence of craft objects across the globe. Craft objects simply could not have been created in one place by one group in a unique response to physiological necessity and subsequently spread outward to all other groups; they must have been independently invented countless times across the globe by different groups. In other words, the worldwide response of human beings to their physiological confrontation with nature was basically the same: rather than simply accommodate themselves as had their ancestors and as do most other life forms, human beings consciously and purposefully began to wrest a degree of security from nature through the creation of craft objects.

That basically all humans participated in this process is highly significant, for it is an indication of how craft objects embody both our nonsentient and sentient relationship—as a species—to the realm of nature. On the one hand, they make clear we have a nonsubjective, noncognitive connection to nature founded in physiological necessity—that is, we are connected to nature through our animal/biological needs; these needs are not thought up by us, but as Mikel Dufrenne would say, they are nature speaking through us.[3] On the other hand, craft objects demonstrate how human subjectivity (as that capacity of the human mind to cognition, knowledge, and awareness) has transformed such a basic relationship and transported it to a higher plane. In this sense, craft objects must be seen as nothing less than a physical manifestation of human subjectivity in confrontation with nature. They are a concrete expression of human subjectivity's worlding capacity, of human subjectivity's potential to create a world of culture out of the realm of nature. Moreover, craft's fulfillment of human physiological need, because this fulfillment is the result of a conscious act, also has a psychological di-

3. For more on Dufrenne's ideas about man and nature, see his *In the Presence of the Sensuous*.

mension to it that cannot be divorced from consciousness; after all, consciousness itself has a psychological dimension at its core.

From this perspective, the fulfillment of practical functions essential in the struggle for survival must be understood as *the* historical dimension of craft. Nothing less than the colossal weight of historical necessity itself is brought to bear on the field of craft by its applied function. Traces of craft's struggle still survive in the craft objects we use in our daily life. Pots are still needed to hold liquids as are cups, mugs, and bowls (something we should reflect upon every time we drink our morning coffee or eat our evening meal). Still necessary in our life routines are baskets to hold grains, fruit, vegetables, and herbs. Every time we use blankets to keep warm, however elaborate they may have become, we are reenacting an actual, not imaginary, response to bodily needs that is probably as ancient as our species. Considering this, it is hardly surprising that craft objects and the functions they fulfill play an essential role in most of the world's cultural rituals. Yet we have internalized these rituals to such an extent that their meaning seems to have disappeared from conscious notice, as have the meaning of proper names like Potter, Weaver, Glass, and Turner. We have forgotten the significance of kings and queens being enthroned just as we imagine God enthroned in heaven; that bishops are appointed to seats in churches, churches that are called cathedrals (the word itself derives from the Latin "cathedra," meaning seat). In a similar way we seldom reflect on the fact that judges sit on the bench and committees have chairs to run them and that candidates are elected to seats in Congress. We also speak of the "seat of wisdom," though seldom in the same breath as "a seat in Congress." We also seem to have forgotten the significance of the fact that nobles are robed as a sign of their nobility and judges as a sign of their station; not unrelated to this is the tradition of presenting the winner of the Masters Golf Tournament with a green jacket that he is allowed to wear for a year as a sign of his victory; also that people dress up for special occasions from weddings to funerals. Moreover, the importance of food and drink are reflected in the biblical story of Christ's Last Supper as well as the practice of giving the condemned man a last meal or of having "state" dinners for important people. Such fundamental cultural practices are a reflection of the importance of food and drink for survival. Fasting during the month of Ramadan or forgoing meat on Fridays or during Lent is directly connected to this, as is feasting on special occasions. We also have the deeply embedded cultural practice of toasting a new birth

or birthday, brides and bridegrooms, and at banquets of thanksgiving; we also toast someone's health or the laying out of the dead in their final sleep. The sacred rituals of the Christian mass, which involve the symbolic breaking of bread and drinking of wine, and the Japanese tea ceremony are examples of the codification of these more vernacular, though still ancient rites. All these rites and rituals are a recognition of the role physiological necessity plays in shaping human life.

Having said this, I think it is also important that we not forget that these are needs we share with essentially all other life forms on the planet. These needs tie us to everything that lives, to all the other organisms in the world regardless of how small or evolved they may be. These needs make us part of that larger community that is life itself, and in doing so, because we possess a degree of consciousness beyond that of any other living organism, responsibility for protecting life on the planet falls to us. This means that in our struggle for survival we cannot ignore the rest of the world's life but must find a way to accommodate ourselves with it.

In a very real sense, purpose springing from the realm of strict necessity must be understood as a fundamental, universal, and archetypal condition of mankind that relates us to our historical development as well as to all other living creatures, no matter how insignificant they may seem. In craft objects this historical past is linked together, conflated as it were, with our modern present, for embedded within the craft objects we use every day resides the memory of our evolutionary moment, a memory that transcends ethnic and racial, economic and class, cultural and national boundaries. This is one of the glories of craft that make it a meaningful endeavor.

NATURE AND THE ORIGIN
OF CRAFT OBJECTS

■ ■ ■

While purpose and practical function instigate the making of craft objects, form, material, and technique are the elements necessary to bring them into being as physical, tangible things. Moreover, similar to physiological need, these elements also have a universal aspect to them that affects the way they come together to form the craft object. This helps explain why craft objects are connected morphologically/formally, technically, and functionally in ways that go well beyond accident or chance. This also helps explain why the earliest craft objects can be reduced to a few basic forms, to a handful of different materials, and to a limited number of basic technical processes, all of which have a relatively long-standing history worldwide.

From what is known of the earliest baskets and ceramics made in the later Ice Age, forms have been relatively constant and stable to the present.[1] The same can be said of certain techniques, in particular coiling and weaving. Coiling seems to have been the earliest technique for baskets and then for ceramic pots. Weaving is also extremely old, dating to at least the Upper Paleolithic Age when it attained

1. Unfortunately, as Paul G. Bahn points out, few baskets and other objects made of organic materials have survived from the prehistoric period. As for ceramics, they were not very common among hunter-gatherer societies because they were fragile and not easily transportable. However, ceramic pottery did exist in some areas during the Ice Age, e.g., as early as 14,000 B.C. in Japan. See Bahn's *Cambridge Illustrated History of Prehistoric Art*, 89.

very high levels of technical sophistication;[2] it is the basic technique of basket making and, apparently, preceded both ceramics and textiles. Its basics have changed little since prehistoric times, and all of today's baskets are still made by hand in much the same way they have been for millennia.

This is why we readily recognize craft objects as well as their purpose even though they may be from cultures that are disparate in place and time from our own. They may vary in their details and therefore be culturally distinguishable—this one looks Chinese, this one Mayan, this one French Baroque. But in their basic materials, techniques, and forms they are essentially the same. Differences in climate, social structure, and even variety and quality of materials generally account for what types of craft objects are present in a specific social formation; these differences may even account for their quantity and distribution; for example, nomads tend to have soft goods like carpets and bags, while sedentary societies have hard goods like ceramics, chairs, and tables. But these differences do not explain why craft objects, regardless of where they come from and when they were made, differ only in details while formally, technically, and functionally they are essentially the same.

Connections between material and technique vis-à-vis applied function are important factors in this. But more is involved here than can be explained solely by these connections, especially if we consider the early age at which craft objects appear in the historical record. Add to this their high level of sophistication and the nearly worldwide use of similar elements for their making, and it seems craft's elements must have been independently "discovered" by humans and this "discovery" must have occurred almost simultaneously in many distant places. With the exception of certain specialized techniques such as glass blowing, it seems craft's *basic* forms, *basic* materials, and *basic* techniques all come into being with craft itself. It is a moment in which the "discovery" of form, material, and technique seems to have coincided with the conceptualization of purpose and function numerous times in communities throughout the world.

For this moment to occur in this way, suitable models of form, ma-

2. Anthropologist Olga Soffer's recent finds have pushed back dates of the earliest weaving from the time of the first agrarian societies around 5–4,000 B.C., to the Upper Paleolithic Period of the famous cave paintings around 13–12,500 B.C. See O. Soffer et al., "'Venus' Figurines," 511–37.

terial, and technique must have existed before the objects themselves; they must have preceded, in some fundamental, a priori sense, the making of actual craft objects. This could be possible only if craft's basic forms, basic materials, and basic techniques existed everywhere in nature, in that universal realm which preceded all things cultural.

Such a proposition is not difficult to entertain since containers, as a basic form, can be related to various natural objects including sea shells, coconuts, squashes, gourds,[3] and even bird's eggs. Baskets—as a container made of specific materials—are likewise reflected in constructions like bird, wasp, and hornet nests. Furthermore, the basic technique used in basket making—the weaving of grasses and other materials—is foreshadowed in many types of nests as well. It may even be that wasp's nests and the nests of some birds (which are woven and then "sealed" with other material) influenced the sealing or caulking of baskets with clay. Covers were originally animal skins. Supports were modeled on flat stones and tree trunks. Shelters follow a pattern similar to supports; they were anything serviceable as a shelter—the same caves, dens, and overhangs that animals used. It is hardly stretching one's imagination to suggest that natural objects such as these provided the initial impulse and models for craft objects. What are pools and lakes and rivers if not water contained? Are not flat rocks and logs supports upon which to place things? And are not skins and furs the protective coverings nature provided to animals?

While understanding this relationship helps explain the universality of craft objects, it still doesn't fully reveal the magnitude of what was involved in their creation, for to create a craft object entails a high degree of abstract thought even when models do exist in nature.[4] Creation of a

3. Sophie D. Coe mentions how *Lagenarias*, one of the few species of domesticated plants common to both Old and New Worlds, "were probably mostly used as containers" in the New World before the invention of pottery; she also notes how "the fruit of the calabash tree was worked into elegant drinking vessels for Aztec nobility," a practice that continued millennia after pottery made its appearance. See her *America's First Cuisines*, 37.

4. It could be argued that animals do the same when they build their structures. One may even go so far as to say that they do this with purpose, in order to have shelter. But this is not quite true, certainly not in the sense in which we are trying to understand craft objects. As Erwin Panofsky rightly contends, animals "contrive structures without perceiving the relation of construction." He notes that "to perceive the relation of construction is to separate the idea of the function to be ful-

craft object cannot occur without a conscious conceptualization of the relationship between necessity, purpose, function, form, material, and technique. To do this human subjectivity must evolve nothing less than an abstract system for representing, for imaging reality, both existent reality and some new reality.[5] For it is a long way from seeing a shell or gourd in nature, for instance, to realizing its possibilities as a container. But even the realization that natural things could be functional is only a step in the process. For no matter how functionally useful, natural things are not craft objects. A great leap of the imagination is still involved in the conceptualization of natural things into craft objects.

In light of this, what human consciousness allowed was not only the comprehension of how certain things in nature actually functioned, but also the ability to conceptualize and abstract these functional processes into actual objects that would more easily and conveniently meet human needs. It is in this process of conceptualization and abstraction, one directly dependent upon consciousness itself, that the origin of craft objects as concepts and as actual things is to be found.

Conceptualization of the relationship between necessity, purpose, function, form, material, and technique probably occurred in stages, beginning with the recognition of need or purpose; that is, a problem or need must first be conceptualized as something requiring a solution; it cannot remain in the realm of the purely physiological or instinctual. Following the conceptualization of need or purpose, function, as a solution, must be conceptualized and abstracted. Next, a physical form must be recognized and understood as capable of carrying out a specific functional concept. In this sequence, if it is a sequence, necessity-purpose-function-form, as an abstract/conceptual construct, must preexist creation of the object as a physical entity.

filled from the means of fulfilling it." See Panofsky, *Meaning in the Visual Arts*, 5. We should also note that animals are driven by genetics to build with the result that the beaver cannot not build a dam nor the bird not build a nest; this is why the beaver is unable to build a nest nor the bird a dam.

5. Psychologist Merlin Donald suggests "the human mind evolved from the primate mind through a series of major adaptations, each of which led to the emergence of a new representational system." I think we must be careful to recognize that all sentient things respond to the world, but only conscious beings can represent the world; representation is predicated on the existence of a self, one who is aware of his/her separation from that which is represented. See Donald as quoted in Wilson, *The Hand*, 41.

Containers, for example, could only come into being as independently made entities when necessity, purpose, and function were abstracted as concepts and then related to the idea of containing. Once this is done, containing must be grasped as an abstract concept so that a pool of water, for example, which is a fact of nature, comes to be understood in the abstract sense of water contained. Alone, however, this only leads to the use of the gourd or shell as a container, which means conceptualization of functional form in and of itself is not sufficient to make a craft object. No matter how functionally useful a natural object is recognized to be, it is still not in any sense a craft object; as we have already said, use alone does not determine what something is. For a craft object to come into existence what must be recognized in addition to functional form is a suitable material and then an appropriate technique with which to work that material into the desired form. In short, to actually make a craft object one must have a conceptual grasp of how a functional-form concept can be "filled" with material via technique.

Only when the abstract concepts of form and function are understood in relation to material and technique can the independent physical entity that is the craft object be made. That's why, even though recognition of natural things as use objects is a conceptual leap of enormous magnitude and consequence, it is hardly enough to lead to the creation of craft objects if purpose, function, form, material, and technique are not also abstracted and conceptualized. When they are, the result is an object bearing the traits of form, material, and technique intentionally applied to function.

Another important degree of conceptualization in craft involved the abstraction of technique as an independently existing process, as a method of making that could be understood as something separate from natural and then from man-made things. For example, when it was realized that weaving, as a way of making that was previously linked to such objects as a bird's nests and then baskets, could be completely separated from such objects, that it could exist in its own right, technique could be understood in the abstract sense of a process and not simply the property of certain things. With this conceptualization of weaving as process rather than property, things other than baskets could be created, such as fabric, netting, and, clothing.

In the conceptualizations that brought craft objects into being as physical entities can be seen the workings of consciousness itself. Making craft objects is one of its earliest tangible manifestations. Craft

objects stand as concrete expressions of the power of human creativity to wrest a realm of culture from nature.[6] In the twenty-first century they remain a vital, living tradition that reaches back to our prehistoric ancestors. For craft objects still carry within them the visual memory of their generating natural forms and the human overcoming of nature in the creation of a world of human expression. Unfortunately, in our affluence and the comfort it has provided, it is often forgotten what this means; forgotten is the intensity and drama of the struggle to rest a modicum of security and leisure from nature that craft objects embody. Though they still surround us, they too often are silent, mute, no longer reminders of our prehistorical past and symbolic reflections of the dawning consciousness of our ancestral selves.

6. The question of tools in relation to this is interesting. It seems tools of some sort occur much earlier in the archaeological record than paintings or craft objects, at least as early as 2.5 million years ago with the Oldowan tools of southern Ethiopia, the simplest and most primitive "tools." Yet it is not exactly clear when what I have called the "formed-tool" stage was reached, that stage beyond the "matching" and "adaptive" stages. The oldest hafted ax, found in New Guinea, dates only to ca. 40,000 years ago. Furthermore, though animals also use things *as* tools, only hominids and humans reuse their tools. See Wills, *Runaway Brain*, for background information on the archaeological record and evolution, especially 102–5.

PART II

CRAFT AND FINE ART

■ ■ ■

Part I was concerned with understanding craft objects primarily as physical entities, with how and why they are configured in certain ways in their distribution of matter. In this part, discussion centers on a comparison of craft objects to works of fine art. This is a way to address the argument that there is no significant difference between them, and therefore that there is no justifiable reason to consider them separate categories or distinct activities—the implication being that current fine art aesthetic theory applies equally well to craft as to fine art.

Primary focus is on the relationship between craft and both painting and sculpture (two media generally considered the paradigms of fine art) in order to gain a greater understanding of, first, their physical characteristics as objects, as tangible things, and second, how they relate to the concepts of purpose and function, especially as we have identified purpose and function in relation to craft. To do this requires an analysis of works of fine art as both formal entities and as physical objects geared to purpose.

Fine art advocates contend that functional objects like containers, covers, and supports cannot be aesthetic objects because of their function; they can only be considered utilitarian objects of use. To counter this argument, craft advocates often identify nonfunctional works in traditional craft material—for example, figurative works in wood or clay—as craft objects in order to argue that craft objects can indeed be works of art (see Figure 1). This argument, however, is not very convincing even though it is true that artists

who make such work do have certain affinities with craft artists. For example, they are more likely to give "how to" demonstrations as do craftsmen rather than "artists talks" as do fine artists; they also tend to do these demonstrations in ceramic or woodworking studios instead of sculpture studios or critique rooms. This, however, has less to do with the conceptual/artistic nature of their work than with the technical demands required of the material out of which they make their work. But as already noted, material is not a defining characteristic of craft or of fine art—a sculpture in clay or wood is still a sculpture and a chair in bronze or marble is still a chair.

Making fine art in so-called craft material is nothing new. In fact, there is not only a long history of making sculpture in ceramic that goes back at least to the Etruscans (see Figure 2), but sculpture in wood also dates back many centuries. Besides tomb sculptures from ancient Egypt, there are the fifteenth-century lindenwood sculptures from Germany that are justly famous exemplars of a long and widespread European woodworking tradition. A similar tradition of large-scale figural wood sculpture of religious figures also exists in Japan.[1] By the same token, there are contemporary "functional" craft objects made in materials that are nontraditional to crafts; here one can think of Ken Ferguson's rabbit-handled dishes of bronze. But even these have precedence in ancient Chinese Shang and Zhou dynasty (twelfth and eleventh centuries B.C.) bronze ritual vessels and in the chalices used in the Catholic mass at least since the Middle Ages. More unusual in terms of material are Scott Burton's full-scale, blocky chairs; though they are cut from granite, they function like any other chair despite being very difficult to move.[2] As these examples show, it is not the material out of which an object is made that determines whether or not it is craft or fine art, but how that material is used, to what purpose or end it is being configured.

In the sense of how material is employed, purpose is a defining issue for both fine art and craft. Purpose is also an issue in another sense.

1. For an Egyptian example see the 43" high wood statue of *Ka-Aper* from the fifth dynasty (ca. 2500 B.C.); for Europe see the large-scale lindenwood sculptures of German artist Tilman Riemenschneider from the late fifteenth century; and in Asia see the over life-sized (9′4″) figure of the seated *Amida Buddha* by the sculptor Jocho from the mid-eleventh-century Byōdō-in Temple at Uji, Japan.

2. Though Burton's chairs are difficult to move, they are no more so than Bernini's seventeenth-century bronze *Cathedra Petri* (St. Peter's chair) in St. Peter's Cathedral in Rome.

Because the work of fine art is man-made just like the craft object, it too must respond to some purpose or it would not have come into being. And as I have said, purpose in craft is to serve the physiological needs of the body, something it does by making tangible objects capable of carrying out various applied functions. But what about purpose in works of fine art? What initiated their making?

With this question in mind, I now examine works of fine art to consider whether or not they are linked to craft in some fundamental way such that their functional/nonfunctional differences are rendered insignificant, or whether craft and fine art stand far enough apart to be considered separate entities. If they are different, are they different enough that their differences are betrayed in their particular approaches to important elements such as purpose, form, material, and technique?

WHAT ARE THE FINE ARTS AND
WHAT DO THEY DO?

■ ■ ■

Paul O. Kristeller points out in an important article written in the 1950s that the term "aesthetics" and, according to some historians, even the very subject matter of aesthetics itself, "the philosophy of art," was only invented in the eighteenth century. Even our concept of "fine arts" and their identification with painting, sculpture, architecture, music, and poetry are of recent origin.[1] Furthermore, the term "fine art" itself only came into English in the late eighteenth century from the Continent as a translation of *les beaux arts, le belle arti, die schöne Kunst* (the beautiful arts). It specifically referred to what were known as the arts of design: painting, sculpture, and architecture. In the nineteenth century the adjective "fine" was generally dropped and "art" came to stand alone for this triumvirate,[2] to which have been added in the twentieth century old and new media such as printmaking, photography, performance, happenings, film, installation, and video.

The term "aesthetic" was first used in a distinctly philosophical context by the eighteenth-century German philosopher Alexander Baumgarten. Around mid-century he defined aesthetics as "the science of sensitive knowing." Unfortunately for craft and other functional objects, Immanuel Kant, in his 1781 *Critique of Pure Reason*, shifted the meaning of "aesthetic" toward the transcendental study of the objective preconditions of judgments of taste concerning

1. Kristeller, "Modern System of the Arts," 496–97.
2. See Collingwood, *Principles of Art*, 6.

the beautiful.[3] This reflects the Continental idea of the fine arts as the "beautiful arts." The result is that today the fine arts, as Peter Angeles notes, are generally defined as those "whose primary function is to produce an aesthetic experience of beauty without regard to what economic or practical use they may be put."[4]

The problem with this definition is that the fine arts are not always beautiful in the conventional sense of the term; sometimes they are ugly, sublime, or just ordinary. For example, Classical Greek sculpture from around 450 B.C. was intended to idealize the human body as a thing of beauty, but a Hellenistic sculpture like *The Old Market Woman* (circa 150 B.C.) was intentionally ugly to show the ravages of time on the human body; similarly, Assyrian palace reliefs generally avoided beauty and ugliness and concentrated on showing the power and godlikeness of the ruler. By equating the aesthetic with the beautiful, Kant seems to have ignored these facts of art and raised what are today still much debated issues. Among these issues is the following question: "How do we make judgments of taste and how can we define and identify the aesthetic/beautiful?" Kant's shift away from Baumgarten's definition of aesthetics as "sensitive knowing" also established the basis of the function/nonfunction dichotomy that is used to separate craft from fine art and to deem craft incapable of being art of any kind. While the issue of "the aesthetic" is a philosophical morass in which there is little consensus, there are nevertheless some rudimentary questions that can be asked, such as, "What do the fine arts do and what is their common purpose?" While they do not have a practical, physical function as does craft, they must, as I have said, have an underlying purpose in order to come into being. For them to be made, someone must have a reason, an intention, for making them.

It seems to me that what the fine arts do, as a group, is "communicate." Kant seems to recognize this when he says of the fine arts that they have "the effect of advancing the culture of the mental powers in the interest of social communication."[5] Many of my artist friends would bristle at this idea because they feel it reduces art to something akin to graphic design or advertising. But when I use the term "communicate,"

3. See Davey, "Baumgarten," 40–41.

4. Angeles, *Dictionary of Philosophy*, 102.

5. Kant, as cited in Whittick, "Towards Precise Distinctions of Art and Craft," 47. About fine art as a communication vehicle, also see Mounce, "Art and Craft," 231.

I mean it in the general sense that something is "transmitted" from the object to the beholder; whether this something is as ineffable as a feeling, an emotion, an experience, or as tangible as hard, quantifiable information, does not concern us here. What does concern us is that something is transmitted from a maker to a beholder through the fine art object. It is in this sense that we can say that the fine arts communicate and that "communicating" is their purpose. If communication is their purpose — and I believe it to be so — then the fine arts belong to a larger category of objects, all of which communicate through visual form. This does not mean all objects that communicate visually are works of fine art. We must recognize that "communication" in the fine arts is a special kind, one that makes them different from advertising, graphic design, and all other visually communicative objects. But because they "communicate," however they do it, it is difficult to claim they are nonfunctional; after all, communication is itself a function. This raises questions: How do the fine arts operate? How do they function to actually carry out their special communicative purpose?

Traditionally, communicative purpose in the fine arts has been said to involve the transmission of abstract ideas, concepts, experiences, emotions, feelings, self-expression — the list is almost as endless as the debate. While it is clearly difficult to pin down exactly what it is that the fine arts "communicate," we can at least say that traditional fine art functions to "communicate" something through two- and three-dimensional images of things real and imagined, such as events, places, people, animals, objects, etc. These depictions can be categorized as instructional, mnemonic, commemorative/honorific, inspirational/exhortational, meditative, or documentary/descriptive, etc. While these are not exhaustive categories or even mutually exclusive ones, they are useful to begin thinking about fine art without having to resort to issues involving qualitative/aesthetic judgments. If we look at the fine arts of painting and sculpture, we see that they literally function through two- and three-dimensional visual imagery, usually naturalistic to one degree or another, though sometimes they are abstractions of real things or even concepts.

Instructional works that function through naturalistic representation would include the figural reliefs commonly found on religious structures such as Buddhist, Hindu, and Aztec temples and Christian churches. Specific examples are the reliefs above and flanking doorways in Romanesque and Gothic churches (see Figure 5). Their importance as

educational and instructional devices is something Pope St. Gregory the Great (590–604) made clear in a letter to Bishop Serenus of Marseille. Admonishing Serenus for destroying church art, St. Gregory notes that "word has reached us that you, gripped by blind fury, have broken the images of the saints with the excuse that they should not be adored. . . . To adore images is one thing; to teach with their help what should be adored is another . . . therefore you ought not to have broken that which was placed in the church . . . solely in order to instruct the minds of the ignorant."[6]

As Gregory suggests, typically such works functioned by the way they imaged religious stories, parables, and concepts using a realism of easily recognizable and "readable" devices such as exaggerated gestures, large heads and hands, and simple compositions that focused attention on the moral of the scene or story. Interestingly, the functional value of realistic and semi-realistic imaging strategies for instruction, whether religious, political, or social, was once again made clear in the Cold War era when abstract Modern Art was denounced by Soviet authorities as bourgeois decadence because of what Vladimir Kemenov called its "hostility to objective knowledge and to the truthful portrayal of life." To Kemenov and others who championed Soviet Realism, Modern Art's anti-realistic tendencies meant it did not function very well as an instrument of instruction, which in Kemenov's case was political propagandizing intended for the general populace.[7]

Works intended as mnemonic devices, such as portraits, also usually function through naturalistic imagery of the subject. Sometimes a true likeness is not possible, in which case a generic figural type may be

6. Pope Gregory I, "Letter to Bishop Serenus of Marseille," 48. This position toward the teaching purpose of images is repeated by John of Genoa in his late-thirteenth-century *Catholicon*, and as late as 1492, the Dominican Fra Michele da Carcano even cites Gregory's sixth-century letter to Serenus in his defense of images. For these sources see Baxandall, *Painting and Experience*, 41. In the nineteenth century Boss Tweed of Tammany Hall in New York City did not complain about the newspaper articles chronicling his corruption because his constituents couldn't read; he complained instead about Thomas Nast's cartoons that indicted him for political corruption.

7. It should be noted that on the American right, Modern Art's "anti-realism" was also denounced, this time as subversive of American values. See Kemenov, "Aspects of Two Cultures" (1947), 490–96; and Congressman George A. Dondero, "Modern Art Shackled to Communism" (1949), 496–500.

given associational attributes such as iconographical devices and symbols to identify the image with that of a specific person whose physical likeness is unknown; Christ has his cross, Mary her lilies, and kings and queens their crowns. The Yoruba of Nigeria create a more or less generic statuette as a vessel for the spirit of a deceased twin; such statuettes had a mnemonic quality that did not necessarily function through realistic depiction of the deceased subject, but through conventionalized ritual association.[8]

Honorific and commemorative works tend to be more public in nature like Picasso's 1937 painting *Guernica*; by its distortions of the human figure, it commemorates the horrific bombing of the small Basque village of Guernica by airplanes of the German Condor Legion fighting on the side of Franco. The Washington Monument and Lincoln Memorial in Washington, D.C., honor and commemorate, but they do this through their large size and through other devices as well, the former the abstract symbol of an obelisk and the latter a large classicizing temple structure housing an oversized but realistic portrait statue.

Inspirational and exhortational works like Delacroix's 1830 painting *Liberty Leading the People* and Bertholdi's *Statue of Liberty* in New York Harbor follow the same functional format of visual depiction, as do numerous other works. Last Judgment scenes on church walls, Hindu figures of Shiva, or even the Aztec statues of the goddess Coatlique all employ the same imaging strategy.[9]

Regardless of how one configures or reconfigures these categories, it is clear that all these works function through two- and three-dimensional imagery to "communicate." For these reasons we can categorize all fine art as "communication" vehicles as long as we remember that they com-

8. Mackenzie, *Non-Western Art*, 14; also see Lawal, "Aworal," 498–526, and Baxandall, *Painting and Experience*, 45ff.

9. It is also worth noting that most of the practical features attributable to fine art can be performed or carried out in other ways and by other means. Consider the relief carvings on the entrances to Gothic churches. As useful and, perhaps, as efficient as they are in instructing the illiterate, one could instruct through various other means, including storytelling, sermonizing, or presenting passion plays as was long the custom in the Middle Ages. The same could be said of political paintings and sculptures. While they may be meant to instruct (as well as inspire) the viewer, at least since the nineteenth century most people have gotten their political information from sources other than paintings, for instance, stump speakers, broadsides, newspapers, books, radio, and television.

municate in a very special way and that not all things that communicate are fine art.

When considering tools and craft objects, something was revealed about them by looking at how use does not necessarily correspond to intended purpose or aim. It is also worth considering use in terms of works of fine art, for the way they are used also does not always correspond to their intended purpose of "communication." This was made clear in 1870 when a house rented by the French Impressionist painter Camille Pissarro in Louveciennes, a small town outside of Paris, was occupied by German soldiers during the Franco-Prussian War. In a letter, the owner of the house informed Pissarro (who had fled to London) that the Germans were using the house as a butcher shop and had "caused plenty of havoc [to his paintings stored there]. . . . Some of the pictures we have taken good care of, only there are a few which these gentlemen, for fear of dirtying their feet, put on the ground in the garden to serve as a carpet."[10] That this is clearly a blatant example of misuse of fine art emphasizes the point that Pissarro did have an intended purpose for his paintings, a purpose to which the soldiers were not attuned or for which they didn't care.

This is not the only example in which the use to which fine art is or was put did not correspond to the purpose for which it was intended. Anytime someone speculates on works of art solely for economic profit or for their prestige or status (as opposed to their artistic value), I suspect the artist would say they are misusing them. Buying paintings to decorate a room, for instance, to match the color of a sofa or chair is also a kind of misuse. Even more blatant instances of misuse are using a sculpture as a hammer or doorstop. While such instances are not destructive, I think artists would take a dim view of them because, from a strictly artistic point of view, they undermine the work's integrity and intended purpose.

Instances like these in which use and purpose are at such odds should keep us sensitive to the importance of the maker's intention. Just because a sculpture is used *as* a hammer no more makes it a hammer than using a painting *as* something to walk on makes it a paving stone or carpet. Moreover, that one would treat works of art in such a way also points up the difficulties that fine art, as a "communicative" vehicle, faces when the context of the work changes or when the attitude of the

10. See Rewald, *History of Impressionism*, 260.

viewer is not one of understanding or of receptivity to the work. When Prussian soldiers misused Pissarro's paintings, it was either from mis-understanding or refusal to accept the "message" for political, nation-alistic, or artistic reasons. Either position may be disturbing but not unusual.

Works continually fall in or out of favor, praised by one generation and despised by another. In creating his *Last Judgment* in the Sistine Chapel, Michelangelo destroyed two fifteenth-century frescos by artists promi-nent enough in their own day to have received papal commissions. This can only happen if their "message" is no longer understood or seen as relevant. In our time, museums are filled with religious paintings, not as religious objects but as works of art. This means they are no longer regarded as devotional objects as originally intended by their makers. Their "communicative" meaning has been reconstituted around our contemporary ideas of what an aesthetic object is. Other works consid-ered important in their day, for example works by the French academic artists of the latter nineteenth century, have either disappeared or lan-guish in museum basements; considered inferior, they are no longer believed to be important.[11]

As the above examples indicate, all works of art are not accessible at all times to all viewers; sometimes what they "communicate" simply doesn't seem important and at other times it doesn't register. This, how-ever, doesn't change the fact that works of fine art are "communication" vehicles. "Communication" is their purpose and they functionally carry out this purpose through visual imagery of various kinds; the imagery is the functional instrument of their purpose. We must remember, how-ever, while all works of fine art are "communicative" vehicles, not all communication vehicles are works of fine art. And finally, as our ex-amples of misuse show, works of fine art do embody intention; inten-tion is an important, even essential, factor in their creation.

11. Much the same has happened to craft objects. For years Rookwood art pottery, which was produced in Cincinnati during the late nineteenth and early twentieth centuries, languished in the Cincinnati Art Museum. Today the Rookwood Gallery is the anchor of the museum's new Cincinnati Wing.

SOCIAL CONVENTION VERSUS PHYSICAL NECESSITY

■ ■ ■

Since both craft and fine art are intentionally created for some humanly perceived purpose, they coexist as things consciously created by *homo faber*, by man-the-maker. Despite this, one should be very careful not to blur the lines between them because there are many different kinds of purpose as well as ways of carrying out purpose.

As already pointed out, the making of craft objects is a response to physiological needs that are and have been common to all peoples worldwide. In this sense purpose in crafts can claim universal status. Moreover, as objects, crafts also can claim universal status, for to be capable of carrying out specific physical functions their form and their material must adhere to the laws of matter. After all, not just any form or any material will contain, cover, or support. Once the use of craft objects has been established as a social convention (for example, to drink from a cup rather than the stream), as objects they are formally and materially circumscribed by the physical laws of nature. Moreover, since neither physiological needs nor physical laws change over time, in their basics neither do craft objects. As material entities (as pots, baskets, blankets, chairs), they tend to remain stable over broad stretches of space and time. This is true even though technological invention has created new materials and modern industrial processes the possibility of unlimited production.

The same cannot be said of works of fine art. Their purpose is not founded on material or physical necessity; therefore, rather than being circumscribed within the realm of

nature, they are circumscribed within what can be called the realm of social necessity. Stated bluntly, in their purpose they serve social needs rather than physical needs. Furthermore, even in the way they function to carry out their social purpose, that is to say the way they function in their imaging strategies and their communicative vocabulary, they are socially determined. In short, in neither purpose nor function are they subject to nature or to the laws of matter in the same way craft objects are. This is why they tend to be unstable, to change over time and from place to place.

To "communicate" is defined as a process by which information is exchanged between individuals through a common system of symbols, signs, or behavior. Regardless of whether the system be as specific as the rules of language, religious dogma, and initiation rituals or as vague as feelings of serenity or fear, there must be a commonly understood system shared by both maker and beholder. In this light, "communication" in fine art can only come about through a system of socially established and socially accepted signs. Whether these signs be realistic, abstract, or purely symbolic, always they must be embedded in the social fabric of a community in order to function as communicative vehicles to that community; and only in their community are they "readable" as part of a shared semiological system. Absent such a system they would be unable to communicate, certainly not in their original or full sense, which is one reason why misuse of works of fine art occurs; it is also why works fall out of favor.

All semiological systems are based on conventions learned by the members of a group. As Swiss linguist Ferdinand de Saussure points out, "every means of expression [communication] used in society is based, in principle, on collective behavior or—what amounts to the same thing—on convention. Polite formulas, for instance, though often imbued with a certain natural expressiveness (as in the case of a Chinese who greets his emperor by bowing down to the ground nine times), are nonetheless fixed by rule; it is this rule and not the intrinsic value of the gestures that obliges one to use them."[1] Bearing this in mind, it can be said that while crafts are circumscribed by a priori laws of material

1. Saussure, *Course in General Linguistics*, 68. Of course the opposite is true of crafts, since it is the intrinsic value of the objects in relation to physiological necessity that obliges us to use them. One could argue it is convention to use craft objects, say to drink from a cup (though it certainly isn't convention to protect the body from

and the demands of physical necessity—universal laws that preexist the making of craft objects—fine arts are circumscribed by the a posteriori rules and conventions of society. And since social rules and conventions, by definition, are not universal but specific to individual social structures localized in time and space, fine arts exhibit great variation and change from society to society and from time to time. This is certainly true in the sense of how fine arts are conceived regarding purpose; how they are created regarding "functional" form; how they are perceived as "images"; and even how they are used/treated as social objects.

The effects of being circumscribed by social convention is evident in the great diversity of fine art from East to West and from prehistoric times to the present. Works often look and "function" differently even though similar principles and subjects may be employed. For example, the ancient Egyptians employed a formal convention for the human figure that features a full-front eye and shoulders with profile head and legs. On Easter Island a different convention was used employing a large head with small, truncated torso. Other fine art conventions include the use of silhouette and hieratic scale in which rulers are large and servants small or head and hands of figures large and torsos small, as in much Early Christian art.

Being bound to social conventions also explains why interpretations shift from time to time and place to place. The value viewers place on works is dictated by the conventions of their particular social circumstances; as social values change, so do perceptions and interpretations. Perhaps aside from the Taliban of Afghanistan, who destroyed ancient statues of Buddha, who today would walk on a Pissarro painting as did German soldiers in 1870? Clearly the value accorded Pissarro's paintings has changed as the political and social climate surrounding them have changed. In the same way, an anti-Czarist painting of 1900 would have been perceived very differently after the 1917 Russian Revolution. To the authorities in the Soviet Union in 1947, modernist abstraction was viewed as a symbol of the decadent bourgeois, capitalist West; but to Soviet dissidents in the 1970s and 1980s, it symbolized the freedom of Western democracy.[2] After the fall of the Soviet Union and the estab-

the elements); but, once the convention is accepted, as it has been universally, there are only certain options available vis-à-vis form, material, and technique.

2. See Kemenov's "Aspects of Two Cultures," 490–96, and Dondero's "Modern Art Shackled to Communism," 496–500.

lishment of a degree of free enterprise in Russia in the early 1990s, the same painting could be perceived differently once again, even to the extent of being viewed as an aesthetic object devoid of any specific political content.[3] The work of fine art is always tied to a community's shifting symbol-making traditions and conventions. Such traditions and conventions are fragile and volatile, affecting the community's response to a work as well as that of an individual.

An even more recent example of the way fine art is temporally and spatially circumscribed within the social is the way the National Endowment for the Arts found itself at the center of a heated controversy over the funding of artists' grants as part of its initiative to support contemporary American art. The controversy boiled down to differing perceptions of what constitutes fine art. If responses to art can differ so radically among people living in a relatively homogeneous society, how could a painting or sculpture of, for example, Christ on the cross communicate as a meaningful religious object to someone unaware of Christianity? How much of the artist's intended meaning would a seventh-century Hindu priest or a Buddhist monk, someone from a different society and religious background, understand of such an image? Likewise, how much of the artist's intended meaning would a devout Christian unaware of the Hindu pantheon of gods understand of a statue of the many-armed Shiva or the Boar-headed avatar of Vishnu? Examples of such differences and the level of outrage that can be produced are the cartoons of Muhammad published in a Danish newspaper in 2005. Some saw them as an expression of free speech; others viewed them as heresy, leading to protests and riots.

Even within a continuing and somewhat homogenized social tradition, meaning of images can vary greatly. For example, within Christianity in the United States, biblical subject matter is often charged with meanings that vary, to which the heated 1999–2000 controversy at the Brooklyn Museum over Chris Ofili's image of the Madonna with elephant dung attests. But even works long established as high points of Western art often see their messages drift and get reinterpreted. Art historian Erwin Panofsky has pointed out that the original meanings of the sculptures of Chartres Cathedral have altered over time, not neces-

3. For differing perceptions of Soviet art from the revolutionary era see Nochlin, "'Matisse' and Its Other," 88–97; and Gorys, "On the Ethics of the Avant-Garde," 110–113.

sarily because of changing religious values, but because of different social values that viewers—existing in a different social context—bring to the work (Figure 5). "When abandoning ourselves to the impression of the weathered sculptures of Chartres," writes Panofsky, "we cannot help enjoying their lovely mellowness and patina as an aesthetic value; but this value, which implies both the sensual pleasure in a peculiar play of light and color and the more sentimental delight in 'age' and 'genuineness,' has nothing to do with the objective, or artistic, value with which the sculptures were invested by their makers. From the point of view of the Gothic stone carvers the processes of aging were not merely irrelevant but positively undesirable . . . ; they tried to protect their statues by a coat of color which . . . would probably spoil a good deal of our aesthetic enjoyment [of them]."[4] Something similar happens to our perception and hence our interpretation of Classical Greek temples and sculpture from the Acropolis in Athens. In their original state they were painted with what many today would consider bold, if not gaudy, color, color that has long since weathered away, leaving in its place pristine, pure white marble.

That the modern viewer would value the "aged," weathered look of Chartres's sculpture and attribute "timeless purity" to Classical Greek sculpture has little to do with the artistic intentions of their makers or the religious beliefs of medieval France and ancient Greece. Still, the changed interpretations modern viewers bring to older works has its parallels throughout history. In the Middle Ages Classical art that today is praised was attacked as pagan. In the Italian Renaissance, the Christian Gothic was seen as a debased, barbarian architecture and the Classical was revered.

Every social structure produces its own fine arts and its own particular interpretations of them. This has become abundantly clear in recent years by the growth of such diverse critical methods of interpretation of art as Marxism, feminism, psychoanalysis, and deconstruction.[5] Art history, a relatively new scholarly discipline, attempts to retrieve the value of older and foreign works of fine art by attempting to reconstruct the social and historical context in which they were originally created so they will again be perceived, at least in something of their original pleni

4. Panofsky, *Meaning in the Visual Arts*, 15n11.
5. For more on these critical methodologies, see Risatti, *Postmodern Perspectives*.

FIGURE 5. Men and women of the Old Testament, statues from the left side of the central door of the Royal Portal, ca. 1145–70, Chartres Cathedral, France. Photograph by Erich Lessing/Art Resource, N.Y.

tude of social significance; but even this is, at best, only a hypothetical re-creation of the past.[6] As Heidegger writes of Bamberg Cathedral in Germany and the Greek temples at Paestum in Italy, "The world of the work that stands there has perished." What he calls "world-withdrawal and world decay can never be undone. The works are no longer the same as they once were."[7] It is for this reason many works of art, having outlived their social context, are now in museums. Existing outside their historical era, they often stand mute before the viewer as pure "art for art's sake" objects to be valued only for their formal properties. If they do speak to the attentive viewer in a nonformal sense, it is in faint whispers that resonate from their properties as carefully formed objects, as intentionally made things coming to us from the skilled hand of another human being across a vast expanse of time and space.

Even if socially mute, if they are skillfully made, they can at least still stand before us in their splendor as made things. Writing in his journal in the early years of the sixteenth century, German artist Albrecht Dürer admired various Meso-American objects sent from the New World by Hernán Cortés to Emperor Charles V of the Holy Roman Empire. Dürer describes them as precious objects of gold and silver and calls them "wondrous" and "much more beautiful to behold than prodigies." "All the days of my life," he says, "I have seen nothing that has gladdened my heart so much as these things, for I saw amongst them wonderful works of art, and I marveled at the subtle *ingenia* of men in foreign lands. Indeed I cannot express all that I thought there."[8]

Dürer had no way of understanding what these objects were intended to communicate within the social structure of Pre-Columbian Meso-American religious and political beliefs; he also didn't understand the artistic conventions that their makers employed. If he did, as a devout Christian, he probably would have been horrified and rejected them as pagan. But, as a skilled maker, he approached them as the products of another skilled maker, appreciating the splendid craftsmanship of an-

6. For a discussion of the limitations of reconstructing the social and historical context of the author see Gadamer, especially his *Philosophical Hermeneutics*.

7. Heidegger, "Origin of the Work of Art," 41. For more on this issue see Tompkins, *Reader-Response Criticism*; Jauss, *Towards an Aesthetics of Reception*; and Gadamer, *Truth and Method*.

8. Dürer quoted in Honour, *New Golden Land*, 28. Also see Greenblatt, "Resonance and Wonder," 52ff.

other hand. Their full meaning, as is that of all works of fine art, was un-available to Dürer because it was circumscribed and embedded within a realm of social conventions totally foreign to him—in this case the so-cial conventions that formed the Pre-Columbian Meso-American world-view. This is a fact of fine art even though fine art may share with craft those qualities of wonder attributable to all finely and skillfully made objects.

On the other hand, since semiotic conventions are neither standard-ized nor proscribed in any way other than by social conventions, fine art objects have freedom for great diversity and change. This freedom, how-ever, means they also are subject to the vicissitudes and whims of time and history: meaning in fine art changes or dissipates as social struc-tures change or pass away. While craft objects generally lack this kind of freedom, in the face of social and political changes and upheaval, they stubbornly retain their basic purpose and their applied function. Hence the frequent reuse of antique pots and furniture, for example, predynas-tic Chinese pots and Louis XV furniture. Today such works are still as perfectly clear in their purpose and serviceable in their physical func-tion as they were centuries ago. This is not to argue that something has not been lost, that as art objects crafts do not have what can be deemed a social life; rather it is to stress craft's consistency over time as physical objects.

What can be concluded from the above examples is that fine art ob-jects *"communicate"* something to us as social beings, as members of communities of like-minded people; their purpose is not to be found in what they *do* for us as physical beings with biological needs. But because of their social dependence, if no one is capable of reading their semiotic systems, they no longer will have the same communicative existence they once had. If works of fine art outlive their original social context, they usually are either reinterpreted and reintentionalized taking on new meanings relevant to the current social structure in which they are found. Or, if a potential for this is not possible, they simply descend to the level of "artifact"—artificial objects of solely historical or anthropo-logical interest.

In the modern world in which we live, aesthetic and philosophical thought desires to see fine art as universal and timeless, something re-flected in the way the ancient saying *"ars longa, vita brevis"* is translated today—"Life is short, but art lives forever." Its original meaning, how-ever, was more akin to "the life so short, the craft so long to learn,"

something very different indeed.[9] When Western culture encountered art of other cultures, it extended its own theories of formal abstraction as an aesthetic principle to such work as a way of understanding it; it was a way of bringing the work into the realm of the comprehensible, even though formal abstraction in the Western sense was not the motivating factor in most non-Western art or even most non-modern Western art. In the case of many Native American objects, museums have tended to exhibit them as art in the current Western sense of interesting formal objects to be seen on display. Native Americans, however, still regard many of them as potent religious objects profaned by public display. In recent years this has sometimes resulted in a collision of cultures.[10]

From all of this, I think we can conclude that as physical entities that function, craft objects are "real objects" in the sense that they exist in the world as tangible things apart from our perceptions and apart from language. Moreover, the social existence they have (to be discussed in detail in Parts 3 and 4) stems directly from their physical existence. The opposite is true of works of fine art; their physical existence is predicated on their social existence. As physical objects their existence is socially contingent on a language of signs, so much so that, in a sense, they have little meaningful existence independent of them.

9. The original comes from Hippocrates, *Aphorisms*, I (5th century B.C.), but here quoted in the Latin from Seneca's *De Brevitate Vitae*.

10. Native American and non-Western artists' and critics' resistance to having non-Western work reduced to purely formal objects caused a heated controversy to erupt over the 1984 Museum of Modern Art's exhibition "Primitivism in 20th Century Art: Affinity of the Tribal and the Modern." This occurred despite claims by the curators, especially William Rubin, that they intended only to examine the historical attitude of modern artists toward non-Western art, not the non-Western art itself. Detractors, in particular Thomas McEvilley, argued that this was not what the exhibition actually did, that, in effect, Rubin violated his own position repeatedly in both the catalogue and the exhibition labels. For more on this see McEvilley, "Doctor, Lawyer, Indian Chief," 52–58, and reprinted in his *Art and Otherness*, 27–55. For responses to McEvilley see Rubin, "On 'Doctor, Lawyer, Indian Chief,'" 42–45; and Kirk Varnedoe, "Letter in Response to McEvilley," 45–46; for McEvilley's response see "Letter in Response to Rubin," 46–51. For a second round of letters see Rubin's "Doctor, Lawyer, Indian Chief: Part Two," 63–65; and McEvilley's "Second Letter in Response to Rubin," 65–71. Letters by other parties appeared in *Artforum* (Summer 1985): 2–3. For an anthropological perspective see Clifford, "Histories of the Tribal and the Modern," 164–77.

CRAFT, FINE ART, AND NATURE

■ ■ ■

Craft objects are inextricably tied to nature since their purpose is founded in physiological need, their functional forms reconstitute models found in nature, and they operate by carrying out practical physical functions. Even as objects it is possible to speak of them as being circumscribed by nature since the physical laws of matter dictate their form, material, and technique. A similar conceptualization of fine art is not possible even though fine art is generally based on appearances of the natural world, something already apparent from the earliest Paleolithic sculptures and paintings and, of course, from the earliest images of landscape (Figure 6). Despite such instances of naturalistic appearance, the conceptual and physical relationship of fine art to nature differs from craft's because fine art does not involve the reconstituting of nature into objects capable of actually functioning like their "models." Instead, fine art achieves its goal, as I have already said, by using a semiotic system of visual signs and symbols, something true of the most abstract works as well as of the most naturalistic of works. It is also true of the newest as well as the oldest art, that found in prehistoric caves in France. All operate as representations and conceptualizations of things actual or imagined. Whether rendered in two dimensions as paintings or in three dimensions as sculptures doesn't matter because they always are images and images always are abstractions. So how faithfully and lifelike they may reproduce their models isn't an issue; visual fidelity to nature simply is not a prerequisite for fine art's signs and symbols to function as "communication" vehicles.

FIGURE 6. Bull and horse, cave painting, ca. 15,000–13,000 B.C. (bull ca. 11′ 6″ long). Lascaux Caves, Perigord, Dordogne, France. Photograph: Art Resource, N.Y.

For this reason, they need not be faithful to visual appearance and can even be completely abstract. In Paleolithic caves stick-figure ideograms that are very childlike in form are found alongside more sophisticated naturalistic imagery as well as imagery composed of completely abstract signs and symbols (Figure 7).

Because fine art is dependent on a system of visual signs that only garner meaning from the social complex in which they originated, it is always symbolic. This is why, as Gadamer's argument that I rehearsed in the introduction indicated, being able to recognize an image as that of a bull or a woolly rhinoceros is not the same as being able to understand its meaning and comprehend its significance to the social group that made it. Regardless of how faithful to natural appearance such images may be, if the viewer is not part of the community in which they were made, the viewer can only infer social context from whatever external evidence can be garnered through art historical, anthropological, or archaeological study; in short, meaning and significance are not completely transparent within the images themselves. That's why fine art is as much about the viewer and the act of viewing as it is about what is viewed. As a social construction, it is entangled in a web of meanings intimately tied to and dependent upon systems of symbols that viewers must be able to "read" and understand if the work is to "communicate."

FIGURE 7. Drawing of various abstract signs from the Paleolithic period, ca. 15,000–13,000 B.C. Lascaux Caves, Perigord, Dordogne, France.

$$\text{SIGN} = \frac{\textbf{Signifier} \text{ (the word/sound "tree")}}{\textbf{Signified} \text{ (thing-concept in the garden)}}$$

FIGURE 8. Sign diagram.

In this sense, we can say the difference between craft and fine art is that fine art entails the making of *symbols* while craft entails the making of *things*. These differences, which stem from their relationships to nature, reflect the oppositions "reality and appearance" and "the actual and the symbolic." Understanding these oppositions is essential to our discussion because they go to the heart of what craft and fine art are.

A sign or symbol, by definition, is "something that stands for or suggests something else by reason of relationship, association, convention, or accidental resemblance; *esp*: a visible sign of something invisible <the lion is a ˜ of courage>." In this example, lion, something visible, is used to refer to courage, an abstraction relating to behavior. Having said this, one must not forget that signs are themselves abstractions composed of two parts: a thing-concept and some formal element that calls attention to that concept. The word "t-r-e-e" (as a group of letters or sounds) is the formal element and the actual plant in the garden is the thing-concept to which the word refers. To Saussure this is known as a signifier-signified relationship and composes a linguistic sign, as seen in Figure 8.

In this relationship I am calling the signified a thing-concept, rather than simply a thing, because knowing and understanding the signified at a level beyond just formal appearance is necessary if a sign is to communicate in a meaningful way; this is Gadamer's point about understanding and re-cognition. Communication entails more than just naming, more than just matching a signifier, say the word "painting" or an icon for painting like 🖼 to an object. It entails experiential and conceptual

$$\text{ICONIC SIGN} = \frac{\textbf{Signifier} \quad \text{🌲}}{\textbf{Signified} \ (\text{thing-concept in the garden})}$$

FIGURE 9. Iconic sign diagram.

knowledge. That's why to someone completely ignorant of the American Civil War, a painting of Abraham Lincoln would be just another of many iconic images of a man with a beard. The purpose of this study, in fact, is to expand craft's "thing-concept" in a way that parallels what critical theory has done for fine art's "thing-concept" so that a craft object can come together with a theoretical thing-concept that will give it fuller, deeper meaning.

In written and spoken language, as Saussure noted, the signifier/signified relationship of most words is usually arbitrary. Nothing in nature or anywhere else predetermines this relationship. It is not a relationship existing prior to language; it is simply a socially agreed upon convention that must be learned by the speakers of that language. Thus any combination of letters or sounds could have been agreed upon as a formal element to signify tree; hence, "tree" in English, "*arbre*" in French, "*baum*" in German, "*albero*" in Italian, "*namu*" in Korean.[1]

Not all signs/symbols, however, are based solely on social agreement. Some have a form, usually based on resemblance, so they actually look like the thing to which they refer. Their form (their actual physical or graphic shape) is predetermined by the thing to which they refer. Such signs/symbols are called iconic (that is to say, image) and encompass all representational images, including most Paleolithic cave paintings and sculptures. The close connection between Paleolithic icons and their referents in nature (for example, Ice Age animals as seen in Figure 6) is one of their features that has made these images so intriguing to the modern viewer, not their meaning which remains basically lost to us. To make an iconic sign of our diagram, the word "tree" is simply replaced by a picture (an icon or image) of a tree, as seen in Figure 9.

Another type of sign/symbol which isn't arbitrary but also doesn't resemble the thing it signifies is called indexical because it indicates the signified in the way smoke indicates fire, a knock someone at the door, a siren a speeding fire truck, dark clouds impending rain, or hoof

1. For more material on this see Saussure, *Course in General Linguistics*, 67, 114.

$$\text{INDEXICAL SIGN} = \frac{\textbf{Signifier}}{\textbf{Signified (something burning)}}$$

FIGURE 10. Indexical sign diagram.

prints the existence of an animal. This relationship is neither arbitrary nor iconic, but causal in the sense that smoke is caused by fire.[2] A diagram of such an indexical sign/symbol for fire is shown in Figure 10.

As the above diagrams show, something is a signifier only when it has a link in our minds to something else; the "something else" being the thing signified. But every signifier, whether it be arbitrary, iconic, or indexical, is always separate and different from that which it signifies; it is *always* a stand-in for something that is not there, the absent signified.

Most signs function to refer to and to mean what they are signs of ("t-r-e-e" refers to a thing-concept that is understood as a certain plant among many plants, but also one that has specific characteristics of its own). There is a smaller class of signs, part of whose function, in addition to referring and meaning, is to be beheld in the sense of gazing intently upon and contemplated. A traffic sign picturing a person in a crosswalk is an iconic sign and is meant to be read, but not beheld and contemplated; otherwise we would never get across the street. On the other hand, a painting by Degas of Monsieur Lepic and his daughters crossing the Place del la Concorde in Paris is intended to be read, beheld, and contemplated and move us in certain ways that a street sign does not. Both are iconic and both communicate, but only the latter sign is intended to be fine art.

I have rehearsed this theory of signs because I believe craft also has a beholding factor, one that the function/nonfunction theory of art dismisses or, at the very least, has not taken into account. However, before discussing this I want to first examine craft and fine art in relation to other basic questions raised by signs. Do craft and fine art operate in their primary purpose as signs? And if so, of what type are they composed—arbitrary (signs based on social agreement), iconic (signs based

2. These distinctions between types of signs were made by the American philosopher C. S. Peirce; for more on this see Hawkes, *Structuralism and Semiotics*, 126–28.

on resemblance), or indexical (signs that indicate the way smoke indicates fire)?

Sculptures, paintings, photographs, drawings, and prints are all objects in the sense that they can be picked up, held in the hand, even toted about from place to place. However, with few exceptions, they don't function primarily as physical objects. A representational painting of a tree and the setting sun would not be appreciated primarily for its physical properties as an object. If it were, all pictures would be sold by the square foot and all sculptures by the pound. Rather, it is the image that one looks at and contemplates. In this sense, the representational image of the tree and the setting sun *are* the painting, not necessarily the canvas or the frame. But since the tree and the setting sun are not actually present (the tree in the painting cannot be cut down nor can one see by the light of the painted sun), they must be *re*-presentations of the absent sun and absent tree. As we have said, fine art doesn't reconstitute nature into functioning objects, but conceptualizes it into visual signs and symbols, in this case iconic signs operating as signifiers in a sign system. However, paintings can also be composed of arbitrary signs; for instance, a lamb or fish or the Greek letters "chi" "rho" could symbolize Christ. Paintings can also be composed of indexical signs if, for example, a burn mark was to indicate a flame as in the work of Surrealist artist Wolfgang Paalen or a violent-looking brush stroke the artist's anger as in Willem de Kooning's early 1950s paintings. But regardless of type, they are all signs. Otherwise they would have to be a real tree and the sun, in which case they would be nature and not an image or picture of nature.[3]

3. This brings up an interesting issue. An artist could frame a view of nature so it is seen *as if* a work of art, as in the bronze "sculpture" of hands holding a giant picture frame (30′ × 60′) before the seashore in the Chinese city of Weihei, or bring a tree into the gallery and call it a piece of sculpture. Is this really art? What the artist is doing in such cases is asking the viewer to *think* of this view *as if* it were a picture or of this tree *as if* it were a sculpture. This may seem nothing more than misuse or even tomfoolery, but when we oblige the artist and *think* of them in this way, these real/actual things operate as if they were signs, just as a painted picture and a sculpted tree would. In other words, they would operate *as if* they were works of art; but, because we can't help but remember that they are real/actual things, they also raise questions about the relationship between real things and signs and how one can be mistaken for the other. When one lives in a world filled with signs, signs that intrude upon us constantly from television, films, magazines, newspapers, videos,

Clearly a painting or drawing of a bull on a cave wall is an iconic sign whose form is based on the appearance of the signified (the actual animal). As such, it is always a *re*presentation, and no matter how strongly or realistically it *re*presents that thing in nature, it can never be that thing; it will always be an illusion that, albeit points to that "fact" of nature which it resembles. Whether this "fact" exists, as in the case of the bull, or is imagined like a centaur, it is always an illusion nonetheless.[4] Thus paintings, drawings, prints, photographs, etc., as conceptualizations in two dimensions, are a category of images whose connection to nature is as a parallel world of appearances. No matter the degree of *trompe l'oeil* illusionism, this world is never the same as the actual world it imitates.

But what about sculpture? Since it is three-dimensional, do these same arguments hold for it? A statue or figure is not involved in illusionism in the same way as a painting or drawing of a figure. However, a statue is still an iconic sign based on appearance; that it happens to be three-dimensional does not make it any less a sign nor any less an image nor any less an illusion of a human being than, say, a photograph or a drawing. This holds true even for statues as deceptively human-looking as those of contemporary photo-realist sculptors Duane Hanson and John De Andrea. They are so realistic that they may imitate the appearance of humans by even being outfitted with real clothes as in the work of Hanson and, in the case of the Walt Disney "robot" that supposedly looks, moves, and talks like Abraham Lincoln, they may even appear to be alive and to think. But these are just appearances, deceptions; they are without life, mere fictions. For no matter how close in appearance to the actual thing an iconic sign may be, by its very nature it is always a substitute for the actual thing and never the actual thing itself.[5]

the Internet, it is not an entirely meaningless endeavor to examine the curious seepage of semiology into nature.

4. This is Plato's objection in Book X of his *Republic* to visual art; see his "Art as Imitation," 9–12. Concerning cave art, one could argue, as many have, that the painted or drawn image played a ritual role in helping the hunter capture his prey. While this may be true, playing a ritual role in obtaining food and actually "being" food are totally different.

5. The 1982 futuristic movie *Blade Runner*, directed by Ridley Scott and featuring Daryl Hannah and Harrison Ford, revolves around this very issue, as Ford's character falls in love with a beautiful "female" android. For more on this issue see Shanken, "Tele-Agency."

Considering that fine art functions through its sign value, it becomes clear that fine art is not a specific set of objects per se, objects having an intrinsic, essential nature of their own. There are no natural, a priori requirements that determine what fine art should be or how it should function and "communicate," only a social agreement about how something should be seen and understood as an ideational/conceptual category of signs. As a result, it seems most anything can be deemed a work of fine art, evidently even Duchamp's urinal (Figure 3). In a similar fashion, various works of contemporary art are simply actions performed by an artist in public (for example, the performances of Vito Acconci and Chris Burden or those of Gilbert & George in which they present themselves on a pedestal as living sculptures) or actions "performed" on the earth itself. Michael Heizer's 1969–70 *Double Negative* is a case in point. A well-known sculpture, it consists solely of two deep cuts (30' wide × 50' deep × 1500' long) into facing slopes of Mormon Mesa in the Nevada desert. By all normal accounts it should be thought of as nothing more than an excavation in the earth, a negative quantity rather than a "piece" of sculpture. But it is seen and regarded as sculpture because it fits into the ideational and conceptual discourse surrounding sculptural works of art in the United States at that particular time.[6]

As these examples suggest, fine art objects can only exist and be understood as signs if they are "bracketed" from normal things in the world, that is to say, by being set apart by social agreement as a special class of objects. Such "bracketing" is so powerful a device that it can cause actual objects like a tree or a cut in the earth to be regarded by the viewer as part of the world of fine art. When this "bracketing" is suspended because of the way the artist made the object look or by the perceptions of the viewer, as was the case when viewers in the eighth century supposedly revered Byzantine icons as if they were the actual saints rather than their representations, the work of art slips back into the world of natural things losing its identity as fine art; it then ceases being a sign latent with symbolic value and meanings and "becomes" something else, a saint or a deep trench in the desert. In contrast, craft objects need not be "bracketed" from the natural world to be under-

6. This particular discourse revolves around the belief prominent in the late 1960s that sculpture need not, in fact should not, be subject to the marketplace as a commercial commodity; it could be an integral part of the landscape and could even be about space without having a solid, physical presence in the form of an object.

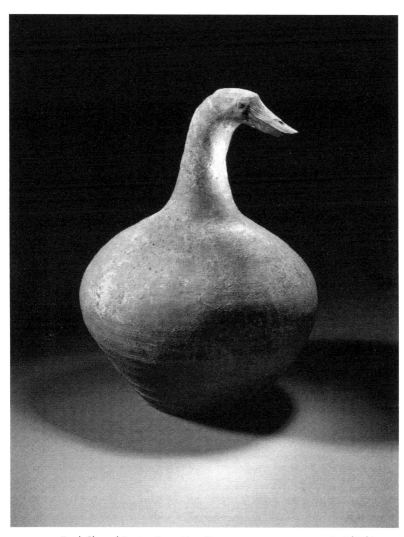

FIGURE 11. *Duck-Shaped Pottery Ewer*, Han Dynasty, 207 B.C.–220 A.D. (10″ high).
Private collection, Amsterdam. Photograph courtesy of Robert Brown Gallery,
Washington, D.C.

FIGURE 12. *Cow-Shaped Creamer*, twentieth century, French porcelain (4.5″ × 7″).

stood in their basic existence as physically functioning entities. This is because, in their basic *form* as functional entities, they are not signs of something that is absent; they are things in and of themselves — the container is the container, the cover is the cover, the support is the support.

Saying this does raise some interesting questions. What happens when a craft object, say a large plate, is "decorated" with an image, even a portrait as was common in Italy during the Renaissance? Does this make the plate a craft object or a work of fine art? And what about a vessel in the shape of an animal: is it a craft object or a sculpture? The plate, though decorated, would still be a vessel. However, when the plate is no longer recognizable as a plate, having been overtaken completely as a support for an image, I would then consider the work a painting on ceramic. The same is true of a vessel in the form of an animal (see Figures 11 and 12); when its vessel form is still apparent, it is still a vessel; when its vessel form disappears, is subsumed by the anthropomorphic form of the animal, it can no longer be regarded as a vessel. Where one actually draws the line in such instances is a matter of judgment for the viewer. In this regard, an interesting aesthetic strategy would be to make an object that hovers on the edge between the two so that the

mind's eye could not easily decide how to see the object. Or perhaps, one could make the object in such a way that the viewer saw both a container and an animal at the same time.

Leaving these "hybrid" examples aside, from the point of view of signs we can say that since fine art always entails the making of formal symbols, its root is always to be found in the signifier pointing to some-*thing* other than itself. By contrast, craft always entails the making of actual things, not signs. The craft object *is* the thing itself. The subject of a bowl *is* the bowl; the subject of a chair *is* the chair, just as the sub-ject of a blanket *is* the blanket. Thus, unlike the fine art object, the craft object's basic physical configuration as formed matter is not dependent on a social system of symbolic signs that point to some thing; the craft object stands as itself in itself; it stands in all its plenitude and function-ality as a man-made physical object with a specific function.

TECHNICAL KNOWLEDGE AND
TECHNICAL MANUAL SKILL

■ ■ ■

The extensive range of formal and conceptual possibilities that exist in the world of fine art—from standing figures to obelisks, from naturalistic landscapes to modernist abstractions—reflect two things; one, the great variety of social structures and conventions from which fine art springs; and two, that fine art functions mainly as a sign and, since anything can be designated a sign, there are few, if any, predetermined strictures controlling it. By contrast, that craft objects remain strikingly similar worldwide in terms of function, form, technique, and material is because a priori elements condition their formal and conceptual possibilities: craft objects are tied to the physical laws of nature, laws applicable universally across the spatio-temporal horizon and laws that are immune to social and cultural circumstances.

This situation has affected craft in two important ways. First, it has drawn craft emphatically to material. In its basic properties as physical matter and in its "willingness" to be formed so as to become a functional object, material is essential in the production of craft objects and must suit the functional requirements of each specific object. So important is material that, as previously noted, craft objects are often identified by it: clay, glass, fiber, wood, metal. Moreover, practitioners often identify so strongly with the material they work that they even identify themselves as woodworkers or metalworkers or glass artists or ceramists or fiber artists. Many surnames follow this pattern, such as "clay," "wood," "cotton," "steel," "gold" and "goldman," "silver" and "silverman," and "glass," among others.

The second way physical laws have affected craft concerns process, especially as process relates to the actual making of objects. So crucial is process that it too is a primary concern and, not surprisingly, traditional divisions within the craft field are often based on it as well: hence the frequent use of processed-based terminology such as "throwing," "weaving," "turning," "joining," "smithing." Similarly, craft practitioners have likewise been identified by process; "turner," "joiner," "smith," have become common proper names, as have "wheeler," "tailor," "cooper," "mason," "carver," and "plumber"; such surnames are testimony to the prestige skilled-hand trades acquired in the preindustrial world.

Stressing the importance of material on the one hand or process on the other suggests a split or separation between the two. This is unfortunate because both material and process are essential to craft and must be understood together as the basis of craft technique, a unity of operations centered in functional purpose. "Technique" is a French word derived from the Greek "*technikos*," which, in turn, has its root in the Greek "*technē*." "*Technē*" refers specifically "to the knowledge of *how* to do or make things (as opposed to *why* things are the way they are)." But more generally "*technē*" denotes a body of procedures and skills.[1] To make a craft object involves procedures for preparing material as well as sophisticated skill in the manipulation of that material by the hand. Because of this, technique in craft generally is not simply a set of procedures or rules that can be verbally communicated and then executed; rather, it is a twofold operation that usually requires a high degree of motor/muscle skill (kinesthetic sensitivity) and specialized knowledge in the preparation and "finishing" of materials. In other words, craft technique entails two kinds of learning that leads to two kinds of knowledge: one is a sophisticated technical knowledge of materials and their properties and the second is a high degree of technical manual skill to readily and effectively work material into the requisite form.

Technical knowledge about preparing materials is theoretical or cognitive, concerned with what modern neurologists would call declarative memory. It involves things like formulas, temperatures, chemical reactions, and properties of various material, etc.; generally it is characterized as factual information that can be communicated verbally. The second type of knowledge concerns the ability to actually do or construct something and involves manual skill, what modern neurologists would

1. See Angeles, *Dictionary of Philosophy*, 289.

call procedural or motor memory. It is defined as skill "acquired through practice or action, rather than [through] theory or speculation."[2]

Unlike technical manual skill, technical knowledge is usually required in the preparation of raw or base matter into workable material and then again at that point when worked or formed materials are transformed to their finished stage. This preparation and transformation can be called the "what to do" stage—what to do to prepare and fire clay into ceramic, to prepare and melt silica into glass, to prepare and smelt ore into metal, to prepare and cast metal, to prepare and cut trees into lumber, to prepare and bend wood, to prepare (card) wool and spin thread, to prepare, dye, and set fibers.

Because materials don't easily give themselves up to becoming the object the maker wishes, technical knowledge is essential. For the maker of ceramic pots, choosing the proper clay is only the beginning of a lengthy process. The clay may need other materials added, such as grog; it must be wedged, and it must have the proper amount of moisture before it can be worked by hand or on the wheel. The situation is similar for preparing fibers for weaving cloth and reeds or grass for making baskets. In glass making, the proper silica (sand, flint, or quartz) must be selected; other materials must be used as well, such as flux. As anyone who has worked with materials knows, exactly what to do to materials takes a great deal of technical knowledge. Only with this knowledge is the maker able to prepare raw material into "workable material" which then can be transformed into finished objects.

Once a material has been properly prepared, technical manual skill comes into play. Technical manual skill occurs at that stage when workable materials are actually worked and formed by the hand. This stage can be called the "how to" stage—how to form the clay on a wheel, how to blow glass, how to chase or hammer metal, how to weave reeds, how to shape/turn/join wood.[3] Manually forming material into the desired object presents challenges. One can quickly gain technical knowledge

2. Frank R. Wilson discusses the neurological discovery of these two kinds of knowledge; see his *The Hand*, 333.

3. I am presenting this as a neat separation of knowledge for clarity's sake; in reality it is not always so. At each stage that raw material is "raised" to another level, technical manual skill is necessary; for example, as much technical manual skill is probably involved in twisting fibers into thread as in weaving it; the same could be said of splitting wood for split-wood baskets.

about materials and the technical procedural skill to transform it into a craft object. Difficulty arises in the doing. Between intellectually knowing how to manipulate a material and being physically capable of doing so lies a vast gulf. This gulf can only be spanned by the kind of learning that comes through much diligent practice. For craft, practice is essential in order for the hand to acquire the necessary technical manual skill to process material into functional form.

Such technical manual skill and physical dexterity is similar to that required to play a musical instrument; in craft as in music, both can only be acquired through extensive practice based on repetition. Thus it is not just by chance that both the performing skills of the musician and those of the maker of craft objects are referred to as technique. And while the musician doesn't actually make a physical object, the acquisition of technique by both musician and craftsman is essential because both must be able to perform so effortlessly that the mind is not engaged with problems of physical execution but is freed to concentrate on the more intellectual, abstract, and conceptual problems concerning form and expression. Because technique, in this sense, is of a practical nature having to do with manual skill, muscle memory, and a kinesthetic sensitivity, it can only be acquired through practice. To this end, reading or listening to theoretical explanations or descriptions of manual technique is of little avail; that's why craftsmen generally do demonstrations in studios rather than give "artist's talks" in crit rooms. One simply must engage in practice, the kind of practice that usually focuses on repetition. In music, repeating scales and arpeggios are a mainstay. In craft it is the repetitive use of the potter's wheel, the glass-blower's pipe, the weaver's loom, the turner's lathe, the smith's hammer.

This kind of manual technique is so specialized that for both musical performer and maker of craft objects proficiency on one "instrument" does not necessarily carry over to another; just as an accomplished pianist isn't necessarily capable of playing violin, an accomplished glass blower doesn't necessarily have the technical skill to work metal or wood or some other material. In this sense technique limits what materials the craftsman can work. However, there is an important aspect of technique that must not be underestimated. Once technical skill is mastered in an area, the making of an object, like the playing of a piece of music, may offer a transcendent experience to the maker as mastery of motor control allows the maker to work in harmony with material substance to give form to mere shape—something of this Zen-like ex-

perience is what M. C. Richards hints at in the title of her book *Centering, In Pottery, Poetry, and the Person.* It is a kind of experience in which conscious mind itself seems drawn through the hands to the tips of the fingers, the farthest outposts of reach and touch. Stretched to the very limits of the body, mind seeps into the object of its intention, giving coherent form to otherwise resistant, inchoate matter.

This is an especially apt metaphor for the making of craft objects. When throwing pots on a wheel, the hands and fingers of the ceramist direct the energy imparted by the wheel's centrifugal force into the clay, gently forming, coaxing the material into a willed object. With the turner's lathe, the hand is extended through the chisel and carefully channels the lathe's energy back into the wood, encouraging it to give up its resistance. A similar situation exists with the glass blower's blow pipe and, in a more methodical fashion, the weaver's shuttle, the knitter's needles, and the metal worker's hammer. In all these cases, the material is gently urged into a functional form, a functional form to which the material is naturally predisposed, but still somewhat resistant. When done properly, technique in craft is never a violent encounter of hand with the material world, but a natural coming together of hand, material, and form.

Traditionally this is not the kind of transcendent experience with technique and material given to fine artists. Their actions are less repetitive and more deliberate; each move of the brush, pencil, chisel, or palette knife is more calculated. Something of a transcendent experience does sometimes enter their work, as in the case of the Surrealists who developed what they called automatic techniques as a way to tap into the unconscious mind.[4] Likewise Jackson Pollock, one of the so-called American Gesture Painters of the late 1940s and early 1950s in New York and one influenced by Surrealism, purposely avoided the deliberate and precalculated mark or gesture in his mature work in favor of semiautomatic, repetitive actions. Ritualistically moving around the unstretched canvas placed on his studio floor, he entered a kind of hypnotic stage dripping, puddling, and flinging great looping skeins of paint to make

4. In an attempt to bypass control of the rational and conscious mind, Surrealists developed various procedures such as automatic drawing and writing in which one purposely did not concentrate on what one was doing; drawing or writing was reduced to a physical, not mental, activity as a way of releasing the unconscious from the grip of rational control.

his famous "drip" pictures. As he wrote, "when I am in my painting, I'm not aware of what I'm doing."[5] While these kinds of physically centered repetitive actions are rare for the traditional fine artist, they are common for the traditional craftsman who relies on skillfully executed repetitive actions as the basis of manual technique. The differences between the traditional procedures of the fine artist and those of the craftsman could be characterized as the difference between "hand-eye" coordination and "hand-material" coordination. This is not to say the eye doesn't play a vital role in craft making, but that craft making is centered in material and its transformation through the hand as sensing agent.

At one time both craft and fine art demanded extensive technical knowledge for preparing and working material. Because of this, they were very close as practices—by practice I mean an extensive set of methods and procedures shared by members of the field in the creation of work. While craft has essentially maintained its practice, fine art has not. Today the technical knowledge requirements demanded in fine art are not very great; many of those that are demanding, like welding, have been borrowed from industry. Change occurred when fine artists stopped making their own paints and when works done in media demanding a high degree of technical knowledge like mosaic, fresco, and tempera fell out of fashion. When this happened and activities like stone and wood carving became less and less common in fine art, much of the need for specialized technical knowledge decreased. Even in the fifteenth century, bronze casting, an activity that requires a great deal of technical knowledge about metals, formulas, temperatures, venting, etc., was commonly done by bell founders; today metal casting is still the purview of foundry specialists rather than individual artists.[6] Print-

5. Pollock, "My Painting," 79. It is interesting that when painter/teacher Hans Hofmann told Pollock that he would repeat himself because he did not follow nature, Pollock supposedly responded by saying "Oh, but I am nature." This link to nature and Pollock's working procedures echoes craft objects and processes.

6. It is worth noting that what industry has taken over from craft is its technical knowledge; this knowledge has been put into mechanized systems that eliminate the need for workers with a high level of technical manual skill. This is the basis of Marx's complaint about workers being reduced to slaves of machines. With manual skill eliminated, workers's jobs are reduced to oiling and adjusting machines and to supplying them with "raw" material, chores formerly done by apprentices to craft artists in the guild system. What industry supplies for fine art is just this kind of

making is one of the remaining vestiges of the older tradition of fine art making; it is a practice still demanding a high degree of technical knowledge, as evident from the sixteenth-century engravings of Dürer and seventeenth-century etchings of Rembrandt. However, as fewer artists learned printmaking technology, this began to change and printmaking became a specialized activity. Prints began identifying both a "designer" (an artist who did the drawing) and a "sculptor" (an engraver who actually made and printed the plate), a practice that was fairly common by the mid-sixteenth century and remained so into the early nineteenth century. From that period on, artists who made their own prints were the exception. Today, presses like Tamarind and Crown Point help fine artists make prints by providing technicians who have the knowledge needed to realize the artist's images.[7]

In terms of technical manual skill, the kind required of the fine artist beginning in the late nineteenth century is also very different from that of the craftsman, so much so that the two fields have evolved different educational and training methods. George Kubler points out these differences, noting that traditional craft education "requires only repetitious actions" while the work of artistic invention "depends upon departures from all routine. Craft education is the activity of groups of learners performing identical actions, but artistic invention requires the solitary efforts of individual persons. The distinction is worth retaining because artists working in different crafts cannot communicate with one another in technical matters but only in matters of design. A weaver learns nothing about his loom and threads from study of the potter's wheel and kiln; his education in a craft must be upon the instruments

technical knowledge and even manual skill in fabricating, casting, producing paints in tubes, making brushes and solvents, etc.

7. I realize that the argument I have made is historically based in the sense that fine art media demanding much technical knowledge fell out of favor many years ago. This may be another factor contributing to the separation of craft and fine art because once technical knowledge of material became less important for fine art, the traditional guild connections that linked crafts, trades, and fine art diminished. However, that Leonardo da Vinci's 1498–99 black chalk drawing for *St. Anne, Virgin and Child* (National Gallery London) can be considered a pinnacle of Renaissance art though it demands only the most rudimentary knowledge of its material (chalk) also is not insignificant in relation to the argument I am making concerning the demands of technical knowledge in fine art and craft. Imitation of both folk art and the art of children also reflects this move away from obvious technical skill in modern art.

of that craft. Only when he possesses technical control of his instruments can the qualities and effects of design in other crafts stimulate him to new solutions in his own."[8]

With the exception of his contention that craft education "requires *only* repetitive actions," the basic differences Kubler outlines are quite accurate. When the fine art student draws from the model, it is not an exercise to train the hand to gain muscle control as in the way of repetitive actions, such as practicing one's musical scales.[9] Each mark made by the fine artist is different and unique, just as each drawing of the model must be different. This is so if for no other reason than each student is standing in a different place in the studio, hence observing the model from a different position. As a consequence, each student is drawing what amounts to a "different" model. More importantly, the object of drawing the model is to see and understand the figure as it exists as a form in space so it can be conceptualized as a two-dimensional or three-dimensional sign. As a result, traditionally what fine art students learn using one medium can be applied to almost any medium because their difficulty does not reside primarily in the medium but in the conceptualization of the model into a sign; it is a problem to be understood through the mind's eye, not the mind's hand. This is why in the Beaux Arts tradition handed down from the French Academic tradition, drawing has always been considered the basis for painting. Since training is centered on "hand-eye" coordination in two-dimensional abstraction, once achieved it remains in play for almost any medium used in two-dimensional conceptualization.[10]

With some reservation, because the technical demands of fine art media are less than those of crafts, fine artists generally are able to move more easily from one medium to another and with less effort than the

8. Kubler, *Shape of Time*, 15. In this remark Kubler is not only echoing Collingwood, but also Diderot's *Encyclopédie* in which it is said that the craftsman produces "the same piece of work made over and over again." See Boden, "Crafts, Perception," 289.

9. Musical scales are practiced to gain the technical manual ability to play each note with equal weight, intensity, and duration. While these are not conceptual issues, only manual technical skills to be gained, conceptual issues are hard to engage without these skills.

10. These generalizations may even apply to sculpture. Though a certain degree of technical-manual skill is necessary in carving material such as marble, less is necessary to model the figure in wood and little in clay.

craft artist. Moreover, we speak of charcoal, oil paint, graphite, water-color, even marble as media because they are the vehicles through which images are conveyed. But as we have seen, the word "material" is commonly used to refer to craft areas. This is significant because "material" has slightly different implications. It comes from the Latin word "materia," meaning matter. Among its English definitions are "physical material"; "relating to, derived from, or consisting of matter"; "the elements, constituents, or substances of which something is composed or can be made." Here the sense is shifted to the thing as thing and to the physical matter of which it is made; hence, the logic contained in the craft classifications clay, glass, wood, fiber, metal. For the fine artist emphasis is on the image, which explains why Leonardo da Vinci, like his teacher Verrocchio and his near contemporary Michelangelo, could work with equal ease in chalk, oil, and modeling clay.[11] Giorgio Vasari, Michelangelo's friend, even stresses this point in the introduction to the second edition of his *Lives of the Artists* (1568), arguing that the faculty of design (*disegno*) defines the artist and with its acquisition the artist is qualified to work in any medium.[12]

Being able to "work in any medium," as Vasari contends of the fine artist, has never been true of the craft artist. Each craft area remains distinct and separate within its own material domain. Each is centered on specific techniques, techniques dictated by its specific material, so much so that technical knowledge and technical manual skill acquired in one area usually do not carry over to another. In fact, the activities of the craft maker are so centered on material that critic Maureen Sherlock has even referred to it as a "fetishism of materials."[13] In this regard, the full sense of what it means to make a craft object—as a physical thing—is lost if form and function are not understood in relation to the skilled hand engaging physical material through technique. This sense of making was once well understood. In the mid-nineteenth century

11. Disaster befell Leonardo in his *Last Supper* "fresco" in Milan when he experimented with new materials of which his technical knowledge was inadequate; this is why the "fresco," though beautifully conceived and painted, began deteriorating almost immediately.

12. See Maclehose, *Vasari on Technique*, 206–8.

13. Maureen Sherlock as quoted in Kangas, "State of the Crafts," 29. Freud, with his typical concern with sex as a basis of all human activity, suggested that rhythmical activities including certain manual crafts are representations of sexual intercourse. See his *Introductory Lectures on Psychoanalysis*, 157.

Gottfried Semper, for example, trying to explain the emotional impact and magic of the granite and porphyry monuments of ancient Egypt, felt it surely must be because "the harsh, resistant material itself and the softness of the human hand with all of its simple tools (like the hammer and chisel) encounter one another and come to a kind of mutual pact."[14] The impact of the meeting of form, material, and technique in harmony with the human hand that Semper observes in Egyptian art forms the very basis of craft. Today an understanding of material and technique as a harmonious union has mostly been lost in the industrial age because, as Semper also observes, machines allow the maker to impose his or her will on material. With machines, material no longer needs to be "lovingly" coaxed into functional form; it can be forced to obey the will of the machine operator; it can be forced into the form desired even if this form is counter to the material's natural tendencies.

14. Semper, *Science, Industry and Art*, 334.

HAND AND BODY IN RELATION TO CRAFT

■ ■ ■

The importance of technique in craft is not limited solely to *"how"* to physically manipulate material. Technique also has a substantial bearing on *why* craft objects are the way they are because technique is a direct expression of the human hand. As I already pointed out, a major aspect of technique in craft involves the hand's ability to carry out certain operations based on technical knowledge of material and mastery of manual motor skills. But more than this, it is in the process of the hand carrying out technique (turning, weaving, throwing, chasing, knitting, etc.) that the craft object is formed and comes into being. In other words, the craft object's manifestation as a physical form is directly in and through the hand of the maker; it is through technique that the hand actually in*forms* the craft object. This explains why the various parts formed in the hand during construction all retain a shape and scale sympathetic to the hand in their final form—the neck of the vase, the handle of the pitcher and basket, the circumference of the goblet, the pull of the bureau drawer, the height of the chest so things can be reached, the thickness of the hand or armrest of the chair, the length and width of the cover. Characteristic of most well-made craft objects is that they gently and naturally fit the hand because, in large part, they spring directly from the hand via technique.

But there is more involved here so we should be careful not to see the hand in craft as simply an instrument to work material. Because craft objects are by their very nature intended to be physiologically functional, they are objects

made for the body and bodily "action"; therefore, they must accommodate the body and be somatically oriented. Containers, covers, and supports (in their parts and their totality) must be gauged to accommodate the body: if baskets are too large to hold in the hands in front of the body, their girth must fit between hip and hand, the cover must echo the rectangular shape of the body, the armrest must accommodate the arm, and the seat and splat must accommodate the buttocks and back. Objects such as these must be somatically oriented in the way they materialize the space in and around the body, the space between the arm and hip, around the seated body, etc. In this way they must retain, in their form, what is essentially a negative imprint of the human body.[1]

The hand in craft plays a central role in this for it is more than a simple appendage of the physical body; the hand is a reflection of the entire human organism; it is a direct extension of mind. When the skilled hand is executing technique, it is mind itself probing material, mind creating viable, functional form in and through the hand.[2] It is in this sense that the skilled hand must be understood as not only making, but also measuring, giving scale and proportion to craft forms so they will accommodate the body both physically and psychically. Thus, when proper technique is combined with suitable material, the skilled hand

1. Even the glass bottle, in its roundness, retains traces of the hand that turned the blow-tube, and in its spherical shape it also captures something of the body by echoing the inflated cheeks used to blow it or the shape of the partly closed hand that will hold it.

2. Neurophysiologist and 1932 Nobel laureate Charles Sherrington early on coined the term "active touch" to refer to the conscious guidance of the hand by the mind. Moreover, research has shown that motor skills of the hand are connected to the development of what is called the pyramidal tract, a special pathway between the cortex and the spinal cord. See Wilson, *The Hand*, 334n10. The experiments of Dr. Daniel Levitin, a cognitive psychologist who runs the Laboratory for Music Perception, Cognition, and Expertise at McGill University, suggest that "watching a musician perform affects brain chemistry differently from listening to a recording" of the same music. What this seems to indicate is that during the process of watching a musical instrument being played, the viewer's mind becomes involved, sympathetically, in the "active touch" of the performer; it is as if the mind automatically grasps something of what it means, literally, to *make* music. I suspect that our sense of sympathetic "active touch," even in relation to functional objects, is reduced as modern industrial production abstracts us from the realm of making. For more on Levitin's experiments, see Clive Thompson, "Music of the Hemispheres."

automatically establishes a physical and psychic resonance between itself as extension of mind and body and the craft object; it is in this sense that it can be said that through technique the hand actually in-*forms* the craft object, actually gives it physical form and formal meaning.

Something of the depth of the physical and psychic relationship that the hand establishes in craft objects is echoed in the older meanings of the word "handsome." Though today "handsome" is commonly used to refer to a person's physical beauty, especially men, it is obviously related to the "hand." According to the *Oxford English Dictionary*, the word is known in English only from the fifteenth century and it applies to objects that are "easy to handle or manipulate, or wield, or use in any way"; they also are "convenient, suitable, appropriate, proper, fitting, seemly, becoming, decent." Handsome objects would also be those that are "of fair size" as well as "having a fine form or figure." In short, "handsome" is a term used to judge how appropriate or good a functional object is by how well it relates to the hand and the body.

Buried deep within the etymology of the term "handsome" is the belief that objects that are awkward for the fingers or hand and out of proportion to the body generally, as gauged by the hand via their handle-ability, are somehow unsightly, even unnatural. Thus one can say that a craft object's propriety and beauty (its "handsomeness") ultimately derives from the hand, the hand as fundamental gauge of scale, form, and an object's utility.[3] In this sense, unsightliness has to do with the fact that it is difficult to make and use craft objects that are oversized or odd-shaped; such objects frustrate the grasp of the human hand and the breadth and comfort of human reach.

Thus if it seems unnatural to weave covers over a certain size or throw pots or to blow glass vases larger than certain dimensions or in

3. Other body appendages are also used to measure the world and the things in it—for example, feet and the cubit, the distance from the elbow to the hand; the hand also is used to measure horses (so many hands in height). The so-called "homunculus" diagram of the brain, published by Penfield and Rasmussen in 1950, implies that control of hand-arm-face imposes a disproportionately large demand on the central nervous system, far more than the rest of the body combined (see Wilson, *The Hand*, 320). It is not surprising that *Webster's New Collegiate Dictionary* lists ninety words stemming from "hand"; the 1971 *Compact Edition of the Oxford English Dictionary* has six pages of definitions for "hand" and ten more for words with "hand" as a root.

odd shapes, it is not only because material is worked by techniques that are dominated by hand skill and the limitations of hand size and function; it is also because beyond a certain size or beyond a certain range of shapes, natural, ergonomic relationships break down and get lost. Rudolf Arnheim, a writer on the psychology of art, refers to a small cafeteria coffeepot he once saw in Germany as a "monster to the eye" for this very reason; its cubic shape seemed to contradict its function because it did not welcome the hand in use (see Figure 20).[4]

Our sense of the proper scale, size, and shape of craft objects is a reflection of the properties of materials as they can be worked by the hand and of our sense of the body. This special relationship between craft objects, the hand, and body also has implications for function. To be functional a pot or a pitcher must be of impermeable material so it can contain, and it must be convenient, suitable, appropriate, proper, fitting, etc. This not only means it must fit the hand so that it can be grasped by the fingers, but its weight and balance must be such that it will be stable in the hand, easy to hold, tilt, pour, or convey from place to place. Construction of glass vases or woven baskets must likewise be geared to the hand; handles cannot be too thick to be firmly grasped nor so thin that they "cut" into the palm. Their surfaces must have proper texture so as not to be too rough on the skin or so smooth as to easily slip from one's grasp. Weight should be such as to make them portable, but also stable.

Making craft objects that conform to these requirements is seldom a problem for smaller objects. They can even get away with being awkward because their small size permits their awkwardness to be overcome, to be "over-powered," as it were, by physical strength. This is not the case with larger objects. Making them entails adapting forms to portability—giving an object an oval form to allow the hand and arm to reach around it at its narrowest point or constructing "hand holds" such as protruding lips and rims or simply adding handles. Whatever the case, such objects cannot be arbitrary but must be physically and logically geared to the hand and body. In this way, through their "handiness" and "handsomeness" they stand before us as rational objects reflecting the mind and body of the maker and user.

In this sense the technically proficient, skilled hand, as an expression of the rational mind, has wider implications that reverberate back onto

4. Arnheim, "Form We Seek," 356.

craft objects and the world they create. As Immanuel Kant noted, man is a rational animal whose rationality is "found even in the shape and organization of his hand, his fingers and the tip of his fingers. . . . It is through their build and tender sensitivity that nature has equipped him, not for just one manner of handling things, but unspecifically for all of them, which is to say, nature has equipped him for the employment of reason and thereby designated the technical capacity of his species as that of a rational animal."[5]

Kant was reiterating the central thesis of the Renaissance and Enlightenment tradition of rational humanism, a humanism soon to be pitted against the techno-scientific rationalism of the modern industrial world. In the humanistic tradition, Protagoras's (ca. 481–411 B.C.) contention that "Man is the measure of all things" is literally true. The hand, as extension of the human body, gave scale, form, and proportion to the things of the world so that they made sense only when understood in relation to the body via the hand. We repeat this sense of understanding every time we say we have "grasped" an idea or we use the metaphorical expression "I can handle this or that situation." When we speak of being able to manipulate something, we are doing much the same thing since the root of "manipulate" is the Latin "*manus*," meaning hand. Thus it is not surprising that it was against the body as gauged by the hand that things should be judged "proper," "fitting," "appropriate," in short, "handsome." Things judged not handsome, or unsightly, often were (and perhaps still are?) things that neither relate to the hand nor accommodate the body, things that don't feel good to the touch or aren't comfortable or that are not in scale to the body.[6]

Arguably, of all man-made things, craft objects epitomize the concept of the *rational hand* as an extension of the rational mind. That craft objects are uncommonly sensitive to hand and body quickly becomes apparent when one confronts things that are not, for example, modern

5. Kant, from *Anthropology from a Pragmatic Viewpoint* (1798), as quoted by Arnheim in "Form We Seek," 358–59. Like Kant, the Athenian philosopher Anaxagoras (500–428 B.C.) argued man's superiority was owing to his hand.

6. Judging things that are out of scale (covers, robes, food containers, etc.) as unsightly also has moral overtones. Traditionally, excessiveness implies waste, pride, hubris, and even gluttony; today we are beginning to take a somewhat similar view toward such excess by judging them in terms of their depletion of environmental resources and health risks.

packaging. Many shipping packages and crates are almost impossible for one person to handle (it is significant that we use the word "handle" for this expression), even though they may be relatively light in weight and relatively small in size. This is not because their design is irrational or arbitrary—far from it. Their design is indeed rational, but it is not a rationalism determined by the hand. Rather, it is determined by their contents or by their "store-ability" and "ship-ability"—how easily and high they can be stacked to efficiently use space during storage and shipping; how stable they will be during transport. These issues underlie their design rationale, not the construction of the human body nor the human hand; that's why they are often difficult to handle.

Understanding this goes a long way toward explaining why such packages and crates are often awkwardly shaped and unbalanced with surfaces too smooth to stay in one's grasp. Such objects, if one can even call them that, reflect a rational industrialism based on an economy of efficiency and machine production. This is not to say they are intentionally anti-somatic, against the body. Rather it is to point out that they are simply indifferent to the body; the body does not play a paramount role in determining their size, form, or weight. Shipping crates are, after all, objects to be moved, toted, hauled, and stacked by machines—dollies, forklifts, cranes, trucks, trains.

Standing in radical opposition to this industrial "packing-crate" approach, the amount craft containers can hold is regulated by the amount one can eat and drink at a sitting; a three-gallon bowl or cup is as senseless as a thirty-pound teapot is useless.[7] The size of furniture must also fit the human body; banquet tables for state functions that seat dozens of people are as unsettling as king-sized beds; they somehow seem ill-

7. Issues of scale in relation to the human body also arise in architecture and are best exemplified by Gothic and Renaissance buildings. While the scale of Renaissance architecture, following the ancient Greeks, was based on the proportions of the human body so as to anchor the structure in the visual and psychological space of the spectator, the Gothic architect strove to reach beyond human proportions to anchor the structure within the dematerialized spiritual space of the deity. This is why in the Greco-Roman and Renaissance tradition columns are based on the width and height of the human body; in the Gothic tradition columns are stretched to the visual and physical limits of their material. See Vitruvius, *Ten Books on Architecture*. Beginning in the early twentieth century, objects and buildings were designed to fit the visual and psychological space of industrial production.

suited to the normal human body. Heights of tables and desks also must be gauged to the body so that hands and elbows rest easily on the top while lower torso and legs are comfortably taken in by the underside and its supporting legs. Likewise chairs must conform to the human seat and back and be at a height such that the sitter's legs rest gently on the floor. Considering this, it is hardly surprising that various parts of craft objects are named after those parts of the human body they accommodate, the most common being handles on containers, but there are also seats, backs, and arm- and footrests, head- and footboards, and parts or areas of craft objects that are even called the hip, neck, shoulder, belly, foot, lip, mouth, and ear.[8]

In a very real sense, it can be argued that properly made craft objects choreograph the hands' and body's movements by making the user respond, literally and figuratively, to the object's physical properties, to its structure, weight, and texture. A heavy-looking object stimulates a firmer grip, a light or fragile-looking object a gingerly touch. This is true of all well-conceived craft objects, including furniture as well as covers. How we sit in a massive chair differs from how we sit in a delicate one — we may plop in one but not the other.

In our modern society the rational mind has increasingly been "liberated" (if that is the correct word) from the natural boundaries established by the physical body through the invention of machines and technological devices such as computers. Packing crates are products of industrialized society in which form is determined by a coefficient based on purpose (to package goods for storage or shipment) and efficiency (the least expenditure of energy and material), and cost. It is the machine and machine techniques in relation to this coefficient that now establish standards and scale, not the human body. The rewards of this have been many, including an increase in the material standards of living. But in the process of gaining these rewards, we have lost something of our sense of the scale and propriety of things in our world and of things in

8. These requirements also apply to adornments — necklaces, anklets, and bracelets. In this it is worth recalling that the word "brace," the root of "bracelet," comes from the Latin *"bracchium,"* meaning arm, hence our expression, "brace yourself." That the word *braccia* was also an Italian unit of measure equal to the cubit and nearly twice that of the English foot is another indication of how the human body, especially the hand-arm (that part of the body employed to make things), was a common standard of reference for things around it, especially man-made things.

nature; this has transformed both our conception of and our connection to nature and to man-made things as well. Renewing our understanding of what craft objects are and how important they are to our sense of our humanity is one way to reconceptualize our existence in the world of both nature and culture.

HAND AND BODY IN RELATION
TO FINE ART

■ ■ ■

Unlike machine-made objects, works of fine art traditionally share certain values with craft objects, at least to the extent they subscribe to the concept of making that extends from the hand. But there are significant differences in the relationship that works of craft and works of fine art have to the human body that their "hand-made-ness" often belies; this is especially true for sculpture. In the past these differences were not so pronounced when the sense of being a made thing accrued to all skillfully made objects because the ability to bring such things into existence seemed so wondrous. Craft and fine art were united at this level until changes began in the Renaissance as fine art's sense of wonder as a made thing was intentionally shifted to stress its intellectual aspects, something begun by Leonardo da Vinci, Giorgio Vasari, and other artists. Eventually fine art's sense of being a thing skillfully made of physical material was suppressed so its abstract creative features could be allied with the intellectual aura associated with the written word, especially poetry. By the mid-twentieth century, the skilled hand and the sense of wondrous making was so thoroughly suppressed as to be effaced from much contemporary art, as evident in Abstract Expressionism (both its color field and gestural varieties), pop art with its Ben Day dots and its commercial-looking silk screening, and Minimalism with its industrially produced objects. This does not mean the skilled hand was necessarily absent from such works, only that it is no longer in plain view. In many ways this suppres-

sion of the skilled hand solidified the craft/fine art split that began in earnest in the eighteenth century.

Suppression of the skilled hand and the wondrousness of making aside, even before this split, the differences between craft and fine art in relation to the body were significant. These differences go beyond how mind is extended into the craft object through the workings of the technically proficient hand during creation; it also has to do with how craft objects, especially covers and supports, betray their somatic sensibilities by materializing the space in and around the body, to present, as it were, a kind of envelope or negative spatial reflection of the body itself. Though they are manifested in a different way and toward different ends, fine art sculpture too has somatic/bodily sensibilities. That's why before the twentieth century sculpture has focused almost exclusively on the figure. Both literally and figuratively sculpture has primarily been concerned with being a replica of the body, a *doppelgänger* of the body, as it were; it repeats the body as a kind of ghostly counterpart to a flesh-and-blood person. This is attested to by the countless guardian figures encountered in the history of art—one has only to think of Assyrian, ancient Greek, Egyptian, African, Pre-Columbian sculpture. Even Michelangelo's *David* (Figure 13) performed such a function; this is why it was erected in front of Florence's Palazzo Vecchio, the old city hall, instead of on the cathedral for which it had been commissioned; it was to "guard" the Florentine Republic from encroachment by Medici and Papal forces from the south, the direction in which it faces.[1]

Sculpture, in its concern with the figure, takes advantage of the physical and psychic space that surrounds the human body and the body of other sentient beings. In doing this the sculptor is taking advantage of a deep-seated neurophysiological mechanism with which humans are endowed. Research has shown that very young mammals "lock their gaze onto things with two dark blobs in a certain position and orienta-

1. *David* was originally intended for one of the buttresses between the exedrae below the dome of Florence Cathedral, but a committee of distinguished artists and citizens, including Leonardo, realizing the statue's political importance as a symbol of Florentine independence, decided it should be placed in front of the Palazzo Vecchio to show the resolve of the Florentine people to resist encroachment by the Medici and papal forces in Rome. For more on Michelangelo's *David* see Hartt, *History of Italian Renaissance Art*, 420–21.

FIGURE 13. Michelangelo, *David*, detail, 1501–4, marble (ca. 17′ high). Galleria dell'Accademia, Florence, Italy. Photograph: Scala/Art Resource, N.Y.

The statue stood in front of the principal entrance to the Palazzo Vecchio until the nineteenth century, when it was removed to the Accademia to safeguard it from the elements. A copy now stands guard in its place.

tion." It also notes that even "new born babies, only seven minutes old, show an interest in such facelike stimuli."[2] At a neurophysiological level we react to figurative sculptures, especially through eye contact, as to other human beings; we sense the same psychic and spatial connection between them that we sense with actual people so that the experience, at a "gut" level, of encountering a figurative sculpture is the same as encountering another person.

This has implications that go beyond the neurophysiological mechanism associated with simple eye contact that conditions our initial response to sculpture. As German phenomenological philosopher Edmund Husserl notes, because the human body is a perceiving agent, when confronted with other human bodies we cannot help but discern the affinity between them and our own. These other bodies, viewed from without, reflect and resonate our own movements, movements that we experience from within. By an inherent mechanism of associative empathy, we, as embodied subjects, cannot help but recognize and respond to other bodies as other centers of experience, as other subjects; so strong is this empathy that it operates even if these other "subjects" are non-sentient sculptural bodies.[3]

Husserl's observations echo what people have intuitively understood for millennia about the powerful effect sight of the human figure has on the viewer. We cannot help but be moved to perceive it as a subject, as another human being. What transpires in this moment of beholding is the feeling, the drama even, that as we look at it, it looks back at us, returning our gaze so that a charged space of social interaction is created between viewer and viewed. While this space is related in a superficial sense to what happens when eyes in a painting seem to follow us around a room, it has a much deeper psychological sense about it, like one that commonly attends to devotional images or pictures of parents—in their presence we tend to feel obliged to act in a certain manner as if being observed. This is why of all the possibilities open to sculpture the human figure has been a dominant theme for millennia.

2. See Boden, "Crafts, Perception," 294. Something of the same effect of sculpture standing in for the body occurs even when sculptures only present part of the body, for example, Alberto Giacometi's *Hand* from 1947; in this work a synecdochic effect occurs in the viewer's mind's eye as the hand and forearm imply the entire body.

3. Abram, *Spell of the Sensuous*, 37.

It is why de-*facing* of images, both two and three dimensional, typically begins with destruction of the eyes and head and only subsequently progresses to the rest of the body. (The placing of coins over the eyes of the deceased person—as in the Shroud of Turin—is related to this.)[4] This is also why the shift away from the figural or anthropomorphic form in the twentieth century may be symptomatic of something more serious than just artistic preference; it may signal the deterioration of intersubjective relationships and the psychic quality of interactive social space in modern mass society—that people in large urban centers consciously avoid making eye contact may be symptomatic of a much deeper cultural malaise than can be explained by the stress and pace of urban life.[5]

In light of these observations, it is clear that in sculpture in which the figure is dominant and the "body-to-body" relationship remains in effect, the observer as a sensing agent cannot easily reduce the sculptural "body" to a mere thing or object. In other words, the way we naturally respond to the human figure makes it difficult for figurative sculpture to be apprehended as an object as are craft objects.

This figural component is so deeply rooted a part of the tradition of sculpture that it is often the case that it even exists in more abstract sculptures as well. A good example of this is *Die*, a work made in 1962 by American sculptor Tony Smith (Figure 14). A six-foot cube of fabricated steel, *Die* is considered a classic example of Minimalist sculpture. Yet Smith's work functions much like figurative sculpture because of its size. When Smith was asked, "Why didn't you make it larger so that it would loom over the observer?" he replied, "I was not making a monument." When asked, "Then why didn't you make it smaller so that the observer could see over the top?" he replied, "I was not making an object."[6] What Smith was making was a sculpture. At six feet square its size replicates the ideal human body (that is to say, the height and width of the normalized/idealized Western human body with outstretched arms). Leonardo da Vinci's universal figure called *The Vitruvian Man*

4. The psychological power of eye-to-eye contact is reflected in expressions like "look me in the eye and tell me. . . ."

5. In a related way, royalty often forbade eye contact by their subjects so as to preclude any suggestion of a personal relationship. It is said that the Byzantine emperor had himself carried through the streets of Constantinople painted like a statue with his gaze fixed straight ahead so his eyes would not meet those of his subjects—he must remain aloof, godlike, aware but unmoved.

6. Tony Smith quoted in Morris, "Note on Sculpture, Part 2," 228–30.

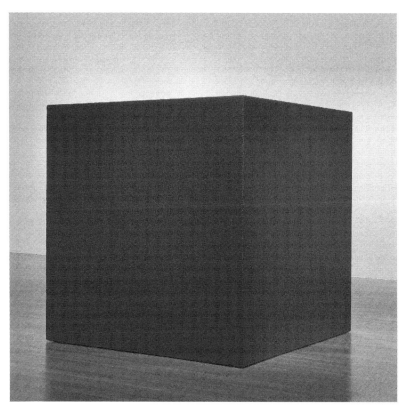

FIGURE 14. Tony Smith, *Die*, 1962, fabricated 1998, steel ("2/3"?) (6′ × 6′ × 6′). Gift of Jane Smith in honor of Agnes Gund (333.1998), The Museum of Modern Art, New York, N.Y. Digital image © The Museum of Modern Art/Licensed by Scala/Art Resource, N.Y., © 2007 Estate of Tony Smith/Artist Rights Society (ARS), N.Y.

(ca. 1492) (Figure 15), a drawing of a standing figure with outstretched arms circumscribed within both a circle and a square, would fit this cube.[7] Thus, Smith's insistence on a height and width of six feet was not an arbitrary decision but calculated to emphasize the anthropomorphic aspect of sculpture; it was calculated to insist that sculpture is not related to the hand (as is an object that is some*thing* to be *hand*led), but is related to the human body as a whole; that sculpture is something with its own integral spatial envelope that stands separate from, and in confrontation to, the human body of the viewer and that spatial and

7. Leonardo's drawing is taken from a written description given by the first century Roman writer Vitruvius in his *The Ten Books on Architecture*, 73.

FIGURE 15. Leonardo da Vinci, *The Vitruvian Man*, ca. 1492, drawing.
Galleria dell'Accademia, Venice, Italy. Photograph: Scala/Art Resource, N.Y.
This figure demonstrating the proportions of the human body is sometimes called the
Universal Man and was taken by Leonardo from the *Ten Books of Architecture* by the
first-century B.C. Roman writer Vitruvius.

psychic envelope that surrounds the viewer.[8] In other words, the human body's relationship to sculpture, even to an abstract sculpture like *Die*, is as to another human body in space. This same effect attends many of the abstract sculptures of Jun Kaneko. A work like his *Untitled, Dango* from 2003 (Figure 16), though it is a rounded form in ceramic with an elaborate surface treatment, echoes the human body enough in its shape and its "up-right-ness" to create the same sense of a psychic space linking it to Michelangelo's *David* and the tradition of all other figurative sculpture.[9]

In presenting a body-to-body relationship, figurative or anthropomorphic sculpture replicates the body as a form as well as our social and neurophysiological experience of encountering other sensing bodies in space. So powerful is this response that even heads and busts are intended to create the same experience as the complete body; this is why they are automatically placed on tall pedestals so that they can be viewed "eye-to-eye," the pedestal being a surrogate for the missing torso. Placed in other positions (on low tables or the floor), heads and busts would lose their bodily integrity, becoming either mutilated figures or decapitated heads. And if turned to the wall like a naughty child standing in a corner, they also become disquieting. When it comes to sculptural busts as well as full figures, we accord them something of the same politeness we do human beings by not treating them as objects.

Such bodily traits, implicit in Smith's *Die*, are explicit in figurative sculpture. As Husserl's observations suggest, without consciously thinking about it we automatically compare and relate statues to the body, our own and that of others. In this way the human body becomes the standard of reference and meaning—we scrutinize and gauge pose, gesture, expression, even facial characteristics and apparent age in relation to our own bodies and those of others as a way of deciphering meaning. Figurative sculptures communicate to us, as perceiving agents, because we cannot help but project onto them our understanding of our own

8. It is not insignificant that gestures of friendship, trust, and comradery involve the shaking of hands and even embracing, acts that are intended to puncture, if only for a moment, this cocoonlike spatial envelope that separates individuals; the act of embracing literally and figuratively makes two people one. The strength of this envelope and the extent to which it is "punctured" is a direct reflection of the formality of a society. In Japan it is very rigid while in the United States very relaxed.

9. For more on Kaneko's work see Peterson, *Jun Kaneko.*

FIGURE 16. Jun Kaneko, *Untitled, Dango*, 2003, hand-built, glazed ceramics, #03-12-14 (81″ high × 28″ wide × 21″ deep). Photograph by Dirk Bakker; collection of Kaneko.

As in the case of Tony Smith's *Die*, a work such as *Untitled, Dango* (the word refers in Japanese to the rounded form of a dumpling eaten during the tea ceremony) also suggests a body-to-body relationship with the viewer because of its size and form; this is true despite the virtual absence of any figural details with, perhaps, the exception of a cyclopean eye (?). Like all the works in this ongoing series of Dangos, *Untitled, Dango* is indebted to the craft practice of ceramics requiring an expert knowledge of material, glazing chemistry, and firing techniques; for *Untitled, Dango* these requirements are even more complicated because of its large size. Nonetheless, its effect is more sculptural than craftlike because, when approached, it seems to confront the viewer physically and psychologically; it is as though the viewer were facing another human being, another psychic entity. This is something its surface patterning may, at times, disturb but is unable to completely dispel.

bodies and how our bodies betray our feelings, emotions, pain, etc. In the way they reflect back to us our own understanding of bodily form, they force us to engage them (on a psychological, abstract, metaphorical, and neurophysiological plane) as we would other human beings.[10] Only through a resolute act of will can we force ourselves to regard them as we would regard objects or mere things.

In this matter, size obviously is important since it is easier to regard something small enough to fit the hand as an object than it is a human-size thing. It is especially easy to regard most crafts as objects simply because of their generally small size and to conclude that size alone is the major factor that conditions our response to things. For example, as already noted, though a grain silo contains grain, it is so large as to exceed the bounds of objecthood and thus can't be considered a craft container; pieces of furniture probably reach the outer limits of objecthood. But size and objectness are not the primary issues regulating the way sculpture relates to the body. If a small version of Smith's *Die* were held in the hand, it would certainly be objectlike as Smith feared, but it would not fit comfortably in the hand nor could it be firmly grasped. In a sense the same applies to figurines. Though small and often easily graspable physically, psychologically they don't sit comfortably in the hand for the reasons stated above—the figurative elements and the resonance and empathy they create between bodies (between the be-*holder* and it) demands a certain psychological space, a certain psychological distance and respect. This does not happen when a figurine is in the grasping hand unless the holding hand can be thought away, suppressed so the figurine can be viewed free and clear. But still, there is something slightly unseemly in the hand touching the body of a figurine, as unseemly as touching life-size statues, whether nude or otherwise. Thus even though one is able to cradle a figurine in one's hand, it doesn't readily lend itself psychologically to being "handled"; it does not elicit active touch and knowing through touch the way a craft object does. Ultimately, the figurine's meaning, like that of full-scale or life-size

10. The "photo-realist" sculptures of Duane Hanson are an extreme case in point. They are so realistic as to appear to be actual, live people; when we carefully look at them, as we presumably are supposed to do because they are sculptures, the uneasy feeling of intruding into that private psychological space of another person becomes almost palpable. This, of course, is the point and the more realistic, the more palpable.

figurative sculpture, does not come from its "grasp-ability" or "handle-ability," from its relationship to and in the hand as does a craft object; it comes from the metaphorical, psychological, and neurological relation-ship the figurine creates as a replica of the human body.[11] It is in this sense that one can, even must, conclude that sculptures traditionally do not operate as objects but as images.

Crafts, on the other hand, are literally and figuratively objects, objects that give themselves over to the body. Rather than reflecting back an image of the body as a relationship to another body, one creating an empathic relationship, craft objects complement the body by physi-cally accommodating themselves to it. By materializing the space in and around the body they offer themselves to the body in their form and in their function.

It is in these ways that the understanding of craft objects and the properties they exhibit is tied to the complex technical-manual skills, sophisticated skills of motor memory essential in their creation as func-tional objects. The nature and size of craft objects is regulated by their function and by the nature of technical manual skills. Because craft ob-jects are functional objects and because they are executed by the hand, a sense of "proper, human" scale is automatically imparted to them so they complement rather than challenge the human body. The inter-action of the human hand, with what Kant called its "tender sensitivity," via the manual demands of technique on material, leads to the inherent serviceability of craft objects and invites enactive touch; that is to say, it invites us to handle them, to use them bodily as complements of our own bodies, something sculpture is not intended to do.

11. Because of this, we have a tendency to read figurines and other small-scale sculpture as miniatures, as shrunken versions of their imaginary larger selves.

PHYSICALITY VERSUS OPTICALITY

■ ■ ■

Other substantial differences exist between craft and fine art besides the way they relate to the body. In their originating purpose all craft objects are made to do something; because of this they are centered on the physical realities of material and form or what can be called physicality. As objects intended to "communicate" through visual appearance, fine art objects are configured as signs to be looked at; they are centered less on physical reality than on optical appearance or what can be called opticality.

In making this opposition between doing and "communicating," one should be cautioned not to presume craft objects are meaningless. The "doing something" that pertains to craft is never empty or rhetorical; always it is filled with meaning, meaning that is latent within the object as a physical entity centered on function. With fine art, meaning is seldom, if ever, latent within the object as a physical entity; it is given to the object from without as part of its function as a sign within a socially determined semiotic system. As a result, fine art is about perceptions and appearance; it always exists within the realm of the subjective. Craft is about physical and material function; hence, it always exists within the realm of the objective. In craft, material is structural in the sense of relating directly to the object's physical function. In fine art material is ultimately visual, so structure is always in the service of appearance. In this distinction is to be found the conceptual difference between physicality and opticality as they pertain to the objectness of craft and fine art. In this sense, physicality and opticality can be

understood as expressions of objective and subjective experiences of the world.

Difference between physicality and opticality is reflected in the varied approaches to material found in craft and fine art. Since opticality is the main concern of the fine artist, works of fine art can be made of any material the artist deems capable of fulfilling the work's function as a visual sign. Whether hard or soft, rigid or pliable, porous or permeable, opaque or translucent does not matter. But for craft objects material must be suitable as physical substance to the specific function of each object. What this means is that material must have the requisite physical properties for a specific function, and it must lend itself vis-à-vis technique to being worked into the form necessary to carry out that function; diamond may be an impermeable material, but its hardness and crystalline structure preclude it being suitably worked into a container. As Heidegger writes, "The form [of the object of use] . . . determines the arrangement of the matter. Even more, it prescribes in each case the kind and selection of the matter—impermeable for the jug, sufficiently hard for the ax, firm yet flexible for shoes. The interfusion of form and matter prevailing here is, moreover, controlled beforehand by the purposes [functions] served by jug, ax, shoes. Such usefulness is never assigned or added on afterward to a being of the type of a jug, ax, or pair of shoes. But neither is it something that floats somewhere above it as an end."[1] As opposed to "mere things of nature" such as stones and boulders, in objects of use, "both the formative act and the choice of material—a choice given with the act—. . . are all grounded in such usefulness."[2]

Heidegger's usefulness (our function) is an essential formative feature of all functional objects *as physical entities* because in them, material, form, and the "formative act" are all locked together in harmony with function. In this sense function must be understood as a generative concept directly related to the physicality of all functional objects, not just craft objects. This underscores the importance a function-based taxonomy has for understanding craft. For unlike purely morphological taxonomies (those based on outward form, surface appearance, or topographic features), a function-based taxonomy draws our attention to the complex relationship that exists in craft between function, material,

1. Heidegger, "Origin of the Work of Art," 28.
2. Ibid., 28, 29.

form, and technique. And in doing so, not only does it make a distinction between physicality and opticality, it makes this distinction meaningful in a larger sense by challenging the older belief that appearance alone can give us the full measure of the world and the things in it. This older approach to understanding, the origins of which Heidegger attributes to Plato and Aristotle, is now being challenged across a broad spectrum of disciplines including language, biology, and artistic style.[3] Linguist Noam Chomsky, for example, makes a distinction between "surface structure" and "deep structure" in language. For Chomsky, "surface structure" falls short because it is restricted to the level of mere syntax (the rules of grammar, for example), while "deep structure" probes into the more general cognitive processes in which language is involved.[4] Similarly, Rudolf Arnheim notes in writing about artistic style that early biological classification systems are being discarded because they were based on "phenotypical description of species as independent entities, distinguished by certain external properties such as shape and color"; the modern genotypical approach, he argues, "amounts to conceiving of the various organisms as the confluences of underlying structural properties . . . so that the taxonomic system must now be based on the underlying strands rather than on external appearance."[5]

Just as modern biologists and linguists believe that external appearances alone do not reveal enough of the complexities and confluences of forces involved in the creation of an organism or of meaning in language, my argument is that classifications of craft based solely on surface appearance are also lacking; they leave important questions unasked because generative principles are left unconsidered. Looks and appearances, after all, are often deceiving—many objects can have the same form but differing structures, as in the case of a spheroid container that is woven and one that is of blown glass. To understand the essence of the craft object, as Gadamer says of works of art in general, one must understand the confluence of factors that brought it into being, including the interaction of material, form, and technique in relation to function. To understand the craft object in this way is to understand it as a "gestalt," a configuration of forces interacting in a field.[6]

3. For Heidegger's remarks see "The Thing," 168.
4. See McCullough, *Abstracting Craft*, 95–96.
5. Arnheim, "Style as a Gestalt Problem," 268.
6. For more on the idea of gestalt, see ibid., 267.

The same caution about appearance needs to be raised with fine art. Just because two paintings look alike does not mean they are comparable; they may stem from different intentions, what I would also call differing generative principles. In the way he applied paint, Monet's late Impressionist paintings, those done in the 1920s at Giverny, resemble Jackson Pollock's drip paintings of the late 1940s. As a result, they are sometimes compared under the assumption that similar morphology means similar content. However, Monet's late works are still landscapes and their generative principle is still the experiential sensation that results from a careful observation of nature that is then captured as subtle nuances of natural light through color and broken brushwork. Pollock's works are abstractions whose generative principle is the creative act itself captured as energy made visible through "flung," dripped, and puddled paint.[7] To see the work of both artists as identical because of *resemblance* based on morphological *similarities* is to misread them as visual signs.

I have already noted how weathered ancient Greek sculptures and the "aged" sculptures at Chartres Cathedral are often misread because of their changed appearance and the different social contexts in which they are now being viewed. With these changes they are set adrift, free from their original meanings to be reinterpreted and reinvested with meanings and intentions located within the contemporary spectator's cultural horizon. What the art historian tries to do is reconstruct something of their original meaning by reconstructing how they would have appeared within their original cultural context. The case of late Monet and Pollock of the drip paintings is slightly different. The misreading of Monet's works occurs because they are being seen from the social context in which Pollock's drip paintings came to be admired as great works of art. From this perspective it is easy to look back and relate the late Monet paintings to Pollock's drips based on their similar appearance as if there were no cultural distance between them. However, if we reversed the situation and saw the Pollock drips from Monet's late

7. For an interesting discussion of the issue of appearance see Maurice Mandelbaum's critique of Wittgenstein's notion of "family resemblances" in Mandelbaum, "Family Resemblances and Generalizations Concerning the Arts," 194–95; in this article Mandelbaum cites the example of two boys wrestling and two boys fighting as an instance in which mere resemblance can be misleading.

nineteenth-century perspective, the vast cultural distance between the artists would be immediately apparent and, I suspect, Pollock's paintings would appear somewhat outrageous.

Basing meaning and intention on resemblances and similarities often is to not look closely enough. In the case of late Monet and Pollock's drips, there are subtle differences between them that are apparent in color, texture, and technique. But there are cases in which appearance, no matter how closely we look at a work, still doesn't serve to reveal meaning or intention. I once saw an exhibition of the work of Vitaly Komar and Alexander Melamid. At the entrance to the exhibition stood a portrait of Adolf Hitler on an easel. Not surprisingly, visitors were shocked and, in fact, at a previous exhibition the painting was even attacked and slashed.[8] Nothing in the work's appearance could tell the viewer that Komar and Melamid are Jewish emigreés from Russia and the painting of Hitler was intended to be ironic! This is why I have stressed a functionological taxonomy for craft. It calls attention to differences at the level of "deep structure," thereby shifting emphasis from simple form, appearance, or topography to the complex interrelationship between material, technique, form, and function. In this way, revealing a craft object's identity at the level of "deep structure" also transforms understanding of surface appearance.

To approach fine art in a way analogous to a functionological examination would include an analysis of the work's connection to the social structure out of which it developed, to seek the "deep structure" behind its simple morphological appearance. Artistic intention is always socially motivated since the sign is always a social construction.[9] However, even without analyzing the social structure of fine art in detail, just looking at material as the stuff out of which signs are made shows how differently material in fine art is treated from material in craft. In fine art one manipulates material into visual signs so that appearance always

8. In 1981 members of the Jewish Defense League, not understanding the satirical basis of the portrait, slashed the canvas while it was on exhibit in Brooklyn. See McDonald, "Komar and Melamid," 15.

9. I am not suggesting that the work of fine art or craft, for that matter, be reduced to nothing more than an instrument representing a social structure; rather, knowledge of the social structure helps the beholder to know the direction in which the aesthetic object is focusing attention.

takes precedence over structure; appearance dominates structure. In craft, because one manipulates material into things, structure always takes precedence over appearance; structure determines appearance.

Recognizing these differences is crucial for any understanding of the relationship craft has to fine art. As Heidegger notes, makers of craft objects have little choice in their selection of materials and form because of the dictates of function. Containers intended to hold liquids must be made of impermeable materials; covers intended for warmth must be made of insulating materials; supports must use materials rigid enough to carry weight. But not being constrained by the physical laws of material as dictated by physical function, material in fine art need only lend itself to the optical effects desired by the artist as maker of visual signs. As a result, the way the fine art object ultimately looks need not be a factor of its physicality as a functioning thing, but a response to its visual requirements. Thus requirements of the visual sign take precedence over everything else. Robert Rauschenberg, for example, used his pillow, sheet, and quilt as a canvas to make a work he titled *Bed* (1955) and hung upright on the wall (Figure 17). He also used oil paint as well as such unconventional materials as toothpaste and fingernail polish. Unlike a conventional bed, Rauschenberg only required his *Bed* to "communicate" as a visual sign, not function as a support; that's why he could hang it on the wall.

In their form and appearance, materials in fine art need not stand for themselves but can represent other materials. So even though works of fine art and their materials have physical properties, the form and the visual appearance of these materials are more important than their functional properties. These reasons make Rauschenberg's *Bed* an interesting example. In a certain sense and at a certain level the bed in *Bed* is transformed (some would say mistreated and misused) by being framed and hung on the wall to become a visual element in a work of fine art. But the full impact of *Bed* results from its remaining a bed in the viewer's mind's eye; the viewer must be able to recognize the work as an actual bed—an actual sheet, an actual quilt, and an actual pillow. In this way the viewer is presented with a visual conundrum because he or she is encouraged to see an actual bed functioning as a sign of itself— an actual bed representing a bed. However, since the bed in *Bed* can no longer be put to the test of functional use, it need not be an actual bed to have the same impact; it need only appear to be an actual bed. A *tromp*

Figure 17. Robert Rauschenberg, *Bed*, 1955, combine painting: oil and pencil on pillow, quilt and sheet on wood supports (6′ 3 ¾″ × 31 ½″ × 8″). Gift of Leo Castelli in honor of Alfred H. Barr Jr. (79.1989), The Museum of Modern Art, New York, N.Y. Digital image © The Museum of Modern Art/Licensed by Scala/Art Resource, N.Y. Art © Robert Rauschenberg Foundation/Licensed by VAGA, N.Y.

Rauschenberg is said to have used his own bed for this piece because it was summer and he had nothing else on which to paint. Whether true or not, he referred to such works as "combines," that is to say, combinations of painting and sculpture. In this case it would be more accurate to say "combination of craft, painting, and sculpture" because the power of the work is directly related to the fact that the quilt used in it retains its identity as a quilt. Unlike Duchamp with his *Fountain*, Rauschenberg does not want the quilt to become something else, for example, a sculpture; despite having been painted in some areas, he does not want the quilt to merge into and get absorbed by the ensemble as a visual sign (as a representation of something it is not).

l'oeil bed would have worked just as well so long as the viewer believed it to be a real bed presented as a sign for bed.[10]

In this sense the approach to material demanded of the craft maker is different, even opposite that of the fine artist. For the maker of craft objects it is not the opticality of material that is of the utmost importance, but, as I have said, it's physical properties in relation to a specific function (impermeable or flexible or sturdy or pliable, etc.). Regardless of how inviting, when choosing material opticality must give way to the dictates of function when making a physically functioning object. A chair that has the look of sturdiness but topples over because of the wrong choice of materials is as useless as a winter cover that looks warm but cannot retain body heat and a drinking container that is not made of an impermeable material and therefore can't hold liquids.[11]

Material also plays a role in determining whether something is a good or bad craft object. For example, materials must be safe. Containers can be made of lead or untreated copper and be perfectly functional in terms of the demands of containing, but since lead and un-tinned copper are known to be toxic, they aren't safe for food or drink. Asbestos fibers for covers must also be avoided for similar reasons. And materials that splinter, though they may be sturdy and look attractive, are not suitable for things like chairs and other supports.

Material is also a factor in determining how practical a craft object is. A carrying basket made of materials that are so heavy it cannot be lifted is functional and may be safe, but is as impractical as a thirty-pound teapot. Likewise, a chair that can support a person's weight but is too heavy to be moved around or is too small for a normal-sized person is also relatively impractical. Moreover, for practicality material must be durable and reliable. Durability means the materials chosen must be able to withstand a considerable amount of stress in their use; and reliability means they must give the same satisfactory result time and again; function cannot deteriorate appreciably after each use. Thus for

10. Other related examples are the works of Haim Steinback, which feature various objects, including pottery on shelves. They remain pots and retain their function as containers to the viewer, even though they are treated as visual signs because of their presentation context. Like Rauschenberg's *Bed*, their impact within the work is because they retain their identity as actual craft objects.

11. This is not to say issues of practical function always prevail, certainly not in the face of social pressure as seen in fashion, for example.

craft objects (as for all applied objects), material must first lend itself physically, not optically, to the form-giving act so as to "become" a form capable of carrying out a specific function. To be good craft objects, material also must be regarded in terms of safety, practicality, durability, and reliability. In this way, functional form in craft has made us appreciate certain materials and has made them attractive.

Though the fine artist is also concerned with materials, these concerns are different because fine art's generative principle is "communication" through the visual sign.[12] Communicability through visual appearance, through opticality, plays the essential role in dictating choice of materials. If a work is about entropy and decay or the impermanence of modern urban life, unstable and otherwise unreliable materials and techniques may be perfectly acceptable. But the material of functional objects must be reliable and therefore must submit itself to usefulness and, in a sense, disappear into the object it becomes. As Heidegger observes, "Because it is determined by usefulness and serviceability, equipment [objects of use] takes into its service that of which it consists: the matter. In fabricating equipment—e.g., an ax—stone is used, and used up. It [the material] disappears into usefulness. The material is all the better and more suitable the less it resists perishing in the equipmental being of the equipment."[13] Leather becomes pouches, reeds a basket, fibers a blanket, and clay a pot. For tools metal becomes chisel, knife, or saw. In all cases, the better suited and more willingly the material gives

12. Of course at the practical level, fine artists should be concerned with the stability of materials, the way thick paint must be applied over thin so as not to crack and flake or in the use of acid-free papers and glues so they do not discolor and degrade; however, none of these concerns are of the same paramount importance as they are in craft.

13. Heidegger, "Origin of the Work of Art," 46. Heidegger goes on to say that material is used up and reliability disappears and so does usefulness: "A single piece of equipment is worn out and used up; but at the same time the use itself also falls into disuse, wears away, and becomes usual. Thus equipmentality wastes away, sinks into mere stuff [i.e., ordinary matter]. In such wasting, reliability vanishes." Heidegger's comments pertain particularly to tools; they give up usability because they transfer kinetic energy to raw matter through violent collisions in pounding, chiseling, sawing, scraping, and sanding. Such kinetic energy transfers are opposite crafts' basic functions of holding and keeping (preserving energy by containing, covering, and supporting). Works of fine art never have their physical condition altered through viewing (see 34–35).

itself up to containing, covering, and supporting, or, in the case of tools, tearing or severing, the more reliable and functional it will be; still the material retains its presence in the object—the leather remains visibly itself, as does the glass, the wool, the silver, the clay, etc.

In fine art, when material gives itself up completely and totally to the object it is intended to *represent*, the object risks disappearing into the world of non-art things. As German philosopher Arthur Schopenhauer (1788–1860) noted, works of art are different from waxworks because waxworks are created as optical illusions meant to deceive one into thinking them real, while with works of art we always know they are representations.[14] Schopenhauer understood that opticality pushed beyond certain limits was a danger to fine art. When the work of fine art is mistaken for the actual thing it is meant to represent, it disappears as a visual sign and inevitably returns to the world as the thing it *represents*. If Rauschenberg's *Bed* did not also establish itself as a visual sign by being framed and hung on a wall, it would simply remain a bed, albeit a very messy one. As I have said, its impact, in fact, occurs precisely because it is viewed as a real bed treated (mistreated?) as a sign. Thus when the material and form of a sculpture (say, a sculpture of a tree) becomes so realistic, so optically convincing as to be indistinguishable from an actual tree, its sign function disappears and to the viewer it becomes indistinguishable from its intended referent. For this reason, materially fine art cannot give itself up completely in its opticality to the object it represents. Strategies to hold opticality in check and prevent this from happening so the work will continue to "communicate" as a sign include the use of frames, pedestals, labels, distortions of form, any device that will hold it apart from the real world, that will "bracket" it to keep it within the realm of the sign.[15] The more realistic the work, the more "pronounced" the bracketing device must be to prevent this slippage.

With exceptions beginning in the twentieth century, I think it reasonable to say that in general the fine artist works to overcome the resis-

14. Schopenhauer, *World as Will and Idea*, 118–19.

15. A good example of this is Bernini's 1645–52 statue *Ecstasy of Saint Teresa* in the Cornaro Chapel in Rome; as realistic as Bernini carves her flesh, drapery, hair, etc., he left the marble white so the viewer would always be aware that she was a statue and not the saint herself.

tance of materials in order to make material serve optical ends. Painters work to transform paint into signs for grass, tree, sky, light, even flesh. In the late work of Titian or the work of Franz Hals and Velázquez, where to the twenty-first-century eye used to seeing abstract art, paint is often noticed as a physical material, to their contemporaries it usually appeared as optical effects. Their approach to painting was not to reproduce the thing in two dimensions as did earlier painters like Jan Van Eyck and let optical sensations occur in the eye of the viewer; instead, they painted the optical effects directly. The result, however, is the same in its concern with appearance. Much the same holds true for sculpture. Sculptors work to transform stone or bronze or wood into convincing iconic signs usually representing living, moving flesh and bone. Coloring of statues so common in the ancient and medieval worlds (for example, at Chartres Cathedral; see Figure 5) was an aid in this opticalization process, at times even crossing over the border to complete *trompe l'oeil* illusionism; this tendency is explained by the fact that such works were concerned, not with making art as we understand it, but with making the invisible visible—with making religious belief palpable to the viewer.

Nonetheless, usually some feature was present to dispel the optical illusion, to hold it in check by anchoring the work within the realm of fine art practice—to keep it a sign. Whether it was the material (the viewer's realization that the work was wood or stone or bronze and not human flesh), the form (the elongated, cylindrical bodies as in the figures at Chartres), the context (the placement of the figures on columns at Chartres or in the pediment of Greek temples), or scale, some such "bracketing" device was necessary to contain the work, to hold it in check so it would remain to the viewer an optical experience of the sign. Fervent religious belief, however, was always in danger of turning the image into an apparition. The issue of idolatry throughout the Middle Ages in Byzantium and the West was waged precisely over the issue of the sign becoming reality (Is it an image of the saint or the actual saint?).

Considering this, it is not far-fetched to argue that the fine artist works to overcome the material's resistance to being transformed into a visual sign in the service of the optical, while the traditional craft artist works in concert with material, using technique to coax material into the desired physical form required by function. Thus, it seems reason-

able to conclude that the depth of the difference between the work of fine art and the typical craft object resides in the fact that works of fine art, as "objects" to be looked at, are anchored to the realm of the optical as iconic signs while craft objects, as objects to be used, are anchored to the realm of the physical. In this, the central concern of fine art is with opticality while that of craft is with physicality.

THINGNESS OF THE THING

■ ■ ■

To say only containers contain, only supports support, only covers cover is, of course, a tautology. Yet it is an instructive tautology, for it reminds us that the identity of craft objects, qua objects, is inherent in their ability to function and their ability to function is inherent in their "thingness" as things, as physical objects. This is not true of works of fine art; their ability to function, to "communicate," is not directly dependent on their thingness as things. As I have already said, they are *re*-presentations of the world and whether real or imaginary, *re*-presentations are always signs for or of something they are not. But craft objects qua objects are not signs but objects that function, and objects that function are first understood by and through function. Take a jug as an example; it is what it is (a jug) *in* its physical form and by *virtue* of how its physical form allows function to exist. It does not stand before the user as a socially constructed image, as a pseudo-object dependent upon a socially constructed signifying system. As such, the essential nature of craft objects is co-terminus with their physical form. In this sense, as physical things they are independent in and of themselves, ends in and of themselves; social convention does not dictate their technique, material, and essential form, the laws of matter do. However, social convention does play a role in the creation of craft objects, a very limited role. What convention dictates is whether or not craft objects will be made and used; once this has been established, what and how they will be in their basic materials and forms is an a priori given.

This is not to say crafts are without a social life, a life in society beyond pure function; rather, it is to say that in their essential nature as physical objects they are presentations rather than *re*presentations, things rather than images.[1] That this is so regardless of the cultures, geographic locations, or eras from which they come is one of the trans-cultural, trans-spatial, and trans-temporal truths of craft.

As *re*presentations/signs, works of fine art exist (that is, have meaning) only in relation to a signifying system; they are what they are, *re*presentational images/signs, specifically because their appearance symbolizes, resembles, or indicates something that they, in their physical reality, are not. This is why their physical forms are neither a priori determinants nor categorical determinants. As a result, their appearance *as images* need not correspond to their physical distribution of matter *as objects*. In this sense, as physical objects works of fine art are basically nondescript, arbitrary entities; one could even say that in their essence they are pseudo-objects.

Painting presents an obvious example of what I mean. Using perspectival devices, painters can create the appearance of three-dimensional objects (trees, landscapes, people) and even deep recessional spaces. Since paintings are ostensibly flat, two-dimensional surfaces, these appearances cannot correspond in their physical form as two-dimensional images to the three-dimensional form of the things they are representing.[2] (This is even more apparent with movies that have no physical substance but still create the appearance of vast spaces and even solid, tangible, and animated figures.) Much the same is true of sculpture even though sculpture is three-dimensional. Take as an example a marble carving *re*presenting figures that are angry or sleeping or dressed in delicate linen lace. Aside from the fact humans are not made of stone,

1. As Heidegger notes, "The jug remains a vessel whether we represent it in our minds or not. As a vessel the jug stands on its own as self-supporting." For more on this see Heidegger, "The Thing," 166–67.

2. One could argue that paintings represent not trees, landscapes, or people, but our perception of these things. However, our perceptions of the world/reality are stimulated by the objects themselves, not abstracted images of them; furthermore, paintings don't capture/reproduce our perceptions because we perceive differently than paintings represent—that is to say, our perceptions are focused but continually shifting and reorganizing sense data as part of a larger viewing and sensing context.

since stone doesn't sleep and, no matter how delicately carved, can never be linen lace, these too are only appearances that the mind's eye reads and construes as representations.[3]

Appearances in this sense have more to do with the viewer (as a sentient being who experiences through visual *sensa* and then interprets) than with the "thingness" of the thing. Painted marks on a canvas become whatever the eye interprets them as (a tree or a figure) even though in reality they are merely marks on a flat surface. In "reading" the image sign, the knowing viewer momentarily suspends disbelief to reconstitute the image into a perceived "object." But a basket or a chair, even if misinterpreted, in reality remains functionally what it is—a container or support. This is why in the fine artist's studio the model's chair exists as a functional thing, but in the resultant drawing or painting it becomes abstracted to the level of a visual sign.

Following this, it seems reasonable to conclude that since fine art is based in signs, not things, and craft is based in things, not signs, fine art transforms the world of things into images as sign-concepts, while craft transforms function-concepts of nature (containing, covering, and supporting) into worldly things. Furthermore, because dependent upon a signifying system, in its "thingly" character the work of fine art can never be an entity independent of its social world and still "communicate." It is always entangled as a signifier in the social web that is a signifying system. This is why Duchamp's *Fountain* (Figure 3) has come to be thought of by many people as a piece of sculpture; still, to the extent it has been accepted as sculpture, it has to "give up" its "thingness" as a functional object in order to be seen as an entity critically commenting on the condition of sculpture as an enterprise. It is in this sense that sculpture can be said to be willed into existence by social convention and agreement. But a craft object cannot. Unless it is physically able to contain or cover or support, it can never be made to do so through social dictate or agreement. No web of social meanings can make something

3. This is something that Duchamp, a master of misdirection, exploits in a work of 1921 titled *Why Not Sneeze Rose Sélavy?* Comprising a thermometer and a cuttle-bone placed in a birdcage filled with small marble cubes, the work seems very light in weight because to the eye the marble cubes appear to be of sugar; it is only when one tries to lift the cage that the true nature of the cubes is revealed; the difficulty today is that viewers in a museum, unlike the artist or the collector, are *not* allowed to touch or lift sculpture so Duchamp's misdirection is never fully realized.

physically function as a craft object if it is not capable of containing, covering, or supporting.

Because the relationship between apparent form and actual form in works of fine art is nondescript and arbitrary, classification of fine art based on objecthood is difficult. In examining painting and sculpture as objects one soon realizes they are not easily identified and categorized by their physicality. One could categorize them in terms of dimensionality, sculptures being three-dimensional and paintings being two-dimensional. But all three-dimensional things are not sculptures and all two-dimensional things are not paintings (they could be street signs or breadboards). Likewise, identification and classification based on materials don't help since many non-fine art things are made of so-called fine art materials such as bronze, marble and oil, or acrylic paint.

If one attempts to categorize works of fine art based on the process used to make them, one again encounters problems. Of all the painted things in the world, very few are actually paintings in the fine art sense; they could be announcements, billboards, or any number of other things. And, considering the quantity of carved stonework on buildings alone (railings, steps, balustrades, moldings, etc.), it must be admitted that the same is true of sculpture: not all things sculpted, carved, or molded are sculptures. Even the opposite is not true. All sculptures, even traditional sculptures, are not sculpted, some are cast and some are modeled. Modern sculptures may even be welded, nailed, or glued, assembly processes common to any number of nonsculptural, non-fine art activities. As for the question of whether or not all paintings are painted, can one really say that Jackson Pollock's works were painted if the paint was actually dripped, flung, poured, and puddled? What about the stain paintings of Morris Louis and Helen Frankenthaler? Louis let his thinned paint run down the canvas to create free forms, and Frankenthaler, placing her canvas on the floor, soaked it using rags and sponges as if she were dyeing a fabric or scrubbing a floor. There are also the sprayed paintings of Jules Olitski and the works of Andy Warhol that were silk-screened. Considering the traditional definition of painting, as understood as late as the early twentieth century, can such works really be considered painted in any traditional sense of the word?[4] In the

4. For an interesting philosophical parallel having to do with a posteriori and synthetic statements (statements in which meaning is only known by experience) and a priori and analytic statements (statements in which meaning is part of the

artistic sense, perhaps yes, but in the strict sense of the term, probably not.

The point I am trying to make here is that the processes used to make works of fine art reveal little about what they actually are as works. Even defining them in terms of "communicative" purpose doesn't resolve these problems and get us any closer to the work's identity as a physical entity or as fine art. For as I have already said, while all things that communicate are communication vehicles, all things that communicate are not necessarily works of fine art; they could be letters, advertisements, posters, documents, newspapers.

Intent to communicate or dimensionality or the process of making are not very helpful in getting us closer to understanding the work of fine art, qua object, because the identity of works of fine art, what they are—especially before the modern period—is not a factor of their objecthood; it is not something directly related to their "thingly" character as physically existing things. Which is to say, they are not what they are, works of fine art, in or because of their "thingness" as things.

This also holds true when one tries to categorize them in terms of form. That something is sculpted into a certain form, even if it is done in a fine art material like marble, does not automatically make it a work of fine art, even if that form is of a human figure. While such a work could be designated a statue, it would not automatically be designated a work of fine art. Many statues are made specifically as commercial advertisements or window displays with no fine art intent whatsoever— one has only to think of mannequins and studio props; others may have been made with fine art aspirations in mind but simply lack sufficient aesthetic quality to be defined as such. Thus, even though statues would fulfill the requirements of a taxonomy based on form or even the requirements of taxonomies based on communication, process, and perhaps material, they still cannot automatically be declared works of fine art based on such criteria.

From this it seems to me we must conclude that unlike craft objects, which exist first and foremost as objects and only secondarily as concepts, works of fine art exist primarily as sign-concepts and only incidentally as physical objects. Even in saying this, one must add the caveat that works of fine art are visual-sign concepts of a special kind that

statement) that nicely fits our parallel between fine art and craft, see White, *Age Of Analysis*, 203ff.

can be characterized but not specifically defined.[5] This is not to imply paintings and sculptures don't have physical properties. Clearly they do. With few exceptions they, like works of craft, are constructed of physical materials just like other objects in the world. But being constructed of physical materials and having an identity in those materials is not the same. For example, sculptures have a connection to craft objects since they share a common existence as three-dimensional physical forms; this makes them unlike paintings and all two-dimensional images. In this, sculptures and craft objects both seem to be real things, ontological facts if you will, while paintings and all two-dimensional images are always abstractions of the world and therefore have only a nominal or incidental existence as tangible objects.

It would be misleading, however, to suggest that sculptures are more closely allied to crafts objects than to paintings because of their dimensionalities. For though paintings and sculptures are dissimilar in their dimensionalities,[6] as works of fine art, they share a more important existence as conceptual-perceptual image signs. As such, in their essence, sculptures also exist as the merest of objects, even as pseudo objects, while craft objects exist primarily as things. It can even be said that craft objects, qua objects, are ontological in their "thingness" in that their essential character of being is found in their material distribution of matter as functional form.

Having said this, it is of interest to note an exception to this approach to fine art. In the period of late modern art in America there was a moment when artists placed emphasis on what they called the "objectness" of the work; this was especially true of sculpture but also happened in

5. In fine art little is as contested as what constitutes aesthetic quality. Critic Clement Greenberg argued that taste (aesthetic preference) has varied over time, "but not beyond certain limits; . . . We may have come to prefer Giotto over Raphael, but we still do not deny that Raphael was one of the best painters of his time." Greenberg goes on to say that "there has been an agreement then, and this agreement rests, I believe, on a fairly constant distinction made between those values only to be found in art and the values which can be found elsewhere." What these values are even he found difficult to articulate. See his *Art and Culture*, 13.

6. Reliefs present an interesting case as a kind of hybrid of painting and sculpture. Low or *bas* reliefs are closer to painting in the way their opticality is achieved through an abstraction that approaches two-dimensionality, while high reliefs are closer to sculpture in the way their opticality is more dependent on physically matching three-dimensional things.

painting. It was a much-discussed critical issue concerning the nonreferential sculptures that the artists Donald Judd and Robert Morris, among others, made in the mid-1960s. The very discussion of "objectness" by these artists underscores the difference between craft and fine art because the idea of "objectness" departed radically from the established tradition of sculpture as iconic sign, so much so that often the works of Judd and Morris were not even referred to as sculpture. For them the term "sculpture" was not literal enough; they preferred "Specific Objects" or "Primary Structures" and their discussion centered around the work's "gestalt" qualities, around its "objectness" as a physical entity. Even the non-objective paintings Frank Stella made from 1959 through the next decade were discussed in such terms.[7]

This was a departure from painting's and sculpture's traditional orientation toward *re*presenting things through the creation of image-signs that function at the level of the signifier. But the attempt of these late modern artists to collapse the space between signifier and signified meant fine art was inexorably approaching the independent, self-supporting condition that exists in craft. This may have been done unwittingly, but nonetheless it was an inevitable result of Judd's and Morris's and Stella's attempt to make the work of fine art self-referential—that is to say, to have it be, in terms of its meaning, what it was in terms of its physical form. Making fine art that stood in its "thingness," in its self-referentiality as an autonomous object, inevitably drew it to craft even though this was never discussed as part of the work's critical dialogue. Nonetheless, collapsing of the space between signifier and signified made the fine art object a pure signified in the sense that it now referred to nothing outside itself. Minimalism, a term often used to refer to such work, now approached the same state of being (vis-à-vis objecthood) as that which traditionally exists in craft objects. For Minimalist artists the fine art object, qua object, was no longer to be an imaginary social construct, but a real thing.[8] Their attempt was nothing less than a radical

7. The idea of gestalt comes into fine art from psychology and refers to objects whose properties are not derived from their parts, but from their sense of wholeness. Such objects gained this sense of wholeness or "unitaryness," as it is sometimes called, by avoiding additive elements and compositional balancing of unique, individualized parts in favor of singular form or modular repetition. For the situation in sculpture see Judd, "Specific Objects," 181–89, and two essays by Michael Fried, "Shape as Form," 18–27, and "Art and Objecthood," 12–23.

8. Something similar happens with some performance art beginning in the late

shift and reorientation of the status of the object from that of signifier to that of signified. And it is somewhat ironic that, as this happened, their work inevitably approached the condition of craft.

All of these late modernist works, however, could not entirely escape being a part of the social realm that we call fine art if they were to have any meaning beyond the purely literal. Like all previous artists, these artists, in one way or another, had to declare their works part of the realm of fine art. Otherwise they risked having them appear meaning-less, something that often happens when viewed by the uninitiated or seen outside of an art context (for example, on a department store floor or loading dock rather than in a museum or gallery).

Craft objects, however, are distinctly different from Minimalist objects even though both can be said to be "real" objects in the sense that their essential nature is of actual physical entities existing as organized matter in space. Their differences are to be found in the way Minimal-ist objects "communicate" their physical existence; they do it solely through their visual appearance; that's why they can be indifferent to their material. For example, often they are painted a neutral color so as not to betray their material; at other times they may be made in one ma-terial, say plywood, as a temporary substitute for a more expensive and permanent material such as steel, which may still be painted a material-neutral color. For all of its radicalness, in doing this Minimalist art fol-lows the long-established pattern of all fine art. So when we speak of experiencing a Minimalist work we are referring to the same kind of experiencing that occurs with all fine art, an intense visual experience. It is through the eye of the viewer that the work communicates. That's why we can say that works of fine art, in their very nature, are optical constructions centered on "to-be-looked-at-ness." When we speak of ex-periencing a work of craft, however, we are not referring solely to the visual since they are intended to be experienced in more complex ways

1960s. California artist Chris Burden's performances were not acting, but real—he actually crawled through broken glass in a 1973 performance in Los Angeles titled *Through the Night Softly* and he was actually shot in the arm in *Shoot*, a performance at F Space in Los Angeles in 1971. English performance artists Gilbert & George, when they performed *The Singing Sculpture* in London in 1969, stood on a pedestal like sculptures so that their bodies referred to sculpture referring to the human body. Obviously, these works are entangled in a web of meanings that accrue significance specifically because they reduce the gap between appearance and reality, between signifier and signified if you will, a gap that fine art traditionally maintained.

that include the tactile alongside the visual. That's why they encourage active physical engagement, why they lend themselves to the gathering of haptic information by being sensitized to "active touch," to what Frank R. Wilson defines as "the conscious guidance of the hand to examine and identify objects in the external world."[9] As he argues, "The hands were moved, among other reasons, to obtain information that could be obtained *only* by acting upon the object being held. The information returned to the brain was written in the tactile and kinesthetic language of manipulation and was compared with information coming from the visual system, as part of a process through which the brain creates visuospatial images."[10] In craft, Wilson's "visuospatial" images are configured of the tactile and kinesthetic sensations of actual physical objects, objects that are purposely oriented to the hand and body to encourage, even demand, haptic experience and "active touch." Informational form and informational material is form and material that reveals itself to the body through tactile and kinesthetic sensations, through the acts of grasping, touching, holding, feeling, etc., so that the hand and body, as sensing organs attuned to texture, form, weight, balance, temperature, etc., come to know and understand the object as a physical thing. This happens almost automatically with craft objects since they are defined by their material and their form and made in the hand; they purposely reveal themselves to users through the sensations of "active touch." It is in this way, not through sight alone, that we come to understand and experience the craft object in its essence.

Such experiencing of informational form and material does not exist in fine art. Other than art handlers who move works of art, who really gets to know how heavy a sculpture is or how warm or cold to the touch it may be? These kinds of sensations are usually secondary to the work; if they are important, they are abstracted and encoded for the eye in the hope that the mind's-eye will mentally recall previous tactile, haptic, and kinesthetic experiences garnered by the hand and body on other occasions. Rather than offering actual haptic sensations, fine art traditionally offers only abstract analogies, optical substitutes based on memories of actual experiences with physical matter. This is another reason why we can say that fine art objects exist in the realm of optical space as pseudo-objects, as signs; when they do evoke the tactile and the

9. Wilson, *The Hand*, 334.
10. Ibid., 276.

haptic, it is translated and abstracted for the eye as part of its sign value. Craft objects, on the other hand, exist in the realm of actual space as real objects because they are constructed along the concept of informational form and informational material; they relish enactive touch.

Unfortunately, these very qualities that distinguish craft from fine art also work against crafts gaining intellectual and aesthetic parity with fine art. This is because, at least since the time of Saint Augustine (354–430), Christian thought has contained an ascetic component that regards the human body, sexuality, and bodily sensations with a great deal of suspicion.[11] This asceticism was especially evident in the puritanism that accompanied the Reformation and Counter-Reformation in sixteenth-century Europe. Works of art like the *Ghent Altarpiece*, painted by Flemish artist Jan van Eyck in 1432, were hidden to protect them from destruction by Protestant iconoclasts. Others were reworked to cover the naked body; even as venerable a work as Michelangelo's *Last Judgment* fresco in the Sistine Chapel had drapery painted over the genitalia of its nude figures after the artist's death during the Counter-Reformation. This attitude toward the human body, which is prominent today in many religious sects of a fundamentalist bent, parallels a long-standing philosophical tradition in the West that regards what can be called "distance senses" (such as sight) as superior to what are thought of as "bodily senses" (taste, smell, touch). Hegel argues that "the sensuous aspects of Art only refers to the two theoretical senses of *sight* and *hearing*, while smell, taste, and feeling [touch] have to do with matter as such, and with its immediate sensuous qualities. . . . On this account these senses cannot have to do with the objects of art."[12]

These two attitudes are reflected in the way Christianity imagines the grace of God as rays of light and philosophy the concept of knowledge as enlightenment. Philosophically, distance senses are deemed superior to bodily senses because only they are able to detach the observer sufficiently from the state of his or her own body to yield objective knowl-

11. For more on this see Cameron, *Later Roman Empire*, especially 81–83. Something of this suspicion of the body is also evident in the Islamic tradition of covering women as if they are agents of seduction through their bodies.

12. Hegel, *Introductory Lectures on Aesthetics*, 43. Sigmund Freud also gives priority to sight as the basis of his theory of the Oedipus Complex (see his *An Outline of Psycho-Analysis*, 12); in his *Civilization and Its Discontents* (66–67n1) he also discusses the decline of the olfactory senses.

edge. Bodily senses are believed more subjective because they direct attention inward to one's own body. However, the body provides an important complement to the mind because it is anchored in the world of actual, lived experience. It expands the mind and tempers the intellect by providing us with a sense of being in the world that ties us to all other living things.[13]

Craft's connection to bodily experience through physical use may be one reason why some people believe it cannot go beyond being a purely functional object. This is the claim of people who invoke the function/nonfunction argument to separate fine art from craft. Rejecting this claim are those who say there is no difference between the two fields. Saying that craft is fine art, they either reject function outright as an inherent feature of craft or imply function does not matter one way or another, that the craft object is for sight alone. I believe function does matter. The concepts containing, covering, and supporting, as I have argued, are in a very real sense natural (part nature) and in another sense historical, human concepts (based on social convention). The uniqueness of craft is that, being a confluence of these two, it has both a "natural" life and a social life. Because of this, craft does go beyond the purely functional; or more properly, the purely functional in craft is never pure but is always latent with meaning. It is this contention that will be discussed at length in the second half of this study.

13. One of the dangers of divorcing ourselves from the tangible world and the things in it is that everything tends to become an abstraction; plants, animals, and people become numbers, not real, living things. One result of this is reflected in the way events and people are translated (reduced) into statistics—body counts, collateral damage, unemployment figures, crime rate, homeless numbers, etc. See Wilson, *The Hand*, especially 275ff., for how hand and body affect the development of the mind.

ISSUES OF CRAFT AND DESIGN

■ ■ ■

The second half of this study shifts discussion from function and the physical properties of craft objects to examining them as part of the larger social and aesthetic realms. While this approach opens the discussion to the more subjective realm of interpretation, it builds on observations made in the first half of the study. Part 3 begins the discussion by looking at craft objects in relation to design objects. In particular, it examines craft and design objects from the point of view of how they are conceived and made, how craftsman and designer go from initial idea to its realization as a tangible object. Understanding this will help us understand the differences between craft and design and the wider social implications of these differences.

In terms of function both craft and design objects belong to the same class and adhere to the same a priori laws of nature. Thus, to understand the differences between craft(ed) containers, covers, and supports, which are directly tied to the hand, and design(ed) containers, covers, and supports, which are a product of machine production, the social implications of the process of making must be examined. Only by doing this, by placing the hand next to the machine, can we begin to understand how process has helped to shape and continues to shape our conception of the world and our attitudes toward things in it.[1]

1. Process is not only an issue of functional objects. In the late 1960s and 1970s, a genre of fine art developed known as "process art." Works of process art could be as simple as a "circle" of spray paint. To

A detailed discussion of the processes of making would hardly have been necessary if not for the Industrial Revolution and the development of machines and modern industrial techniques that began to flourish in Europe and America in the late eighteenth and early nineteenth centuries. With this development came the radical transformation of production itself, and as a consequence the social status of all objects, especially those made by hand, was thrown into question. In the Pre-Industrial age, identifying craft objects as containers, covers, and supports was sufficient; there was no need to distinguish between handmade and machine-made because all objects produced before the Industrial Revolution were essentially handmade. In that age the interrelationship between skill, material, function, hand, and creative mind *was* the social context in which the object existed; it was a context that needed no conscious articulation because it was understood and internalized by all. With few exceptions, in the ordinary world of lived experience there was no estrangement between the hand of the maker, the object made, and the user.

Today, in the face of modern industrial production, this is no longer the case. Granted the difference between the handmade and the machine-made is not one of kind—after all, machine-made containers, covers, and supports still contain, cover, and support. But machine production has altered how we see and understand the world and the materials and things that compose it. It is this change, this alteration, that makes it necessary to examine the machine-made and the handmade, not so much in their existence as physical objects per se, but in terms of the way their making and their existence reflect our social structure and help shape our social values. For craft to continue viewing itself as a making process divorced from such issues is to reduce craft to an empty, anachronistic activity destined not to survive in the wake of machine production's economic benefits.

It is instructive to note that even in the face of photographic and other mechanized image-making processes, an activity such as painting is still not viewed as an anachronism; people still make paintings and they are still taken seriously as part of our critical dialogue about culture. This is because painting, like all of the fine arts, has been "intellectualized" through aesthetic theory so that it continues to be understood as

understand such works, an understanding of the process through which they were made was essential.

a discursive, critical activity laden with metaphorical meaning and cultural significance. Like painting, craft cannot compete with mechanical production and, like painting, if craft is to survive in the modern world of the twenty-first century, it must make itself understood as a way of bringing objects into the world that is meaningful in and of itself (just as painting is understood as a meaningful way of bringing images into the world). In this sense, the subject of our discussion engages the wider issues of qualitative human values as reflected within the social realm through craft, design, and fine art. These human values are part and parcel of what I consider the social life of craft objects.

Anyone not appreciating the fact that the culture of industrial production has done much to transform the craft object's social standing in our society would do well to remember that the Museum of Modern Art (MoMA) in New York City ignores the function/nonfunction dichotomy at the heart of the craft/fine art debate and at the center of fine art aesthetic theory; it does this by collecting both fine art and functional objects. The functional objects it collects, however (and this is the crucial point), are those of modern and contemporary industrial design, not what it considers modern and contemporary craft. It leaves the collecting of those to its neighbor across the street, the Museum of Arts and Design (MAD), formerly the American Craft Museum; that MAD changed its name in October 2002 to emphasize design rather than craft suggests that it is no longer convinced about the viability of craft as a field and as an activity of cultural significance. For my part, what I believe the examples of both MoMA and MAD indicate is that the debate craft is having with fine art is not the only one in which the field should be engaged. Craft should also examine its activities and goals in relation to design. After all, in the modern, industrialized world, it is not fine art but design that has marginalized craft by usurping its primary role of making functional objects. Because of this, any discussion of the status of craft must address the role of design; and to do this, one must begin by examining the relationship that exists between the hand and the machine.

Differences between handmade craft objects and machine-made design objects can be revealed by examining terms such as "skill," "workmanship," and "craftsmanship," but especially "design" and "designer." Both of these latter terms have their origins in the early Industrial Revolution. In the mid- and late-eighteenth century in England, for example, there was Thomas Sheraton, a designer who apparently never actually

made furniture and Robert and James Adam, founders of a very successful firm dedicated to design and interior decoration.

The dedication of Sheraton and the Adam brothers to design has antecedents that go back to seventeenth-century France in several ways that are connected to the establishment in 1648 of the Académie Royale de Peinture et Sculpture. Similar to Giorgio Vasari's sixteenth-century Accademia del Disegno in Florence, the Académie Royale was a free society whose members were not subject to the rules and regulations of the traditional guilds that, until then, controlled the production of most trade work in France. However, while the Académie Royale freed its members from the guilds, after receiving a royal subvention in 1655, it became a state institution with a strictly authoritarian board of directors and its members became directly dependent on the king. Its special function soon became, as historian Arnold Hauser recounts, to make "art an instrument of the state with the special function of raising the prestige of the monarch." Eventually the king became "the only important patron of art in the country."[2] With the reorganization in 1661–62 by French minister Jean-Baptiste Colbert of the Manufacture Royale des Meubles de la Couronne in Paris (commonly known as the Manufactures des Gobelins, or just Gobelins), Colbert declared the age of private patronage over in France so that control over craft and the decorative arts in France likewise passed to the king. Under Charles Le Brun, who was placed in charge of Gobelins soon after its purchase on behalf of the crown, all works of craft, fine art, and decoration for the King's properties were produced in workshops under Le Brun's management; his control of Gobelins' production extended to the style and quality of all work; he supplied designs for much of the work produced at Gobelins. In this setting, craft objects, works of fine art, and decorations have a consistent style and are organized and treated as decor to enhance Louis XIV's properties and make them into a kind of decorative stage setting for his glory.

The term "decorative arts," in Le Brun's conception, encompasses craft, decoration, and fine art as elements of a larger decorative design scheme. In this scheme, craft and craftsmanship, as elements of individual expression, hardly exist. As Hauser notes, "individual works of art lose their autonomy, and amalgamate into the total ensemble of an interior . . . ; they are more or less all merely the parts of a monumental

2. Hauser, *Social History of Art*, 194–96.

decoration." Hauser goes on to point out that, though this was in the preindustrial period, at Gobelins "the mechanized, factory-like method of manufacture leads to standardization of production both in applied and in fine arts."[3] While Le Brun's techniques of manufacture produced consistently high quality items, it foreshadowed modern design concepts associated with firms like Tiffany and Roycroft, and modern industrial production in the way it suppressed individual craft production as it had come out of Italy. The result of Le Brun's techniques have what Hauser calls the impersonal character of "the stereotyped article" and "under-estimate the value of uniqueness, of unrepeatable and individual form."[4]

As one can see, the idea of decorative arts as developed by Le Brun in the late seventeenth century subordinates the effort of the individual craftsman to an overall plan and design scheme. The opposition between craft, as a unique individual expression of a craftsman not subject to a collective style or movement, and design, as a plan reflecting a predetermined overarching style, is already inherent in this scheme and is fully realized with the advent of industrial production in the late eighteenth and nineteenth centuries. By the mid-twentieth century in America the professional designer was as well established as the concept of design itself. As Penny Sparke notes, "The English word 'design' is currently used widely in countries such as Japan, Italy, France, the Scandinavian countries, and the USA, a fact which indicates that its meaning in contemporary society has moved away from its definition in previous centuries when it was interchangeable with the Italian word *il designo* and the French *le dessin*. The fact that these countries have abandoned these native terms in favor of 'design' suggests that more than just a mere shift in meaning has taken place and that what has occurred is, in fact, the emergence of an entirely new concept."[5]

This new concept originated in the rationalization of production and was fully realized by the development of machines and mass-production systems. Before industrial production took over, the idea of "design" as it had come out of Italy was not understood as an endeavor abstracted from the practical realization of objects by separate individuals working

3. Ibid., 191, and 196–97, respectively.

4. Ibid., 197.

5. Penny Sparke, *Introduction to Design and Culture*, xxiii. It is this new concept that Sparke goes on to discuss in the rest of her book.

with their hands but as a feature integral to their making. Embedded within the traditional terms "skill," "workmanship," and "craftsmanship" is not only an understanding of the various ways in which a man-made object can come to be, but also how and what this means culturally. Embedded in such terms is a cultural context that gave them meaning both as physical objects and as intentionally made things that did more than just fulfill a physical, instrumental function. Examining these traditional terms as well as the new term "design" is a way to help us understand the implications of how making—as a process and as a conceptual attitude—affects our perception and understanding of an object's existence in the social world as a made thing.

MATERIAL AND MANUAL SKILL

■ ■ ■

Since both craft and design objects belong to the same class of applied objects, difference between them is predicated on the presence or absence of the hand in the making process. Because of this, the question of manual skill seems an obvious place to begin our discussion. "Workmanship" and "craftsmanship" are terms that imply something done by and with the hand, as in handwork or handiwork. Underlying these terms is the understanding that they involve a high degree of manual skill. Yet there are many different kinds of manual skill, not all of which involve workmanship or craftsmanship. The manual skill in which we are interested is a specific and special kind; it is technical manual skill actually capable of manipulating physical materials with the hand. The realization of technical manual skill in connection to actual physical materials is extremely important, if not absolutely fundamental to the basic concepts of workmanship and craftsmanship as they apply to craft. To fully understand the importance of craft objects in the face of industrially produced design objects, one must understand this skill.[1]

Many kinds of activities involve a high degree of technical manual skill, for example playing a musical instrument or typing. Likewise, there are many activities to which terms like "workmanship" or "craftsmanship" have been applied; one may comment on the workmanship or craftsmanship of

1. Recently these issues have also surfaced in relation to fine art. See Stockholder and Scanlan, "Dialogue: Art and Labor," 50–63, and Perlman, "Wastrel's Progress," 64–69.

musical or literary compositions; one may even say of writers that they have taken great pains to hone their craft. However, in none of these are the terms linked to the manipulation of physical material and the making of an actual physical object. Neither a musical performance nor a musical composition nor a written essay can be considered physical objects. Performance is an aural phenomenon, and written compositions, though they may be recorded and stored in physical form as a score or book, are less objects (even in the abstract sense of the term) than instructions for their performative recreation. Musical compositions and books, after all, need not exist in physical form; they can exist in memory as part of oral tradition, as Homer's *Iliad* did for many centuries and as does much genuine folk music today. So even if one were to say a musical or literary composition is well crafted, one wouldn't say great technical manual skill was involved in its creation—the degree of difficulty in composing music or writing essays is not in manually writing notes or jotting down words. Composing and writing certainly involve skills, and performing and typing even involve technical manual skills, but none employs technical manual skill to grasp material physically and metaphorically with and in the hand; none employ technical manual skill in the creation of actual, physical objects capable of standing before us as functioning and functional things.

Examples of technical manual skills that do have to do with the manipulation of physical material still survive in the traditional building trades, modern counterparts of the medieval guilds. As previously mentioned, the connection that existed between craftsmen, tradesmen, and even fine artists in the medieval guild system reflects the fact all possessed a high degree of technical manual skill in the working of some particular material. Even today a tradesman is thought of as one who works something physical, as someone who applies a technical manual skill to work and form some*thing*. Crews at building or construction sites are considered workmen or workers because we envision edifices being built of raw, physical materials.[2] However, because of industrial

2. Under the influence of Marxist ideas about the proletariat, the use of the term "worker" to refer to artists and writers has become somewhat fashionable; thus people often speak of art workers instead of artists. Unfortunately, this tendency subverts the full meaning of the term (especially its implications for making/working material) for political ends and adds to the confusion by blurring further the distinction between fine art and applied objects, including craft.

production and machines this is not as simple a situation as it was in the Middle Ages when the same guilds might include painters and carpenters or sculptors and masons because all worked the same type of material, in these cases wood and stone. A brief look at skilled work in relation to building trades will help us recoup something of the meaning of manual skill as it relates to craft; it will show how modern mechanization has altered our understanding and even use of terms such as "manual skill" and "skilled tradework" or "tradesman" and changed how we understand the "handmade-ness" of the craft object.

All workers on a building site are involved with physical materials to one extent or another; however, they work with materials in vastly different ways, requiring vastly different degrees of skill. Digging holes with shovels (as opposed to using digging machines) is neither a highly skilled activity nor a sophisticated manipulation of material but a comparatively rudimentary activity depending less on manual skill than physical force.[3] In contrast to common labor of this kind, plastering of walls, today an almost forgotten trade, is a highly skilled activity demanding much manual skill. Being able to apply a smooth, even coat of plaster requires much practice in order to gain the requisite technical manual dexterity and sensitivity in handling material. Since few people in the general population possess such skill, it was highly regarded and costly, something reflected in the wages of plasterers. This is also why plastering is seldom used today; it has been replaced by new and less costly industrially based methods. As industrialization of this type commodified labor, the nature and degree of the manual skill demanded of workers in the manipulation of material was decreased as were their wages.[4]

3. Even though it involves strenuous physical labor, because it requires only low-level manual skill, the kind possessed by most in the general population, it is held in low regard and is usually at the bottom of the pay scale. By contrast, workers who dig using machines are near the top of the pay scale because they don't sell common physical labor, but an uncommon ability to operate expensive and very productive equipment.

4. As Daniel Bell notes, "Capitalism is a socio-economic system geared to the production of commodities by a rational calculus of cost and price." See his "Modernism and Capitalism," 210. A logical outcome of this "calculus" is that in the United States, to reduce costs and speed construction, systems are continuously being devised to speed skilled handwork or to replace it altogether with methods requiring less expensive unskilled labor. One such system is drywalling; it uses factory/machine-

If common laborers and plasterers present opposite ends of the spectrum regarding levels of technical manual skill, electricians and plumbers present an entirely different situation. In their cases the word "skill" has taken on very different meanings even though they too are considered skilled tradesmen. This is because, in reality, their "work" has been industrialized and now doesn't actually require much technical knowledge in the manipulation of material nor much technical manual skill. What it does involve is a certain kind of specialized "abstract" knowledge. In this sense they retain that medieval meaning of the word "craft" that referred to intellectual, abstract knowledge as in the "craft of writing" or as betrayed by the word "witchcraft"; but they have lost that sense that referred to the technical knowledge of materials and their preparation, something still essential to the craftsman. This makes electricians and plumbers different even from plasterers. Plasterers must have some technical knowledge about their material, for example, how to slake lime in preparation for application. Though slaking is a simple process demanding only rudimentary knowledge, it shows how plasterers still retain a connection to their material. More important is the high degree of technical manual skill required of them; knowing a thin, even coat of slaked lime is required as a top or finish coat on a wall is the easy part; physically being able to apply such a coat is the difficult part.

With electricians and plumbers, it is more a question of knowing specifically what to do in terms of installing materials. Technical knowledge of materials or highly honed manual skills in working them is not required. While it is true the work of electricians and plumbers entails a certain degree of nonscientific knowledge of electricity or hydraulics, it is a familiarity with the complicated and often convoluted local, state, and federal building codes that is most important for their work. So, if traditional skilled work is defined as that which involves both technical manual skill in forming material and technical knowledge of material preparation, plumbers and electricians are not skilled workers in

<hr />

produced sheets of plaster that are easily cut with a knife and nailed to studs. Installation, compared to wet plaster, is much faster, requires minimal technical manual skill, and, as a result, is considerably less expensive. The economic incentives in this are testified to by the increased use of drywall today and the virtual disappearance of wet plaster, though unions in various cities vigorously fought drywall's acceptance in building codes.

any traditional sense.[5] Rather, they are experts in rules and regulations; and while this is important, it represents a significant change from the past.

Even when referring to trades and tradesmen we must recognize that the meaning of the word "trade" and the relationship between manual skill, worker, and handiwork varies greatly. Electricity and plumbing are modern and modernized trades, respectively. That is to say, the electrical trade did not really exist before the twentieth century, and plumbing, though very old, was transformed in the modern period so that both trades now reflect modern industrial production in terms of their materials. Electricians, for their part, never made their own wires or junction boxes and plumbers no longer make their own pipes as they once did in antiquity;[6] in fact, today plumbers seldom even thread pipes because soldered copper pipes have replaced galvanized steel pipe. Moreover, like electricians and plumbers, the materials used today by most tradesmen are industrially manufactured so tradesmen have become more like assemblers than makers or manually skilled workers. They "work" best by assembling standardized material prefabricated by machines in factories. These new approaches, in their reliance on prefabrication, standardization, and quantity output, reflect machine production and modern industrial concepts. Residing at the core of modern society, they have had great consequence for our perception of craft as a cultural activity related to the hand.

5. Admittedly, electricians and plumbers must possess some skill in order to thread galvanized pipe, sweat copper joints, and bend electrical conduit, but the level of manual skills demanded by these tasks is hardly analogous to that of plastering.

6. The term "plumber" comes from the Latin "plumbum," meaning lead, the material out of which pipes generally were made beginning in antiquity; since metal was very expensive in the ancient world, one can presume the people who made and installed pipes of lead were already highly regarded. Even after the late nineteenth century, the term continued to refer to a person who installed pipes, even though pipes were now industrially made of lead and then steel. "Plumb," as in vertical, and "plumb-line" also derive from lead and are related to both the plumber's and the mason's trade.

DESIGN, WORKMANSHIP,
AND CRAFTSMANSHIP

■ ■ ■

Aristotle grouped knowledge into three categories or general classifications, two of which are *theōria* and *praxis*. According to Aristotle's classification, *theōria* is theoretical or cognitive knowledge (for example, the technical knowledge of formulas and temperatures needed to make ceramic out of clay or glass out of silica). *Praxis* is practical or "how to" knowledge that comes by doing (for example, the ability to manually form clay or glass into a vessel). Aristotle's third classification is *poiēsis* or *poietikos*; it is knowledge involved in the making, producing, or creating of something. Referring to these Aristotelian categories, I would like to explore the differences between workmanship, craftsmanship, and design in comparison to technical manual skill.[1]

The English woodworker David Pye explores the question of differences by contrasting design and workmanship. "Design," writes Pye, "is what, for practical purposes, can be conveyed in words and by drawing: workmanship is what, for practical purposes, can not."[2] As an activity, design is the conceiving and creating of a plan or instruction in the form of an illustration, drawing, ideogram or some other abstract notation with the intent that it be realized as some thing. Regardless of the notation used, a design is always an

1. Here I am referring to the modern conception of design and the design profession as opposed to the traditional views expressed by the terms "*il designo*" and "*le dessin*."

2. Pye, *Nature and Art of Workmanship*, 17.

abstraction; never is it the same as the thing intended to be made from it.[3]

Workmanship is different from design in that it is directly connected to the technical ability of the hand to work physical material. Workmanship is that which is actually done to the material by the hand; it is the product of the hand. Because of this, the more skilled or dexterous the hand, the greater the skill, the better the workmanship can be. Thus the quality of workmanship, as the output of manual skill, is directly dependent upon several factors: the degree of manual skill possessed by the hand, the worker's technical knowledge of how materials can be worked, and the standards of quality to which the worker is committed. Not all work, however, demands the same degree of manual skill, which is one reason why salaries vary so greatly among workers. To dig a ditch requires a strong back but a very minimal degree of manual skill, which is why most people are capable of digging one. On the other hand, to make an acceptable kitchen cabinet requires a much higher degree of manual skill, which is why fewer people are capable of doing so.

A designer is a person who conceives and creates a design; in this sense design is a product of the creative imagination. A worker is the person who realizes a design by first interpreting the notation and then translating this notation into actual material form; the worker does this by using manual skill to technically manipulate physical material. Because this manipulation must be along the lines specifically designated by the design, workmanship can be defined as simply labor produced by the noncreative hand. For its part, the design must communicate something about workmanship even if it is only the invocation of traditional procedures as a set of ready-made conventions that the worker already understands and knows how to employ. Since the worker is required to follow the dictates of the design, regardless of how skilled he or she may be, the outcome of his or her workmanship is always relatively predictable. In this sense, workmanship is basically a rote process of making and should not be confused with craftsmanship, as some people are wont to do.[4]

3. In the language of semiotics, one could say it is a sign *representing* the thing to be made. But since no original exists before the design is realized, there is nothing to re-present; hence, the design must be considered a presentation or a concept, something to be realized.

4. See Collingwood, *Principles of Art*, 15; Bayles and Orland, *Art and Fear*, 98ff.

Craftsmanship differs from both design and workmanship. But defining exactly how is difficult because modern technology and machines have altered our views and expectations of production. Today to many people the term "craftsmanship" either has taken on a broader, less precise meaning or, simply being equated with workmanship, it has come to represent contested territory because of its connection to the hand. Its less precise meaning is used by John Harvey when he collapses the distinction between craftsmanship and technology. In his book *Mediaeval Craftsmen*, Harvey argues technology is nothing more than craftsmanship; if there is a difference, it is essentially one of degree. But Harold Osborne rightly points out that the two terms should not be confused. The Amerindians of ancient Peru, Osborne observes, were extremely accomplished craftsmen and craftswomen in masonry, metal working, ceramics, textiles, but they were technologically backward, lacking the saw, wheel, and a true kiln.[5] We might also point out that Meso-American Indians did have the wheel but they did not exploit its use for things other than children's toys. Lacking the technological mindset that characterizes modern Western societies, they were not predisposed to exploiting ideas and technological innovations and discoveries.

As to the second point about craftsmanship being contested territory to many people, this view too is a product of the advancement of modern technology and the technological mindset. Pye notes that "craftsmanship," considering the "strange shibboleths and prejudices about it . . . is a word to start an argument with." For there are people, argues Pye, "who say they would like to see the last of craftsmanship because, as they conceive of it, it is essentially backward-looking and opposed to the new technology which the world must now depend on. . . . There are also people who tend to believe that craftsmanship has a deep spiritual value of a somewhat mystical kind."[6]

As Pye goes on to discuss this contested term, it becomes apparent that even he is not quite sure how to define it. He approaches crafts-

While I am using paradigm examples of these activities, sometimes the designer also realizes the design, in which case the separation between conceiving and making may not be as great, but even so, with industrial/mechanical processes there must be a separation in terms of the way material is treated.

5. See Harvey as quoted in Osborne, "Aesthetic Concept of Craftsmanship," 138–39.

6. Pye, *Nature and Art of Workmanship*, 20. For more on the skill/design debate see Anonymous, "Comment: Skill-A Word to Start an Argument," 19–21.

manship from a viewpoint greatly influenced by the transformation of the world by modern industrial technology, mass production, and the predictability and certainty characteristic of machine work. As a consequence, while Pye correctly sees design as something opposed to workmanship, like Harvey, he too believes workmanship and craftsmanship are basically the same. Calling craftsmanship an "honorific" title for workmanship, Pye concludes craftsmanship to be an activity only qualitatively different from workmanship. Referring to craftsmanship as "the workmanship of risk" and regular workmanship as "the workmanship of certainty," he notes that just as there is always an element of risk in craftsmanship, there is a high degree of certainty in workmanship.

Following this line of thinking (which probably owes something to American Abstract Expressionist "Action Painting," in which painters such as Jackson Pollock and Willem de Kooning were said to routinely risk the failure of their paintings in order to push the creative process to its limits), Pye contends that the "workmanship of risk" (what I am calling craftsmanship) would be "workmanship using any kind of technique or apparatus, in which the quality of the result is not predetermined, but depends on the judgment, dexterity, and care which the maker exercises as he works. The essential idea is that the quality of the result is continuously at risk during the process of making." To the "workmanship of risk," says Pye, "we may contrast the workmanship of certainty, always to be found in quantity production, and found in its pure state in full automation. In the workmanship of this sort the quality of the result is exactly predetermined before a single salable thing is made. In less developed forms of it the result of each operation done during production is pre-determined."[7] Pye's qualitative distinction between "risk" and "certainty" makes sense and is important because it captures something of the tension and drama involved in truly difficult handwork. In another sense it is unfortunate because it dismisses or, at the very least, ignores several extremely important differences between workmanship and craftsmanship. These are differences that on one level the modern conception of design and industrial production have obfuscated and on another have made abundantly clear.

7. Both quotes from Pye, *Nature and Art of Workmanship*, 20. Pye goes on to make the important point that one must be careful not to overly romanticize the handmade since some mass-produced things cannot possibly be better if handmade, things such as nuts and bolts (see 23).

The modern conception of design, in which the designer's creations only exist in the form of abstractions until they are given material form, reflects a kind of Cartesian dualism separating mind and matter. It makes explicit what had previously only been implicit—the division between mental conception and physical execution. The formalizing and even widening of this gap, very much the result of the demands of modern industrial mass production, reveals how the making of an object can be a two-part process involving "design-man-ship" and workmanship. In this process, one can judge the quality of the design conception separately from the quality of the finished object. In this sense, used qualitatively, the term "workmanship" would refer to the quality of the realization of the design plan, to the quality of the worker's manipulation of the material in the execution of the designer's abstract conception. Though a worker may have an inordinately high level of technical manual skill/dexterity, he or she (or the demands of cost) may set very low standards of workmanship for their work. On the other hand, how inventive or practical a design may or may not be is not a question of workmanship or the responsibility of the worker, but of the designer's creative ability. Simply put, then, design involves the creative imagination; workmanship involves the skilled hand. The two, however, needn't always come together at the same level of quality as the example of reproduction furniture attests. Making such furniture is basically a matter of rote work; and, no matter how skilled the workmanship, it is never a matter of creative design.

The conception of design that has come from modern industrial technology has accentuated the modern dichotomies of "design conception/workmanly execution," "abstract design/concrete object," "designer/worker." By accentuating the "division of effort" at the heart of machine processes, design has inadvertently linked itself and workmanship together as opposing, but complementary, partners in production.[8] This is reflected in Pye's conception of "workmanship of certainty" in which, as he states, "the quality of the result is exactly predetermined

8. As early as his 1906 article, which John Heskett calls a foundation document for the Deutsche Werkbund in the following year, German author and politician Friedrich Nauman recognized that the craftsman's activities included being an artist, producer, and salesman, but since the applied arts were no longer synonymous with handicrafts because of machine production, these three functions had become separated. See Heskett, *Industrial Design*, 88.

before a single salable thing is made." Workmanship of this kind, he says, is "found in its purest state in full automation."[9]

In saying this, I believe Pye is mistaken. There is no workmanship whatsoever, neither of risk nor of certainty, in full, automated production. For as I have argued, workmanship is that which is done to material by the hand. Things made by machining, stamping, pressing, and any number of other mechanical/industrial processes intentionally do not involve the hand. Thus the partnership implied between design and workmanship, if it actually exists, is unequal, with design being privileged in this hierarchy and workmanship debased—the goal of machine production, after all, is elimination of the skilled workmanly hand and thus the elimination of work itself. In the industrial world, machine-made things may be welded, glued, screwed, bolted, stapled—that is, assembled by the human or robotic hand in any number of ways—but as material they are seldom actually worked by hand.

This "division" of effort also has affected our conception and understanding of craftsmanship as a process of conceiving and making. Using Aristotle's ideas of *theōria*, *praxis*, and *poiēsis* (though probably not scrupulously enough for some philosophers), what I want to suggest is simply this: that designing or "design-man-ship" and workmanship should not only be considered opposites, but that design should be seen as relating to the realm of *theōria* since it involves abstract, theoretical knowledge—designs, after all, are abstractions, formal inventions for things that exist "in theory," not in reality.

Workmanship, on the other hand, should be seen as relating to the realm of *praxis* since it involves practical manual skill—workers who follow designs must, of course, possess a knowledge of abstractions since they are required to "de-abstract" designs to bring them into reality as made things. But despite this, their activities, which are essentially at the level of practical, manual skill, must be predictable. It is in this sense that we can say that in the modern world design is a process of inventing form and workmanship is the process of filling that form with material.[10]

Craftsmanship, however, is a third kind of activity, one that can be

9. Pye, *Nature and Art of Workmanship*, 20.

10. The form that workmanship fills with material need not be presented in a design; it could be form received by the workman through tradition as in the making of a "contemporary" Windsor chair or Shaker basket.

said to fuse *theōria* and *praxis* because it has both an abstract and a practical, material aspect. It involves risk at the level of workmanship through technical manual skill, as Pye claims, but it also involves an element of abstract conceptualizing as in design. In other words, craftsmanship is not limited solely to the execution of sophisticated technical manual skill (whether risky or not); it also involves the creative imagination in the employment and guidance of sophisticated technical manual skill through the hand. Thus craftsmanship should be seen as existing within the realm of *poiēsis* because technical skill and creative imagination come together in craftsmanship to bring the thing into being as a physical-conceptual entity. Craftsmanship, like *poiēsis*, should be understood as a creative act in which actual physical form is brought together with an idea/concept. This is the creative act at the basis of every original craft object. In this sense, craftsmanship is a process of formalizing material and materializing form that results in the creation of an original craft object.

Identifying this type of activity explicitly with the term "craftsmanship" serves to distinguish it from design on the one hand and workmanship on the other. As a term, it stresses the creative dimension, the quality of thought involved in the making of craft objects while also distinguishing between the technical manual skill found in workmanship and the creative technical manual skill found in true craftsmanship.

As noted, before the modern division of design and production, making entailed both design *and* workmanship in a fusion of what modernism increasingly has come to set apart in the manner of a Cartesian dualism—mental conception versus physical execution. In this dualism abstract formal invention has gained precedence over both manual skill and workmanship because abstract formal invention reflects the values of progress and efficiency typical of modern industrial society. Machines, by eliminating costly technical manual skill, are economical and have become symbols of technological progress. In doing this they undermine the value and meaning of workmanship and thereby foster a new social context for both craft and fine art, a context in which the word "craftsmanship," as Pye says, comes to represent contested territory because it seems to symbolize old-fashioned, anti-progressive thinking. That the Museum of Modern Art collects design, not craft, reflects the general shift in societal values from skillful execution and quality workmanship to the machine and its penchant for abstract conceptualizing,

something that characterizes modern fine art as well as modern design. This also explains why the American Craft Museum changed its name to the Museum of Arts and Design and why the California College of the Arts dropped the word "craft" from its name several years ago. In the present industrial-technological climate, conceptualizing is valued over execution, execution seemingly being reduced in importance to the level of the rote or mechanical. I presume the logic runs as follows: "After all, if machines can do it, how important and creative can the process of execution be?"

Going against the social grain, the craftsman, following the traditional practice of craftsmanship, both conceives *and* executes. But doing this entails more than just a simple unity of operations. For contained in this fusion, as I have tried to express by relating the process of craftsmanship to Aristotle's *poiēsis*, is a profound act of creativity. Instead of being separated into stages, conception and execution are integrated so that a subtle feedback system occurs when physical properties of materials encounter conceptual form and conceptual form encounters physical material. In this encounter, thinking and making, visualizing and executing, *theōria* and *praxis* go back and forth, hand in hand. As this happens, as ideas lead to the manipulation of materials and materials condition ideas, a truly dialectical and dialogical process takes place. It is this process of mutual conditioning and modifying that occurs during making that is at the heart of the creative act of craftsmanship. It is this that makes craftsmanship a unified process of formalizing material and materializing form. This is why for the craftsman the concept, the idea, only exists in and as the form; idea and form are one and the same.[11]

Pye's conception of workmanship as either certainty or risk fails to stress these important distinctions. It instead emphasizes the quality of workmanship and the level of technical manual skill involved, something that Rudolf Arnheim, in his writings about the psychology of art, also echoes when he says that "the criterion of acceptable quality of form remains what it always was, namely the question: is the maker's intu-

11. As described, this is only a conceptual abstraction; in practice there always must be some planning, at least to begin the process. However, planning is analogous to the sketch of the painter or sculptor; it is not a preconceptualization of the finished work in all its elements and details, such that the realization of the piece is never in doubt both as an idea and as a material form.

itive judgment in charge of the tool, or does the tool force the maker to accept its own preference of mechanical monotony and repetition?"[12] Surely we must recognize as categorically different activities the applying of an even coat of plaster or making perfect dovetails on a drawer or the turning of a standard wooden bowl using technical manual skill on the one hand and the conceiving and making of a unique craft object on the other. The application of the tool may be repetitive for the craft object, but the resulting object need not be if the tool is in the service of invention and the creative imagination.

For the traditional craftsman conceiving/executing, imagining/making, link together mind and body and creative imagination such that mind extends through the body into hands and fingers and even into tools that are their extensions. Through this act mind and creative imagination come into direct contact with the actual physical substance of tangible reality itself, the raw matter that is nature. This linking together of mind and body, of *theōria* and *praxis* in the manipulation of the physical material of nature is a transformative process the essence of which is a creative, poetic act, one that lies at the heart of craftsmanship in its highest sense. It is a poetic act that entails creation of a human world directly out of the raw substance of nature itself. It entails transformation of our direct sensuous experience of nature into a world of culture.

12. Arnheim, "Way of the Crafts," 39. These remarks apply especially to machine production, but also to Pye's "workmanship of certainty."

CRAFTSMAN VERSUS DESIGNER

■ ■ ■

Despite what I have said so far, it would be inaccurate to conclude that the activities of the craftsman and the designer are absolutely foreign to each other; parallels do exist in the way they operate. Not only must the designer solve problems of functional shape, he or she, like the craftsman, also invents, elaborates, and hones the design during the process of creating it. However, the great difference between them is that while the craftsman ends with a finished, functioning object, the designer does not. He or she ends with a drawing or some other type of abstract notation that may, at a later stage, be made into an actual object; until it does, it remains an abstract sign—the term "design" itself comes from the Latin "*signum*," meaning sign. Thus, designing, as the making of a sign, is the first stage in what I have called a two-stage process; only in the second stage is an actual object made.

The significance of this is that in the process of designing, the designer does not encounter directly the physical world of matter; no dialogical/dialectical process occurs, no give and take, as it were, between idea, form, and matter through which they eventually come together as a fully fledged design object. Any direct encounter the designer has is with notational systems—with how to notate (whether on paper or on computer) his or her mental conception of the would-be object in order to "capture" this conception as an instructional design plan. If the plan is realized as a physical entity, it will be by someone else or, more likely, by a machine during the second stage of the operation.

In contrast to the transformative process at the very heart of craft, a process that involves, as I have said, *theōria, praxis,* and *poiēsis,* design is a dialogue between conception and what can and cannot be abstracted into a notational system on paper or computer. As such, the tension in design exists at a stage removed from the ideational-izing, formalizing, and materializing process that is craftsmanship. What can actually be made through the design process thus is largely a question of what can and cannot be both conceived *and* notated as a set of instructions; this makes it difficult, if not impossible, for features that cannot be easily communicated in some way to the worker or the person who programs the machine to eventually be realized in the finished object. As Pye writes, design "is what, for practical purposes, can be conveyed in words and by drawing."[1] Because of this situation, design must be seen as an abstract process on several levels. First of all, for the designer the relationship between physical matter and functional form can only exist as an abstraction because matter is not directly engaged in the creation of form; second, the design object itself must be considered an abstraction because it only exists on paper; and finally, as the design is "worked-out," "captured," as it were, through drawings or computer modeling, a dialogue of abstractions occurs because all notational systems, by their very nature as signs, are abstractions.

For the worker who must realize the design plan, the situation is somewhat analogous to that of the craftsman. He or she also must rely on imagination to bring the design as an abstract plan into being as a tangible object. The difference, however, is that for the craftsman, imagination also is used to conceptualize the object *during* the process of making. While the workman need only worry about means, about how to fill the design form with material, the craftsman must worry about means and ends. For the worker, imagination is used to "de-abstract" someone else's conception of the object from a preexisting set of instructions—a drawing or other form of abstract notation. In having to realize the design in this way, the worker is like the designer: both must overcome limitations imposed by the very means of communication they must interpret. In this sense, the design as abstract notation exists as an intermediary between the designer and the worker, but it is a mute, silent intermediary floating, as do all signs, somewhere be-

1. Pye, *Nature and Art of Workmanship,* 17.

tween conception and reality.[2] Thus the worker's imagination must be directed toward an interpretation of the mind of the designer through the designer's "drawing." Rather than being engaged in a direct dialectical relationship with material reality as is the craftsman, the worker is forced into a "dialogue" with the designer as a presence that exists in an abstract notational system. In advanced industrial production, of course, there usually is neither a true worker nor true workmanship involved in producing the finished object, only someone who knows what machines can do and how to get them to do it. Engineers make machines, designers "program" them with their designs, and workers are reduced to serving them by supplying material and then assembling the parts they produce.

Another significant difference between designer and craftsman, one that should not be underestimated, occurs as the craftsman engages material in the process of giving it form. In doing this the craftsman always ends with a finished original, a one-of-a-kind object. This occurs even when the craftsman makes several objects of the same type as in a dinner service or a set of chairs; each object simply enlarges the set to which it belongs—in this sense a set is a collection of individual, original objects or members. While the making of an original or set of originals is the goal of the craftsman, it is not the goal of the designer because of the nature of the design process. Designers are compelled to conceive objects for mass production, so even though a specific design conception may be original and even unique, there seldom results from the process an original, one-of-a-kind object—industrial production simply isn't intended to do this. What does result are huge numbers of identical, uniform products. These products, what I am calling *multiples*, stand in direct opposition to the craft object. They are a typically modern phenomenon that was only made possible by industrialized mass production.[3]

2. I have, of course, simplified this process to make a conceptual point. In reality, there is no reason why the designer cannot speak directly to the worker explaining the design. And, of course, craftsmen also get involved in production procedures with templates, gigs, etc. However true this might be, the relationship between design as a set of instructions and the worker who must realize these instructions is precarious, analogous to the musician who must re-create the performance practice of older musical styles, for example that of Baroque music, when the composers have long been deceased.

3. Ancient coins and early printed books may be seen as predecessors of mul-

To understand what a multiple is and its implications for craft and our conception of the world, we need to see it in relation to the preindustrialized world of handmade objects. This world was composed of originals, copies, and reproductions, all of which are related to each other. An original, as I have said, is a unique, one-of-a-kind object whether part of a set or not. A copy, in the strict sense, is an object that replicates in materials and appearance its original—its original being the object it copies. And a reproduction is a remaking or reproducing of an original, though without absolute fidelity to the materials and appearance of the original as in a photographic reproduction of a painting.

Copies and reproductions are always dependent on their original. And by being dependent on an original, they reaffirm the original's existence and priority as both an object and as a philosophical concept. Multiples, on the other hand, not only challenge this relationship, they completely undermine it. They do this not so much because they are not one-of-a-kind, individual objects, nor because they can exist in unlimited quantities. Rather, it is because they are identical objects conceived and produced with the idea that they are not originals and are not based on an original as their source. In other words, multiples are related neither to copies, nor to reproductions, nor to any other existent object; every multiple is related only to the other multiples in its production stream; moreover, each multiple is the equal of every other multiple in its stream; there are no physical or philosophical differences between them.[4] This is what makes them a strictly modern phenomenon. It is also why multiples actually undermine our idea of the original object as a philosophical concept and as a unique thing:[5] they not only

tiples; however, because they were handmade, they are not uniform, standardized products; each is different, each is unique.

4. In philosophy, as worked out by C. S. Peirce, we would describe this as a situation in which a multiple, as a design concept, would be a type and the actual object would be a token. As a design concept the *Barcelona Chair* (Figure 24) is a type of chair, a one-of-a-kind type, while every actual *Barcelona Chair* made is one of an unlimited number of tokens of it.

5. Though related, multiples are not to be confused with simulations that are even more destructive of originality and our sense of reality. Simulations simulate an original object or event which does not exist and never did. As in fakes of paintings by artists who never existed or fabricated historical/news events, simulations simply "pretend" to restate a truth, further transforming and corrupting our understanding

displace the original from its position atop a hierarchy of creative objects, they dissolve the hierarchy itself and with it our traditional basis for understanding the creative act through the physical object.

An example of what I mean is to be found in the way the term "vintage" has come to replace "original." We speak of old automobiles in terms of their model years—a 1932 Ford coupe, a 1957 Chevy Impala—rather than in terms of copies or originals. Each individual automobile is an example of its year and model type. While we might wonder about how many original parts a '32 Ford or a '57 Chevy may still have, we generally refer to such automobiles as vintage or antique cars, not originals. In this usage, "vintage" does not refer so much to age as it does to an object's connection to its production stream. To a certain extent this is also true of fine art photographs. Since most photographs today are made through mechanical processes rather than as singular images made by hand as they were in the mid-nineteenth century, the term "vintage" has been substituted for both the term and the concept of "original." In photography today, "vintage" distinguishes a photograph taken and printed by the photographer at or about the time the negative was exposed. A nonvintage photograph would be one printed from a negative by the photographer or someone else well after the negative had been exposed.

But there are still some interesting dilemmas about objects that the term "vintage" cannot clarify. If expatriate American photographer Man Ray exposed a negative and printed an image of it in Paris in 1925 and printed a second image of it in New York in 1960, only the first would be considered a "vintage" print even though both are by Man Ray. What would the second print be? It is neither an original work nor a vintage work, so what are we to make of it? Where would we place it in the hierarchy of being vis-à-vis creative objects? Another example of the difficulties that multiples pose for our conception of originals is the machine-printed snapshot photograph commonly made from film developed at chain stores. Which would be the original print, the first one out of the machine? Perhaps, but the second, third, and every other print are not copies or reproductions of the first. Like the Man Ray photograph, all the prints, including the first, come from the same negative and are re-

of the original. For more on this see Baudrillard, *For a Critique of the Political Economy of the Sign.*

lated to each other because of this. This is why one can have more prints made even though the first batch of prints no longer exists. However, we also can't say that the negative is the original and the prints are copies or reproductions of it. The prints, by definition, are the exact opposite of the negative; they are positives. What we must conclude is that, like the designed object, photographic prints are multiples of themselves generated from a single negative that is a source without being an original. There is no original print, just as there is no original designed object.[6] We identify some prints and some designed objects as "vintage" because they are produced closer to the time the design or negative was made,[7] but we can't consider either a creation in the way we would a work of craft or even an original object in the way we would something handmade.[8]

Making of multiples is the goal of the designer. And though a model or "prototype" may be made to test design and production possibilities, seldom if ever does an original exist in the traditional sense in which we understand the term. The alliance of the designer with mass-production techniques to produce multiples makes the difference between designer and craftsman a matter of quantities of identical objects versus the singular, unique object or set of objects made by hand.

These differences in goals and how they are achieved shape the outlooks of craftsman and designer at both the practical and the concep-

6. The term "vintage" also doesn't acknowledge the creative effort put into printing each photograph from its negative. Ansel Adams was very particular about this in an effort to make all his prints perfect. I suppose the more perfect his were, the less unique and more like a multiple they would be. Perhaps a subtle distinction is implied when, in discussing photographs, it is common to speak of the quality of the image as if the image is something distinct from the photograph and may be the original creative idea of the photographer.

7. The classic discussion of mechanical reproduction is Benjamin's "Work of Art in the Age of Mechanical Reproduction," 217–51. In this article Benjamin praises mechanical reproduction for depleting the artistic aura of works of art and thereby laying bare to the viewer their "un-romanticized" subject matter. What he doesn't consider is the effect of the depletion of the artistic hand and, as a consequence, the individual since the hand in art acts as a metaphor for individual being.

8. Again, from a philosophical perspective we can separate old Chevys and Fords, as multiples, into types and tokens. Each Chevy or Ford is a token of a type, the type being the design conception and the token being the actual auto in my driveway.

tual level. If craftsmanship (as opposed to workmanship and "design-man-ship") is the ability to originate and create things by hand through the manipulation of material, then the craftsman must have a sense of how something should be and can be based on an extensive knowledge of the properties of materials. Equally important, the craftsman must also have the requisite technical manual skill to manipulate material in very sophisticated ways to bring the craft object into existence. While the designer should also understand the properties of materials and have an acute sense of shape and form, it is the knowledge of materials in relation to their "machine-ability" that is a prerequisite for the designer; technical manual skill to manipulate material can be left to skilled workers or, more likely, to machines. In this way the designer's experience tends to become divorced from the organic properties of materials and the skill processes used to make or even fabricate objects. These changes began to occur when, for example, production factories like Josiah Wedgwood's Etruria opened near Stoke-on-Trent, England, in 1769. With such factories the division between concept and execution became marked. In later years it only became more acute as industrialization and automation increased.

Machines, by providing the possibility of mass production, raised the issue of cost-effectiveness as a central concern of object production—a slight reduction in the cost of production for one object multiplied by thousands of objects produced becomes a considerable sum, something that is seldom an issue with hand production. In this environment the designer holds sway, not the craftsman; the designer holds the key to quantity production by gearing design to the needs and capabilities of the machine. Thus not only is design circumscribed by what can be communicated through abstract design notation; it is also circumscribed by what machines can do—machines ultimately determine the parameters and limits of designed objects. And because machines are most economical and efficient when they make quantities of things quickly and simply, objects must be designed with these considerations in mind.

The result of all this is that designers tend to lose touch with the natural, organic qualities of materials and how they can be worked. They come to view materials and understand design principles according to what can be communicated *and* what lends itself to the capabilities of the machine and machine processes. As designers accommodate themselves to machines, the spirit of the machine increasingly comes to

dominate both their and our worldview.[9] Such changes became notice-able already at the beginning of the twentieth century as industrial pro-duction methods raised standards of living in industrialized countries; soon an environment developed in which the worldview of people living in these countries was shaped to accommodate the machine and the values of industrial production methods. For instance, at the turn of the last century Gustave Stickley began showing a line of furniture that was cheap to make because it was geared to the machine—straight cuts and little decoration. In 1901 he founded the periodical *The Craftsman* to pro-mote the idea that the aim of his furniture was "to substitute the luxury of taste for the luxury of costliness."[10] After designer Richard Riemer-schmid joined the German firm of his brother-in-law Karl Schmidt, he designed in 1907 what were called "machine furniture" for mass pro-duction in series. According to design historian John Heskett, they were "undecorated, with plain elements, and flush, veneered surfaces." Heskett also points out that many features of modern apartment and kitchen design also were influenced by the clean lines and efficiency of transportation vehicles such as those designed by Germans August Endell and Walter Gropius.[11] By the late 1920s, full-fledged machine styles developed that expressed this mass-production sensibility (Figure 18). Streamlining in the 1920s and 1930s is an example of this; it repre-sents an aesthetic in which the traditional metaphorical value of work-manship, rather than being viewed as necessary and desirable, came to be understood as something to be avoided as too slow, too individual, too expensive, and too old fashioned. Streamlining attempted to express in visual form through aerodynamic styling the inner driving forces, the essences of industrial-age technology and its promise of endless progress. This was so for a vast array of things from toasters to trains, regardless of whether or not they were actually industrially produced or even needed to be aerodynamically streamlined (Figures 19). In this way, Streamlining came to represent an aesthetic display of function by

9. The invention of new processes and synthetic materials is almost always in response to the capabilities of machine production; it would not be economically feasible otherwise.

10. See Flemming and Honour, "Gustave Stickley," 758. It is worth noting that the title of Stickley's magazine indicates the changes taking place in the conception of craft and craftsmanship at this time.

11. Heskett, *Industrial Design*, 91–92.

FIGURE 18. *20th Century Limited Locomotive*, New York Central System, 1938, designed by Henry Dreyfuss (American, 1904–72). Henry Dreyfuss Collection, Cooper-Hewitt, National Design Museum, Smithsonian Institution. Photograph by Robert Yarnall, courtesy of Cooper-Hewitt, National Design Museum, Smithsonian Institution.

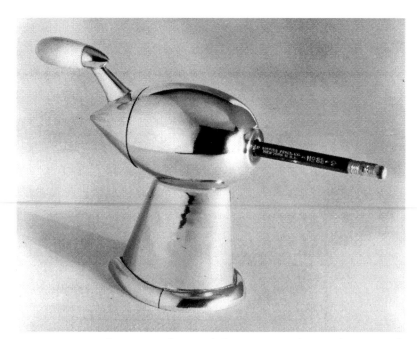

FIGURE 19. Raymond Loewy, *Teardrop Pencil Sharpener*, 1933. Photograph courtesy of Hagley Museum and Library, Wilmington, Delaware.

Dreyfuss's train design (Figure 18) makes an interesting formal comparison to Loewy's pencil sharpener. Even though Dreyfuss's train is at rest, both it and the pencil sharpener have a sense of speed and surging energy about them that is a result of their streamlined design; this design style originated in the science of aerodynamics explicitly to reduce the air resistance of moving objects. However, Loewy's pencil sharpener, which was never actually manufactured, doesn't encounter air resistance the way a train does as it moves through space. What Loewy was doing, as were many other designers of the time, was treating Streamlining Design as a visual sign to denote efficiency despite its irrelevance to the object's practical function. In this sense, the incorporation of streamlining elements in order to give the look of aerodynamic efficiency is a response to the social requirement of the time that objects evoke a sense of the modernist future, something epitomized by speed, energy, and aerodynamically efficient design. One might also notice that there is a sense of "scale-less-ness" to Loewy's design; in terms of size, it could be as small as a pencil sharpener or as large as an airship or even a spacecraft of the *Star Trek* variety.

turning actual function into a sign that garnered metaphorical content and meaning from the increased value assigned efficiency in modern industrial society.[12]

In large part as a result of the growth of industrial methods we are left with machines *producing/machining* most of the objects we have rather than people *making/working* them or craftsmen *crafting* them. Today relatively few of the things we own and use are made through workmanship and even fewer are a result of craftsmanship. As a consequence, the meaning contained in the act of "making" as a specific kind of activity related to the value of work and workmanship has suffered greatly, as has the value of craft and craftsmanship that relies on both to create singular, unique objects. In light of this, it hardly seems necessary to point out that today all craft people should be cognizant of the influence of design and the culture of industrial mass production on the state and prestige of their profession.

12. For more on Streamlining see Meikle's *Twentieth Century Limited* and his *Design in the USA*. For more on the idea of representing technology see Rutsky, *High Technē*.

CHAPTER 18

IMPLICATIONS OF CRAFT AND DESIGN

■ ■ ■

As I have already argued, for something to contain, to cover, and to support, it must con*form* to the physical laws of nature, to what we can call the brute facts of nature. These brute facts dictate the physical forms of such objects while society and social conventions dictate only whether or not we shall use them. However, despite their naturalness, the making of such objects is still a very complex process, one in which brute facts must get conceptualized into abstract idea-concepts that, in turn, must be reconfigured as abstract form-concepts that relate to utility/applied function; and finally, these form-concepts must be realized as material objects.[1] For instance, a pool of water must first be conceptualized as the idea-concept of "containing" before it can be *form*alized into the form-concept "container" and then realized as an actual physical container or vessel of some kind. In more abstract terms, we could say that the verb or active forms of the idea-concepts "to contain," "to cover," and "to support" must be conceptualized as noun or thing forms (as the form-concepts "container," "cover," and "support") before they can be materialized as physical objects.[2] It is in

1. Does fine art operate in the opposite direction by giving an idea-concept to preexistent form—for example, in figurative art by infusing the human body with meaning? Much of the tension between craft and fine art in the late modern period may have to do with fine art's abandonment of its traditional forms so that it too had to find a form to give to idea-concepts—is this not the struggle of Cubism, Futurism, Surrealism, Abstract Expressionism, and Minimalism?

2. In speaking of language and thought, French philosopher Mikel

this sense that basic functional form in applied objects like craft objects is not just material that is organized in some arbitrary way, it is ontological. That is to say, as both an idea-concept and a form-concept embodied in physical material circumscribed by the brute facts of nature, functional form is thought that exists outside of language and all social conventions; in this sense it can claim ontological status as an actual, rather than an illusory, thing.

Having said this, however, there still are several important questions that have not been addressed. What, for instance, is the connection between applied function in craft objects and applied function in machine-made design objects since both can claim an origin in the brute facts of nature? And, can craft objects and even machine-made objects, despite having an origin in such facts, also have a vital social life? If they can, how are function, material, technique, and the hand-made-ness of craft objects, as opposed to machine-made objects, reflected in this social life?

As already noted, the term "applied" refers to objects that carry out practical as opposed to theoretical functions. However, as modern design and industrial production techniques have demonstrated, the term "applied" is not inextricably linked to the hand. Functional objects can be made by any process or method whatsoever, including machines, and still fulfill all of the functional requirements defining the class "applied object." In light of this, the presumption held in the preindustrial world that all applied objects are a product of the human hand can no longer be maintained. This raises serious questions for craft as an independent field of activities. If the making of containers, covers, and supports need not involve the hand nor handwork of any kind, does it automatically follow that machine-made containers, covers, and supports are the same as craft objects? Are they, in fact, craft objects? If so, then identifying handmade, handwork, and craftsmanship with craft is just an accident of history that has become tradition, a tradition that is no longer valid or even relevant in the modern world of machine production.

I don't believe this to be true and I don't believe machine-made containers, covers, and supports should be considered craft objects. Differences in the way they are made should not be ignored for several

Dufrenne describes this process by saying, "If the subject is a predicate that is realized, then the predicate is a subject that is thought. . . . To construct the subject is the same thing as to think the predicate." See Dufrenne, *Language and Philosophy*, 90.

reasons. With many applied objects, say two chisels, whether they are machine-made or handmade is relatively unimportant. With craft objects this is not the case. First of all, being handmade is important to the identity of craft objects as objects because the unique relationship they have to the human body, especially the hand, originates in large part from their being made by hand. As we have already seen, this "handmade-ness" accounts for a host of properties that give them handiness in use. When the hand is abandoned to the design process and the machine, these properties are in danger of disappearing as design drifts away from the requirements of the hand. This is something Rudolf Arnheim noted when he encountered that coffeepot in a German cafeteria that he described as a "monster to the eye" (Figure 20). What troubled Arnheim about it was that its shape had its origin not in the hand, but in a machine sensibility that prizes efficiency and practicality of storage over handiness of use.[3] It was, in fact, a coffeepot in name only since its form was a simple ceramic cube without a spout or a handle; there was a finger hole in one corner while the opposite corner was notched with a pouring hole. Though very efficiently designed in terms of utilization of space and stackability, it was not very conducive to friendly use. Its design, more akin to that of a packing crate, did not keep the handle cool and it made the pot difficult to hold and to pour coffee from. These functional features, evidently, were of less concern to its designers than achieving an industrialized look that suggested efficiency and progress.

The second reason being handmade is an essential aspect of craft objects is because of the dialogical/dialectical process that *is* craftsmanship. As I have argued, this process springs from the *form*alization of both idea-concepts and form-concepts in the hand as material is actually being worked via technique. Design does not involve a dialogical/dialectical engagement with material because it separates the conceptualization of form done during the designing stage from the actual materialization of form done during the making stage. And moreover, the result of the design process is that thoroughly modern object, the multiple, an object that undermines the philosophical concept of originality by being neither an original object, nor a copy, nor a reproduction.

These three reasons alone should suffice to warrant both the preservation of the term "craft" and to restrict its application solely to those containers, covers, and supports made by hand. But more is at stake

3. Arnheim, "Form We Seek," 356.

FIGURE 20. *Cubic Coffeepot*, ca. 1920s–30s, German.
This is a drawing of what Arnheim's cubic coffeepot may have looked like. While he referred to it as a "monster to the eye" because its form was so unfriendly to the user, it is very modern in its conception and in its relation to the products of machine production it tries to emulate.

here than just the identity and formal appearance of objects. For both craft and machine-made objects have a social life, a social existence, if you will, in the sense that they help shape how we see and understand the world, the things in it, and our relationship to these things. Craft objects do this through craftsmanship. When we engage the social life of craft objects we come to understand something about ourselves in relation to other things in the world in a way that is different from that of machine-made objects. This is because, through their connection to the hand, the light that craft objects shed onto the world helps us see both nature and the world differently from the way we see them based solely on the light that comes from the machine-made and machine production. This difference, one of understanding, occurs because the

hand is a factor limiting what can be done to materialize matter into form. Unlike the machine which is characterized by unlimited power and endless production, the human hand is limited in size, strength, skill, and even endurance and speed. These limits not only establish the scale of craft objects, but because they are limits shared by all humans, whether craftsmen or not, they also give us a sense of how to relate to other things in the world, man-made as well as natural. In doing this the hand provides a basic, universal gauge of what constitutes the human in terms of scale and proportion, material and form; it offers a standard with which to judge quality and to differentiate abundance from excess. In essence, the hand provides an inherent human sense of what is proper and fitting, a sense of propriety about how to be in the world that can't help but reverberate throughout all of our social and cultural institutions. In this way craft offers an important corrective or counterbalance to an institutional mentality that today is more and more modeled on a mechano-techno-scientific rationalism that has done much to disenchant the world and the things in it; by disenchant I mean taking the magic and even the wonder out of the world by accounting for everything, including all actions and experiences, in rational, empirical terms.[4]

The point I am making is not a question of craft being different or better, nor is it a question of nostalgia for tradition and the past—the so-called "good old days." Rather, it is about seeking ways to be in the world that recognize the importance of human values and human relations in order to counteract the "limitlessness" that mechano-techno-scientific culture encourages. The problem is not that this mentally is bad per se; clearly it is not. By its promotion of a coefficient of rationalism and efficiency in production, it has dramatically improved the material well-being of most people in developed societies. Yet this is exactly where the problem arises, for it has been so successful that the light it sheds onto the world is so strong it tends to blind us to all other ways

4. For more on the penetration of all spheres of social life by the modernist logic of "formal rationalism," see Arato's discussion of Max Weber in *The Essential Frankfort School Reader*, 191ff. An instructive parallel to our issue of limits is that of drug use in organized athletics. Drugs undermine the relationship players have to spectators because they destroy all natural human limits. The achievement of any performer, not just in sports, must be understandable in human terms by being gauged against the viewer's own limits, otherwise all meaning in human terms disappears.

of seeing and understanding. In essence, it forces us to see and understand the world in only one way, its way. In the social realm of daily life, convenience and material acquisition has been promoted as a sign of efficiency and progress to such an extent that consumer spending now represents two-thirds of the U.S. economy. Consumption has become a value in and of itself; we consume the latest fashions, the latest foods, the latest gadgets, the latest fads, all of which shape attitudes toward work (we must work longer to earn more so we can buy more), toward social interaction (gadgets like the Internet and text messaging replace face-to-face interaction), and toward material resources. In the intellectual realm the mechano-techno-scientific view has even shaped the methodologies used to study social institutions and human behavior. We now speak of "political science," "social science," and "the liberal arts and sciences" as if the scientific model of formal rationalism can account for all human experience, even that offered by art and culture. It is this scenario that gave birth to Arnheim's "monster" coffeepot and its anti-human design.[5]

In the face of increasing environmental degradation, pollution, and global warming, an alternative view might be to ask: just how efficient must we become and how convenient must life be to be enjoyable and fulfilling? Are there not some things worth having and doing for themselves alone, regardless of how time-consuming and inefficient? I would say yes. But what is it that will provide limits to hold in check, to humanize if you will, the unlimited possibilities of material consumption that the mechano-techno-scientific worldview provides?

I think handmade craft objects, perhaps more than any other type of object, can help do this because they fit naturally into our daily life routines; their functions are an essential part of our life world so they are always ready at hand. In this way they can offer a genuine alternative to the view of life that machine-made design objects offer; after all, both are conceived around the same functional needs. In fact, it is because they serve the same functions that machine-made design objects have been able to seamlessly graft themselves onto the worldview already established by craft objects.[6] Taking over the function and ap-

5. For a full discussion of the question of methodologies in social studies and the humanities, see Gadamer, *Truth and Method*.

6. This has not happened to painting, in spite of the creation of that mechanical image maker, the photographic camera; this is because of painting's theoretical and

pearance of craft objects by emulating craft's forms, design has made the modern industrial production system seem like the only viable process for making things because of the economic benefits. So powerful has this attitude become in transforming our worldview that design can even ignore the cost-efficiency coefficient as seen in Mies van der Rohe's high-end *Barcelona Chair* (Figure 24).

But the "hand-made-ness" of the craft object, when understood as a process of both hand and mind engaging material together, still offers a meaningful alternative worldview to the one offered by the possibilities of unlimited material consumption that the limitlessness of machine production encourages.[7] It does this by encouraging us to pay careful attention to how something is made so that we come to regard what something is by how it came to be; the process of making becomes an essential part of the object's identity. In doing this the craft object can help us challenge the belief that outward appearance and reality are the same. By linking means and ends together in this way the craft object calls into question the long-held Western tendency to base reality solely on appearance, something that goes back at least to Plato and his cave analogy. The craft object, as an act of craftsmanship, questions this tendency by challenging us to look deeper into an object's origin, encouraging us to appreciate how the act of making can have a direct bearing on the object's meaning and the social world we construct through that act. The Western tendency to link reality to appearance, which is now becoming increasingly prevalent in our age of mediazation with its proliferation of images, is another instance of sight being privileged over other senses. But there are many examples in which appearance and reality don't coincide or are completely at odds. We already have mentioned how Monet's late works from Giverny and Pollock's drip paintings are similar in formal appearance but stem from vastly different

critical underpinning as a fine art process. When the camera sought to challenge painting on these grounds as a substitute image maker by copying typical fine art compositional strategies, a critical reaction resulted that showed why this could not be, thereby not only "saving" painting as a unique image form, but forcing photography to critically examine itself, with the result that photography came to be seen as a unique art form in its own right.

7. Obviously this is only one alternative view; but in its emphasis upon human values it also encourages limits in other areas, for example in the exploitation of child labor or the environment simply for profit.

intentional realities. Another instance in which appearance is at odds with reality are the churches of St. Peter's in Rome and Les Invalides in Paris. Both are crowned with dome forms to invoke the dome's metaphorical associations. However, while St. Peter's is a true dome of masonry construction based on the arch rotated in 360°, Les Invalides is a wooden timber-truss construction that simply imitates the shape of a dome. Structurally, a true dome is a complex interplay of elements held in equilibrium by tension and gravity; otherwise the whole would collapse. This is one reason why it stands as a grand symbol of the celestial realm and the harmony of the universe. When we know this, we begin to have a more profound sense of what a dome actually is and why it has the metaphorical meanings it does; we also develop a better sense of reality—after all, reality is pieced together from a myriad of separate experiences. In contrast to a true dome, however, a timber-truss structure in the shape of a dome is a very stable and inexpensive construction. Unfortunately, by imitating an actual dome in order to exploit its metaphorical associations and meanings, the faux dome undermines all domes; eventually domes will be reduced to nothing more than another architectural element in a grab bag of otherwise meaningless shapes.

In a similar way, an example of what I mean at the level of process would be two paper-thin porcelain containers that appear exactly alike but one is machine-made and the other made by hand. Like our domes, should we consider them the same just because they look the same? I would argue no. The handmade container, we must remember, purposely continues a tradition of making that is thousands of years old, laborious, and manual-skill intensive; moreover, it does so not out of ignorance, out of an inability to do something else. No, it does so in spite of the availability of cheaper and easier machine processes. This is a crucial point that must not be overlooked. In the case of the handmade porcelain cup, the handmaking process at the heart of craft is being intentionally embraced in the face of machine alternatives. This, in itself, makes the handmade container different from its modern industrial counterpart, a counterpart that the craftsman is purposely rejecting. In doing this, the handmade container is intentionally made to bear the weight of an enormous historical tradition at the same time that it casts a new light onto the machine-made objects this very tradition rejects. With two such objects, there is so much involved beneath the surface at the level of deep meaning that it is not enough simply to identify some-

thing as a container, cover, or support so it can be placed in a class of like objects based on appearance or function alone. We must take into consideration *how* the object was made and *how* making, as a conscious process, is a bearer of meaning, whether the object is machine-made or handmade.[8]

Heidegger attempts to understand the object's nature (in this case, a jug) in a deeper, more meaningful sense, one that goes beyond the limitations of mere appearance and beyond pure function as an idea. According to Heidegger, "what and how the jug *is* as this jug-thing, is something we can never learn—let alone think properly—by looking at the outward appearance, the *idea*. That is why Plato, who conceives of the presence of what is present in terms of the outward appearance, had no more understanding of the nature of the thing than did Aristotle and all subsequent thinkers."[9] For Heidegger, "the jug's thingness resides in its being *qua* vessel," in its ability to hold and to pour. "The vessel's thingness," he writes, "does not lie at all in the material of which it consists, but in the void that holds." It is in understanding this, argues Heidegger, that we come to understand the jug; it is in understanding this that the thing's "thingness" becomes manifest to us.[10]

For Heidegger, this manifestation, one that seeks to reinstill into the object its full plenitude and significance, can only happen by understanding the object within and against the larger world. "Standing forth" in this way, writes Heidegger, the object "has a sense of *stemming from somewhere* whether this be a process of self-making or of being made by another."[11] Heidegger tries to experience the object in a different sense by focusing discussion on function, eventually attributing mythopoetic proportions to function itself, to holding and pouring as an act of giving that comes from the gods through the rain that feeds the spring which fills the jug. What he does not reflect upon is the importance

8. This applies to acts as well. A expensive feast catered for one's guests, no matter how excellent, is never the same as one prepared personally by the host or hostess. One is simply an occasion to meet that has been paid for with coin while the other, like every meal prepared by a mother for her family, is a genuine gift of time, effort, and affection, the value of which cannot be measured by an economic coefficient based on material, money, and time.

9. Heidegger, "The Thing," 168.

10. Ibid., 169, 170.

11. Ibid., 168 (italics added).

making, but especially making by hand, has for the jug, how the jug's "deep structure" as a handmade object stems from a constellation of technique, material, and form all coming together through the thinking hand. The hand "thinks" the subject and the predicate in the service of function through the materialization of form that results in a unique, one-of-a-kind object.

This uniqueness, this one-of-a-kind-ness, as I have argued, is especially important in the age of industrial production. But instead, speaking of the potter working on his wheel, shaping and forming the clay, Heidegger takes for granted the "hand-made-ness" of the thing. He feels no need to address the question of making in the age of machine production and thus he fails to stress the uniqueness that comes of the jug's origin as a handmade object as opposed to the sameness of the machine multiple. As a consequence, he fails to recognize that whether or not objects appear the same on the surface, if they are *not made* the same, they *are not* the same in terms of meaning and, therefore, do not, to use Heidegger's words, "stand forth" before us in the same way.

Georg Simmel (1858–1918), one of the founders of modern sociology, seems to have understood that in its "hand-made-ness" the handmade object "stands forth" before us in a way the machine-made object does not. Teaching at the University of Berlin at the turn of the last century, Simmel was concerned with the effects modernization and industrial technology had on the individual, especially the individual living in the metropolis where industrialization was at its greatest. Simmel grasped the magnitude of change the machine had wrought in the way we understand objects and the worldview they help create. Simmel believed that in the way objects "stand forth" before us they reflect our identities, but he cautioned they only do this when *we* make them, not when machines make them. With machines there is no reflection of a single maker's identity—commerce plays the major role in determining what is produced and how it will look.[12]

12. For an introduction to Simmel's ideas see his *On Individuality and Social Forms* and Wolff, *Essays on Sociology, Philosophy, and Aesthetics*. As if echoing Simmel, the American ceramist Rob Barnard noted upon seeing "Shino, Seto, and Oribe style bowls and boxes—with imperfections that are not perfected, seeing the lumpiness, seeing that these things do not flatter you, that they are honest, and as raw and real and different as real human beings—that was a part of what was amazing to me." Barnard quoted in Heimann, "Rob Barnard," 7.

What concerned Simmel, who was experiencing the social and political changes caused by industrial production firsthand, was that with machine-made objects there is no interaction between hand, material, and concept that would give them a sense of autonomy and the one-of-a-kind status necessary to reflect a single maker's identity and an individual being's essence. In their "machine-made-ness," they just seem to exist; they are objects without an origin(al), something mass production, by definition, guarantees. To say objects come from somewhere, in the old sense, was to say they come from someone's hand, that they and their maker had an autonomous existence in the world. Or to put it in more philosophical terms, objects were not alienated from an origin in the life-practice of social subjects. They were not reduced to signs without reference to the meaningful practice that produced them. When one experienced such an object, one had an individual, autonomous experience as well, one that was a reflection of the object's autonomy as well as that of its maker. In such an environment one was open to new experiences, encouraged not to objectify, to simply classify things into a group as if this were enough to "know" something. But in the machine age this sense of autonomy and openness to new experience disappears, both from the object and our experience of it. Every machine multiple offers essentially the same experience to every viewer; all that is different is the experience that the individual viewer may bring to the object. The unique and individual, as a *reciprocal* relationship between the handmade object, maker, and viewer, is no longer extent. Experience is flattened out, made uniform—this is standardization and multiplication in action.

This is such a drastic change from the way the world was encountered and understood in the past that it should startle us as it did Simmel, but it doesn't, perhaps because it is so much in tune with other values dominating modern society. One need look no further than those values established by the modern scientific method to see how this occurs in other arenas. Through its approach to experience, the scientific method objectifies experience to guarantee that it can be repeated and thus verified—in this scenario, verification *is* confirmation *is* truth. As Gadamer notes, in modern science, "experience is valid only if it is confirmed; hence its dignity depends on its being in principle repeatable. But this means that by its very nature, experience abolishes its history and thus itself. This is true," says Gadamer, "even of everyday experience, and

much more so of any scientific version of it."[13] In this way experience, as an encounter with the world, gets flattened and made uniform by its repeatability. Repetition becomes the normal state of affairs, and it becomes not only the way we expect things to be but also how we judge what is creditable; advertising works this way through repetition, as does propaganda and ideology.[14] When we encounter multiples, we are encountering the same object(s) again and again and our experience of it/them is repeated again and again, suggesting that it is a true experience and an essential aspect of the world. At the same time, repeated experience becomes expected and comfortable and reassuring as well. This happens so often that we regard it as normal so that new experience, experience that is not shared by the group, begins to seem strange, even an aberration.[15]

This is just one way in the wake of machine production that our sense of the tangibility of the material world and the world of culture based on it is dramatically altered. "Standing forth" in the old sense of the handcrafted object and in the new sense of the designed, machine-made object are vastly different propositions that cannot be understood by accepting the object at face value. We must weight the implications inherent in the making process because it is through this process that we are normalized to understand the world and our relation to it.

13. Gadamer, *Truth and Method*, 347. Gadamer is not saying that science is wrong to operate in this manner, only that its methods may not be the appropriate model for the humanities, what we tend to refer to now as the human sciences.

14. One obvious example is the standardization of taste in America pioneered by franchises like McDonald's and Holiday Inn (whose first advertising slogan was "The best surprise is no surprise!"). These are only two examples of many showing how the mindset promoted by machine production and its multiples has seeped into other areas of society as part of its social life.

15. Mass society can be characterized as a society of "multiples" rather than individuals. For a discussion of the idea of alienation within the crowd, see Kuspit, "Crowding the Picture," 108–20.

HAND, MACHINE, AND MATERIAL

■ ■ ■

Another way that machine production has transformed how we are normalized to see and understand the world has to do with how machines engage material. Machines are so powerful they simply dominate material; they force material into forms that have little to do with a material's organic properties or natural inclinations. Machines also are so efficient and fast in the way they "work" material that they are able to process large quantities of material, almost effortlessly, into untold numbers of objects. As I have argued, before industrial technology the ability to bring some*thing* into being—whether an image, sculpture, or a functional object—was a kind of wondrous act because the ability of the hand to wrest a realm of culture from the material realm of nature was limited and limiting; this gave the hand and the handmade special metaphorical qualities that the viewer understood and appreciated as part of a larger worldview. It is these very qualities that the power of the machine undermines (perhaps even destroys) by its unlimited scale of production and its overwhelming power to master material.

Quite prescient in recognizing this is German architect Gottfried Semper. Already in the mid-nineteenth century he lamented how machines have changed our view of things, even ancient monuments from the past, by the way they seem to conquer material. For him the emotional power, magic, and style—features he finds in Egyptian monuments deriving from the interaction between simple tool, soft hand, and hard granite—is obliterated with the introduction of machine technology. For Semper, "the sublime repose

and the massiveness displayed by these [Egyptian] monuments . . . the modesty and reticence with which this awkward material [granite] is fashioned, the atmosphere which surrounds them, all these are beautiful expressions of style, ones which now, when we can cut through the hardest stone like bread and cheese, no longer possess the entire necessity that formerly attached to them."[1] What Semper is saying (their symbolism, age, and exoticism aside) is that machines have dramatically transformed how we understand such monuments and all other manmade objects. In this new world of the machine, the sense of *praxis* that brings objects into being simply loses meaning because it is cut loose from an autonomous maker's hand.

For our understanding of the craft object as a product of craftsmanship, this is a point too important to pass over lightly. In craftsmanship material must be worked in harmony with its inherent material properties. This means that from the very beginning, in the creation of the craft object, the hand could not resort to raw power but had to rely on skill and technical knowledge of material to coax material into the form desired by a maker. Moreover, when irregularities are encountered in material, for instance discolorations or knots, say in pieces of wood or in fibers, the hand of the craftsman can negotiate around these natural occurrences or work with them and incorporate them into the finished piece. In this way, rather than liabilities, irregularities become positive factors that contribute to the creative process. The result is that rather than the alienation of technique, material, and hand that is found in machine production, in craftsmanship, of necessity, there is respect for these elements, a respect that unites them in the formalization of the craft object. Moreover, special qualities also adhered to material itself, even before it was worked into functional form. This is because raw material also had to be prepared and worked into usable form by the hand, something that was difficult and time-consuming. If nothing else, this meant material was expensive and scarce and, as a consequence, was valued enough to be carefully and thoughtfully approached before the actual making process began.[2] These special qualities imparted even to

1. Semper, *Science, Industry and Art*, 334.

2. Living as we do in a world of the wrecking ball, in which buildings are regularly demolished and material carted off to landfills, we tend to forget that in another age material was so valued as to be reused whenever possible. Historical examples of this abound. The Coliseum in Rome is a partial ruin today, not from natural decay, but

unfinished material were appreciated by the skilled maker and helped to ensure that material maintained a close connection to its source in nature and to the object of which it would become a part; it was not easily reduced to a simple, abstract commodity divorced from its origins in nature or the human hand.

Considering this and the fact that the union of technique, material, and hand is inherent in craft objects, it should be clear that craftsmanship is more than just an old-fashioned way of making that has been updated by the machine process. Just as the machine process involves more than simply making things faster and more economically, craftsmanship involves more than simply making things in a slower, more time-consuming manner. Craftsmanship is a way of making that provides a universal standard for judging objects and work itself that transcends cultural horizons because, as a process connected to the handworking of material, it is available to everyone and thus occurs worldwide; in this sense the hand in craftsmanship provides a reference by which and against which made things and the raw material used to make them can be placed in a human perspective and comprehended in human terms that are not bounded by cultural, social, spatial or temporal horizons.

Through the hand in craftsmanship, craft objects capture the efforts of their makers and make these efforts visible and palpable for us to see and comprehend; and in doing so, they reflect back to us our own efforts; they become mirrors of our own aspirations and possibilities. When we compare what our hand can do to that of skilled makers, we develop an awareness and appreciation of other human beings and, in the process, a greater degree of self-understanding and self-awareness. In this, craftsmanship in craft objects fosters a worldview that projects the creative imagination firmly within a humanly defined, a humanly scaled, and humanly understandable tangible reality. Albrecht Dürer's appreciation of the incredible skill evident in those Pre-Columbian gold objects that he saw from Mexico is just such an example of human

from being "quarried" for building material, as was the great twelfth-century Benedictine Abbey of Cluny in France after the French Revolution. For their churches, early Christian builders reused material (called *spoglie*), including columns and capitols from antique temples. Even fifteenth-century architect Leon Battista Alberti, rather than demolishing several buildings in Florence in order to construct the Rucellai Palace, simply wrapped them in a new facade.

understanding founded in the "thinking hand" that is able to transcend time, space, and cultural horizons.[3]

Machines encourage a different worldview because of the way they operate. For one thing, they are so powerful they need not be sensitive to the nuances of material; they need not coax material into the desired form as must the hand. Moreover, to work efficiently, machines demand a uniformity and standardization of material, not only in size, but in density and consistency—irregularities of any kind simply cause problems. When nuances or irregularities are encountered, machines either plow through them as if they didn't exist or get jammed and break down. But when all goes as planned, machines simply overpower material, shaping it with little effort to the designer's will.[4] But since the designer must design for the machine, for what the machine can do to material in a practical and economic way, the designer's will is, in turn, shaped by the machine. This means shaped not only by the fact that machines require uniformity and standardization of material, but by their propensity for repetition. With machines, repetition not only occurs with production of the multiple as a finished object, but also in terms of the multiple's general form and even its specific details. This is because machines are prone to mechanical shapes and forms—for example, manipulation of flat planes joined at right angles, straight-line or right-angle cuts, circular or rectangular perforations in grid patterns. Organic shapes and forms are more difficult to make and, therefore, more expensive.

This results in a concentration on material's "machine-ability" that, ultimately, transforms our sense of material itself. At the same time that it does this, it also abolishes that universal standard—the hand—which previously had given a human measure and scale to both things and endeavors. In the end, such procedures obliterate any human-based standard with which work and effort can be valued and judged. Before machines changed how we encounter things, in the world of the hand-

3. As Donald Schrader pointed out to me, Dürer's appreciation of these gold objects may have been aided by his first training with his father, who was a goldsmith.

4. An example of this is the sense of immateriality that can pervade modern objects like the extruded aluminum can; when empty its weight, skinlike surface, and shape betray nothing of its strength, process of making, or permanent impermeability; it exists as an inscrutable space-age object.

made, twenty chairs was a substantial number because of the great effort involved in making each one of them (Figure 21). This effort, however, was (and still is in some parts of the world) universally measurable and comprehensible—an African, a Chinese, an American, even an ancient Roman chair maker would have understood this effort, as would anyone who lived in a world of hand-made things.[5] In machine production this is no longer the case. There is no such measure: 20 chairs, 200 chairs, 2,000 chairs are all the same (literally as multiples, but also figuratively and experientially) (Figure 22). The only caveat is that unit price decreases as quantity increases so, in fact, more in number actually represents less in terms of an individual item's value.[6]

This is in inverse proportion to the handmade and gives a hint of the different worldviews attending craftsmanship and machine production. One elevates skilled effort and material while the other eliminates them and reduces material to a resource or commodity. The worldview fostered by the machine values convenience, disposability, and planned obsolescence, values that could hardly exist without the machine. In a deeper sense, to the extent machine production has flooded the earth with stuff, it has transformed our relationship to things by altering those traditional conceptions of work, production, value, and proportion that formerly derived from the human hand and body.[7]

5. In the eighteenth century, as a rule of thumb, it took a skilled workman two working days to make a chair; this included marking, sawing, and joining its members as well as finishing. See Montgomery, *American Furniture*, 38.

6. Capitalism and machine production present a symbiotic relationship. Capitalism facilitates distribution of industrial production. Distribution based on use-value through traditional barter systems are no longer practical with such unlimited quantities. A monetary system of exchange facilitates the economics of industrial production by translating the value of all things into monetary units—this is the crux of Marx's observations. Consequently, rather than valuing things for the effort and skill required to make them (values automatically understood in a society of the handmade), value is based on market conditions of supply and demand; this helps explain why used things seldom command the price of new ones even though the material, skill, and effort needed to make them is the same.

7. In the ancient world quantity, quality, and size of monuments was intended to impress the spectator in one sense or another, but always with the human body and skilled hand as referent, as gauge of the amount of effort and skill expended to work the material and raise the monument. In this way the body was assured of its central and humanizing role in the world. An example of this is the way the size of

FIGURE 21. Sam Maloof, *Michael M. Monroe Low-Back Side Chair*, 1995, zircote wood (29 ¾″ × 22 ¾″ × 22 ⅛″). Gift of Alfreda and Sam Maloof in honor of Michael W. Monroe (1995.29), Renwick Gallery Curator-in-Charge, 1989–95, Renwick Gallery of The Smithsonian American Art Museum, Washington, D.C.

As this chair demonstrates, master craftsman Sam Maloof continues a long tradition of chairmaking that goes back to the ancient world; see, for example, the chair from the New Kingdom in Egypt shown in Figure 26. Interestingly, though the Maloof chair has all the hallmarks of a handmade wooden chair, it has nevertheless been influenced by the appearance of modern industrial design—note the look of a streamlined functional efficiency in the "swooping" curve of the armrests as well as the rounded joints, features typical of industrially cast metal elements. A comparison with the aluminum multiple seating "chairs" shown in Figure 22 is instructive in this regard.

FIGURE 22. Charles and Ray Eames, *Aluminum Multiple Seating*, ca. 1950.
This variation of the Eames's *5-Seat Aluminum Multiple Seating*, which was designed in the 1950s, has become ubiquitous in American public spaces, especially in airport waiting areas.

In the modern world quantity, quality, and size have broken free of human dimensions in terms of effort expended and in terms of scale (Figure 23). In a way, they have moved beyond human comprehension into a realm of "limit-less-ness" where there is little to give an absolute perspective and value to things, to anchor them except their comparative size or price. As a result, most machine-made things, and even many handmade things, now tend to drift in a realm beyond our grasp. Yes, they have value as commodities, but they seem to have little inherent value as made things.

With these ideas in mind, I think we can say that true craftsmanship

containers had a deliberate metaphorical function; kraters, amphora, and lekythoi of near gigantic size used as memorials in ancient Greek burials suggest a large quantity of wine or oil offered at the deceased's grave. In this way size, as a factor of what one normally consumes, expresses the quantity and value of the offering and the immense sense of grief felt by the survivors.

FIGURE 23. Teacup, 2004, ceramic (2 ¾" high), Korean; soft drink container, 2006, plastic (9 ¼" high), American; champagne flute, nineteenth century, glass (6 ¼" high), French.

The sense of abundance as well as "limited-less-ness" that has resulted from modern industrial production methods has been so widespread as even to affect social attitudes toward the consumption of food and drink. Not only in the United States but also in Europe, the rise in obesity in recent years is reflected in the size of food and drink portions, especially those served at fast-food restaurants. At 64 ounces, fully one-half gallon, this soft drink container, in size and capacity, dwarfs both the champagne flute, which holds a respectable 4 ounces, and the teacup, which holds 8 ounces. Moreover, both the teacup and the champagne flute are carefully made with user and contents in mind; note that the teacup has a handle to prevent the user from being scalded by the hot liquid, while the champagne flute has a stem so that fingers will not warm the chilled liquid. The soft drink container, on the other hand, is made indifferently to both use and user—in its diameter it is too large to be comfortably held in the hand, and in holding it, the hand warms the contents at the same time the contents chill the hand.

results in a worlding (a making of a realm of culture from that of nature) like no other. Fine art certainly does not engage issues of function and the human hand interacting with material and nature as part of its world-ing process, despite the important theoretical-aesthetic ground that it occupies. Neither does design, even though it seems so similar to craft in its appearance and its practical function. The way the dialogical/dia-lectical process at the heart of craftsmanship demands intimate knowl-edge of and respect for material reality produces a far more humanly based, certainly very different, worlding experience than "design-man-ship." In this way the craftsman's engagement with material expands the craftsman's imaginative horizon of possibilities by offering a process of experiencing while the work is imaginatively formed into an actual, real entity. This is why true craftsmanship is different and more com-plex than either workmanship or design. It is a "thinking" of the subject/predicate relationship carried out by the skilled hand with deliberate in-tention and purpose, always in direct engagement with material reality to produce an actual object. In this way it is more than simply a fusing of workmanship and design; it is *theōria* and *praxis* coming together as *poiēsis*, as a creative, form-giving act of the imagination. In this creative, form-giving act the skilled hand and the inventive mind together em-brace material as part of the making process. When considering this, it is hardly surprising that material and technique play such important roles, physically and expressively, in craft objects.

Pye's distinction between craftsmanship and workmanship (that is to say, his idea of "workmanship of risk" versus "workmanship of cer-tainty") doesn't fully appreciate the conceptual, creative, and transforma-tive component involved in craftsmanship's relationship to form giving. His distinction is more attuned to the monotony and predictability of mechanical production than to the differences between workmanship and craftsmanship or craftsmanship and design. This is understandable given how mechanized production and the multiple have so drastically altered the way we see and understand objects. But this is also why, when confronted by machine-made multiples, the craft object takes on an urgency it didn't have in the preindustrial world; this is why the handmade object of craftsmanship needs to be accorded a more promi-nent place in our thinking, for it sheds a light onto the world that offers a needed counterpart to that anonymousness and "unlimited-ness" that industrial production encourages.

An example of what I mean can be seen in Mies van der Rohe's *Bar-*

FIGURE 24. Ludwig Mies van der Rohe, *Barcelona Chair*, 1929, stainless steel bars, leather-upholstered cushions (29 ⅜″ high, 29 ¼″ wide, 29 ¾″ deep; seat, 17 ⅜″ high), manufactured by Knoll International, New York, N.Y. Gift of Knoll International (552.1953), The Museum of Modern Art, New York, N.Y. Digital image © The Museum of Modern Art/Licensed by Scala/Art Resource, N.Y. © 2007 Artists Rights Society (ARS), N.Y./VG Bild-Kunst, Bonn.

Mies originally designed this chair for the German Pavilion (which he also designed) for the International Exhibition of 1929 in Barcelona, Spain. The original was made of a chrome-plated flat steel frame with leather-covered horse-hair cushions. It has become a classic example of the Modern International Style and is still in production.

celona Chair (Figure 24) and Marcel Breuer's *Wassily Chair*. In these chairs the complex interplay of hand, eye, and materials that are unified in the hand-crafted object at the level of "deep structure," giving it meaning and value, are no longer relevant. These chairs "stand forth" as machine-made objects—conceived, designed, and made as multiples in separate processes and by different people whose handwork is kept hidden so as not to betray or reflect an actual maker's identity. Mies's *Barcelona Chair* is especially notorious in this sense; it is designed to appear a mass-produced multiple even though it requires a vast amount of skilled handwork in its welded and ground joints and the stitching of its leather cushions. In suppressing the hand and hence the presence of individual spirit, such works intend to create an almost palpable sense of a perfect, utopian world of ideal entities. Such a perfect world is predicated on entities that themselves exude an experience of timelessness in their purity and in their apparent resistance to decay—no sense of historical development, no sense of coming into being through a process of making or forming, no sense of entropy betrayed through material, even when organic materials are employed—each one is verifiably the same (this is "quality-control" in operation in the production of multiples). An aura of otherworldly anonymity, of existence outside the stream of history, must be created, something the presence of the hand of the maker would immediately disrupt. Each one is the same and projects the same anonymous, flattened experience of nonhistorical being to every viewer.[8] Saying this is not to attack wholesale all industrial products or even Mies's *Barcelona Chair*. Not only do I think the *Barcelona Chair* wonderful, but without machine-made products the quality of our life would be appreciably diminished. What I am trying to do is acknowledge the different worldviews they establish and to seek a balance between them and the worldview attendant the handmade.

In conclusion, only the handmade should be properly considered a craft object. "Craft" implies a specific way of making an object and a special way of expressing one's *being* with and in the world. More impor-

8. Interestingly, Jean-Paul Sartre argued that "the quality of 'smooth' or 'polished' symbolizes the fact that 'carnal possession' offers us the irritating but seductive figure of a body perpetually possessed and perpetually new, on which possession leaves no trace. What is smooth can be taken and felt but remains no less impenetrable, does not give way in the least beneath the appropriate caress." Sartre as quoted by Kuspit in *New Subjectivism*, 447; for Sartre's original see his *Time and Nothingness*, 579.

tant, this way of *being* is not restricted to the maker but is open to any and every beholder of the craft object who attends closely enough to the object's objectness. When this happens, the object reflects back to the beholder a deeper experience of effort, work, and skill, one that links the object to all other human efforts. Perhaps this kind of experiencing explains why the term "craft" has gained such common currency today while the term "applied" has fallen out of favor. "Applied" tends to conflate, or at least obfuscate, handmade and machine-made by focusing on function alone. In doing this, the very possibility of and potential for meaning that is inherent in the autonomous object is itself being denied to the hand-crafted object.

Today making by hand is as much a symbolic statement about how to be in the world as is the making of pictures with a paintbrush. It is about trying to understand our place in the world by understanding the source of things, something implied in Heidegger's belief that the jug unites earth and heaven, divinities and mortals, by gathering water from the spring in the ground that is fed by the rain from the sky.[9]

9. Heidegger, "The Thing," 172–74.

AESTHETIC OBJECTS AND AESTHETIC IMAGES

■ ■ ■

In Part 4, I address the question posed at the outset of this study: "Can craft objects have an existence that extends beyond the purely physically functional and into the realm of the aesthetic, into the realm of art?" As I already have indicated, the nonfunctional, noninstrumental aspect of fine art has been used to separate it from craft along a line demarcated by such binary oppositions as "purposiveness/nonpurposiveness," "functional/nonfunctional," "useful/useless," and "instrumental/noninstrumental." Based on this opposition, craft, as well as anything deemed functional, has been proclaimed incapable of being a work of art. Critic and philosopher Arthur C. Danto, in comparing functional things and works of art, says that "the distinction between art and reality, like the distinction between artwork and artifact [he has in mind an African fishing net], is absolute." Danto goes on to say, following Heidegger on the system-bound nature of tools, that "an artifact implies a system of means, and its use just is its meaning—so to extract it from the system in which it has a function and display it for itself is to treat a means as though it were an end." Paraphrasing Hegel on Greek sculpture as the "perfect wedding of form and meaning," Danto says that the work of art gives material embodiment to a kind of spiritual content. . . . Art, in his [Hegel's] view, belongs to the domain of thought, and its role is to reveal truth by material. . . . Universality belongs, after all, to thoughts or to propositions."[1] Concluding that "an artwork

1. Danto, "Art and Artifact in Africa," 94, 107–9.

is a compound of thought and matter," Danto separates art from artifact by saying "an artifact is shaped by its function, but the shape of an artwork is given by its content."[2]

However, by reducing the distinction between artifact and art to whether something is shaped by its function or shaped by its content, he seems to reiterate the usual craft/fine art opposition implied by Kant. This opposition overlooks the possibility that the actual form of the functional object may, in fact, be such that it imparts meaning to its function, that it raises function to the level of the symbolic and metaphorical, or, conversely, that function itself may impart meaning to the object's functional form. Here one has only to think of how functional objects used in religious rituals do both; their material preciousness gives meaning to the religious rituals in which they are used at the same time that these religious rituals impart sacred meaning to them. Moreover, the view that function precludes art status also ignores the meaning/content latent in functional form as a result of the processes of making, something already discussed in our comparison of handmade craft objects to machine-made design objects. Since all artifacts, even the hypothetical baskets and pots Danto refers to in his essay (which he does, in fact, consider art) are shaped by function, we seem to be back to our original question: "Is the possibility of meaning for a craft object precluded by its function; is its use 'just' its meaning?" Or, can craft objects, despite being objects whose form follows a priori functional requirements, also have an existence in excess of their function, in excess of their instrumentality? Put another way, can craft objects also have an existence as social objects that embody thought and content and have aesthetic import? Accepted wisdom as it derives from Kantian aesthetic theory tells us that this is not possible, that objects cannot be both functional and expressive at the same time. Accepted wisdom is not always correct. With these questions in mind we now return to those issues posed at the outset of this study.

2. Ibid., 110. From the examples Danto uses in his essay (baskets and pots), it seems he would not presume craft objects can't be art; however, if this is so, it is not clear what he means by the word "artifact."

A HISTORICAL PERSPECTIVE OF CRAFT AND AESTHETIC THEORY

■ ■ ■

Until recently it was common to refer to crafts as the "minor" arts and to refer to fine art as "high art." The underlying belief is that "high" arts are superior to the "minor" or "decorative" arts. This is made clear by H. W. Janson in an introductory college survey text that was the standard in the field of art history for over two decades. According to Janson, "what the apprentice or art student learns are skills and techniques. . . . If he senses that his gifts are too modest for painting, sculpture, or architecture, he is likely to turn to one of the countless special fields known collectively as 'applied art.' There he can be fruitfully active on a more limited scale: . . . their purpose, as the name suggests, is to beautify the useful—an important and honorable one, no doubt, but of a lesser order than that of art pure-and-simple." He goes on to write that architecture may be an applied art, but "it is also a major art (as against the others, which are often called the 'minor arts')."[1]

Janson believes craft, as an "applied art," cannot engage serious aesthetic issues and should be done by people whose gifts are, as he says, "too modest" for the "high arts." In his conception of the arts, craft is of a "lesser order than that of [fine] art pure-and-simple." Unfortunately, the matter is not pure-and-simple. Value judgments like major versus minor and "high art" versus "low art" elevate fine art to the superior

1. Both citations Janson, *History of Art*, 16. For other references to craft as "decorative art" see Frank, *Theory of Decorative Art*.

status of the major or beautiful arts. They also make it seem that this has always been the case, that fine art has always been regarded as "fine" and craft has always been thought of as something less.[2] In reality this is simply not the case. Despite what Janson's remarks imply, this attitude simply reflects historical developments of aesthetic theory in fine art that began only in the eighteenth century.

The term "fine art" itself is actually of relatively recent origin. Even the concept of fine art as something separate from craft only began to take place in the sixteenth century, and its exclusive association with the realm of beauty and the aesthetic began only in the late eighteenth century.[3] Before aesthetic issues per se became a special domain of fine art theory, there was little practical or theoretical distinction made between the words "art" and "craft," and neither word specifically implied the aesthetic as it is understood today.

In other words, the concepts of "art" and "craft" and even that of fine art are not universal but historically situated. In Latin, for example, the word "*ars*" (the root for our "art") was synonymous with "craft" and referred to a specialized form of skill or ability that included the making of what we would today consider objects of craft and fine art as well as carpentry, smithing, and surgery.[4] Basically "ars" and "craft" distinguished between man-made things and things of nature; in other words, the opposition they demarcated was not between high and low art, but between nature and culture. The concept of "*ars*" was taken over by the Romans from ancient Greek, which used the word "*technē*" for both art and craft. However, according to Heidegger, "*technē*" did not simply denote a "practical performance," but something more akin to a "mode of

2. While this attitude tends to persist even today, the terminology has changed under pressure from various quarters, including the craft field and feminist theory, which often feels craft is denigrated because it is seen as "woman's work." The second edition of Helen Gardner's *Art Through the Ages* (1936) features sections titled "minor art" accompanying sections on architecture, painting, and sculpture, even though by the seventh edition (1980), the term "craft Art" is used in its stead; separation of the two fields still implies the old hierarchy. For a feminist response to such terminology, see Frueh, "Towards a Feminist Theory of Art Criticism," 153–66.

3. As Kristeller notes, "The system of the five major arts, which underlies all modern aesthetics . . . did not assume definite shape before the eighteenth century, although it has many ingredients which go back to classical, medieval and Renaissance thought." See his "Modern System of the Arts," parts 1 and 2.

4. See Collingwood, *Principles of Art*, 5.

knowing"; it grouped craft and art together under the idea of "making something appear."[5]

During the Middle Ages the meanings of "*ars*" and "craft" broadened with the result that they lost their specific reference to knowledge connected to practical performance. "Craft" and "*ars*" came to refer to the practical skill necessary in the performance of a trade or profession and the requisite knowledge trades and professions demanded. They also came to include knowledge of a more theoretical kind such as any form of book learning—hence the inclusion of knowledge of magic and the occult in their meanings. Thus, though in medieval Latin "*ars*" and "craft" still referred to trade professions, their former emphasis upon practical skill and even the idea of "making something appear" in the literal sense were greatly diluted, so much so that various scholastic subjects of the medieval universities came to be known as either the Seven Arts or the Seven Crafts.[6] The term *artista*, which was coined in the Middle Ages and obviously has its roots in *ars*, indicated either the craftsman or the student of the liberal arts.[7] As Collingwood notes, "*Ars* in medieval Latin, like 'art' in early modern English which borrowed both word and sense, meant any special form of book learning, such as grammar or logic, magic or astrology. That is still its meaning in the time of Shakespeare: 'lie there, my art,' says Prospero, putting off his magic gown." But Collingwood goes on to argue that in the Renaissance in Italy, and then elsewhere, the old meaning was reestablished so that artists again thought of themselves as craftsmen as they did in the ancient world.[8]

Collingwood is correct in noting that the Renaissance did recoup the older sense of the terms "art" and "craft"—the sense in which in the

5. Heidegger, "Building Dwelling Thinking," 159, and "Origin of the Work of Art," 59.

6. These areas of study were established in the sixth century and composed the *trivium* of grammar, logic, and rhetoric and the *quadrivium* of arithmetic, geometry, music, and astronomy; these subject areas have come down to us in the modern university as the liberal arts. In the Middle Ages Hugo St. Victor formulated a scheme of seven mechanical arts to correspond to the seven liberal arts. And while it is tempting to associate these mechanical arts with modern day crafts, they do not actually correspond: they refer to wool working, navigation, agriculture, medicine, and theater. See Kristeller, "Modern System of the Arts," part 2, 507.

7. Ibid., 508.

8. Collingwood, *Principles of Art*, 6.

ancient world they were understood as equal and as skilled work. This is not to say the Renaissance was a time in which crafts held an exalted position. The reality for fine artists and craftsmen alike meant that both were reduced in social class to the status of mere tradesmen. As their former connection to the liberal arts was severed, their work was likewise accorded the lowly status of manual labor. This is why Dante was criticized for immortalizing visual artists, who his critics referred to as "petty artisans" and "men of unknown name and low-class occupation."[9] Meanwhile, the medieval association of *"ars"* with the Seven Arts and book learning in general continued into the Renaissance so that great prestige still accrued to the literary arts, especially poetry.

The situation in the Renaissance in which crafts and the fine arts were considered mere trades was more or less a reflection of the lowly status in which both were held generally in the ancient world. In Greece, especially in Hellenistic times, manual work was mainly executed by slaves; painters and sculptors, like tradesmen and craftsmen, in theory if not always in practice, were hardly ranked any higher because they too had to toil with their hands for their bread.[10] The allying of visual art to mathematics and science in Greece, just as in Italy during the Renaissance, may have been an attempt to change this and raise the status of visual art to that of a more liberal arts/academic profession.[11] It certainly seems that the important exceptions to the rule of the lowly artist in the ancient world were those artists who were learned in literature and geometry. The ancient Greek Polykleitos was known for his sculpture as well as his written works demonstrating the relationship between mathematics and art—his famous "canon" is both a statue and a treatise about proportions. The Hellenistic painter Apelles, who was a friend of Alexander the Great, was likewise an artist and theorist.[12] Despite these examples, however, the status of fine artists and craftsmen, with very few exceptions, changed little until the late eighteenth century and the

9. See Wittkower and Wittkower, *Born under Saturn*, 8.

10. Ibid., 4.

11. See ibid., 3. The addition of geometry and anatomy to academic studies of art in the late sixteenth century in Italy may also relate to this attempt; see Kristeller, "Modern System of the Arts," part 2, 514.

12. For a general discussion of writings on art theory and the rise in status of artists, see Wittkower and Wittkower, *Born under Saturn*, 2–7, and Plutarch in Pollitt, *Art of Ancient Greece*, 227; for Polykleitos see Pollitt, *Art and Experience*, 75–79, 105–8, and for Apelles see Pollitt, *Art of Ancient Greece*, 158–63.

burgeoning of the Industrial Revolution. Before then, the difficulty for craft and all the visual arts arose from the fact that they involved the creation of real, tangible objects through the manipulation of physical material with manual skill; though the making of skilled works retained a sense of wonder, apparently the physical labor over material that they involved was too much like that of the common tradesmen with whom they were associated for craftsmen and fine artists to transcend class barriers.

In order to change the perception of their work and to raise their status, artists in the Renaissance tried to dissociate themselves from the notion of workmanship as a strictly physical labor by stressing the intellectual elements that their art entailed. Leonardo da Vinci, in an effort to raise the prestige of painting to the level enjoyed by literature and poetry, argued that painting was a science and that painters rely on the liberal art of mathematics in order to create perspectival space. And to suggest painting was a gentlemanly activity rather than a dirty trade he pointed out that painters work in quiet solitude, remain clean, and can even paint accompanied by music; in short, he argued painting is a learned, intellectual, and refined activity much like the writing of poetry. To emphasize this, Leonardo pointed out that sculpture demanded brute manual skill, that it was a noisy, dirty occupation requiring a great deal of brawn and crude physical power much in the manner of the common trades; it did not rely on intellectual acumen.[13]

Clearly the gap that Leonardo's remarks underscore was not between craft and fine art, but between the high status given the literary arts as opposed to the lowly status accorded all the visual arts, including craft.[14] Embedded in Leonardo's arguments, as well as those of other artists such as Leon Battista Alberti and Giorgio Vasari, though not very deeply, are issues of class, both economic and social. Those professions and artistic genres with the highest status were the so-called "learned professions" including mathematics, literature, and poetry. To enter one

13. For Leonardo's comments and those of Benedetto Varchi, who tried to resolve the conflict between painters and sculptors, see Blunt, *Artistic Theory in Italy*, 48–55. As early as 1450 in his *De Re Aedificatoria*, Leon Battista Alberti argues that architects as well as painters need to be well educated, particularly in history, poetry, and mathematics (for his remarks see Blunt, *Artistic Theory in Italy*, 10).

14. As Anthony Blunt points out, as late as the 1490s, Pinturicchio omits painting and sculpture from the frescoes of the liberal arts he painted in the Borgia apartments in the Vatican. Ibid., 48.

of these professions required education. But education was reserved for the wealthy and the upper classes since there was no system of public education as we know it. With the exception of some religious orders, only the wealthy could afford the schooling necessary for their children to learn the literary arts. Thus being able to participate in the literary arts was a sign of one's upper-class standing. By contrast, craftsmen and fine artists, like tradesmen, learned by working in the apprenticeship system, a practice that continued for crafts well into the mid-twentieth century. For these reasons, their very professions relegated craftsmen and fine artists to the lower social and economic standings in society. This is why Leonardo insisted painting was a learned and gentile profession and it is also why Michelangelo proudly wrote sonnets.[15]

However, in attempting to show that the painter was not a tradesman but an intellectual and therefore painting a noble endeavor deserving of equality with the literary arts, Leonardo began a process in which manual skill would be almost entirely subordinated to intellectual ability (this process came to full fruition in the modern period of industrial production). Since manual skill is the basis of craftsmanship, his argument, directly and indirectly, denigrated crafts as well as sculpture, sculpture being that fine art which most closely resembles craft in its three-dimensionality and its physically demanding procedures.

The struggle for higher-class status for visual artists is also reflected in the origin of the art academy. The use of the term "academy" for organizations of fine artists, instead of "*arti*" as guilds were called in Italy, first began in the early 1560s in Florence; it was officially sanctioned in 1563 by the Medici government through the personal influence of Florentine painter and art historian Giorgio Vasari. This first academy was a calculated attempt to garner the intellectual prestige of the literary associations of the time since these associations called themselves "academies."[16] The idea of an art academy also had the more practical

15. Leonardo's argument was part of a general trend in which painting was elevated by being related to poetry. Horace's famous simile from ancient Rome, *ut pictura poesis*—"as is painting so is poetry"—came to be understood by Renaissance painters to mean "as is poetry so is painting," in much the same way *ars poetica* became *ars pictoria*. See Lee, *Ut Pictura Poesis*, 3 and 7, respectively.

16. See Barzman, "The Florentine '*Accademia del Disegno*,'" 14. A forerunner of Vasari's academy is the so-called Platonic Academy sponsored under the influence of Cosimo and Lorenzo de Medici in Florence during the last quarter of the fifteenth

purpose of liberating painters and sculptors from the restrictions of the craft or trade guilds to which they had been bound by tradition. This is why Vasari called his artist's society the Accademia del Disegno, just as he had referred to painting, sculpture, and architecture as the *arti del disegno* in his *Lives of the Artists*.[17] Under the traditional guild system skilled makers were tied to their materials. This is why painters were grouped with glass makers, gilders, wood carvers, cabinet makers, etc., while sculptors and architects were organized with stonemasons and bricklayers.[18] With the institution of art academies, visual artists were effectively liberated from the authority of the trade guilds and, unlike craftsmen, freed from their strict identification with material. Vasari admits as much in the introduction to the second edition of his *Lives of the Artists* (1568) where he says artists trained in *disegno* are able to work in any medium. Likewise in France, the foundation in 1648 of the Académie Royale de Peinture et Sculpture as a "free society" meant it was protected from the regulations of the guilds who still controlled skilled work.[19] As this occurred, fine art became separated from the crafts in other ways, as the prestige in which the skilled hand, workmanship, and craftsmanship had been held continued to fade as fine art increasingly promoted itself as primarily an intellectually centered activity.[20]

After fine art left the trade guilds and guilds eventually became trade unions, jewelry, stained glass, and most other nonconstruction activities were left alone and eventually coalesced around the idea of crafts as any object-making activity demanding a great deal of technical knowl-

century; it is at this "academy" that Michelangelo is said to have learned about Neo-Platonism; see Blunt, *Artistic Theory In Italy*, 20.

17. See Kristeller, "Modern System of the Arts," part 2, 514. The full title of Vasari's 1550 book is *The Lives of the Most Excellent Painters, Sculptors, and Architects*.

18. See Wittkower and Wittkower, *Born under Saturn*, 9.

19. In France, unlike Italy, once the Académie is established as independent of the guilds it soon comes under the control of the crown. See Hauser, *Social History of Art*, 2:194ff.

20. The extent of this shift is reflected in Whistler's remarks during the 1878 trial in which he sued John Ruskin for libel over the latter's criticism of Whistler's painting *Nocturne in Blue and Silver*; when Whistler said it took him two days to paint the picture, the defense lawyer asked if 200 guineas was not too much to charge for only two days' work. Whistler replied: "No; I ask it for the knowledge of a lifetime." See Gaunt, *Aesthetic Adventure*, 90.

edge and technical manual skill in the working of material. This has reinforced the notion that the results of any and all such activities are basically the same, that is to say, they are all craft. This is a notion that, as I have shown, is simply mistaken.

While the intentional promotion of fine art as a liberal art was done to raise the status of the artist rather than demote that of the craftsman, it initiated a separation between the way fine art and craft were viewed that was to become more extreme in the next centuries. For what started out as a distinction based on the exertion of brute force, as opposed to refined manual skill, eventually came to be simply a distinction between manual and nonmanual, a distinction in which the manual was stripped of all intellectual resonance and the intellectual severed of all manual ties. Eventually, the link between "hand and mind" and "mind and hand" that had been at the center of all visual art production was dismissed as irrelevant or nonexistent. This is probably the main reason why many fine artists assume that craft has no intellectual basis.

Theoretical support was given to this distinction in the late eighteenth century when the issue of beauty and the concept of "the aesthetic" began to enter modern philosophical discourse about the arts, especially as proposed by Kant, who notionally linked the concept of the aesthetic to that of beauty. The ultimate effect was to formalize the separation not only between fine art and craft, but also between all functional objects; it did this by classifying objects as either useful or nonuseful, as either with or without practical purpose. In this scenario, as Kant argues in his "Analytic of the Beautiful," published in 1790 as part of his *Critique of Judgment*, only the nonuseful is deemed capable of being judged beautiful. "*Beauty*," writes Kant, "is the form of *purposiveness* in an object so far as this form is perceived in it *without the concept of a purpose*." And he goes on to say that "there are things in which we perceive purposive form without recognizing their purpose, such as stone instruments with a hole as if for a haft . . . and although they clearly betray by their shape a purposiveness for which no purpose is known, yet this purposiveness without purpose does not cause us to declare them to be beautiful. However, we do regard them as artifacts; and this suffices to force us to admit that we relate their shape to some intention or other and to a definite purpose."[21] In writing this, Kant was

21. Kant, *Analytic of the Beautiful*, 45, including n41 (italics added).

echoing what Leonardo had said two centuries earlier, "*utilizzia non puo essere bellezza*" ("utility cannot be beauty").[22]

Kant's division of the world of the man-made into two large but unequal classes comprising the useful and the nonuseful gained widespread intellectual support despite the obvious inconsistencies that arose, architecture being the clearest example. Even Janson repeats this inconsistency, which he then accepts, when he argues that architecture may be an applied art, but "it is also a major art (as against the others, which are often called the 'minor arts.')"[23]

In the years that followed, as industrial production increased, the adjective "fine" was added to the word "art" to become "fine art" so a distinction could be made between the mechanical or useful arts, between "those in which hands and body are more concerned than the mind" and the fine arts, "those in which the mind and imagination are chiefly concerned." The word "fine" now referred not to delicate or highly skilled or refined arts, but the "beautiful" arts. By the early nineteenth century the term "fine art" continued to refer to the beautiful arts but began to be used specifically to identify painting, engraving, sculpture, and architecture. Eventually it would be used interchangeably with "art" and still retain its meaning to this day.[24] Craft, on the other hand, continued to be associated with skills centered on "hands and body" as opposed to "mind and imagination." From here it was a short step to identifying craft as the "minor" or "decorative" arts.

It is out of these historical circumstances that the pitting of craft against fine art has developed, sometimes surfacing as heated debates about status and critical value, usually with a monetary subtext. Unfortunately, as the historical circumstances make clear, this dichotomy developed more from the desire of fine artists, first in the Hellenistic

22. Leonardo as quoted in Panofsky, *Meaning in the Visual Arts*, 13n10. Leonardo's assumption that the beautiful and the aesthetic are the same, as many later philosophers accept, is debatable. While his *Mona Lisa* may be considered both a beautiful painting and arguably a beautiful subject, the same cannot be said of his now lost fresco *The Battle of Anghiari*, which he began for Florence's city hall but supposedly never finished; from the extant drawings, in the fierceness of its subject and figures, it certainly was not beautiful in any conventional sense.

23. Janson, *History of Art*, 16.

24. For a discussion of this see "Art," *Compact Edition of the Oxford English Dictionary*, 117, and Collingwood, *Principles of Art*, 6.

world, then in the Renaissance, to attain the elevated status of a liberal art for their work than from any serious theoretical or conceptual disagreement with craft or even any theoretical understanding of craft. Even Kant's argument based on "purpose/nonpurpose" gives little consideration to the fact that there is a wide range of purposeful objects in the world or that, as Pye observes, people have always done much "useless work on useful things."[25] Moreover, Kant's argument also poses questions for fine art. One has only to remember Duchamp's *Fountain* (Figure 3); as a urinal it is a utilitarian, functional object of the most ordinary kind. How then can it belong to the class of fine art objects called sculpture?

Nonetheless, despite contradictions to the theory of fine art like that posed by Duchamp's *Fountain*, the argument for art based on Kant's "nonpurposiveness" continued and has had great influence on the terms and the manner in which theoretical and aesthetic judgments are made even today. Craft, rather than being discussed in its own right and on its own aesthetic terms and merits, is discussed in comparison to fine art. Today the useful/nonuseful distinction remains entrenched, allowing fine art theory to set the critical/aesthetic terms of debate for all the visual arts, including craft. And while craft has more than survived as an activity, making judgments in this way has taken a toll on our view of craft as an artistic, expressive endeavor, so much so that recent attempts to elevate the status of craft apparently are compelled to rely on the status of fine art to do so. As I have already noted, some craft advocates claim there is no difference between the two categories. Craft and fine art, they argue, are not separate entities. But as I have argued, in terms of their materiality and "thingness," craft and fine art are demonstrably different. I believe that it is because of these differences, not in spite of them, that craft can be an art form, an expressive, artistic endeavor in its own right with its own realm of meanings. Once one recognizes that aesthetic notions as they relate to fine art and craft are of only recent origin, uncritical acceptance of such views as being historically inevitable becomes less obligatory and alternatives more interesting.

25. Pye, *Nature and Aesthetics of Design*, 13.

AESTHETICS AND THE FUNCTION/ NONFUNCTION DICHOTOMY

■ ■ ■

Kant's arguments concerning the useful and the beautiful, though made 300 years ago, have become so ensconced in our thinking that whether an object can be judged aesthetic or expressive generally is dependent on its not having function. This is a belief that Kubler, writing in *The Shape of Time*, an important book published in 1962 and still in print forty years later, reiterates as he defers to Kant over Lodoli. "On this point," writes Kubler, "Lodoli anticipated the doctrinaire functionalists of our century [the twentieth] when he declared in the eighteenth century that only the necessary [i.e., the useful] is beautiful. Kant, however, more correctly said on the same point that the necessary cannot be judged beautiful, but only right or consistent."[1] So powerful has been Kant's declaration that the function/nonfunction dichotomy has become a kind of litmus test to separate art from non-art, in particular fine art from craft. What, we must ask, is the logic behind this belief that drives Kant to make such an unqualified, absolute statement?

Kant is speaking in such terms because he is constructing a philosophical argument about art and aesthetic properties based on abstract reasoning rather than on an engagement with actual art objects. Having lived his entire life in and

1. Both quotes from Kubler, *Shape of Time*, 16. The Lodoli referred to is Carlo Lodoli (1690–1761), a Franciscan monk from Venice who argued against the excesses of the Baroque and for a rationalized "design" whose form expressed its function. His pupils recorded and disseminated his ideas, especially in Florence.

near Königsberg in East Prussia, he was not a connoisseur of visual art in any real sense of the word; moreover, he couldn't have imagined craft as a concerted form of individual expression as it has existed for many centuries in non-Western societies and as it developed in the contemporary Studio Craft movement in the twentieth century. Nonetheless, Kant's view needs to be taken seriously because of its philosophical as well as historical importance.

Kant's assertion that a purposive object can only be judged "right or consistent" implies that all that can be said (judged) about such an object is how it carries out its function. This deduction is based on the premise that purposive objects are heteronomous. That is to say, they are objects subject to and governed by external rules and laws. As I have already shown, for craft objects the external rules are the demands of containing, covering, and supporting and the laws are the physical laws of matter as they relate to material and technique. The opposite of heteronomous objects are autonomous objects. Fine art objects are considered autonomous because they supposedly are not subject to laws dictated by some external source, such as the brute facts of nature of which we have spoken. Instead, they generate their own rules and conditions, rules and conditions made up by the artist in the very process of creating the work. It is in this sense that works of fine art can be said to be wholly self-contained and autonomous.[2]

Kant seems to envision the demands of function as so all-encompassing that no latitude is left for the free play of the maker's imagination; the maker is simply unable to manipulate the object's form for ends other than function. In this sense purposive/functional objects offer no option whatsoever to the maker for aesthetic expression—there is purpose/function and nothing else. Works of fine art, on the other hand, supposedly offer complete freedom of imagination to the maker—in the service of aesthetic expression they offer no formal or material requirements or limitations to the artist. Thus it seems the very possibility of making judgments about an object's expressive/aesthetic qualities, as opposed to just evaluating its "functionality," depends

2. The self-containedness and autonomy of works of fine art is more persuasive an argument when fine art objects are juxtaposed to purposive objects. But when scrutinized on their own, this argument is less convincing if, for nothing else, they are always subject to systems of signification which, as I already have noted, are always external to them.

on whether or not it allows the maker complete freedom to manipulate its form in the free play of the imagination. This appears to be the unstated crux of Kant's position regarding art and judgments of beauty,[3] a position that continues to remain influential. Gadamer repeated it in 1973, saying of the work of art that "it intends something, and yet it is not what it intends. It is not an *item of equipment determined by its utility*, as all such items or products of human work are."[4]

By these definitions, all purposive objects must be considered what I shall call deterministic objects—objects 100 percent determined in their physical characteristics by the demands of function. Such objects, and I agree with Kant on this, can only be identified and judged in cognitive and instrumental terms, which is to say, by their function and how well they carry out that function. In recent decades this premise has become the major theoretical factor separating fine art from craft, and for good reason. If the maker is deprived of choice, of free will in the making process, he or she also is denied any chance at expression; there is no possibility to freely and willfully "shape" the object so that it can be the bearer of the maker's intentions to artistic meaning. The resultant object can still have value, but meaning and value are not the same. All things that have meaning also have value, but all things that have value don't necessarily have meaning in the sense of being an intentional "utterance" by a human being to signify, to "communicate" something. To mean is to signify, and for an object to signify something, as opposed to just carrying out a physical function, two things must be present. One is that its formal demands must be such that they allow for manipulation on the part of the maker in the name of expression; and two, this allowance for expression must be intentionally exploited by the maker in a desire to express something. Otherwise the object will not be a bearer of meaning as a signifying sign. Consequently, not only must the object offer the possibility of meaning but, as German philosopher Edmund Husserl (1859–1938) argues, there must also be the intention

3. For Kant, freedom to choose is essential to his philosophy. As Isaiah Berlin notes, "Man is man, for Kant, only because he chooses. The differences between man and the rest of nature, whether animal or inanimate or vegetable, is that other things are under the law of causality, other things follow rigorously some kind of foreordained schema of cause and effect, whereas man is free to choose what he wishes." See Berlin, *Roots of Romanticism*, 69–70.

4. Gadamer, "Play of Art," 77 (italics added).

to mean. Intention to meaning is just as important as the possibility of meaning. This is why I believe there is a difference between just doing something such as mindless rote work and making a work of art.

It is in "Expression and Meaning," the first essay in volume 2 of his *Logical Investigations*, that Husserl explores the concept of sign in terms of meaning and intentional signification. As he notes, there is a difference between signs that indicate and signs that are expressive. Peggy Kamuf, in writing about this issue, notes that Husserl is "principally concerned with separating sign (*Zeichen*) in the sense of expression from sign in the other sense of indication. Only the former, he will argue, can be understood as a meaningful sign since the concept of meaning (*Bedeutung*) is reserved for the intention to mean. Indicative signs, on the other hand, signify but they are not themselves the bearers of an animating intention which infuses life into the body of signs."[5] The example she cites is that of gathering dark clouds. We know that dark clouds indicate an impending storm. However, they are not dark to warn of a storm; they are dark simply because moisture that makes up clouds blocks the passage of sunlight. Because of this, dark clouds can never be expressive or meaningful signs in the sense of wanting to tell us something. On the other hand, when an artist paints dark clouds in a painting, it is with the intention to express something. The fact that they are not real clouds betrays this intention and the viewer "reads" them as expressive, meaningful signs.

In this sense I agree with Husserl that meaning should be reserved solely for the intention to mean; it must always be the product of an animating, human intelligence and a will to signify.[6] Moreover, I believe

5. Kamuf, *Derrida Reader*, 6. Husserl's *Logical Investigations* was published in German in two volumes, the first appearing in 1900 and the second the following year. Husserl's concern with intention has a life outside philosophy that is extremely important to any civilized society. Whenever we speak of accidental fires as opposed to arson or manslaughter as opposed to homicide, we are making a distinction that hinges on intention, hence the often heard plea, "I didn't mean to do it."

6. In *The Shape of Time*, when Kubler notes that "purpose has no place in biology, but history has no meaning without it," he was referring to the fact that history is about volition, about the motivations of humans to action, whereas biology is not (see 8). Also, only writing that is concerned with human events and actions should properly be considered history; to write about biological, geological, cosmological, and all such developments and occurrences, because these developments and occur-

art to be a willful and intentional act of human expression, not something arbitrary or natural as in something from nature. Having said this, I would now like to address a couple of examples of meaning that seem to contradict what I have just said about intention. They are examples in which meaning apparently occurs without the artist's intention: one is so-called intuitive meaning and the other is so-called naive meaning. In art, the term "naive" implies a simplicity in rendering due to a lack of training or skill as in the work of children, folk artists, or "outsider" artists. So when we speak of naive art we are referring to a work's visual qualities. However, to equate the actual quality of rendering in such work with the intended level of rendering sought by the maker is a mistake. It is also a mistake to equate simplicity of rendering with depth of intentional meaning. Genuine naive artists intend to make work that looks like that of sophisticated artists, just as children intend to make work that looks like that of adults; both are only prevented from doing so by lack of ability. Moreover, as the example of children's art testifies, though they may be unsophisticated in their rendering capacities, they routinely attempt to express the deepest of emotions, including love and grief. Work intentionally made to appear naive is another matter. Such works adopt a pseudo-naive style as an intentional reaction against the polished realism of the academic tradition. Regardless of appearance, pseudo-naive works are extremely sophisticated in their rendering and intentions. If we have come to admire them as "honest" and "true," it is because this is what the artist has intended. They have been rendered in a naive style to reflect certain values of modernist culture, especially those that admonish the effete in favor of the supposed purity and directness of more "primitive" societies. But we need to be very careful because there is a great deal of difference between attributing certain values to a pseudo-naive work, for instance reading its flatness of space and skewed perspective as metaphors for primitivistic modernity itself, and attributing these same values to the formal traits found in genuinely naive work, as if such works were actually intended by the naive artist to carry the same metaphorical meaning.

As to the question of intuitive meaning, does it really occur outside the bounds of intention, as many modernist "primitives" contend? Are

rences lack volition, motivation, and intention, is to write a record of events. That's why we speak of a statistical, dendrochronological, or dental record.

we supposed to accept on face value, say, French *Fauve* artist Vlaminck's statement that "I try to paint with my heart and my loins, not bothering about style"?[7] I think not. For one thing, we know he was a serious student of art, especially that of Cézanne, and for another he carried on many discussions about art with his friend Henri Matisse. I think we can account for what seems like intuitive meaning by seeing it as the outcome of thoughts and ideas that are so internalized by the artist that they need not be articulated in an act separate from their enunciation in the work itself; it is like the motor memory skill of musicians, craftsmen, and artists like Pollock. This may be why artists often are reluctant to talk about their work—they don't want to articulate its meaning separate from the act of creation itself, perhaps for fear of stifling inspiration or because the articulation is in the act of creation.[8]

Now to return to our main subject, the role of intention in the creation of a meaningful object. Because craft objects are rooted in models in nature and their functional form is subject to the physical laws of matter, it seems they can only be viewed as indicative signs. But we must remember that craft objects are not actually nature the way a coconut shell or an animal's fur covering or a rock ledge is. Craft objects are still man-made objects, even if inspired by the conditions of containing, covering, and supporting that exist in nature. Taking advantage of these conditions as do animals when they go to the watering hole to drink is one thing. To conceptualize them as idea-concepts, then form-concepts related to function, and then, ultimately, to realize these conditions as objects through a *form*alization of physical material through technique is a willful, creative act of making and worlding. In short, craft objects are abstractions from nature given physical form through a human will and a human intellect. As such they should be understood as part nature and part culture. At the risk of getting ahead of ourselves, I think this is an extremely important point, and I want to stress it because this "part nature, part culture" makes craft objects distinctly different from works of fine art. As I have argued, works of fine art are all culture because embedded in socially determined signifying systems. But crafts

7. Vlaminck quoted in Chipp, *Theories of Modern Art*, 125.

8. The word "intuition" comes from the Latin "intueri," to look on; moreover, its German counterpart "anschauung," which is used by Kant, also connotes "insight," "perception," hardly meaningless, nonintentional qualities. See Angeles, *Dictionary of Philosophy*, 137.

straddle both sides of a line between nature and culture, at least in the sense that they are determined by nature but made by man.

Having said this about craft objects, we must also admit that man-made objects with an intention to do something, especially to carry out a physical function, are not the same as those made with an intention to signify something. Intention to signification and intention to function are vastly different. This is why Kant's deduction regarding purposive objects as heteronomous is so crucial for crafts. If natural laws make everything about craft objects predetermined, then we would have to admit that all craft objects deprive the maker of the possibility of the intention to meaning and therefore can only be like indicative signs. So the issue that must be addressed is whether or not having purposive function automatically makes all craft objects heteronomous. Do the external laws regarding function deprive the maker of the possibility of "shaping" the object's form for expressive ends? While it is doubtful we even live in a world in which there can be such absolutes like an autonomous object (one free of all external rules) and a heteronomous object (one completely bound by external rules), these questions must be addressed.

For Kant object and function are one and the same, so much so that he regards function as co-terminus with the object. He doesn't allow for judgments about how well a function may be carried out by an object to be considered separate from the physical object itself, from how it looks to the eye or feels in the hand or conforms to the body. There is no middle ground. But conflating object completely with function is to not see the object at all; it is to focus solely on the end, treating the object simply as an instrument, as a means to that end.[9] This may be appropriate to a tool, but it is not appropriate to an object that is an end in and of itself as are all craft objects.

Philosophically it can be argued that function can, in fact, determine an object to such an extent that it could be 100 percent determined by its function, what I have called a "deterministic object." With everything predetermined by functional requirements, nothing is left to the free

9. Martland reiterates this attitude when she says of the painter Brueghel that "before he began his 'action' he knew the end for which he worked and he had no need or room for the contribution of 'the thing wrought' other than bringing it into being." See her "Art and Craft," 234. This attitude goes back at least to Book X of Plato's *Republic*.

play of the maker's imagination—no choice about material, technique, form or anything else. Only an intention to fulfill purpose through function could exist in such an object so that it would preclude expression and preclude meaning, for, as Husserl notes, "the concept of meaning is reserved for the intention to mean." So we could conclude of such objects that *they may be functional and they may have value because of their functionality, but they are devoid of meaning; they signify nothing.*

Kant probably would agree that because of function our responses to craft objects can only be objective; they cannot be subjective and related to what he would call judgments of taste. To believe this of craft objects, however, is to conflate their form and function as if craft objects were actually deterministic. But are they? Consider three identical chairs (Figure 25). If someone paints one of these yellow and the other red, are they any less functional than the unpainted chair? And could we say that the yellow chair is more or less functional than the red chair? One may prefer the unpainted chair over either of the painted chairs, but this is a matter of personal preference, of subjective judgments of taste, not a quantitative and objective judgment of "right or consistent" performative function.

Since it is difficult to see how changing the color of a chair can alter its physical function, we would have to admit that color is not subject to pre-given laws, that color in craft objects is autonomous, subjective, and therefore expressive. Of course, one could argue that a change of color is too insignificant as an expressive act to refute the idea of absolutely separate categories of expressive/nonexpressive objects. But I don't think so because an object cannot be absolutely purposeful (100 percent determined by function) and also have expressive features. If it has expressive features, it cannot be deterministic because expressive features allow us to make subjective judgments of taste about the object—for example, "I prefer the yellow over the red because yellow is a more cheerful and Spring-like color." Such a statement is not about how "right or consistent" the object functions.[10]

10. One could argue the color of an object could function to keep the object cooler or warmer, depending on conditions and needs. One could also argue that color could help distinguish an object, say a basket carried into the field, from its surroundings so as not to get lost among the vegetation. However, this would apply to very specific situations and still would not dictate exactly which color was necessary,

However, for the sake of argument let's allow for color changes. In that case, in our example Kant's deduction would still hold. Yet shouldn't we also expect, following Kant, that all objects having the same function would look and be, if not exactly alike, at least extremely close since their form is supposedly being predetermined by their function? I think we would have to say yes. Let's take as examples a 3,500-year-old chair made during the New Kingdom in Egypt and now in the Louvre in Paris (Figure 26), one of John Dunnigan's 1990 *Slipper Chairs* in the Renwick Gallery in Washington, D.C. (Figure 27), and Mies van der Rohe's *Barcelona Chair* that he designed in 1929 for the German Pavilion at the International Exhibition in Barcelona (Figure 24). All three are recognizably chairs, though they were made thousands of years apart and in cultures vastly different in geography, climate, and political and social values. In fact, all three are so chairlike in their basic conception and structure that it is difficult not to regard them as sharing a family kinship. But this is not the same as saying they are exactly alike. Few people would not recognize that their forms, materials, and techniques are significantly different. These differences betray their cultural origins and are the basis of what is known as art historical style. Through a study of these styles, one not only can identify the Louvre chair as Egyptian, but more specifically as New Kingdom ca. 1570–1085 B.C., and if a significant enough number of chairs from this period existed it might even be possible to identify the "hands" of the different makers as well. Much the same can be said about Dunnigan's *Slipper Chairs* and Mies's *Barcelona Chair*. Such differences in style contradict the notion that functional objects, regardless of whether craft or design, are deterministic. These differences also undermine the philosophical proposition of absolutes embodied in the concepts of autonomous and heteronomous.

I suppose that one could argue that the different appearances of these chairs have to do with materials. The Egyptian chair maker didn't have steel as did Mies's chair maker. But this is to imply he would have made Mies's chair if he had had steel. John Dunnigan used wood as did the Egyptian chair maker and still did not make the Egyptian chair. Furthermore, since Dunnigan and Mies had both steel and wood to choose from, and since both made chairs that function perfectly well despite choos-

only one light or dark in value in the first instance and one that was different in the second so preferences would still be made.

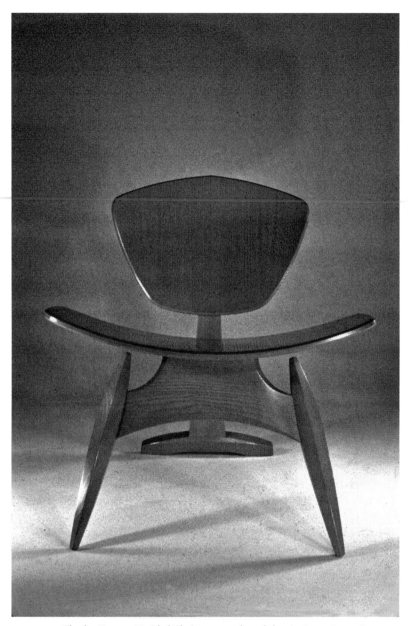

FIGURE 25. Charles Yaeger, *Untitled Chair*, 1994, ash, red dye (29″ × 20″ × 20″).
Photograph courtesy of the artist.

Since we don't want to violate the artist's original intentions, we will have to imagine
what this chair would look like in versions that are yellow and a natural-wood color.

FIGURE 26. Chair with blue legs, New Kingdom, ca. 1570–1085 B.C., Egypt, legs in the form of a lion's paw, back with incrustations of lotus flowers, wood and incrustations, paint (91 × 47.5 × 59 cm). Louvre, Paris, France. Photograph by Erich Lessing/Art Resource, N.Y.

FIGURE 27. John Dunningan, *Slipper Chairs*, 1990, purpleheart wood with silk upholstery (left: 26 ¾″ × 25 ½″ × 23″; right: 43 ½″ × 26 ¼″ × 24″). Gifts of the James Renwick Alliance (1995.52.1–2), Renwick Gallery of The Smithsonian American Art Museum, Washington, D.C.

ing different materials, the choice of material must have been made for nonfunctional reasons. Thus, clearly the maker of functional objects like chairs (whether crafted or designed) has a great deal of latitude in how they will look. This, of course, doesn't answer the question of why wood or steel was chosen, only that the option to choose one or the other existed. In both cases the choice had to do with preference. But in our examples preference is not simply an arbitrary or mindless decision; it is a decision founded on a desire for signification, which is another way of saying on an intention to meaning. Since all three chairs function, ultimately their different materials and outward forms are not functionally driven but are sociologically and culturally driven. What this means is that differences in outward form spring from social requirements, from the need for outward form to be charged with signification so that the object, rather than being a "mere" thing, can take its place within a

social system of meaningful signs. This is why all three are chairs and yet all three are also very different. Their differences are responses to expectations that the way they fulfill their physical requirements also express the social (artistic) dynamics of their age;[11] like Streamlined objects in the 1920s and 1930s, they are required to have a sign value as well as a function value.

When we look at craft objects from different societies, not just those of the three chairs in our example, it is clear they all share common formal traits, what we would identify as functional form. It is also clear they have formal differences, these we would identify as their different stylistic forms or styles. Style or stylistic form in craft objects always exists along with functional form; but unlike functional form, stylistic form springs from the realm of culture and the intention to meaning, to signification. Moreover, because craft objects are an embodiment of both functional form and stylistic form, they must be understood as having a life as both physical objects and as social objects. They must be understood as objects having an existence as actual, tangible things that springs from their rootedness in nature, and as objects having an existence as semiotic signs that springs from their rootedness in a social system of cultural style. It is through their style that they participate in the signifying system that is the aesthetic, the artistic. In this sense, craft objects are related to fine art in that both have a social existence as aesthetic objects. Yet craft objects are different from works of fine art because of their rootedness in nature. It is this rootedness that makes them special because it means they are both nature and culture. In this sense, and it is an important sense, they occupy a unique position in the world of man-made objects because they bridge the gulf between the world of nature and that of culture. They straddle the line between the two, partaking of both.

11. These distinctions are not unlike those found in works of fine art, say portraits from different periods such as the Renaissance and the Baroque; all are recognizably portraits and yet all are recognizably different.

KANT AND PURPOSE IN FINE ART

■ ■ ■

It is my contention that how something functions and how something looks is not the same proposition. It may be proper to ignore the relationship that physical form and physical function have to social form and social function, as Kant does when referring to tools and equipment (his example is a stone ax or hammer missing its handle), because such things are primarily constructed as mere functional objects; they aren't necessarily intended to have a vibrant social/aesthetic life. But as I have shown, craft objects are a class separate from tools and machines. Furthermore, from the historical and prehistorical record, it is clear that there have always been craft objects that were intended to be more than just functional, that people have always expended a great deal of useless work on useful things. As our example of chairs indicates, it has been possible for people to do this because craft objects allow for great formal latitude in meeting their functional requirements.

The latitude inherent to craft objects is apparent from the variety of materials, techniques, and forms that can be used to make containers, covers, and supports. It is also apparent from the many different styles of craft objects that have been created over the centuries—Egyptian New Kingdom style and John Dunnigan's contemporary Studio Craft style are but two examples among many (Figures 26 and 27). Such diversity alone argues for craft as an enterprise concerned as much with expression as with function. For unlike tools and machines, the historical differences in the outward forms of craft objects cannot be attributed primarily to improved

function. Material and technological developments may change tools and machines as function is improved, but with true craft objects, such developments tend to alter production methods and lower costs, but seldom do they improve function—our New Kingdom chair functions just as well as Dunnigan's contemporary chairs made many thousands of years later.[1] With craft objects change is usually a result of factors extraneous to function such as cost and expressive intention.

If craft objects are purposive objects that still allow for expressive manipulation of form without disrupting function, then they cannot be considered heteronomous, deterministic objects. This throws into question Kant's contention that purposive objects can only be judged "right or consistent," that in them form strictly follows function. But what about works of fine art: are they autonomous objects, as Kant implies when he opposes them to purposive objects? Are they, in fact, totally free of strictures of any kind and subject solely to their own internal laws so as to allow for the unbounded free play of the imagination of the maker? This view had strong support in the twentieth century; it was endorsed early on by British aestheticians Roger Fry and Clive Bell, who argued that the formal properties of the work of art were all the artist need consider; Bell called this "significant form" and Fry referred to it as "aesthetic unity" found in the "rediscovery of the principles of structural design and harmony."[2] Around the middle of the century American critic Clement Greenberg championed a similar view and even cited Kant's ideas as the basis for what became know as Greenberg's formalist theory of art.[3] Clearly Kant's view is important, because it still resonates in the world of contemporary art theory; it is also important for our discussion because it demarcates the function/nonfunction line from the opposite side, that of fine art, and thereby defines fine art as craft's opposite. Craft is purposive, fine art is not; craft is functional, fine art is not.

Though works of fine art are not instrumental because they lack practical, physical function, they do have purpose. As I have said, purpose

1. Often with disposable containers, covers, and supports, cost/production factors dictate appearance; but this is more a feature of commercial "culture" geared to price and convenience than traditional craft culture.

2. See Bell, *Art*, 177, and Fry, *Vision and Design*, 12.

3. For a cogent view of Greenberg's theory see his essay "Modernist Painting," in Risatti, *Postmodern Perspectives*, 12–19.

in fine art is communicative in the sense that something is "communicated" to the beholder—whether an idea, feeling, expression, emotion, does not matter. But just because their purpose is not instrumental in the physical sense, does it follow as Kant contends that they are also totally free, so free that there is, in fact, no normative ground against which fine artists are obliged to operate? Are fine artists free to manipulate formal elements in whatever way they choose and still be able to "communicate" as Bell, Fry, and Greenberg suggest? I firmly believe that this is not the case, nor has it ever been.

If "communication" (however one wishes to define it) is an essential aspect of the work of fine art, as I believe it to be, then the idea that artists freely make their own rules is thrown into question. For fulfilling communication's demands automatically places strictures on the fine artist because all fine art must operate as a sign within a system of signs. And in order for art's signs to communicate, fine artists are obliged to follow the rules of the system in which these signs exist, just as do the speakers of any language. Whether one speaks English or French, Swahili or Nahuatl, Korean or Russian, all languages, as communication systems, have a syntactical, grammatical structure that must be followed. Ignorance of this system is like trying to communicate in a language we do not understand, something that often leads the frustrated tourist to resort to a pantomime of facial and hand signals.[4] This is not to say that one is bound by language as in a prison house; one can "push," "pull," and "stretch" a language system; but one must always operate from *within* a shared language system for communication to take place.

If the fine artist does not follow an established system of signs, his or her work simply will not be able to communicate. Thus, the fine artist has no choice but to embrace a system and work from within its language of signs. In other words, the artist's symbol-making power, like the form-making power of the craftsman (in terms of both craft's physical and social function), is always tied to a community's symbol-making traditions and conventions.

4. We often resort to pantomime because it seems a universal language. Smiles and frowns may be pantomime, but not all hand signals are: many are culturally specific and must be learned. For example, repeatedly cupping the fingers in one's palm indicates "come here" to an American; to an Italian it means the opposite, "goodbye."

Obviously the signifying system of fine art is visually based, being made up, as I have said, of symbolic, indexical, and iconic signs. In the West, fine art has traditionally been based on visual appearance through iconic signs that resemble things in nature.[5] In this way, visual appearance of the natural, even if made fantastic, is a crucial part of the normative ground to which Western fine art has been tied, from prehistoric cave art to the beginning of the modern period, and only by being made to adhere to this system can signs be constructed that signify. In this sense, not only do fine artists follow tradition in the form of genres (for example "landscape," "portrait," "still life," "Madonna and Child"), but from the Renaissance onward such genres have had the requirement of closely resembling in physical appearance the subject. In religious works strict canonical rules based on religious dogma, beliefs, and tradition also have had to be adhered to. The fine artist has no choice in doing this if the work is to communicate.

Social structures and sign systems do change over time, just as languages change—Shakespeare's English is no longer our English. When this happens, the signifying systems that underlie meaning in fine art, that make meaning possible, also change. Renaissance Italy was so different from twentieth-century America that to Leonardo da Vinci and Michelangelo the abstract paintings of Jackson Pollock or his contemporary, Barnett Newman, would have been incomprehensible and meaningless, as would the works of Andy Warhol and many works of today's twenty-first-century artists. Furthermore, neither Leonardo nor Michelangelo could have made such work. Not because they couldn't drip and fling paint in the manner of Pollock or paint large monochromatic fields of color in the manner of Newman or execute cartoonlike imagery in the manner of the Japanese anime artists; they couldn't do it because the sign systems in which such works signify was not the system in which Renaissance artists operated. Leonardo and Michelangelo understood, as do all artists, that for something to be a sign and signify, to actually mean something to an audience, it must be part of a signifying system that both maker and viewer share. This is why, if one discovered a monochromatic canvas in Leonardo's studio, it would make no

5. As Arthur C. Danto observes, "Opticality penetrates our consciousness of art so deeply that we perhaps have no access to . . . [non-Western arts] save through our eyes." See Danto's "Art and Artifact in Africa," 111.

sense whatsoever to consider it an early abstract work of art rather than a blank canvas awaiting the artist's brush.

It is reasonable to conclude that every system of signification, including that which supports fine art, is a controlling or regulating agent. What the fine artist and craft artist are free to do is "push," "pull," and "stretch" its rules; to manipulate the structure given them by their society for aesthetic, expressive ends; what they are not free to do, if they wish to communicate, is totally abandon the system. In short, the freedom given the artist (like that given to the rest of us) is always within limits, never total.

In light of these arguments, Kant's contention that purposive objects, including craft objects, can only be judged "right or consistent," never beautiful, is questionable from two fronts. First, it implies fine art is autonomous and in its autonomy is subject only to its own rules with no external strictures whatsoever impinging upon it; it implies the fine artist has free play of the imagination to do whatever he or she wishes. This, it seems, is Kant's standard of possibilities necessary for something to be art and for art to be made, a standard reflected in his view of purposive objects.[6] On the second front, to argue purposive objects can only be judged "right or consistent" is to believe they are completely predetermined by function, that in them form is strictly a determinant of function.

Neither the first nor the second contention reflects the world in which we live and in which works of fine art and craft are made. While the twentieth-century slogan "form follows function" evokes a world in which function takes absolute precedence over form, supposedly giving us, in the process, perfectly "engineered/ functional" buildings, vehicles, appliances, and machines, the reality is something else, as we have already seen in the case of Streamlining. Despite slogans to the contrary, form continues to be given a great deal of expressive consideration in the making of functional objects, just as it has always been. Because of this, the creation of form in functional objects, whether made by machine or by hand, should be seen as a two-pronged affair having both functional and social requirements. Both requirements af-

6. Kant himself seems to qualify this when he says that judgments of taste covering the beautiful are determined through the imagination in harmony with reason. "Reason" is the key word and it seems to me to apply regardless of whether it refers to instrumental or ideological/social purpose. See Kant's *Analytic of the Beautiful*, 65.

fect the object's appearance; one affects its function-value and the other its sign-value. As art historian Erwin Panofsky noted already in the middle of the last century, "We now less often have houses and furniture functionalized by engineers, than automobiles and railroad trains de-functionalized by designers."[7] What he realized was that how something looks is as important, sometimes even more so, than how it functions. As an example of this, we can look to the 1920s and 1930s when the impulse toward "functionalism" was so powerful that, as Panofsky noted, for things to look as if they functioned efficiently, say aerodynamically, often was of greater importance than whether or not they actually were efficient. Again we can look at the style known as Streamlining; it evolved to make functional objects *express* aerodynamic function. This was done by simply giving an aerodynamic look to functional and nonfunctional objects alike, even craft objects. In this way Streamlining became a semiotic sign, a visual style-symbol given to objects to have them express aerodynamicity without their necessarily being or needing to be aerodynamic. Immobile objects such as toasters and buildings were Streamlined to resist air pressure; some buildings in the 1930s were even Streamlined in the manner of ocean liners. Streamlining style transformed functionality into a sign in a language system, one that overruled actual functionality as a property inherent in an object's ability to perform a physical function.[8]

This "de-functionalizing" tendency that Panofsky identifies is an exemplary indication that functional objects are subject to and capable of more than just function, that in them form does not strictly follow function; it is an indication that there are nonfunctional forces that affect the way functional objects look. This applies equally to craft objects as well as to functional objects that are machine-made. So, the question of whether or not something is art cannot be reduced, as Kant implies, to a simple either/or case of its being functional and therefore completely without expressive possibilities *or* being nonfunctional and therefore

7. See Panofsky, *Meaning in the Visual Arts*, 13.

8. Ibid., 13n10. Important designers in America connected to Streamlining include Harvey Earl, head of General Motor's Styling Section; Norman Bel Geddes, who began as a stage designer, also worked for G.M., and designed sleek, organic, and futuristic objects; and Raymond Loewy, who began as a display designer and redesigned everything from household appliances to locomotives. For more on this see Heskett, *Industrial Design*.

free to be completely expressive. Like the sign system that is the "language" of fine art, material functionality is the ground within which the craftsman must work. It too is not a prison house; one can "push," "pull," and "stretch" it so that the craft object can move into the realm of expression while still retaining its function, so that the intention to mean can be realized by the maker through the object's social dimension as a sign.[9] With this in mind I would now like to examine those features of craft objects that move beyond the realm of function and into the realm of signification.

9. To reiterate, signs automatically presuppose a system of rules and structures. There can be no meaning without given rules and structures. Clouds painted dark can only have expressive meaning if one already knows in nature such clouds portend rain. Furthermore, to people in the Saharan desert they may not have the exact same meaning/significance as they do for people in the British Isles, where rain clouds appear frequently.

FINE CRAFT, FINE ART, FINE DESIGN

■ ■ ■

The use of post-Enlightenment aesthetic theory to separate fine art from craft along strictly functional/nonfunctional lines is a very neat, even tidy proposition. However, one problem with identifying art, whether fine or not, by the absence of function is that not all objects absent function are actually art objects. Another problem is that it imagines the world of man-made things as simply a binary opposition between purely functional objects with no aesthetic qualities and strictly nonfunctional objects that are completely given over to the aesthetic.[1] And finally, inherent in this approach is the presumption that man-made things can actually be

1. In reality, there are many objects in the design field that are given over to the ideology of industrial mass production, objects that are purely commercial objects of desire. How to avoid making such objects goes to the heart of the Anti-Design or Radical Design movement in Italy during the 1960s. Radical Italian designers, as Penny Sparke notes, believed it was the responsibility of the designer "to work towards humanitarian rather than economic ends, and to use their creative powers to improve the quality of life rather than simply assisting in the inevitability of the capital-accumulating process" (see her *An Introduction to Design and Culture*, 200). It is in this light that Ettore Sottsass, so-called father of Italian Radical Design and associate of the Radical Milanese design studio Studio Memphis, said, "I just thought that if there was any point in designing objects, it was to be found in helping people live somehow, I mean in helping people to somehow recognize and free themselves." Sottsass as quoted in Sparke, *Ettore Sottsass Jnr*, 63.

separated into two such groups—the purely aesthetic on the one hand and the strictly non-aesthetic on the other.

Considering what we have noted in our example of chairs, one can't presume craft objects are strictly functional, that nothing about them exists in excess of their function—not their form, not their weight, not their materials, not their texture, perhaps not even their color. Surely such deterministically functional objects could never exist outside of a Platonic world of pure concepts. What this means is that even if it is easy to identify things that are strictly nonfunctional, it is not so easy to imagine, much less identify, things that are purely functional. So in reality, unless we have a deterministic/purely functional object, every functional object will have nonfunctional features. The question then is, "What is the nature of these features and how do they co-exist within functional form?"

Throughout this study I have made much about the idea that intention be a determining factor in understanding objects. I have argued that intention tells us a great deal about an object—why it is made and why it has a certain physical form. If we ignore intention and base understanding on use, we could argue, for instance, that paintings are physically functional objects because they can be used as "stepping stones" in a muddy garden or to cover holes in walls. We would then have to conclude that no nonfunctional objects exist, for surely every object can be put to some use or other, even if only as a doorstop or paperweight. Intention not only prevents us from the pitfall in which all objects end up being the same, but also helps explain why objects are made the way they are.

However, intention also forces us to question whether the nonfunctional features found in functional objects are actually intentional or features that simply have "seeped" into the object unbeknownst to the maker. This, I believe, is an extremely important question because it shifts the discussion away from the function/nonfunction dichotomy as a litmus test for art and moves it toward the more pertinent and fruitful question: "What is the role of nonfunctional features in all objects, functional and nonfunctional alike?" As David Pye correctly pointed out, in almost all craft objects, the quality of workmanship far exceeds the necessary requirements to make functional the object in question. "Whenever humans design and make a useful thing," says Pye, "they invariably expend a good deal of unnecessary and easily avoidable work

on it which contributes nothing to its usefulness." People have always, says Pye, done "useless work on useful things."[2]

Unless we believe a Platonic world of ideal forms exists on earth, we must acknowledge that, in varying degrees, all functional objects possess nonfunctional features. And if these nonfunctional features are not accidental but *intentional*, they must be understood as being in the service of the aesthetic. How else could we describe the "useless" work done on useful things? This means aesthetic qualities also are available to the maker of functional objects to exploit in the service of artistic expression. It also means, and I think this extremely important, that it is possible for all kinds of objects to be works of art, not just those that are nonfunctional like paintings and sculptures.[3] The only thing that is required is for the object to possess sufficient aesthetic qualities marshaled by the maker in the service of artistic expression.

Given this conclusion, even though the binary division nonfunction/function may help us separate fine art from craft, it doesn't help in what must now be recognized as the real problem, how to distinguish between aesthetic and non-aesthetic objects; that is to say, between art and non-art, an especially difficult problem given that most objects, even non-aesthetic (non-art) objects, possess aesthetic qualities. How can we conceptualize and define true aesthetic/art objects so as to separate them from objects which have aesthetic qualities but are not actually aesthetic/art objects? Consider, for instance, the elaborate engraving often found on tools and machines; it cannot be construed as enhancing practical function so it must be intended to enhance appearance, how it looks aesthetically. The same conclusion must be drawn from qualities that are not "applied" to surfaces of such objects but exist at a subtler level that includes the graceful shaping of tool handles and machine

2. Pye, *Nature and Aesthetics of Design*, 13.

3. Kubler himself notes that "human products always incorporate both utility and art in varying mixtures, and no object is conceivable without the admixture of both." See his *Shape of Time*, 14. We must recognize that some craft objects can be so rudimentary as to have few intentional nonfunctional features. And while we may interpret the lack of such features as aesthetically based—for instance, as expressions of the "primeval"—such an interpretation would not only be false to the object and to the maker, but would be like viewing the poor of London in aesthetic terms based on Dickens's characters; doing this would be to aestheticize their poverty.

parts, even the careful polishing of exposed metal.[4] These are surely intended to enhance the look, to be aesthetic. But are these features sufficiently expressive aesthetically to make such things works of art?

To answer this question I think we must imagine a spectrum with a gradient of objects on it. Kubler proposes such a gradient, but when he says "let us suppose a gradient between absolute utility and absolute art," it is clear his conception still reflects the traditional function versus nonfunction opposition. And while he admits that "the pure extremes are only in our imagination,"[5] I don't think, as an argument, it will do to suggest aesthetic qualities in functional objects are impure, tainted, even, because of their function, and therefore to imply the aesthetic qualities in nonfunctional (that is, in fine art) objects must be pure. First of all, I don't think there can be such a thing as an impure aesthetic quality; it either is or isn't an aesthetic quality. Benedetto Croce would even argue something either is or isn't art. But unlike Croce, I am making a distinction between having aesthetic qualities and actually being an aesthetic/art object.[6] Second, the argument that fine art is a pure aesthetic object is not very convincing. Not only have we shown that it must adhere to a sign system; but if it were pure it would ring clear in its purity for all to see without involving often acrimonious subjective decisions as is evident from the vast body of critical literature on fine art.[7]

4. One could argue the polishing of metal on chisels may, for instance, reduce rusting (something oiling would do better) and aid in cutting; but since polishing is not confined solely to cutting edges, it also must be seen as having a sign-value that goes along with its function-value (that is to say, tools that are well cared for connote a careful person, someone who has a respect for workmanship and materials; plus, they look better and are more welcoming to use).

5. Kubler, *Shape of Time*, 14.

6. For Croce, see his *Guide to Aesthetics*.

7. Of course, one could claim that critical arguments in the art magazines and journals are about the quality of works of art, how good or bad they are, not about whether or not they are works of art. But this argument, it seems to me, is not accurate. In his *Guide to Aesthetics*, Croce argues that there is no such thing as good art or bad art; it either is or it isn't art! I would agree to the extent that works universally condemned by critics as bad quickly drop out of existence as works of art; they disappear from view into closets, attics, or museum basements and are not talked or written about or exhibited. However, this still leaves a vast number of works that are argued over, being accepted by some critics and rejected by others.

Because of this, rather than Kubler's gradient of "absolute utility and absolute art," I propose one that goes from the completely non-aesthetic to the completely aesthetic. Even if it is unlikely that either end of such a spectrum can actually exist in reality, such a gradient is a useful conceptual framework as long as we understand not all objects on it possessing aesthetic qualities are aesthetic/art objects; as experience tells us, just possessing some aesthetic qualities is not enough to make an object art. What a gradient does is remind us that a way to distinguish between the aesthetic/art object and the non-aesthetic/non-art object must be found, but that it can't be automatically based on function; it will have to entail subjective decisions made on an object by object basis — the vast amount of critical reviews in journals and magazines about the relative merits of claimants to art status already make a case for this in practice if not in theory.

This brings us back to the question, "If there are aesthetic and non-aesthetic objects, and non-aesthetic objects also possess aesthetic qualities, how do we distinguish between them?" Kubler tries to solve this problem by saying that "we are in the presence of a work of art when it has no preponderant instrumental use, and when its technical and rational foundations are not preeminent. When the technical organization or the rational order of a thing overwhelms our attention, it is an object of use." While this statement shifts the issue from the object to its reception by the viewer, where I think it should be, Kubler reverses himself and confuses the matter at the end of the paragraph by saying: "In short, a work of art is as useless as a tool is useful."[8] This, it seems to me, leaves little doubt as to his attitude toward the useful, an attitude that presumably excludes craft objects because of their functional base unless they can be disguised as something else, something less rational in order. If we use intention as a measure, we can, at least categorically, separate those intended by their makers to be aesthetic/art from those not so intended, regardless of whether or not "technical and rational foundations" are preeminent.[9] Intention to the aesthetic, I will argue,

8. Kubler, *Shape of Time*, 16.

9. It is worth noting that in Western museums many non-Western functional objects are displayed as aesthetic objects, including predynastic Egyptian pottery and African furniture. Such objects were originally viewed in the West as anthropological materials. Now they are considered art, even though the physical objects have not changed. This indicates a changed perception of them, especially in relation to

is just as important for understanding the object as art as the intention to fulfill physical function is for understanding the object in terms of purpose.

The class of objects called crafts and composed of the sets "containers," "covers," and "supports" can be refined by extending to them some of the implications embodied in the term "fine" as it has developed in reference to fine art. The adjective "fine" was added to the term "art" to establish fine art as a class apart from closely related objects that had many of the same salient features. Among the meanings of the word "fine," aside from refinement and delicacy of form, is "having a delicate, subtle quality," "subtle or sensitive in perception or discrimination," something "performed with extreme care and accuracy." As used in relation to art, it has a qualitative meaning that seems to have taken on categorical, perhaps circular, properties: it defines painting and sculpture as belonging to the class "art" and it implies that all the members of this class, all paintings and sculptures are of sufficient aesthetic quality to belong to this class. Of course the assurances implied by this classification are misleading since art critics are constantly making subjective assessments about which paintings and sculptures are good enough aesthetically to be considered fine art. Furthermore, as I have already argued, all works painted and sculpted are not only not examples of fine art; many are not even intended to be fine art. This doesn't mean they don't have features in common with fine art, though the term "fine" seems to imply a completely separate category of objects that is unique unto itself. For instance, in addition to being painted and sculpted, many works that are not intended to be fine art share with fine art the intention to communicate through visual means; often they also share in the same stylistic vocabulary as part of a visual language system.

If we consider the realm of man-made things, most can be divided into those whose purpose is served through physical/instrumental func-

function, a changed perception that inexplicably doesn't always extend to more recent craft objects. This changed perception is not based on any knowledge of the intentions of the non-Western makers to make aesthetic objects, but reflects the imposition of Western aesthetic values onto the objects, perhaps because of the theory of "aesthetic primitivism" so prevalent in the twentieth century. For more on this transformation from anthropological material to art, see Goldwater, *Primitivism in Modern Art*, especially Chapter 1.

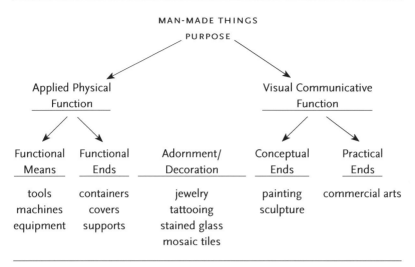

FIGURE 28. Diagram of man-made things #1.

tion and those whose purpose is served through a systematic vocabulary of visual signs, as in Figure 28.[10] Grouping fine art under "Visual Communicative Function" should make at least two things clear: one, that fine art is part of a larger class of visual objects, and two, that the term "fine art" is very restrictive and selective in order to separate the vast majority of visual images, including commercial art, from ones deemed of sufficient aesthetic quality to actually be art. The continued employment of terms linked to art such as "graphic art," "art & design," "communication arts," "advertising art," and "industrial arts" betrays the close kinship fine art has to these more commercially oriented activities, a kinship so close that it is not always clear where to draw the line between them.[11]

10. I have not formally included jewelry in this diagram or the diagrams that follow for many of the reasons I explain in Chapter 2. Jewelry, like all ornament and decoration, doesn't stand alone as an independent, self-sufficient "thing," and it doesn't possess a sense of objecthood. If I were to include jewelry in this and the following diagrams, it would be as a separate category called something like "Adornment/Decoration," located between "Applied Physical Function" and "Visual Communicative Function," since it could be applied to objects in both of these categories.

11. The U.S. Congress stipulated a difference between fine and commercial art in the Visual Artists Rights Act of 1990, legislation that is related to the Berne Convention to which the United States began adhering in 1988. Excluded from the moral-

Such commercial activities began in earnest with the Industrial Revolution of the nineteenth century, not surprisingly, at the same time the term "fine art" began to be used. This supports my contention that the term was coined in response to these commercial industrial activities, specifically because they "looked" so much like art even though they lacked art's "higher" intention, motivation, and overall aesthetic quality. Use of the term "fine art" was a way to distance the tradition of so-called high art from these newly invented commercial activities. It was a way to separate a specific kind of visual image by referring to it as *refined* and beautiful. So even though the term "art" continued as an umbrella term for commercial and noncommercial activities alike, addition of the adjective "fine" established a separate category for what was deemed "serious" painting and sculpture; it became a way to separate work made with the intention to art from look-alike objects, objects that had a family resemblance but were primarily means to commercial ends.[12]

To clarify and extend the logic of this nomenclature, I propose that visual works that are not *refined* but are intended to serve commercial needs be called utilitarian, even though they may possess some aesthetic qualities. Just as there are painted and sculpted works that are simply vehicles of communication, there are craft objects that are intended to do little more than be simply and basically functional even

rights protection given to fine art and fine artists by the U.S. legislation are works "such as posters, maps, models, applied arts, motion pictures, or other audiovisual works, periodicals, databases, and art produced for primarily commercial purposes, such as advertising, packaging, or promotional material." See Cunard, "Moral Rights For Visual Artists," 6.

12. In discussing what he refers to as "language games" in the first part of his *Philosophical Investigations*, Wittgenstein proposes "family resemblances" as a way of identifying and grouping together activities that exhibit a network of overlapping similarities. Even though we can't define the concept "game," according to Wittgenstein, we still can recognize one and understand it—Wittgenstein cites the card game solitaire and wrestling. If we know how solitaire is played we would recognize someone playing a form of it. Similarly, once we understand art, we should be able to recognize it and distinguish its salient characteristics from things that are not art. When comparing commercial art to fine art, something more than just resemblance is needed. For art intention is essential and the term "fine" is used to make intention clear. For disagreements with Wittgenstein, see Mandelbaum, "Family Resemblances," 192–201.

though they too will possess some aesthetic qualities. This is not to say they are intended to be deterministic objects. Rather it is to say that despite displaying a high degree of workmanship that goes beyond the needs of function, what Pye called "useless work done on useful things," there are craft objects that are intended only to be handy and useful in a simple and practical way—nothing more and nothing less. Such objects display a humble dignity in the way they stand ready at hand to serve; so, despite undoubtedly possessing some aesthetic qualities, they will be called utilitarian craft. Along with such objects there are those made with an intention to do more; they are made with careful consideration given to aesthetic qualities. Such works shall be designated with the adjective "fine," as in "refined." Thus the term "fine craft" will be used analogous to the term "fine art" and will be reserved for craft objects that are intended from the outset to be special, to go aesthetically well beyond what is demanded by mere utilitarian function. Only those made by hand will be considered craft objects—the tradition of making by hand, after all, is the tradition of craft.[13]

Like craft objects, design objects also can be separated into fine and utilitarian, fine being those intended to be special because of their aesthetic qualities while those intended to simply serve everyday needs are utilitarian. Whether or not fine design objects are strictly the product of industrial production and made in large quantities for a mass market as are utilitarian design objects, they always embrace the concept of industrial production, which is inherent in the very nature of design. Thus along with fine art and fine craft, the existence of fine design objects must be recognized as a separate grouping. In this way a categorical and qualitative statement can be made about all three of these kinds of objects whose social requirements are intended to be as important as their functional requirements.[14]

13. The desire of craft to align itself with fine art is connected, in part, to the handmade in opposition to the machine-made; it must also be seen as an attempt to distance craft from design that has encroached on craft's traditional field of activity. Unfortunately, an alignment with fine art does not address design's role in industrial production's shifting attention away from craft and the hand.

14. One could use the term "Studio Craft" instead of "Fine Craft." Edward S. Cooke Jr. uses the term "studio furniture" to refer to furniture makers who maintain independent studio practices. This is a useful way to separate independent studio work from production furniture based on the concept of studio as opposed to the workshop or factory. However, for craft generally, it doesn't make a connection to

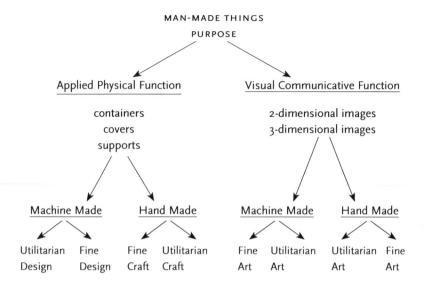

FIGURE 29. Diagram of man-made things #2.

The relationship between these various objects can be diagrammed as shown in Figure 29.[15] These two diagrams, seen in Figures 28 and 29, besides giving an idea of a basic relationship between the elements they display, are meant to emphasize two points. One is that fine art is part of a larger category, that of visually communicative imagery of which some is very commercial in purpose (graphic art, commercial design, billboards), some strictly informational (street signs, maps), some "communicative" in a deeper artistic, aesthetic sense.

The second point these diagrams (Figures 28 and 29) are meant to emphasize is that though fine craft and fine design objects are instrumentally functional, they also are very carefully and intentionally refined; they are the products of artists, not simple object makers. With fine craft, fine design, and fine art, this refinement is perhaps achieved in differing ways, but always with the idea that what the object intends is always more than what the object literally is or does. Borrowing the term "fine" from fine art and using it to refer to craft and design objects

aesthetic quality/purpose the way "fine" does by relating to fine art. For Cooke's discussion see his "Defining the Field," 8–11.

15. Photographs and prints are typical machine-made visual images that can be both fine and utilitarian.

of the highest artistic, aesthetic quality is to reserve a space for such objects and make it clear there are functional objects purposely intended to be aesthetic/expressive objects. I am talking about a functional object the aesthetic components of which are such that it is an aesthetic/expressive object in its own right; this is to say, it is an object intended to be a work of art. And I am including in this craft objects as well as design objects; both have the potential to be works of art if they possess the proper aesthetic qualities.

One final observation about the diagram featuring "fine" and "utilitarian" object (Figure 29): it makes it easier to understand why terms like "minor" and "low" came into use. As the Industrial Revolution progressed, visual images geared to commerce began to proliferate. Even though they were given primarily to commercial functions, making these images demanded most of the same skills demanded of fine art. But since commerce was not considered high purpose, to separate such images from their noncommercial kin, adjectives such as "high," "low," "minor," and "fine" were applied depending on the intention of the maker and of the nature of the work made. Eventually this resulted in a further debasement of skill as a valued artistic quality and of function. As this happened and function came to be viewed as little more than an instrument of commerce, commercial art and craft both were cast in a pejorative light; hence terms like "minor" or "low" art become commonplace. The "art for art's sake" attitude of Theophile Gautier, Baudelaire, and Flaubert in France and Whistler, Walter Pater, Oscar Wilde, and the English Aesthetic Movement of the mid- and late nineteenth century in England, with their insistence that art have no purpose other than providing an aesthetic experience (that it be art), can be seen, at least in part, as an extreme reaction against the growth of commercial and kitsch objects and their effect on established political, social, and cultural values.[16] Refinement of taste, even when dealing with craft objects, was a stance against commercial culture and against kitsch.

The use of the function/nonfunction dichotomy to separate art from non-art that has come down to us today is a remnant of this. It is not

16. The widespread concern about the *nouveau riche* and "moving beyond one's station in life" again raises class issues and is symptomatic of this and a society in flux because of the immense wealth middle-class industrialists made using the new commercial systems of production. That craft is not devalued in nonindustrialized/commercialized countries, even today, is not insignificant in this regard.

solely a philosophical edifice but has embedded within it social, political, cultural, and class values. Identifying categories of utilitarian craft and fine craft helps encourage examination of all objects of craft with greater sensitivity to their inherent values. It especially encourages appreciation of those craft objects intended from the outset to be of the highest artistic and aesthetic quality.

INTENTIONALITY, MEANING, AND THE AESTHETIC

■ ■ ■

Since the mere presence of aesthetic qualities in an object (whether functional or not) isn't sufficient to identify it as an aesthetic/art object, we are back to our question of how to identify and separate aesthetic/art objects from the vast array of non-aesthetic/non-art objects that exist in the world. One approach is to consider how important and how prominent aesthetic considerations were in generating the object in the first place. With functional objects, if function was literally the overwhelming concern of the maker, it is unlikely the resulting object would have sufficient qualities to transcend the realm of the utilitarian. With works whose purpose is communicative, if communication in the literal sense was the overwhelming concern of the maker, it also is unlikely the resultant work would be able to aesthetically transcend the realm of illustration. But if aesthetic concerns played a prominent enough role in an object's creation, it is then possible the object could transcend the mere utilitarian and become an aesthetic/art object. So, in theory and in practice, *any type of object offers the possibility of being an aesthetic/art object; it does not depend on material or medium nor on the presence or absence of function.*

While this opens up enormous possibilities for art, judgments about what is and what isn't a work of art still must be made. Such judgments should always begin by considering the intention of the maker in light of the object made. Intention is essential for art to come into being. Without the intention to make art, an object cannot be art; art status cannot simply be bestowed upon an object as Duchamp seems

to have attempted with his *Fountain* (Figure 3). Why is this? It is because art making is an expressive act of a human being, an utterance that is captured, embedded if you will, in the art object. Such an expressive act, as seen in the visual art object, can only occur as the result of a conscious, intentional act of making on the part of a maker.

As I have argued, understanding the difference between use and intention is crucial to an object's identity; intention goes to the heart of the made thing qua thing, but use needn't have anything at all to do with a made thing's *raison d'être*. Think of wood furniture: just because it can be used as firewood doesn't mean it is kindling. I would now like to extend the examination of intentionality to the realm of meaning by considering its philosophical implications as a deliberate act of making. As I have already noted, intentionality in this sense occupied Husserl in his *Logical Investigations*. Husserl made a point of separating indicative signs from expressive signs. His concern was less with signs per se than with signification and communication, with meaning and the intention to mean.[1] For Husserl, intentionality refers to the thesis that all consciousness is consciousness of objects—whether a physical object or an idea doesn't matter. He argues that just as one cannot have a thought about nothing, one cannot think, believe, wish, or hope without thinking of or believing in or wishing for or hoping for something: "I must think of something, I cannot think of nothing." Thus, "I *think* it might rain" or "I *hope* my car does not breakdown" or "I *wish* I would win the lottery" or "I *believe* in God." Furthermore, when the act of consciousness is creative, it transforms its object in a way that "thinking it might rain" or "hoping my car won't breakdown" does not.

From this Husserl concludes that Descartes's "*cogito ergo sum*" ("I think" or "I am thinking, therefore I am") is correct, but insufficient because it does not place enough emphasize upon the fact that "awareness is always implicated in a world of 'meanings' which is present to it whenever there is consciousness. The 'I think' can never be empty; it is always directed beyond itself (and beyond what is most immediately present, i.e., sensation) to an object." The act of consciousness (my

1. As French philosopher Mikel Dufrenne points out, "In order to know the meaning, one must know more than just the elements of the language and the system of their combination. What is signified is of a different order from that which does the signifying." See his *Language and Philosophy*, 32. For Gadamer on this same point, see his "Aesthetics and Hermeneutics," 96.

thinking) is the intentional act and the thing that I think is the intentional object. And when this intentional act is creative, it is also transformative in relation to its object.[2]

The philosophical concept of intentionality is instructive for fine craft and fine art when one realizes that just as the intentional "object" is the bearer of the thinker's thought, so too the thing the maker makes must be the bearer of the maker's thought. Thus Descartes's "*cogito ergo sum*" can be applied to *homo faber*, to man-the-maker, and be transposed into "*facio ergo sum*" ("I make" or "I am making, therefore I am"). However, it is not enough to understand "I make, therefore I am" as simply a Cartesian declaration of conscious existence; it must be understood in the expanded sense of a conscious, intentional act in which "to be a maker" means "I am making some*thing*." And just like the act of thinking, the act of making can never be empty; always it must be directed beyond itself to an intentional object; and more important for our discussion, when this act also is creative, it becomes an act that transforms its object.

In this sense, the maker of craft objects, just like the maker of any object, becomes a maker of a world, the maker of a cultural realm that stands apart from nature. However, all man-made objects make a world in the sense that they all separate nature from culture and therefore they are all the same; they are all not nature. Thus, the simple recognition that for *homo faber* the intentional object is always a man-made thing is not enough. We must also realize that intentionality, when understood as a creative act that transforms its object as in fine craft and fine art, automatically directs the maker to the question "What am I making?" and the beholder to the question "What am I beholding?" In terms of

2. For a brief discussion of Husserl's ideas about intentionality, see Velkley, "Edmund Husserl," 870–87, especially 876. The question of intentionality, particularly Husserl's conception of it, has become the basis of much of the writing of the French philosopher of deconstruction, Jacques Derrida. In *Of Grammatology* and *Speech and Phenomena*, Derrida has called into question Husserl's ideas about consciousness, signs, and an undifferentiated present. For Derrida the central question raised by Husserl is whether or not meaning is immediately present to consciousness through the sign, something Derrida doubts—he uses the word "*différance*" to stand for the category "difference/deferral" to express this doubt. Despite Derrida's position of doubt vis-à-vis signs, a position that is spelled out in a complex argument, for our purposes the gist of Husserl's argument about signs and intentionality is important as a way to look at what is and what isn't an aesthetic/art object.

art and craft it is a practical as well as a philosophical question because it deals with the relationship between the maker's thought (as a transformative act) and the physical form that that thought (as an intention) is given for the viewer to behold.

Furthermore, the viewer is always implicated in this situation because the "I" that is the artistic self, far from being isolated and alone, is always part of a community as is the viewer—this is the only way a semiotic system of signs can function. In this sense, the question "What am I making?" is an address to the viewing community as well as to the artistic self. For the object to be apprehensible to the viewer, the artist, like anyone else who wishes to communicate, must use the language of his or her artistic community; whether this community of viewers be local, regional, national, or international does not matter.

But intentionality as a creative and transformative act does more than just link fine craft and fine art together with all other man-made things as the realm of culture. By being embedded in its object, intentionality, as a creative and transformative act, directs us to ask the question, "What in the act of making is the maker's intention?" This is a question fundamentally related to the concept of meaning because, as Husserl correctly observes, "meaning is reserved for the intention to mean."[3] Meaning does not occur by chance or by itself. It must be made through a willful act, in this case, a willful and creative act of making that transforms its object.

At this point I want to clarify some issues so as to anticipate certain critical concerns that may arise. In speaking of "intention to mean," I am not aligning myself with those literary critics associated with the New Criticism of the 1940s. Their view, which has its counterpart in the 1950s and 1960s formalist art criticism of Clement Greenberg, argues for the self-sufficiency of the work of art. Seeing it as a self-contained object, they agree with W. K. Wimsatt and Monroe C. Beardsley, who label the reliance on external sources as evidence of meanings intended by the author as "The Intentional Fallacy." In the view of Wimsatt and Beardsley, the "design or intention of the author is neither available nor desirable as a standard for judging the success of a work of literary art."[4]

3. Kamuf, *Derrida Reader*, 6.

4. Monroe C. Beardsley and William Kurtz Wimsatt first proposed this theory in an article by that name published in 1946. See their "Intentional Fallacy," 1–13.

Arguing as I do against appearance as the sole source for understanding should make my position on this clear. For even if two objects look exactly the same, when we know that one is handmade and the other machine-made, how can they be the same? Although their making is not betrayed by their appearance, the fact that one maker is intentionally employing a millennia-old technique connected to the hand, with all that that implies in terms of skill and history, while the other is intentionally rejecting tradition and history in favor of a modern industrial method, with all that that implies, certainly has a bearing on what these objects are intended to mean! Such facts of their making simply cannot be ignored if we are to do justice to both the maker and the object.

At the same time, I reject the more recent view that all meaning resides outside the object. In the last several decades literary criticism has led the way in promoting this view, shifting attention from the work of art to the role of the reader in shaping meaning. Known as Reader-Response criticism, it has become fashionable of late to argue that meaning is actually "created" by the reader/viewer, not the author, hence the notion of the "death of the author" often associated with French essayist and critic Roland Barthes.[5] I find this view questionable for several reasons. While clearly the reader/beholder brings a degree of personal information to his or her understanding of the work in question, to suggest he or she actually creates the meaning is to suggest the work can have any meaning a reader/beholder wishes it to have; it is to presume all meanings are possible at one and the same time for every text because meaning is not located within the work nor within the community of which both reader/viewer and artist are members.

The problem with this position has become quite evident in recent years. Not only have Native Americans complained of their sacred objects being displayed in art museums as purely aesthetic objects, they have even demanded the reburial of ancient skeletal remains currently housed in anthropological museums and have been granted legal standing to do so. The controversy that erupted in 1984 over the "Primitivism in 20th Century Art" exhibition at the MoMA in New York City is not unrelated, as scholars and critics argued that strictly Western meanings were being imposed on Native American, African, and other non-

5. See Tompkins, *Reader-Response Criticism*, especially ix–xxvi.

Western art objects by decontextualizing them from their historical and cultural background. The tempest revealed the great disparities that existed in people's minds about works of art. Much the same occurred with the 1989 Magiciens de la Terre exhibition at the Pompidou Center in Paris; known as the "Whole Earth Show," it became embroiled in controversy because again it was argued its curators were treating Western and non-Western art alike as if all the work were the same, that visual appearance trumped intention.[6] Clearly the assumptions that meaning resides solely with the viewer and can simply be made up to suit the viewer's temperament, however uninformed about the work that temperament might be, were being challenged.[7]

Implicit in these controversies is the belief that the viewer has an obligation and responsibility to the maker because works of art are intentional objects of human expression. For the artist, intending to be an artist and to make meaningful things is the point; for the viewer, that it may sometimes be difficult to know artistic intentions is not the point. The viewer must act in good faith with the artist and must accept the challenge to understand the work. Such understanding must spring from the communal framework from which the art springs; it is this framework that generates the concept "work of art." What I think Reader-Response criticism often underestimates is how viewers automatically grasp intention when viewing works of art from the cultural milieu of which they are a part. For example, Peter Voulkos's platters are immediately understood to be platters (Figure 30); at the same time, it is immediately understood by the viewer that they have been intentionally scored, chipped, and slashed—two facts that are central to their meaning. Few westerners viewing them in a gallery or museum setting, because of our understanding of these institutions, would have to be

6. For more on the MoMA controversy see Chapter 8, note 10. For the Magiciens controversy see Buchloh, "Whole Earth Show," 158, and Brenson, "Is Quality an Idea Whose Time Has Gone?" 1, 27.

7. To favor the reader/beholder so that meaning can be derived without consideration of authorial intention may be new to literary and art criticism, but it is not new to totalitarian societies where it long ago raised serious ethical and moral issues. The case of Hitler's 1937 "Degenerate Art" exhibition of works he deemed "anti-human," or the Moscow "Show Trials" of the 1930s in which Stalin purged countless innocent people on charges of treason, or the fate of Soviet composers such as Dimitri Shostakovich should sound a note of caution to anyone thinking authorial voice can be ignored without consequences, especially in our post 9/11 society.

FIGURE 30. Peter Voulkos, *Untitled Platter*, 2000, woodfired stoneware (ca. 15″ diameter). Collection of John Jessiman, Cub Creek Foundation for the Ceramic Arts, Appomattox, Virginia.

In this work Voulkos relies on the traditional platter form (a shallow bowl with raised rim) as a basic form for his gestural actions. With its identity clearly apparent, he is free to gouge, scrape, break the edges, and otherwise "disfigure" his platter without it losing its identity as a platter and becoming an inchoate mass of clay, something akin to an unformed thing of nature. In doing this Voulkos both reaffirms the persistence of craft as a tradition that exists almost outside of time while challenging the continuity of that tradition by literally attacking it physically. For these reasons it is essential that the work's identity as a platter be apparent to the viewer, otherwise the artist's intentional act of "disfigurement" would not be apparent and therefore be virtually meaningless.

told these were intentional acts and not the result of incompetence or vandalism.[8]

To return to our main argument that meaning is reserved for the intention to mean, as I have stated, things of nature do not have meaning because they have no intention to meaning nor to expression. Dark clouds are not the result of a creative and transformative act. And though we may value and take great pleasure in them or reel back in terror from their destructive force, we must recognize a significant difference between regarding nature as valuable and as a source of ideas and inspiration and assigning an intention to mean to it. On the other hand, meaning should not be arbitrary or gratuitous to man-made objects either; nor should it be assigned or imposed on them from without. Meaning should be understood as being *made* into the object as an intentional act of its maker. And while I am borrowing the idea of intentionality from Husserl, it is not just a philosophical abstraction, but an important codification of concepts that form the basis of our social as well as our workaday world. Our complicated system of judges and juries underscores society's premise that regardless of how close the resemblances between things and actions, intention plays a primary role in defining them. This is what judges and juries do: determine intention.[9]

Instructive in this sense is Duchamp's *Fountain* (Figure 3). It certainly cannot be considered a work of sculpture in any traditional sense of the term; in fact, it may not be a sculptural object in any other sense, either. Duchamp, by purposely entering it into a sculpture exhibition, was offering it to the public as an object latent with aesthetic (sculptural) meaning. He defended it this way, saying that "whether Mr. Mutt with his own hands made the fountain or not has no importance. He CHOSE it. He took an ordinary article of life, placed it so that its useful significance disappeared under the new title and point of view—created a new thought for that object."[10] As his defense suggests, he was asking

8. Other examples might be de Kooning's near abstract gestural paintings of women from the early 1950s; who would presume they were not intentional, but failed attempts at making realistic Ingres-like portraits? Or who would believe the fantastic space in Dali's paintings was not intentional, but result from a lack of perspectival knowledge?

9. For more on the issue of intention and the problems involved, especially with older works, see Gadamer, *Truth and Method* and his *Philosophical Hermeneutics*.

10. For more on this see Ades et al., *Marcel Duchamp*, 127–28. Dickerman et al., in the exhibition catalogue *Dada* (489) attribute the statement, which appeared in *The*

them to look at it *as if* an object whose form was a product of sculptural intention and possessed of sufficient aesthetic qualities to be art. But, in reality, the meaning he was "suggesting" was not part of the object (neither its physical form nor its maker's intentions). This may be why Duchamp chose it; it was basically devoid of aesthetic intention and as a urinal he knew it would be an assault on the viewer's sense of propriety and "good taste"; in this way it would have a political dimension as well. Duchamp may have been purposely exploiting its identity as a urinal for its shock value vis-à-vis sculpture.[11]

This helps explains why *Fountain* was so controversial and why it and the incident have remained so intriguing to the art world ever since; however much he tried, he could not make it disappear as an "article of ordinary life"; in short, he could not create a new thought for it.[12] However, we must keep in mind that the interest in *Fountain* lies in its historical circumstances, in its historical context, not in any meaning apprehended by the viewer through an understanding of the object's intentionally configured visual properties. After all, as an object in and of itself, it may offend one's sense of propriety when placed in an art

Blindman in 1917, to Beatrice Wood; if so, since she was a close friend of Duchamp and together they published *The Blindman* with Henri-Pierre Roché, she could hardly have done so without Duchamp's approval (typographical emphasis in the quote is as it originally appeared in the magazine).

11. In an interview many years later with Otto Hahn, Duchamp said: "Choose the object which has the least chance of being liked. A urinal—very few people think there is anything wonderful about a urinal. The danger to be avoided lies in aesthetic delectation" (see Taylor in Dickerman et al., *Dada* exhibition catalogue, 287). To say a simple "piece of plumbing" is somewhat misleading since the urinal was surely designed, not only to be practically functional, but with certain features to make its appearance attractive to a buyer and user. Nonetheless, it was not made with the intention to meaning in the way a work of art would be; it is not *refined* in the aesthetic sense necessary to be a work of art.

12. For example, when *Fountain* was exhibited at the Carré d'Art in Nîmes in a 1993 exhibition, French performance artist Pierre Pinoncelli urinated into it, saying he wanted to return it to its original function, after which he attacked it with a hammer. When the same version of *Fountain* was shown in an exhibition at the Pompidou Center in Paris on January 4, 2006, he again attacked it with a hammer. Though Pinoncelli maintained his attacks were a form of Dada action, in both cases he was arrested and heavily fined by the French court. In 2000 two Chinese artists also urinated on the Tate Modern's version of *Fountain* that is seen in Figure 3. See Anonymous, "Duchamp's Dada Pissoir Attacked," *Art in America*, 35.

exhibition, but it is hardly an offensive object, nor is it shocking the way a picture of the *Mona Lisa* with a mustache would be; it is simply a bathroom fixture, something encountered daily. This is why it is more historical artifact than sculptural object.[13] However, *Fountain* does represent an important, even seminal event in the history of Modern Art, but not as a urinal per se. It was Duchamp's act of entering it into an exhibition *as if* it were a work of sculpture that was so important, so radical. It was this act, in its challenge to artistic conceptions of sculpture, that was full of meaning; *as an act* it intentionally called into question the signifying system of art's sculptural language. When understood in this way, it is clear that Duchamp's heritage is of immense proportions and involves not only the readymade and assemblage art via the assisted readymade, but the aesthetic gesture or aesthetic act which is the foundation of happenings and performances of all kinds.

The conceptual implications of readymades and recontextualizations of objects and materials can be troublesome if one is not careful to consider the original maker's intentions. While the urinal was a mere utilitarian object, an image of the *Mona Lisa* to which Duchamp appended a mustache and the letters "L.H.O.O.Q." (when pronounced in French the letters sound like "she has a hot butt") was not. It was already latent with meaning, which Duchamp then exploited to make a Dada gesture confronting Western society that had tolerated the senseless destruction of World War I. Because of this, *L.H.O.O.Q.* also was not an arbitrary, pointless gesture.[14] Nonetheless, in arbitrarily assigning meaning onto someone else's creation, another's thought and work is being subverted. I think that this is exactly what Duchamp was doing, and it is also why such works were so unsettling to viewers; it was less a question of misunderstanding them than one of understanding them only too well.[15]

13. In keeping with this, Duchamp did not seem interested in preserving *Fountain* or many of his other readymades until many years later, around 1950. For more on this see Stuckey, "Dada Lives," 145–47 and note 9.

14. When Robert Rauschenberg included his quilt in his work *Bed*, the quilt not only remained a quilt/craft object with all that that means, but the intended meaning as well as the success of *Bed* depended on its staying a quilt. The very fact that he titled the work *Bed* is hardly insignificant in this regard.

15. That it is often difficult to know intention isn't the issue. If judges and juries decide intention in cases of law, then critics, curators, and thoughtful viewers, among others, do so for art. Sometimes intention to art is taken on faith, as when sculptor Martin Puryear exhibited old, anonymously made wooden farm implements along

Having said this, I wish to stress that not every object intended to be art, whether instrumentally functional or not, is art. Not every maker's intention to make art is successful. That's why I suggest calling those objects not intended to be art "utilitarian" and those intended to be art, and also successful aesthetically, "fine," as in fine craft, fine design, and fine art. So among all the objects in the world with aesthetic qualities, only those made with the intention to enter the realm of art have the possibility of being considered art. And among those objects, only those with sufficiently compelling aesthetic qualities should be considered art. This means facing a gradient of objects, all of which have some aesthetic qualities. And while we may wish to separate them into classes such as fine art, fine craft, fine design, among others, it is the individual viewer and beholder who must make a subjective decision as to which of the objects along this gradient possess sufficient aesthetic qualities to be judged art. The best that can be hoped for is that viewers are informed and knowledgeable about art, that they have been educated into the practice of serious looking. Whether this education is gained through formal or informal means does not matter. What does is that viewers are able to aesthetically behold the work of art as a contemplative, meditative object; the depth of the aesthetic experience they have depends on this, as do the decisions they make about which works are art. If one has any belief in art's social and cultural importance, then it is clear that much is at stake in these choices. For while each decision that an individual viewer/beholder makes is a personal, subjective one, in the aggregate, it is these decisions that shape our cultural landscape.

with his sculpture in his exhibition at the Hirshhorn Museum and Sculpture Garden in Washington, D.C., several years ago, *as if* they were art. On the other hand, in regards to intention, it is mistaken to believe that we can do without the object and simply accept what the artist tells us is his or her intention; works of visual art "communicate" through the aesthetic experience they generate in the perceptive viewer, not through the written or spoken word. The artist's or the critic's words can only direct the viewer's attention to the work; they can never replace the work itself.

BEAUTY, CONTEMPLATION, AND
THE AESTHETIC DIMENSION

■ ■ ■

In Western culture it has been a long-standing practice to de-
termine whether or not something is a work of art by evalu-
ating it in terms of its beauty.[1] Beauty, in fact, has been con-
sidered a prerequisite of the aesthetic and of works of art in
Western culture for so long that among the definitions Web-
ster's dictionary gives for "aesthetic" is "of or relating to the
sense of the beautiful" and "having a love of beauty," and as
"the branch of philosophy that provides a theory of the beau-
tiful and of the fine arts." For these reasons, understanding
something about theories of beauty and "the beautiful" is
helpful in understanding something about how judgments
have been made about works of art as well.

The underlying belief these definitions betray is that art
is physically beautiful and things that are physically beau-
tiful must be art—no difference exists between the two.
These definitions continue into the present, even though
the history of art clearly contradicts them.[2] If the *Venus de*

1. For a discussion of the theory of beauty see Kirwan, *Beauty*. In
French, Italian, and German the fine arts are "the beautiful arts."

2. The issue of beauty generally, but particularly in art, is often
regarded by feminists with suspicion because it is seen as the objec-
tification of the female body by the male—that is to say, women are
physically beautiful for men to look at. See Hixon and Weins, "Edito-
rial," 7; for more on beauty see Plagens, "The Good, the Bad, and the
Beautiful," 18–20; Schwabsky, "The Sublime, the Beautiful, the Gender
of Painting," 21–24, 55; Cottingham, "The Damned Beautiful," 25–29,
54; Risatti, "The Subject Matters," 30–35; and two recent books, *The
Invisible Dragon* by Hickey and *Venus in Exile* by Steiner.

Milo (150–125 B.C.) may be considered a physically beautiful figure in the classic sense, the more or less contemporaneous *Old Market Woman* (2nd century B.C.) cannot. If Botticelli's *Birth of Venus* (1483) is about ideal Platonic beauty, one cannot say the same of Michelangelo's *Last Judgment* (1534–41) in the Sistine Chapel. Even Michelangelo's contemporaries recognized the difference and spoke of the sense of *terribilità* in many of his works. Similar examples of art that are not beautiful in any conventional sense abound in the modern period, including works by German Expressionist and French *Fauve* artists in the early twentieth century and those by the American Abstract Expressionist gesture painters around mid-century.

In the philosophical realm of late-eighteenth-century post-Enlightenment aesthetic theory, art and beauty also are linked. This is true even though the word "aesthetics" was taken from the ancient Greek word *"aisthētikos,"* which referred, not to art and beauty, but to "one who is perceptive of things through his sensations, feelings, and intuitions." This is basically the meaning given it in the second quarter of the eighteenth century by German philosopher Alexander Baumgarten (1714–62) when he first introduced aesthetics into modern philosophy as a separate discipline; he defined it as the science of sensitive knowing.[3] But as I have noted, in his "Analytic of the Beautiful" (published in 1790 as part of his *Critique of Judgment*) Kant shifted the meaning of aesthetics away from Baumgarten's toward beauty and judgments of taste. Moreover, in formulating a systematic theory of beauty, he did not distinguish beauty in art from beauty in nature; he placed both on an equal footing. The logical outcome of this is to regard things we consider beautiful, such as a sunset or a waterfall, the same as works of art and to equate the aesthetic with beauty.

German philosopher Georg Wilhelm Friedrich Hegel (1770–1834) realized the problems this view presented and complained in his *Introductory Lectures on Aesthetics* about people being "in the habit of speaking of beautiful colour, a beautiful sky, a beautiful river, and moreover, of beautiful flowers, beautiful animals, and above all, of beautiful human beings."[4] He argues for a distinction to be made between beauty in na-

3. Baumgarten's two-volume *Aesthetica* was published in Frankfurt in 1750, forty years before Kant's *Critique of Judgment*. For a critical discussion of the issue, see Kirwan, *Beauty*, 93–118.

4. Hegel, *Introductory Lectures on Aesthetics*, 3–4. Gadamer, among others, includ-

ture and beauty in art. Referring to beauty in art as "artistic beauty," he argues for its uniqueness because it "stands higher than nature. For the beauty of art is the beauty that is born . . . of the mind; and as much as the mind and its products are higher than nature and its appearances, by so much the beauty of art is higher than the beauty of nature."[5] In his 1913 *Guide to Aesthetics*, Italian philosopher Benedetto Croce (1866–1952) reiterates Hegel's belief and in no uncertain terms says that "we declare . . . that 'nature' is stupid compared to art, and that she is 'dumb,' if man does not make her speak."[6]

Regardless of a long-established tradition, I believe we must follow Hegel and Croce. Not only must we separate art from nature, regardless of how beautiful either may be, but we must not automatically equate physical beauty with art or the aesthetic. As I have said, vast numbers of works of art from all periods simply cannot be considered beautiful in any conventional sense of the word. Many are intentionally frightening, some sublime, others ugly, even grotesque. Moreover, as Hegel and Croce contend, art and the aesthetic have an intellectual motivation expressed through their physical form as the result of intentions to meaning. Considering this, it makes sense to insist art and the aesthetic always belong together but not beauty. As the history of art shows, beauty is not a prerequisite for either art or the aesthetic.

If the presence or absence of beauty cannot be used as a defining characteristic of the aesthetic or of art, and if the aesthetic cannot be circumscribed by ideas of the beautiful,[7] how are we to identify an aesthetic/art object? On what basis can a distinction be made between an ordinary, non-aesthetic object and an aesthetic object? In an address marking the 175th birthday of German composer Conradin Kreutzer, Heidegger distinguished between what he called "calculative thinking" and "meditative thinking." Heidegger's distinction suggests a way to do this. Calculative thinking, according to Heidegger, computes, plans,

ing F. W. J. Schelling and Oscar Wilde, likewise disagrees with Kant's view in the matter of art and nature, contending, after Hegel, "that natural beauty is a reflection of the beauty of art"; see Gadamer's *Philosophical Hermeneutics*, 98ff. and Kirwan, *Beauty*, 99–118.

5. Hegel, *Introductory Lectures on Aesthetics*, 4.

6. Croce, *Guide to Aesthetics*, 37.

7. For a discussion of some of the problems of defining the aesthetic, see ibid., especially 11–12. Also see Kant, *Analytic of the Beautiful*; Hegel, *Introductory Lectures on Aesthetics*, 3; Elton, "Introduction," 1–12; and Kirwan, *Beauty*.

organizes, and investigates for economic and practical ends to serve specific purposes; it always "reckons with conditions that are given." To this kind of thinking he contrasts meditative thinking, "which contemplates the meaning which reigns in everything that is." Meditative thinking tries to understand the meaning of events and the value of things in human terms.[8]

Heidegger's idea of calculative thinking fits nicely our concept of the utilitarian object. With utilitarian craft, utilitarian design, and utilitarian visual art, one automatically calculates whether they are right or consistent in terms of the practical advantage they offer;[9] moreover, this is how they are intended to be understood. The opposite is true of fine craft, fine design, and fine art objects. They open the beholder to a realm of meditation and contemplation; this is their intended reason for being made. According to the *Oxford English Dictionary*, "contemplation" is defined as "the action of beholding, or looking at with attention and thought, mentally viewing; thinking about a thing continuously; attentive consideration." And, it defines "to meditate" as "to muse over or reflect upon; to fix one's attention upon . . . [with] intentness." It is in this sense that fine objects of all types can be characterized as "meditative or contemplative" and they can be identified by the way they open a realm of meditation and contemplation to the beholder.

However, there are many objects that are not art but still open a realm of meditation and contemplation—for instance, there are nostalgic objects of all kinds, including old photographs and heirlooms, as well as historical artifacts and documents and philosophical tracts, to name just a few. All can trigger "meditation and contemplation" in the beholder, but they are not necessarily made with the intention to be contemplated, certainly not to be contemplated as art objects. Art objects are special because they open a realm of contemplation through the aesthetic dimension, which is another way of saying, through their aesthetic properties. These properties make them unique because of the way aesthetic experience effects the beholder's engagement with the object. One of the reasons beauty has had such a strong connection to art is that experience of the beautiful effects the viewer's relationship to the object in a way similar to that of the aesthetic. Arthur Schopenhauer

8. Heidegger, "Memorial Address," 45–47.

9. Purely "Commercial Objects of Desire" would also be calculative objects because the way they are, the way they look, is intentionally geared to salability.

(1788–1860), that most pessimistic of German philosophers, explains that beauty "lifts us out of the endless stream of willing, delivers knowledge from the slavery of the will, [so that] . . . attention is no longer directed to the motives of willing, but comprehends things free from their relation to the will, and thus observes them without personal interest, without subjectivity, purely objectively, [so that attention] gives itself entirely up to them so far as they are ideas [or concepts], but not in so far as they are motives."[10] In the presence of beauty, says Schopenhauer, the beholder experiences "disinterested contemplation" of the object so that the object is seen for its own sake and not primarily for any practical or economic benefits it may offer the viewer. What this means is that we don't regard the beautiful object with calculative thinking; we don't see it in terms of its economic value or its practical function, but impartially in terms of itself. If we did see a beautiful object in terms of economic or practical value, we wouldn't be experiencing its beauty.

In practical terms, the special power of the aesthetic affects us very much like that of beauty; that's why art, the aesthetic, and beauty have long been equated in aesthetic theory. Like beauty, the aesthetic affects how we experience the ordinary, daily world around us, what Husserl calls the "life-world." Confronted by a steady stream of data through our senses, we are naturally inclined to interpret such data as indications of possible actions and instances of practical, functional use.[11] If we do not find things immediately useful, we tend to dismiss them from conscious consideration. As Stuart Hampshire says, "To hold attention still upon any particular thing is unnatural; normally, we take objects . . . as signs of possible actions and as instances of some usable kind; we look through them to their possible uses, and classify them by their uses." And he goes on to say, "There is no practical reason why attention should be arrested upon a single object, framed and set apart; . . . One

10. Schopenhauer, *World as Will and Idea*, 118–19. Like Kant before him, Schopenhauer also equates beauty and art. I think it important to note that love has an effect much like that of both beauty and art. True love upsets the normal course of one's life, suspending time and obligations in an almost surreal manner in even the most practical of people. Love often compels otherwise sensible people to act against their economic interests and to flaunt familial, religious, and social/class strictures and taboos. In this regard, it is not insignificant that we speak of loving a work of art or a piece of music.

11. For more on this see Boden, "Crafts, Perception," 289–301.

may always look through a picture as if it were a map, and look through a landscape towards a destination; for everything presented through our senses arouses expectations and is taken as a signal of some likely reaction."[12]

One can easily understand why this is so. If we didn't separate the immediately practical and useful from the nonuseful and impractical, we would be fatigued from sensory overload; if we were to scrutinize every house on our drive home from work, for instance, we would be a danger to other drivers. Thus to focus attention on an object for its own sake, to bracket that object from the constant stream of data that makes up the "life-world" of ordinary experience, is counter to our survival instincts that logically give priority to economic and practical ends. But this is exactly what both beauty and the aesthetic experience cause us to do, to suspend our natural inclinations toward calculative thinking. As Hampshire says, having an aesthetic experience means "the spectator/critic . . . needs to suspend his natural sense of purpose and significance. . . . Nothing but holding an object still in attention, by itself and for itself, would count as having an aesthetic interest in it."[13]

Thus aesthetic experience, like beauty, is unusual, even unnatural in the way it disrupts our ordinary habits of experiencing the world. In opening up a realm of "disinterested contemplation" in which the beholder is compelled to fix attention upon its object, the object's essence is able to be grasped and understood. Before going on to discuss the ramifications of this, there are several points that must be kept in mind. One is that "disinterested contemplation" does not mean hermetically sealed off from all other experience as suggested by "The Intentional Fallacy" theory and the New Criticism of the 1940s that I referred to earlier. It means nonprejudiced, impartial attention; attention bracketed from immediate practical interests and concerns. Any experience, to be contemplatively meaningful, as opposed to practically functional or a purely bodily experience, must be had in relation to human experience within a social setting; knowledge of what the object is intended to do or reference cannot be precluded from the concept of disinterested, impartial viewing. In this sense, the work's subject matter, as an aspect of what it is, is always relevant to the beholder.

12. See Hampshire, "Logic and Appreciation," 166. Hampshire is reiterating ideas from Heidegger's "Origin of the Work of Art"; see especially 26.

13. Hampshire, "Logic and Appreciation," 166–67.

Furthermore, not all disruptions of ordinary experience are aesthetic or beautiful. A fiery car crash or a mountain village beset by an avalanche also disrupts normal patterns. But these are neither aesthetic nor beautiful; they are tragedies and the thought they evoke in a sensitive human being should be immense sorrow at the loss of human life.

As I have noted, there is a long-standing tradition of equating the beautiful, including natural beauty in the human figure and in nature, with art. This is because beauty is alluring, riveting, and even intoxicating, just as is the aesthetic dimension in art; it too stops the beholder in his or her tracks and keeps the ordinary world at bay.[14] However, the beautiful and art are not the same because essential to the work of art is always an indivisibility of form and content. With the work of art there is always something to understand even though it can never be translated into words or be extended through another medium (say language) beyond the object itself. A beautiful sunset and a painting of that sunset are obviously linked visually, but they differ because the painting is a signifying object that intends to "communicate"; it is an object made by a human being with intentional expressive content. Though we may be encouraged to look at landscapes and all objects of natural beauty because of their beauty, in themselves they have no expressive content, no expressive intention. The aesthetic dimension at work in the painting, however, compels the viewer to engage the work's content by holding attention on the work in such a way that the work itself determines the contemplative thought engendered in the beholder. In other words, landscape paintings, like all works of art, compel us to hold them in attention in such a way that they engender thought about themselves, which is to say, about their content. Even if the intention of the landscape artist is to faithfully capture the physical beauty of nature, this still holds true because the painting always intends something more than just depiction; in this case, as a conscious depiction of natural beauty, the painting implies natural beauty and nature itself as values to be contemplated and beheld. Erupting volcanos, no matter how beautiful, aren't able to offer themselves up for contemplation because they can't disrupt our normal inclinations and instincts to flee for safety. But great paintings of erupting volcanos can encourage us to contemplate them, to visualize the spectacle of their pyrotechnic beauty against their ter-

14. Again, it is not insignificant that we typically describe the person we love as beautiful.

ribly destructive forces, because they are not what they depict, what they literally intend to represent.

To treat beauty very generally and to equate it with art is to ignore their differences.[15] Unlike beautiful things of nature, works of art are always animated by a human artistic intelligence purposefully conveyed to the beholder through the physical configuration of the object. Any beauty (or for that matter ugliness or sense of terror) that may be perceived in nature or natural objects is purely happenstance because it is without purpose or intention to meaning. This is why viewing nature and natural objects aesthetically is mistaken; it is to construe in their visual form an animating artistic intelligence that is not there; it is to raise mere nature to a higher plane by regarding it as more than what it is, a mere indicative sign (Figure 31).[16]

By the same token, we also must be careful not to regard all manmade objects as aesthetic even though, as I have argued, all may possess some aesthetic qualities. Aesthetic objects are those whose aesthetic qualities are intentionally configured by their maker to coalesce in the object so as to compel the attentive viewer to regard the object with

15. In his early work on the beautiful and the sublime, written in 1763, Kant recognized different feelings, namely the sublime, but also nobility; he included these as forms of the beautiful found in both nature and art, but unfortunately he seems to have changed his mind by 1790 when he wrote his *Critique of Judgment*. See his *Observations on the Feelings of the Beautiful and Sublime*. See Gadamer on this same issue in his *Philosophical Hermeneutics*, 97ff.

16. The concept of natural beauty, certainly in Western art and theory, came to prominence relatively late in the post-Enlightenment period, a fact which supports the view that it is a transference of the concept of the aesthetic from art to nature so that people came to view nature aesthetically from having viewed works of art. According to the *American Heritage Dictionary* (fourth edition), "It would seem that in the word *landscape* we have an example of nature imitating Art, at least insofar as sense development is concerned. *Landscape*, first recorded in 1598, was borrowed as a painters' term from Dutch during the 16th century, when Dutch artists were on the verge of becoming masters of the landscape genre. The Dutch word *landschap* had earlier meant simply 'region, tract of land' but had acquired the artistic sense, which it brought over to English, of 'a picture depicting scenery on land.' Interestingly, 34 years pass after the first recorded use of *landscape* in English before the word is used of a view or vista of natural scenery. This delay suggests that people were first introduced to landscapes in paintings and then saw landscapes in real life." For Gadamer on this in relation to Kant and Hegel see his *Philosophical Hermeneutics*, 97ff.

FIGURE 31. Ryoan-ji Garden, Muromachi Period, 1499, Kyoto, Japan, design attributed to Soami (1472–1523). Photograph courtesy of Peter Lau.

In China and Japan there is a long tradition of creating gardens to be contemplated as landscapes. The Ryoan-ji Zen garden in Kyoto is one such example with its surrounding walls and fifteen isolated stones "floating" in a sea of raked gravel. In the West, looking at nature *as if* it was art was already a feature of the Picturesque tradition in late-eighteenth-century England when it was the custom to view actual country cottages and other irregular configurations of natural and man-made elements aesthetically *as if* one were viewing a painting. In mid-nineteenth-century America sunsets were viewed in a similar way. Standing in stark contrast to this practice are the English Romantic garden and Japanese gardens like the Ryoan-ji Garden. Though man-made of natural elements that are themselves without intention, because these elements are carefully and intentionally rearranged for expressive purposes, such gardens have aesthetic meaning and therefore can be art (something that cannot be said of raw nature). In which case, instead of viewing nature *as if* it were art, we would be viewing art *as if* it were nature, a very different proposition indeed.

"intense" and "disinterested contemplation." Man-made objects whose intention is primarily functional and practical are not aesthetic objects; they are not art. This means commercial, graphic, and industrial arts, and utilitarian craft and utilitarian design objects as well as most tools, machines, and equipment of all types, would be excluded from the category art. Only those objects can be art whose aesthetic qualities successfully dispel calculative thought in favor of contemplative and meditative though and reflection in an attentive viewer; when an attentive viewer is having such an experience, he or she is having an aesthetic experience. This brings up an interesting situation that proves the point. When utilitarian works like illustrations, graphic designs, advertisements, videos, television commercials, anything intended to sell a product or idea, are too compelling aesthetically, they tend to be ineffective commercially. That is because, by compelling disinterested contemplative and meditative thought on the advertisement as aesthetic object, attention is deflected away from the products that the advertisements are meant to sell. Commercial artists must walk a fine line between the utilitarian and the aesthetic: works that are too unaesthetic are ignored as boring, while those that are too good aesthetically don't encourage the viewer to reach for his or her pocketbook.

Identifying works of art by the aesthetic experience they engender means that where one draws the line between a utilitarian and a fine object cannot be absolute—the nature and quality of aesthetic experience is itself subjective. This does not mean that we cannot define what a traditional craft object is or that we cannot enumerate the characteristics of objects traditionally declared fine art. What it means is that we cannot rely on something as simple (and convenient) as a function/nonfunction classification to separate art from non-art. We must accept, all arguments to the contrary aside, that a work of art is not determined by lack of function or by medium; an object can be art even if functional and made of traditional craft materials such as metal, clay, fiber, glass, or wood. By the same token, being made of traditional fine art material such as marble or bronze, or oil or acrylic paint, doesn't necessarily guarantee something is a work of art either. What counts is the aesthetic experience that the work engenders in a beholder who accepts the work's challenge to be understood.[17]

17. At one time such a viewer/beholder would have been identified as someone of "cultivated taste." Today the term "taste" seems elitist to some. However, Gadamer

It would make matters much easier if works of art could be identified simply by lack of function or by material. But since they can't, the task is to decide if the work was made with the intention to be art and if it successfully engenders an aesthetic experience; doing this entails that subjective decisions be made by a competent beholder. If the answer to these questions is yes, then and only then are we in the presence of a work of art.

argues that for centuries taste had both a moral dimension and communal sense to it, what in Latin was called a *sensus communis*. Though it has lost much of its meaning today, something of its former meaning still survives as reflected by the fact that some things in our society, though unfortunately not many, are still considered offensive because they are "in bad taste." See Gadamer's *Truth and Method*, especially 35ff.

HOW AESTHETIC CONTEMPLATION
OPERATES

■ ■ ■

How aesthetic contemplation operates is an important question that now needs to be explored. For while it is through the aesthetic dimension that craft objects transcend the realm of simple utility and become works of art, it is through aesthetic contemplation that their identities as works of art, as fine craft objects, are revealed to the viewer; the same holds true for works of fine art.

The aesthetic dimension makes art objects different from all other objects by endowing them with an almost magical quality to heighten sense perception and promote intense, impartial contemplation and reflection in an attentive viewer; the aesthetic dimension makes art objects capable of projecting meaning and purpose beyond that of ordinary objects. It is able to do this because, in holding the object still in attention, the thought the aesthetic dimension engenders is always directed back onto its object, back onto the work of art.

One might argue that non-art objects, say old family photographs, artifacts, or even philosophical tracts, do this as well so it is not a feature found solely in art objects. But this is not true. Objects like family photos, artifacts, and philosophical tracts may trigger contemplation and reflection, but they themselves as objects are not the actual focus of that contemplation and reflection; as physical objects they are not what attention is held still upon. Rather, they lead the viewer away to some other realm. For example, in reading a philosophical tract one is not led to contemplate the book as a physical object; one does not contemplate its

binding or the texture and weight of its paper as an embodiment of the work's philosophical thought. In this important sense even books as literature differ fundamentally from visual art; they are instructions for the recreation of the literary work just as the musical score is a set of instructions for the recreation of the musical composition; neither book nor score are physical embodiments of the work itself. The visual art object, by contrast, does not exist as a set of instructions for its recreation; it exists outright as a work in the object itself; the art object is itself an embodiment of the art.

However, even works of visual art can be reduced to non-art status if viewed inattentively; that is to say, if viewed in such a way that aesthetic contemplation is prevented. This is why we must always distinguish the response of the attentive from the inattentive viewer; it is also why the artist's ideal viewer is the attentive viewer. Take the Sistine Ceiling as an example; if the only reaction that viewing it elicits is to trigger fond memories of a previous trip to Rome, this hardly counts as attentive viewing or as having an aesthetic engagement with the work; it is not holding the Sistine Ceiling still in attention as a work of art. It is simply an instance of nostalgic memory. Nostalgic memories, whether of a Roman holiday or some other event, can be triggered by any object or experience, even something as simple as a plate of pasta or an old family photograph. All that is required is that some kind of associational relationship be triggered.

The aesthetic operates differently. Instead of acting as an associational trigger unleashing nostalgic contemplation or reverie, in bringing the work of art itself into intense focus, the aesthetic dimension actually precludes nostalgic reactions from occurring; it precludes the attentive viewer from having the kind of mental wandering upon which nostalgic reverie depends. By the same token, in an attentive person, the aesthetic would disrupt the kind of contemplation evoked by philosophical tracts because it would focus attention on the tract as a physical object rather than as a written text. And since the tract, as a physical object, does not embody its philosophical thought, since form and content are not fused together in it the way they are in a work of visual art, this would be a pointless, disruptive distraction. That's why to have a book whose physical fabric and graphic design are too aesthetically engaging does not serve the author's intention very well.

For much the same reason, when it comes to the work of art, the aesthetic also precludes the engendering of generalized aesthetic ex-

periences of unbounded reflection. Because of the almost self-reflexive nature of the aesthetic onto its object, when viewing the art object held still in attention for itself and by itself, directionless musing by even the attentive viewer on just any thought cannot occur; it is simply not an option opened to the conscientious viewer of a work of art. This is why, in contrast to reader-response critics who argue for the "death of the author"—that meaning is created solely by the reader/viewer—I am arguing the opposite, that not just any meaning is available to the attentive viewer. Meaning must always be appropriate to the work in question because being an attentive viewer means responding to the work itself, to the object upon which attention is fixed; in this sense meaning cannot help but be appropriate to the object.[1]

The ramifications of this, I believe, are crucial to art generally, but especially for understanding the differences between fine craft and fine art. For in focusing attention onto the art object, the aesthetic dimension opens a space for the object to come into view and speak to the beholder, speak in the sense of becoming the intense focus of the beholder's thought. In doing this, the conscientious beholder is dissuaded by the art object itself from imposing an arbitrary, extrinsic reading upon it. Instead of just any reading, it is that reading offered by the object that comes forward into consciousness for contemplation. In this way the beholder is, in a sense, "presented" to the art object as the object's audience, thereby allowing the art object to open the beholder to its realm, to allow the beholder to "enter" its realm. Of course the viewer must be willing to enter this realm, to accept the work's challenge to be understood. And in fact, accepting this challenge is what is meant by being an attentive, conscientious viewer.

From this, I think, one can see why the issue of intentionality in relation to *homo faber*, man the maker, is so important for our discussion. From the point of view of the maker, that the art object is an intentional object means it can take its place among other expressive signs. But it

1. The implications of this is that the reader/viewer engages in a dialogue with the author/artist through the object. Such a dialogue, by involving an engagement with another in which ideas are exchanged, carries the participant to new levels of understanding and awareness, both of him/herself and the other. This, it seems to me, is a model for social interaction. To insist meaning is created solely by the reader/viewer not only precludes such a dialogue, it is anti-social in that it implies meaning doesn't exist outside the self, that the self is all-knowing and self-sufficient. For more on reader-response criticism, see Tompkins, *Reader-Response Criticism*.

also is intentionally realized through a creative and transformative act of making which embeds meaning into the physical fabric that is the art object. Because of this, its realm of meaning is circumscribed and articulated in and through the object so the object becomes the physical embodiment of its maker's expressive-artistic thought. In this way it stands forth as the object of the maker's intentions. In this sense it is special even among expressive signs. Yet there is still more than this that makes the art object special. In the way it operates aesthetically to hold the beholder in its spell and open the beholder directly to the maker's intentions, its mode of expression also is unlike that of any other expressive sign.

This in itself, however, does not explain the full extent of what is unique about intentionality in the work of art from the point of view of both the artist and that of the viewer. Considering Husserl's premise that every thought must have an object, then both the fine artist and the fine craftsman, as conscious and intentional makers, must make some-*thing* and the some*thing* they make must be the object of their thought. If we ask what this some*thing* is, what this vehicle that carries artistic thought is, for the painter and sculptor it is of course the painting and the sculpture. But what is it that the painter paints and the sculptor sculpts in order to make a painting or a sculpture? What the painter paints and the sculptor sculpts is the subject matter of the work; it is in painting and sculpting the subject matter that the work comes into being. Thus, in one sense, it is the subject matter of the work that is the direct intentional object of the maker's thought.

The craftsman too must make some*thing*, he or she cannot make nothing. But it is not sufficient to say that "the craftsman makes the craft object" because, to make a craft object, the craftsman must craft something. Of course, we could say that the craftsman crafts the material just as the painter paints the paint and the sculptor sculpts the wood or stone. In the wake of 1950s American Abstract Expressionist gesture painting, a time when the artist worked directly on the canvas in a kind of existential moment, it became fashionable to account for the work of the painter and the ceramist in this way—one has only to think of painters Jackson Pollock and Willem DeKooning and ceramists Peter Voulkos (see Figure 30) and Jim Leedy as artists working material. But this just evades the issue, since the paint must be painted into something to be a painting, as must the wood or stone be sculpted into some-

thing to be a sculpture and clay handbuilt or thrown into something to be a craft object—one cannot paint or sculpt or handbuild or throw material into nothing.[2]

So we may conclude from this that the craftsman crafts the object's function. Function comes into being as the immediate object of the craftsman's thought; it becomes the vehicle that embodies and carries the maker's thought. In this sense function is part of the tradition of craft, what can be called the "tradition of fore-understanding" just as subject matter in painting and sculpture are part of the "tradition of fore-understanding" of fine art. When I say "fore-understanding," I am referring to the complex of ideas, concepts, images, works, values, and presumptions that make up the individual's realm of understanding; it is also part of tradition in the larger sense of a practice and is brought to the process of making by the maker and to the process of viewing by the viewer. Practice for fine artists would include genres such as "portraiture," "landscape," religious scenes and subjects, even "abstraction." For craft it would include genres like "teapot," "chair," "quilt," and any number of others.

Seen in this light, it should be clear that our previous discussions of the craft object's origin in conceptualizing nature and material was an attempt to articulate and expand the ground of craft's "fore-understanding," a ground left largely unexplored to this point in the literature on craft. A tradition of "fore-understanding," something shared by both maker and beholder, accounts for how both maker and viewer are able to approach the object with a capacity for comprehension and meaning. The nature of this "fore-understanding" and the degree to which it is shared determines the capacity for comprehension, something avant-garde artists have exploited in the last 150 years or so by

2. It must be stressed that, in saying the painter paints the subject matter just as the sculptor sculpts the subject matter I am not speaking strictly of representational art. For even abstract works of art that don't rely on representational forms have subject matter; in the cases of fine artists it may even be the concept "painting as picture" or the concept "sculpture as physical object" that is their subject matter; for ceramists like Voulkos and Leedy, it may be the concept "platter" or "vessel." I would argue that this is actually the unspoken basis of Clement Greenberg's thesis of self-critical formalist art, for one cannot manipulate form in a painting, for example, unless one already has a preconception, a "fore-understanding," of what a "painting" is and of what constitutes a picture.

pushing work to the edge or sometimes even beyond the bounds of their communities' shared tradition, something that certainly seems to have occurred with Duchamp's *Fountain* (Figure 3).

Though craft and fine art traditionally approach the idea of thought/content from opposing directions, both treat function/subject matter as their immediate intentional object.[3] Seen in this way, we can argue that function and subject matter are analogous and that function makes the expression of the fine craftsman possible, just as subject matter makes the expression of the fine artist possible. But again I must caution that simply realizing the desired function/subject matter isn't enough to make something a work of art. It must also possess sufficient aesthetic qualities; otherwise every work with the prescribed material and function/subject matter would be art. From experience we know this simply is not the case.[4] With fine art not every painting of Christ on the cross or Madonna and Child or every sculpture of the seated Buddha are considered works of art. If we believed function as the "subject matter" of craft was sufficient to deem any craft object a work of art, every teapot, every quilt, every chair would be art. This position is just as untenable as its commonly held opposite—that things that contain, cover, or support cannot be art. Distinctions must be made based on the aesthetic result of the intentional formalization and materialization of function through technique.[5]

3. Craft gives physical form to an already conceived function-concept, while fine art gives thought/content to an already existing physical form. In principle this is the idea behind the Duchampian readymade—take an already existing object and try to infuse it with meaning/content. In this sense readymades reflect a very traditional fine art practice; what is new is that because the object is appropriated from another existence, sometimes it resists this process and refuses to be transformed; sometimes there is a collision between old and new meanings, creating a tension around the object that would not have otherwise existed.

4. In the eighteenth century the French Academy tried to rank works as art based on their subject matter with religious and history subjects atop a hierarchy that had still life at the bottom.

5. Equally important, not all works with the same subject matter or function and possessing sufficient aesthetic properties to be considered art have the same expressive content. We recognize differences in expression between works of fine art with the same subject matter because different material, formal, and technical treatments of subject matter make possible a wide range of expressive thought. The same is true of craft objects—their different formalizations in material through technique

Husserl's contention that every thought must have an object simply means that to be a maker, one must make something. But this observation immediately prompts the question, "What am I making?" on the part of the maker and "What am I beholding?" on the part of the viewer. In other words, the act of making and the act of beholding always raises questions. Both of these questions are about understanding. The man-made work, whether art or not, always asks to be understood. This is the challenge it poses to the maker and the beholder.

With utilitarian works, whether craft or tools and machines, the understanding asked by them is simply how they function. When I know what the work of commercial or graphic art says or how to use the tool or machine properly, I understand it properly. In a very real sense I have exhausted its "meaning." With such objects, function in the literal sense is the limit of their maker's intention; hence, they imply only use as their end. It is these kinds of objects that fit Kant's notion of "purposive objects" because all we can judge about them is whether they are "right or consistent" in their function. With fine craft objects, because intentions go beyond the making of an object of strict utility, the question of understanding that they pose is not just about how they function: understanding function in the literal sense doesn't exhaust them. In such objects, function is the subject matter of the work in the sense of something to be understood as part of a complex matrix that includes nature and culture, material and technique, function and form.

The aesthetic dimension is essential in this because it allows the question of understanding posed by the object to come forth, thereby dissuading the viewer from his or her natural inclinations to *simply* use the object in the most practical sense; the aesthetic encourages the viewer to contemplate the object as a physical embodiment of function as a concept laden with meaning. In this sense the aesthetic dimension in the fine craft object demands an attentive viewer/beholder. It demands someone who accepts the work's challenge to be understood as more than just a utilitarian object. It demands someone who will understand the object within a conceptual framework with all that implies—vis-à-vis material, technique, form, and function, even the hand—as a transformative event of the creative imagination to make a world of culture out of nature and physiological necessity.

also make a wide range of expression possible—one has only to compare a platter by Voulkos to a woodfired platter by Rob Barnard to understand this.

For this to happen, the fine craft object must be located within a tradition of "fore-understanding" that recognizes the historic consequences that surround its conceptualization and creation. Holding the object in attention for itself and by itself must be an activity of understanding through the mind's eye that opens a realm of contemplation about the object as the thingly bearer of intentional meaning. Part of this experience, for both fine craft and fine art, includes sensitivity to subject matter, technique, process, and material as well as form. So while function in craft is analogous to subject matter in fine art, function must be understood as working in conjunction with form, material, and technique as a vehicle through which the object comes into being providing a venue for meaning to occur. When this conjunction produces an object whose aesthetic qualities come together to open up a realm of intense contemplation, then we are in the presence of a genuine work of art.

With the fine craft object, when this happens, the object comes forward into the viewer's consciousness. This, in turn, focuses the viewer's contemplation in the object's direction, providing a specific locus for the viewer's contemplative thought. In this way, a very specific occasion is created for the object to speak to the viewer and from which reflection and contemplation can spring.[6] Together they guide the viewer along the intentions of the maker's thought so that a deeply human connection is created between viewer and maker with the fine craft object as intermediary between them. It is in this way that the fine craft object speaks the artist's intentions and opens a dialogue with the beholder.

6. To return to our example of Michelangelo's Sistine Ceiling, in particular the depiction of the "Creation of Adam," the subject matter in this scene directs our thought to a certain locus (that of human creation), but the form that that subject matter takes in its almost somnolent line, as distinct from other depictions of Adam, refines that locus to the very specific realm — that of dawning human consciousness as a gift of God and the question of our subsequent existence as conscious beings. This becomes the specific occasion for contemplation and reflection that the work opens for the attentive beholder through its subject matter in conjunction with the formalization of that subject matter. For more on the relation between language and content, see Ricoeur, *Conflict of Interpretations*, 48.

DEVELOPMENT OF THE CRITICAL
OBJECTS OF STUDIO CRAFT

■ ■ ■

Throughout this study I have emphasized the importance of function as something essential to the identity of craft. I have argued that it is around function that form, material, and technique revolve as a constellation of elements necessary to bring the craft object into being. Yet in 1961 Rose Slivka wrote about a new generation of what she labeled "painter-potters" who avoid "immediate functional association" in their work so that "the value of use becomes a secondary or even arbitrary attribute." She went on to write that such work only ceases to be craft when "all links to the ideas of function have been severed."[1] How could Slivka argue that the idea of function could replace actual function and yet the object still retain its identity as craft? To an earlier generation such remarks would have made little sense because craft had always been functional. But to many craftsmen of a new generation her statement simply reflected contemporary craft practice. In order to understand her views it is helpful to look briefly at the changed social, political, and artistic environment out of which they sprang. For it is in this environment that the intellectual standing of craft vis-à-vis fine art becomes an acute issue, eventually leading some people to conclude Slivka's position did not go far enough because it still recognized the "ideas of function" as a prerequisite of craft. Those who rejected her position were trying to gain for craft the prestige of fine art and to do so they argued function should be ignored, if not discarded altogether.

1. Slivka, "New Ceramic Presence," 36.

Among the changes that occurred in the years following World War II was a shift in the cultural landscape as New York replaced Paris as the art capital of the world. These years also saw an unprecedented expansion of American higher education. Aided by passage of the Servicemen's Readjustment Act, popularly known as the G.I. Bill for veterans of World War II, college and university enrollments grew, as did the numbers of departments teaching fine art and craft.[2] By the early 1960s when Slivka wrote her essay, a new generation of artists that included ceramists like Jim Leedy and Peter Voulkos entered the art world. Rather than being self-taught or *trained* in an apprentice system, these craft artists were *educated* in a formalized academic setting with the specific goal of being artists and artist teachers. I think it hard to overestimate just how significant this changed situation was for how they understood their work in relation to fine art and in relation to craft practices of the past.

At least since ancient times, both craftsmen and fine artists were trained in an apprentice/guild system. In the Renaissance when fine artists broke free of the constraints of this system and organized themselves into art academies, they did so by stressing the intellectual foundations of their art in an attempt to increase their economic and social status. Craft remained behind as part of the guild system, and craftsmen continued to be trained as apprentices, as were tradesmen. Thus a pattern set already in the ancient world that affected the economic, social, and artistic status of craft would continue through the Renaissance and up until the educational expansion of the post–World War II period brought craft into the new academy, the college and university system. With this expansion, craft finally became part of the intellectual realm in a way that fine art had been, at least in principle, for nearly four hundred years. In many ways the craft/fine art debate that we have been discussing can be seen as an attempt by craft to realize, to actualize the implications of the new intellectual and social milieu in which it now found itself.

Being in this new academic setting was important for would-be practitioners of craft because, unlike the apprentice system, a certain amount of abstract conceptualization occurred even if art theory was

2. The G.I. Bill was unanimously passed by both houses of Congress in June 1944 and remained in effect until 1956. Though not all veterans went to college or universities, in total almost 8 million veterans took advantage of the bill, including 65,000 women.

not yet a staple of the art school curriculum. Typical college and university curricula required of all students a wide range of liberal arts and science courses. Such courses demanded extrapolation of ideas and data into formal principles and concepts. Courses in literature emphasized symbolism and metaphor as expressive vehicles while courses in the social and the physical sciences revolved around the establishment of theoretical models to explain behavior and events. Never before had craft learning been done in such an environment.

There were other reasons why being in an academic, intellectual environment was important for craft. For one, it placed craft students in the same artistic milieu as students of fine art with whom they came to share many artistic attitudes, including what it meant to be an artist. This certainly did much to instigate ideas and discussions about craft and fine art and helped to blur the line, at least in principle, between the two fields. Another direct result of learning about craft in a formalized academic environment was the shift from workshop to studio practice. That is to say, academically educated craftsmen and women now were more likely to maintain studios rather than workshops.[3]

This shift signaled a profound conceptual change in craft thinking. In the older system, the name of the workshop or firm took precedence over that of the individual artist. If an individual artist's name did appear on a workshop piece, it was always secondary to that of the workshop and was there to add to the workshop's prestige. Moreover, with workshops, especially those connected to large firms like Tiffany, Rookwood, and Roycroft, artists and designers were subsumed artistically under the firm's label and style; this meant that as a member of the workshop they couldn't exercise their own independent artistic vision. By contrast, maintaining a studio practice means the artist's name comes first and the studio is a visible extension of the artist's creative identity. An offshoot of this is that instead of producing work in a wide variety of different media, materials, and techniques, as was typical of firms like Tiffany and Roycroft who hired numbers of artists with varying specializations,[4]

3. For a discussion of the studio in the Studio Furniture movement, see Cooke, "Defining the Field," 8–11.

4. Interestingly, workshop practice continues today with design firms like Alessi that offer a complete line of household goods, most if not all of which they don't actually make. As a brand name, Alessi has things designed for it and stands for a certain level of style and quality.

the studio is limited to the individual artist's expertise and interests. In this way the craft artist's studio is like that of the fine artist. If there are studio assistants involved, they generally are paid a salary to do specific tasks that have more to do with workmanship than craftsmanship. Creative responsibility resides solely with the craft artist. That studio assistants learn and progress by stages as in the older apprenticeship system so as to become "masters" in their own right is not the aim of the studio nor the concern of the studio artist.

Reflecting this change, today contemporary craft is often referred to as "Studio Craft." But changes in work space are only an indication of more profound changes occurring in the field. Early on in this new, academically oriented art environment, visual artists (both in craft and fine art) began to frame their endeavors in more conceptual terms. This was especially significant for craft because it meant what had been taken literally before (for example, function) could now be understood metaphorically and treated abstractly. When function no longer needed to be literal, new expressive possibilities opened up for the craft artist. And significantly, while these possibilities were influenced by the conceptual model of the fine artist and fine art practice—especially the idea of abstraction as part of a continuing avant-garde—they could not have developed from the concept of the fine art object. This is another point that needs to be stressed, for as already noted, the fine art object, whether realistic or abstract, is always an image, a re-presentation of something it is not. Therefore, the change from realistic to abstract imagery is not a change fundamental to the nature of fine art, certainly not in relation to its operational strategy based on the sign. This holds true equally for painting as for sculpture.[5] However, for Studio Craft, the change from insisting that an object literally function to allowing for one that is about function but need not actually function is a very dramatic and fundamental shift in how the craft thing itself is understood. It is an extraordinary conceptual move in which college and university craft and art

5. Minimalism in the 1960s was so challenging to visual art because it attempted to be three-dimensional without being sculpture. In doing so, it tried to completely change/avoid the terms in which sculpture was understood. This explains why someone like Donald Judd refused to even use the term "sculpture" for his work. The terms in which sculpture is defined have become even more elusive as performance, installations, and even video projections are referred to as sculpture. In fact, today sculpture is often defined as "anything that is not painting!" For Judd and the Minimal object see Fried, "Art & Objecthood," 12–23.

departments played a major role. It was a move that allowed for a wide range of new expressive possibilities, the importance of which should not be underestimated.

To begin with, this move raises the question, "What is this contemporary craft object that is about function but does not actually function?" Since it cannot be said to represent function, say the way a painting might represent something, it isn't an outright image, a sign in the traditional fine art sense. On the other hand, since it doesn't actually function, it isn't a craft object in the traditional craft sense, either. What is it then, a craft object *manqué*? Perhaps, but "*manqué*" means somehow lacking, incomplete. Such craft objects don't so much lack function as engage it on the level of the conceptual. If they must be categorized in some way or other, I suggest they be thought of as "critical objects of crafts," objects whose aesthetic/artistic potential is concentrated in their *exemplary but "unfulfillable function."*[6]

To understand the radically new implications of such objects it is helpful to compare them to Duchamp's *Fountain* (Figure 3). One might argue that *Fountain* already was a radically critical object in 1917 because of the critical dialogue it created about the condition of sculpture as it existed at that time. While it was critical, I think if we examine *Fountain* closely it becomes clear it isn't a critical object in the same sense that I am attributing to the "critical objects of craft." This is because *Fountain* springs from a completely different strategy, one that operates from outside the realm of sculpture, so to speak, so its criticality is neither a "function" of sculpture as an artistic enterprise per se nor is it latent within its objecthood; the object *Fountain*, after all, is a piece of ordinary plumbing. In fact, its criticality is directly a result of its being an object foreign to sculpture (a store-bought urinal) that was inserted directly into that stream of objects called sculpture. Because *Fountain* was so "foreign," so unrelated historically to the conditions of sculpture as they then existed, it could not help but raise critical issues about those conditions if one took the intended comparison to sculpture seriously. But other objects also could have provoked similar critical reactions because it is not the urinal as object per se that is the bearer of critical meaning; it was the act of insertion, something that helps explain why *Fountain* and others of Duchamp's readymades were not preserved by the artist.

6. For more information related to the idea of unfulfillable function, see Boden, "Craft, Perception," 289ff.

This is also why, as the condition of sculpture changed in the modern period, becoming less figurative and more open-ended in the manner of *Fountain*, *Fountain* became less unfamiliar, less "foreign," and less able to provoke a critical discourse about the condition of sculpture except historically. In short, the triumph of *Fountain* through its insertion changed the field of sculpture so much that the physical object *Fountain* itself came to look a lot like the new sculpture and a lot less foreign.

In this sense, the "critical objects of craft" are categorically different from *Fountain* because they do not create a critical dialogue from outside the field of craft. As objects, they don't appear "foreign" to craft, but familiar because they share in the primary conditions of traditional craft as an artistic enterprise of formalization and materialization around function. Thus, fitting more or less comfortably within the stream of objects traditionally identified as "craft," they are able to engage craft critically from inside the field and on its own terms.

From this it is clear that despite parallels that exist between the conceptual transformations of the Studio Craft movement and fine art, most notably Minimalism of the 1960s and 1970s, significant differences remain. Studio Craft explores traditional craft practices and traditional craft issues; its conceptualizations spring from an actual knowledge of craft as a practice of formalizing material. Tellingly, training of the Studio Craft artist still begins with the making of actual functional objects. This entails learning about the properties of material so as to work material into functional form through suitable technique while developing a skilled hand sensitive to both. To my knowledge, even in the most advanced college and university environments, actual making remains the mainstay of the craft curriculum so that conceptualization is always founded in and through the materialization of form. Seen in this light, it is hardly surprising that most of the conceptual explorations of contemporary Studio Craft, whether functional or not, are profoundly tied to traditional craft practices. Yamaguchi Ryuun's *Tide Wave* (ca. 1990) (Figure 32) and Bill Hammersley's *C-Shell* (1996) (Figure 33) are examples of this. Yamaguchi's work is a bamboo construction springing from a traditional Japanese basket form; it captures both the sense of a basket in its material and in its sweeping and flowing lines as well as something of nature's energy in motion. Similarly, Hammersley's *C-Shell* is an interpretation of a traditional bench in its basic form; but it is more organic and complex in the way the top is folded down on one side to create a support while a series of disparate and ungainly

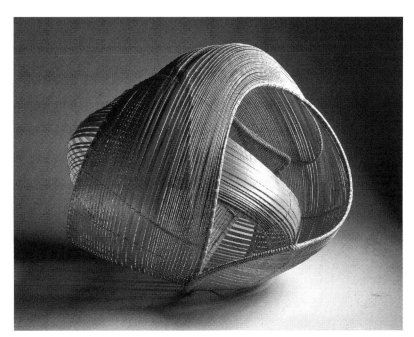

FIGURE 32. Yamaguchi Ryuun, *Tide Wave*, ca. 1990, bamboo (20″ × 19″ × 16″).
Collection of Lloyd E. Cotsen. Photo credit: Pat Pollard.

Yamaguchi's *Tide Wave* is a complex form that could evoke the modern industrial-technological environment as do some of the works of abstract sculptor Naum Gabo. However, because it is made of bamboo rather than plastic mono-filament or of metal wire, it is anchored in the natural world of the organic. Moreover, its material connects it to the tradition of Japanese basket making, which, in turn, brings technique to the foreground, something that emphasizes its handmade-ness. In this way, the tradition of craft itself is embedded in Yamaguchi's work, making it latent with meaning vis-à-vis tradition including function/nonfunction and the hand/the machine. In this sense it is embedded in a discourse that is completely different from that of modernist sculpture.

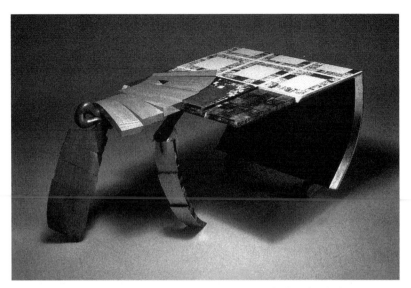

FIGURE 33. Bill Hammersley, *C-Shell*, 1992, wood, copper leaf, and polychrome (30″ wide × 22″ high × 50″ long). Photograph by Katherine Wetzel.

The form of *C-Shell* is based on that of a traditional bench, and in this sense proffers seating, a place of rest and comfort. However, it also makes the possibility of seating somewhat questionable, tentative even, because of the peculiar organic form of its curving lines and its construction of apparently randomly collaged elements in differing materials and surface treatments. The curving elements seem structurally "unsound," almost ungainly, and the collaged elements seem patched together in such a way that they don't so much follow structural form in order to emphasize its strength as migrate over and across it in a way that seems to undermine it.

elements seem collaged together across the top to eventually descend to create a pair of supports on the other; by their odd form, these supports impart a rather crustacean-like movement to the bench.

The explorations of Yamaguchi and Hammersley as well as those of other contemporary Studio Craft artists must be seen as part and parcel of craft. Rather than an abandonment of the field, these nonfunctional Studio Craft objects are a contemporary exploration of craft's particular sensibilities and concerns. Such works show that function need not be taken literally as it traditionally had been for an object to be identified as part of the craft field. Function can be abstract and metaphorical without the object necessarily losing its identity because, even if abstract and metaphorical, function is still the subject matter of the work; it is still around function that the object springs forth into the viewer's con-

sciousness. This springing forth from function is an example of what it means for an object to be critical from within the field of craft.

Changes in the way function is understood in contemporary Studio Craft have helped blur the line between craft and fine art, prompting the question "Is it craft or is it sculpture?" The question is important because it is about the limits of the field, about where craft ends and sculpture and the other fine arts begin. However, it is not always an easily answered question, even when our idea of sculpture is that of the traditional object as sign, because the issue revolves around perceptions of the object that have a long history. For instance, the line between craft and sculpture often seems blurred even when craft artists turn to making sculpture. Though they are not making a craft object, because they have been trained in the practice of craft their sculptural works usually betray an in-depth technical knowledge of material and process, surface and form, that is atypical of most contemporary sculpture; this gives their work the look and feel of a craft object, of being a part of the craft field, even though there are no conceptual connections to craft. Examples of what I mean are some of the works of Allan Rosenbaum (Figure 1), Jun Kaneko (Figure 16), Suk-Jin Choi (Figure 34), and Doug Finkel (Figure 35); their works are clearly sculpture despite being extremely sophisticated in terms of their use of materials.

Some works purposely play on the idea that craft can evoke a sense of sculpture, as in some of Picasso's painted vases (Figure 36). Still others actually blur this line, as in many of the portrait-head containers made by the Mochica and Chimu cultures of ancient Peru (Figure 37). To answer the question "Is it a portrait or a container?" requires the viewer to decide whether what he or she is seeing is a portrait in the form of a container or a container in the form of a portrait. Clearly such a question can only arise if the object exhibits traits of both. Which traits predominate in the viewer's eye determines how it will be understood. In some portrait/containers, just as in some animal/containers, this will be obvious (Figure 11). Others may straddle the line in such a way as to seemingly hover in that tension-filled space between the two, making it difficult to decide which the object is. Rather than a problem, I view such objects as interesting because they are full of aesthetic potential to challenge, even unsettle the viewer's traditional habits of seeing and understanding.

There are a great variety of contemporary Studio Craft objects and while most involve function as part of their critical/expressive vocabu-

FIGURE 34. Suk Jin Choi, *Evolution I–II*, 2004, fired clay and paper (*Evolution I*: 22″ × 24″ × 12.5″; *Evolution II*: 22″ × 21″ × 15″). Photograph by Richard Haynes.

The works of Choi and Douglas Finkel (Figure 35) display a high degree of manual and technical sophistication in their form and manipulation of materials. Choi's works, for example, are hand-built, using a tubular format of multiple parts to which she adds stenciled patterns and heavy glazing. Such sophisticated handling of material and surface reflects traditional craft practices and encourages one to see such works as craft rather than sculpture, even though their forms are obviously more sculptural than craftlike. One must resist this temptation, for these works clearly belong to the realm of sculpture and not craft.

lary, not all take the same approach to function and treat it abstractly or metaphorically. Some expressive possibilities involve function through what can be viewed as "transgressions of scale"—the making of craft objects out-of-scale for the hand or body to actually use as in the work of Howard Ben Tré (Figure 38). Whether overly large or exceedingly small, because of their form they still offer the possibility of function and retain a sense of the hand and body as their gauge. In this way they prompt an awareness of human size, scale, and proportion. Even though function may no longer be practically possible because of size and weight, that it is still theoretically possible sets up a certain tension in the object that comes from within the field of craft; this tension heightens our critical awareness of the size of things in the world as they pertain to the human (body). In doing this, critical issues are raised about handsomeness and

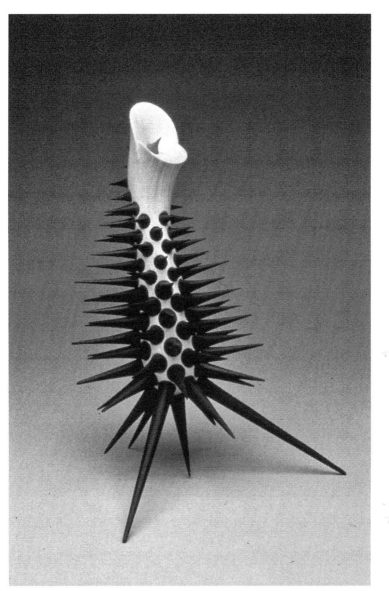

FIGURE 35. Douglas Finkel, *Sex Pistil*, 1999, osage orange and poplar (6" × 6" × 12" high). Photograph by Taylor Dabney, courtesy of the artist.

The actual realization of this work, which is one of a series, involved several complicated technical procedures. To begin with, all of the spikes and part of the central core were turned on a lathe; the remainder of the central core was then hand-carved to give it a graceful, sentient look. Finally, to create the impression that the spikes were organically growing out of the central core, the artist had to cut a special steel drill bit.

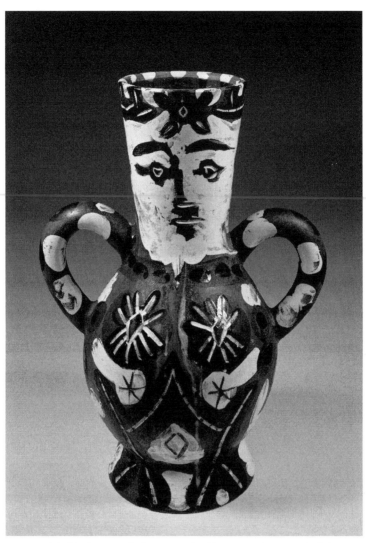

FIGURE 36. Pablo Picasso, *Anthropomorphus Vase*, ca. 1960, ceramic. Private collection, Vienna, Austria. Photograph by Erich Lessing/Art Resource, N.Y. © 2007 Estate of Pablo Picasso/Artists Rights Society (ARS), N.Y.

The general form including the handles, neck, and the opening of this vase clearly indicates that it is a container. However, Picasso plays with the vase's formal relationship to the human figure by painting its body, handles, and neck in such a way as to emphasize their connection to the human body; in a sense he is pointing out the formal and functional reasons why such parts are named after the human body. In spite of this, the vase resists being subsumed by these illusions. We see what amounts to an allusion to a human torso with arms and head imposed on a container; it is this allusion that makes this otherwise mundane vase so visually interesting.

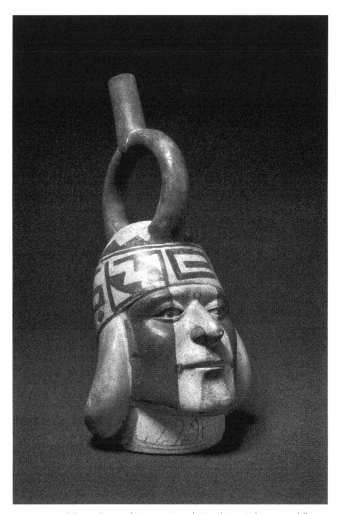

FIGURE 37. *Stirrup-Spouted Pottery Vessel*, Mochica Culture, middle period, ca. 200–500, mold-made, painted ceramic (6″ × 12″). Trujillo, Libertad, Peru. Presented by Dr. and Mrs. Arthur M. Sackler (23/6889), courtesy National Museum of the American Indian (NMAI), Smithsonian Institution. Photograph courtesy of NMAI Photo Services Staff.

Unlike the handles on Picasso's vase in Figure 36, the stirrup-spout handle on this Moche head vessel, which likely is a portrait of a person whose face has either been painted or tattooed, is so inorganically placed that it seems an odd attachment protruding from the head of the figure. The result is that, despite intellectually knowing the vessel to be a container, the viewer tends to read it visually as a sculpture because the shape of the handles and the way they are attached cannot overcome the work's portrait qualities. Thus, a visual tension is created in the work at both the physical and the psychological level.

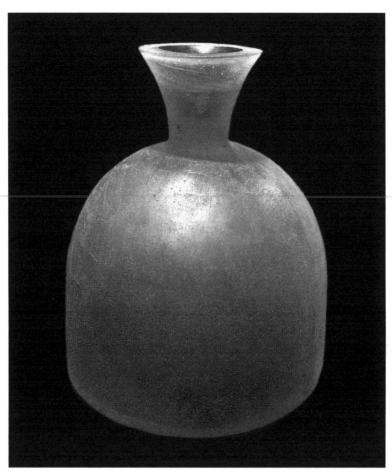

FIGURE 38. Howard Ben Tré, *First Vase*, 1989, cast glass, gold leaf, and lead (55 ¾″ × 43 ⅞″). Gift of the James Renwick Alliance and museum purchase through the Smithsonian Institution Collections Acquisition Program (1990.52), Renwick Gallery of The Smithsonian American Art Museum, Washington, D.C.

Howard Ben Tré's *First Vase* is a good example of how scale can be used to make us sensitive to the size of all the man-made objects we encounter in the world. At over 55 inches in height, it is the size of a child and stands about chest-high to an average adult. Yet its shape is clearly that of a container, not a child or an adult, and its flared neck offers an inviting place for the hand to firmly clutch it antecedent to the act of pouring. But it is much too large to be grasped, and even when empty it is much too heavy to be lifted and poured. Its bottle/vase form and everything that form implies in terms of the human hand and appropriateness of size and quantity are thus contradicted by its actual size, so that, as beautiful and alluring as it is as an object because of its translucent glass and interior gilding that gives it a magical aura, there is something subtly unsettling, even otherworldly and nonhuman, about it.

decorum, about what is proper and fitting and, perhaps, what is in good taste and in moderation.

Other approaches involve making a functional object and then in some way subverting that function. For this subversion to operate critically, function must remain evident as an inherent feature of the work while also being called into question. Slicing, slashing, tearing, or even partially collapsing the object as in the works of Peter Voulkos are ways to do this (Figure 30). Such strategies, by their sometimes violent nature, take on a transgressive quality that seems an attack against the object and craft as a tradition; perhaps this attack is intended as an assault on the overly complex rituals of domesticity that nineteenth-century Victorian culture developed to both define and ensure class distinctions. While such rituals can be seen as characteristic uses of craft objects, one must also remember that in their highest, most profound purpose fine craft objects traditionally have striven to do something quite different. They have served to elevate the profane that is physiological necessity to the level of the sacred. As I have said, that many of our most cherished rituals tend to be centered on food and drink are testimony to this; there is, after all, a profound difference between eating and dining that touches at the core of what makes us human—in dining we curb our physiological, or should I say bestial, instincts and engage in social interaction.

Subtler ways of subverting function in otherwise functional objects can be done by making them unfriendly or unhandy to use; for example, making an object unusable by giving it a surface texture that is too coarse or prickly for the hand, as in Gyongy Laky's basket aptly named *Spike* (Figure 39), or making it appear unusable by making it look unhealthy in some way or another, as in some of the works of Beatrice Wood with her "toxic-looking" glazes. One can even make perfectly functional objects that are then rendered nonfunctional by simply combining or stacking them in such a way that they cancel each other's function. With Richard Marquis's stacked *Teapot Goblets*, one object cancels the other's usefulness (Figure 40). Such "Alice in Wonderland-like" objects invite us to use them but teasingly frustrate our ability to actually do so. By purposely undermining our inclinations to touch and use that are at the heart of a craft sensibility, they bring this sensibility sharply into critical view.

Another strategy of contemporary Studio Craft artists' to open up a critical dialogue around function is to make objects that simply echo

FIGURE 39. Gyongy Laky, *Spike*, 1998, apple prunings doweled with vinyl-coated nails (13 ⅜″ × 23 ¼″ × 22 ½″). Gift of Eleanor Friedman and Jonathan Cohen (1998.143), Renwick Gallery of The Smithsonian American Art Museum, Washington, D.C.

While most baskets can be described as either tightly or loosely woven containers, Laky's *Spike* cannot; it has no usable interior space and its construction is barely there, little more than a skeletal basket form in space. Moreover, the way she has made it of wooden twigs fastened together with metal "spikes," it repels the hand like a crown of thorns, thereby making holding and lifting seem a dangerous proposition indeed. In this way *Spike* calls into question, even suspends, our normal ideas about baskets at the same time that its material construction imparts a psychological aura to its form that hints at some shamanic ritual or sacrificial rite that is both ominous and dangerous.

FIGURE 40. Richard Marquis, *Teapot Goblets*, 1991–94, blown glass (*left to right*:
7 ¾″ × 5″ × 5″, 10 ¼″ × 4″ × 3 ⅝″, 10 ½″ × 4 ½″ × 3 ½″, 11″ × 3 ⅝″ × 3 ⅝″, 7 ⅝″ ×
5 ¾″ × 5 ¾″). Gift of the James Renwick Alliance (1995.24.1–5), Renwick Gallery of
The Smithsonian American Art Museum, Washington, D.C.

In these works, by using teapots as supports for goblets, Marquis makes a series of
fantastic, whimsical objects of great delicacy that are impossible to use either as tea-
pots or as goblets. Thus, while the invitation to use remains apparent in these works,
the artist intentionally frustrates our instincts by depriving these objects of their nor-
mal function since one part of the object cancels out the other. The result is that filling
them remains a delightfully frustrating impossibility—an Alice-in-Wonderland idea
never to be realized but still intriguing to contemplate.

the outward form, the appearance of a functional craft object without allowing for the possibility of function to exist. Objects such as these cannot be said to actually subvert function because actual function was never possible in the first place. In this sense these "critical objects of craft" take on a metaphorical quality as they raise the issue of appearance versus reality, but centered around the question of function as embedded in visual form. A case in point is Sidney R. Hutter's *Vase #65–78* (Figure 41), a vase form made of horizontally stacked planes of clear plate glass. Transparent with no interior space, as an object it is both present and absent, a ghostly object that becomes a metaphor for containing precisely because it is unable to do so in spite of the functional look of its outward form.

Susan Cooper's *Shades of Gray* (Figure 42), a pair of painted wood "chairs," and Joanne Segal Brandford's *Bundle* (Figure 43), made of rattan and other materials, are similar in this sense. Cooper raises the issue of appearance and reality around the function of supporting by presenting a negative-positive version of two chairs that exist somewhere between real and perspectival space; they are both tangible and intangible objects. By its title, form, and material, Brandford's *Bundle* poses the question of bundle/bundling as a function of containing/covering-bundling goods and a hastily bundled body awaiting burial among them. But it does this without literally being functional. Somewhat like Yamaguchi's *Tide Wave*, it relies as much on material as on form to make its complex associations of life, death, struggle, and even dissolution visible to the viewer.

And finally there is Myra Mimlitsch Gray's *Sugar Bowl and Creamer III*, made of copper (Figure 44). These two objects are not containers nor are they even remotely functional, though they are decidedly about containing. In this work Gray evokes presence and absence, being and nonbeing by literally making a negative impression of two familiar functional objects, a sugar bowl and creamer. Because both derive from an American Colonial-style silver creamer and silver sugar bowl, besides the issues of function and status as part of a social ceremony, they also raise questions of the passage of time; they make historical time almost palpable and become reminders of our own fleeting existence, something particularly poetic in the face of craft's transspatial and transtemporal existence. They remind us that we belong in the endless stream of time but also that our time is passing.

Today contemporary Studio Craft may encourage some to argue that

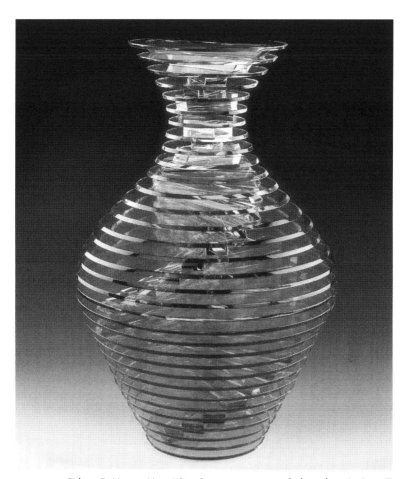

FIGURE 41. Sidney R. Hutter, *Vase #65-78*, 1990, constructed plate glass (23″ × 15″). Gift of the James Renwick Alliance, Anne and Ronald Abramson, Sarah and Edwin Hansen, and museum purchase through the Smithsonian Institution Collections Acquisition Program (1991.67), Renwick Gallery of The Smithsonian American Art Museum, Washington, D.C.

Hutter's *Vase #65-78* is a traditional vase form, almost generic in its commonness and its adherence to type. Yet its construction is rather ingenious in the way a series of horizontally stacked plates of glass are used to determine its physical form without allowing for interior space. This form, which is more a drawing in space than an actual vase and barely visible because of the clear glass used in its construction, seems activated, brought into existence as it were, by the spacers placed between the horizontal plates. These spacers, incrementally rotated around a central axis, create a single helix or spiral form, giving the impression of having generated this traditional vase form by turning in space. This is an example of an object whose exterior form implies a function that its lack of an interior form denies.

FIGURE 42. Susan Cooper, *Shades of Gray*, 2005, acrylic/wood (46″ × 30″ × 8.5″). Collection of the Kirkland Museum of Fine and Decorative Arts, Denver, Colorado. Photograph courtesy of Susan Cooper at Lois Lambert Gallery, Santa Monica, California.

Susan Cooper's work extends a line of thought that Pablo Picasso briefly touched upon around 1914 when he made several three-dimensional collage sculptures that he painted with highlights and shadows. Though Picasso never explored the profound implications of these works, Susan Cooper has done so in a series that includes *Shades of Gray*. It is the oppositions and contradictions of the work that make it so unsettling. Not only do we have a black chair next to its mirror form in white, making the viewer wonder which is the "real" chair and which the mirror image. But Cooper also blurs the line between the real and the imaginary by treating each chair as if it existed in perspectival space; that is to say, she has foreshortened both chairs as if they were two-dimensional objects when, in reality, they exist in three-dimensional space. And as if this weren't perplexing enough, she adds shadows and highlights to them to accompany the real shadows and highlights that occur naturally with any three-dimensional object. It is difficult to look at these objects and not wonder where the line between the real and the imaginary is to be drawn and how we, as viewers accustomed to using chairs as functional objects, fit into their "space" and they into ours.

FIGURE 43. Joanne Segal Brandford, *Bundle*, 1992, wood, rattan, kozo, nylon, and paint (24″ × 28″ × 23 ½″). Museum purchase through the Renwick Acquisitions Fund (1996.58), Renwick Gallery of The Smithsonian American Art Museum, Washington, D.C.

FIGURE 44. Myra Mimlitsch Gray, *Sugar Bowl and Creamer III*, 1996, raised, formed, and constructed copper (bowl: 11″ × 7″ × 5″; creamer: 11″ × 9 ½″ × 4″). Gift of the James Renwick Alliance on the Occasion of the 25th Anniversary of the Renwick Gallery (1997.56.1–2), Renwick Gallery of The Smithsonian American Art Museum, Washington, D.C.

there is no difference between craft and sculpture. I would caution against this because, as I hope I have shown, Studio Craft encompasses a wide range of possibilities from functional works that continue tradition and make historical references through technique, form, and material to works that are nonfunctional, what I call the "critical objects of craft." Despite being nonfunctional, one shouldn't presume these critical works are sculpture. As I have argued, they too are deeply involved in the techniques, materials, and forms of traditional functional crafts. Moreover, they are tied to the concepts of craft whose meanings they explore most often by using the oppositions "function present/function absent" or "function offered/function denied" as a conceptual strategy. In this way such works operate as critical objects from within the field of craft and thereby continue craft's historical practice as an expressive endeavor like no other.

POSTSCRIPT

■ ■ ■

Fine craft objects coming out of the contemporary Studio Craft movement, whether functional or not, have expanded the expressive possibilities open to the craft field. But more than this is needed for fine craft to be appreciated *as* art. The role played by the art audience in how it receives the work is crucial and also needs to be addressed. What does this audience expect from art and particularly from craft? What attitudes and ideas does it bring to the viewing process? In short, what is the frame of mind, the "fore-understanding" that the typical attentive viewer brings to the fine craft object before the viewing process even begins?

It is clear that fine art, as exemplified by painting and sculpture, has an advantage over craft in that it is automatically assumed to be art. This assumption became part of the intellectual discourse of fine art with the development of aesthetic theory as a special branch of philosophy concerned with the beautiful. The result is a predisposition to regard paintings and sculptures as aesthetic objects, as works of art, so that they are approached in a frame of mind that not only allows but encourages the aesthetic to come forth. The opposite is true of craft. There is a tendency to approach craft in a frame of mind that, if not completely indifferent to its aesthetic possibilities, sees these possibilities as extremely limited. In part this is because, as I hope I have shown, fine art aesthetic theory dismissed the functional from the possibility of being art. In many ways this dismissal now forms the core of the tradition of "fore-understanding" that viewers bring to the craft object.

With the onslaught of commercial production during the early decades of the Industrial Revolution, this dismissal became more pronounced. And despite being challenged at various times—for instance, by the Arts & Crafts and Art Nouveau movements of the later nineteenth century—it has essentially remained in place so that craft objects are seldom thought of as capable of opening to the beholder a realm of serious contemplation as works of fine art are presumed to do. It is an attitude that persists despite the high esteem in which crafts are held in Asian cultures, as are the functional objects of Western industrial design culture—here I am thinking of the functional work of Modern architect-designers such as Mies van der Rohe, Marcel Brauer, and Le

Corbusier, and even contemporary Postmodern architects and designers like Frank Gehry, Ettore Sottsass of the Memphis Group in Milan, and Aldo Rossi and Michael Graves for Alessi.

It is this tradition of "fore-understanding" of craft that must be overcome if craft objects are to be received differently by viewers. For as Gadamer astutely observes, "We cannot understand [the work of art] without wanting to understand, that is, without wanting to let something be said."[1] But the paucity of aesthetic theory geared specifically to "craft as art" has made this difficult, even though one would think the blurring of boundaries in fine art between sculpture, painting, video, installations, performances, happenings, theater, documentation, literature, etc., that has occurred in contemporary visual art practice in recent decades would have liberalized attitudes toward craft as well. But generally this has not been the case. Today the tendency still exists to regard all craft objects as basically practical so that they are automatically consigned to the realm of ordinary, everyday experience with the result that, when not needed, they become invisible and disappear from sight. In this sense they are still so deeply embedded in the life-world of ordinary experience as strictly functional objects that, for most people, they are simply incapable of generating aesthetic experience, incapable of being held still in attention for themselves as works of art.

Despite the importance of the academic environment for the Studio Craft movement, these attitudes of mind are both reflected and reinforced by the way craft and fine art are organized and taught in colleges and universities. In most art schools fine art is separated (perhaps segregated is a better word) from more utilitarian forms of visual communication—graphic art, graphic design, computer design, illustration—as if to deny the logical connections between them, to deny that one is essentially a more aesthetically oriented form of the other. This is not the case with craft. Study of what leads to utilitarian craft (what is generally considered production craft) occurs alongside that of fine craft. While this tends to blur the distinctions between them, it is done because an intense amount of technical knowledge and technical manual skill is still demanded of the makers of craft objects, whether these objects be fine or utilitarian. Despite the introduction into the craft studio of labor saving devices like power tools, this remains the case as it has been for millennia. Technical demands are still so strong

1. Gadamer, *Philosophical Hermeneutics*, 101.

that they continue to shape the field today just as they did when craft was part of the old guild system alongside painting and sculpture.

Fine art's successful break from the old guild system beginning in the sixteenth century was motivated less by altruism than by economics and class issues. But the strategy that was employed, the stressing of fine art's intellectual and literary aspects, was nothing less than an attempt to change, to reshape its audience's "fore-understanding." As we can see today from the continuing escalation of fine art's prices at auction, this strategy has been very successful. Unfortunately, this did not happen to the craft field in the Renaissance, nor has it happened yet despite craft's entrance into academia following World War II. The "no-separation between the two fields" argument being made by many craft advocates is an attempt to do this, but it hasn't been very effective. Part of the problem has to do with the continuing technical demands of the craft field itself. Painting's and sculpture's break from the guild system was realized relatively easily, but the rehabilitation of its "fore-understanding" was not completely accomplished in practice until technically demanding media like fresco, mosaic, and tempera fell out of favor and industrial technology provided efficient tools and abundant materials like bronze and steel along with paint in tubes. This gives some indication of the power technical demands can have in shaping audience perceptions of any of the visual art disciplines.

Such demands aside, the fact that craft did not stress the theoretical and aesthetic along with the technical as did fine art centuries ago has made it difficult for fine craft to distinguish itself from utilitarian craft; as I have said, both simply get lumped together as the same activity. The result is that while fine art began cultivating in its audience a sophisticated tradition of "fore-understanding" that was theoretically and conceptually based, craft has continued to define itself, and therefore shape the "fore-understanding" of its audience, around practical matters of function, material, and technique, very much in the manner of the old guild systems. Of course there are very practical reasons for this. That's why this practice should not be abandoned but instead recast in a theoretical and conceptual light so as to expand the "fore-understanding" of craft from within the field, thereby encouraging viewers to bring a different perceptual attitude to the craft object, one that is intellectual but also craft based.

While fine craft objects have always existed, because of the contemporary Studio Craft movement they are now a major focus of the field.

Yet even these objects are not receiving the level of theoretical and conceptual support that underpins fine art, certainly not at the level of audience "reception." The tradition of "fore-understanding" of craft works against these objects by foreclosing the mind's eye to them, blinding the viewer to the very possibility of the aesthetic dimension in them. Thus even the most remarkable of fine craft objects often don't get seen for what they are because "fore-understanding" prevents viewers from fully understanding what these objects have to say. It becomes easier to deal with the difficult objects of Studio Craft (for example, the metaphorically functional objects) by simply regarding them as sculpture. This solves the problem of having to come to grips with the demand for understanding that these works pose to the viewer by simply avoiding it, by accepting misunderstanding in place of understanding.

Simply claiming there is no difference between craft and fine art isn't a solution. For craft to achieve genuine aesthetic parity with fine art, its tradition of "fore-understanding" must be broadened and deepened so as to encourage the viewer of fine craft objects to want to understand what these objects have to say, to approach them with an openness of mind that is attentive to their aesthetic possibilities. The attentive viewer must be encouraged to accept the fine craft object's challenge to be understood on its own terms. Only in this way will the expressive possibilities of fine craft take on a meaningful role as part of living culture in our society.

BIBLIOGRAPHY

■ ■ ■

Abram, David. *The Spell of the Sensuous: Perception and Language in a More-Than-Human World*. New York: Pantheon Books, 1996.

Ades, Dawn, Neil Cox, and David Hopkins. *Marcel Duchamp*. London: Thames and Hudson, 1999.

Allen, Greg. "Rule No. 1: Don't Yell, My 'Kid Could Do That.'" *New York Times*, November 5, 2006, sec. 2.

Allen, R. T. "Mounce and Collingwood on Art and Craft." *British Journal of Aesthetics* 33, no. 2 (April 1993): 173–76.

Angeles, Peter. *Dictionary of Philosophy*. New York: Barnes & Noble Books, 1981.

Anonymous. "Comment: Skill—A Word to Start an Argument." *Crafts*, no. 56 (May/June 1982): 19–21.

Anonymous. "Duchamp's Dada Pissoir Attacked." *Art in America* (March 2006): 35.

Arato, Andrew, and Eike Gebhardt, eds. *The Essential Frankfort School Reader*. New York: Continuum Publishing Company, 1987.

Arnheim, Rudolf. "The Form We Seek." In *Towards a Psychology of Art*, 353–62. Berkeley: University of California Press, 1966.

———. "Style as a Gestalt Problem." In *New Essays on the Psychology of Art*, 261–73. Berkeley: University of California Press, 1986.

———. "The Way of the Crafts." In *The Split and the Structure: Twenty-Eight Essays*, 33–41. Berkeley: University of California Press, 1996.

Bahn, Paul G. *The Cambridge Illustrated History of Prehistoric Art*. Cambridge: Cambridge University Press, 1998.

Barzman, K. E. "The Florentine 'Accademia del Disegno': Liberal Education and the Renaissance Artist." In *Academies of Art Between Renaissance and Romanticism*, edited by Anton W. A. Boschloo, Edwin J. Hendrikse, Laetitia C. Smit, 14–32. Stichting Leids Kunsthistorisch Jaarboek, 5–6 (1986–87). Leiden: Stichting Leids Kunsthistorisch Jaarboek, 1989.

Baudrillard, Jean. *For a Critique of the Political Economy of the Sign*. Translated with an introduction by Charles Levin. St. Louis: Telos Press, 1981.

Baumgarten, Alexander Gottlieb. *Aesthetica*. (1750–1758). 2 volumes. Bari: Modern Latin Edition, 1936.

Baxandall, Michael. *Painting and Experience in 15th Century Italy*. 2nd ed. Oxford: Oxford University Press, 1988.

Bayles, David, and Ted Orland. *Art and Fear: Observations on the Perils (and Rewards) of Artmaking*. Santa Barbara, Calif.: Capra Press, 1993.

Beardsley, Monore C., and William Kurtz Wimsatt. "The Intentional Fallacy." In *On Literary Intention*, edited by D. Newton de Molina, 1–13. Edinburgh: Edinburgh University Press, 1976.

Bell, Clive. *Art*. 6th Impression. New York: Capricorn Books, G. P. Putnam's Sons, 1958.

Bell, Daniel. "Modernism and Capitalism." *Partisan Review* 45, no. 2 (1978): 210–22.

Benjamin, Walter. "The Work of Art in the Age of Mechanical Reproduction." In *Illuminations: Essays and Reflection*, translated by Henry Zohn and edited Hannah Arendt, 217–51. New York: Schocken Books, 1969.

Berlin, Isaiah. *The Roots of Romanticism, A. W. Mellon Lectures in Fine Arts: The National Gallery of Art, Washington, D.C.*. Edited by Henry Hardy. Princeton: Princeton University Press, 2001.

Blunt, Anthony. *Artistic Theory in Italy 1450–1600*. London: Oxford University Press, 1940.

Boden, Margaret A. "Crafts, Perception, and the Possibilities of the Body." *British Journal of Aesthetics* 4 no. 3 (July 2000): 289–301.

Brenson, Michael. "Is Quality an Idea Whose Time Has Gone?" *New York Times*, July 22, 1990, sec. 2.

Brown, Glenn. "The Ceramic Installation and the Failure of Craft Theory." In *Beyond the Physical: Substance, Space, and Light*, 7–10, 14–18. Charlotte: University of North Carolina Galleries, 2001. Exhibition catalog.

Buchloh, Benjamin H.D. "The Whole Earth Show: An Interview with Jean-Hubert Martin." *Art in America* (May 1989): 150–58, 211–13.

Cameron, Averil. *The Later Roman Empire: AD 284–430*. Cambridge, Mass.: Harvard University Press, 1993.

Camfield, William. *Marcel Duchamp: Fountain*. Houston: Menil Collection, 1989. Exhibition catalog.

Chipp, Herschel B., ed. *Theories of Modern Art: A Source Book by Artists and Critics*. Berkeley: University of California Press, 1968.

Clifford, James. "Histories of the Tribal and the Modern." *Art in America* (April 1985): 164–77.

Coe, Sue D. *America's First Cuisines*. Austin: University of Texas Press, 1994.

Collingwood, R. G. "Art and Craft." In *The Principles of Art*, 15–41. Oxford: Oxford University Press, 1972.

Compact Edition of the Oxford English Dictionary. Oxford: Oxford University Press, 1971.

Cooke, Edward S. Jr. "Defining the Field." In *Furniture Studio: The Heart of the Functional Arts*, edited by John Kelsey and Rick Mastelli, 8–11. Free Union, Va.: Furniture Society, 1999.

Cottingham, Laura. "The Damned Beautiful." *New Art Examiner* (April 1994): 25–29, 54.

Crane, Walter. "The Importance of the Applied Arts and Their Relationship to Common Life." In *The Theory of the Decorative Arts: An Anthology of European and American Writings, 1750–1940*, edited by Isabelle Frank, 178–83. New Haven: Yale University Press, 2000.

Croce, Benedetto. *Guide to Aesthetics*. Translated by Patrick Romanell. New York: Bobbs-Merrill, 1965.

Cunard, Jeffrey P. "Moral Rights for Visual Artists: The Visual Artist Rights Act." *College Art Association News Letter* (May/June 2002): 6.

Danto, Arthur C. "Art and Artifact in Africa." In *Beyond the Brillo Box: The Visual Arts in Post-Historical Perspective*, 89–112. New York: Noonday Press, Farrar, Straus, Giroux, 1992.

Davey, Nicholas. "Baumgarten." In *A Companion to Aesthetics*, edited by David Cooper, 40–41. Oxford: Blackwell, 1995.

Davi, Klaus. "Hans-Georg Gadamer: A Conversation in Hermeneutics and the Situation of Art." *Flash Art*, no. 136 (October 1987): 78–80.

Derrida, Jacques. *Of Grammatology*. Translated by Gayatri Chakravorty Spivak. Baltimore: Johns Hopkins University Press, 1967.

———. *Speech and Phenomena and Other Essays on Husserl's Theory of Signs*. Translated and edited by David B. Allison. Evanston, Ill.: Northwestern University Press, 1973.

Dondero, Congressman George A. "Modern Art Shackled to Communism." In *Theories of Modern Art: A Source Book for Artists and Critics*, edited by Herschel B. Chipp, 496–500. Berkeley: University of California Press, 1968.

Dufrenne, Mikel. *In the Presence of the Sensuous*. Translated and edited by Mark S. Roberts and Dennis Gallagher. Atlantic Highlands, N.J.: Humanities Press International, 1987.

———. *Language and Philosophy*. Translated by Henry B. Veatch. Bloomington: University of Indiana Press, 1963.

Elton, William. "Introduction." In *Aesthetics and Language*, edited by William Elton. Oxford: Basil Blackwell, 1970.

Fleming, John, and Hugh Honour. "Gobelins Tapestry Factory." In *Dictionary of the Decorative Arts*, 334–35. New York: Harper & Row, 1977.

———. "Gustav(e) Stickely." In *Dictionary of the Decorative Arts*, 758–59. New York: Harper & Row, 1977.

Flusser, Vilém. *Towards a Philosophy of Photography*. London: Reaktion Books, 2001.

Frank, Isabelle, ed. *The Theory of Decorative Art: An Anthology of European and American Writings, 1750–1940*. New Haven: Yale University Press, 2000.

Freud, Sigmund. *Civilization and Its Discontents*. Translated by Joan Riviere. London: Hogarth Press, 1951.

———. *Introductory Lectures on Psychoanalysis*. Translated and edited by James Strachey. New York: W. W. Norton, 1966.

———. *An Outline of Psycho-Analysis*. Translated and edited by James Strachey. New York: W. W. Norton, 1949.

Fried, Michael. "Art and Objecthood." *Artforum* 5, no. 10 (June 1967): 12–23.

———. "Shape as Form: Frank Stella's New Paintings." *Artforum* 5, no. 3 (November 1966): 18–27.

Frueh, Joanna. "Towards a Feminist Theory of Art Criticism." In *Feminist Art Criticism: An Anthology*, edited by Arlene Raven, Cassandra Langer, and Joanna Frueh, 153–66. Ann Arbor: UMI Research Press, 1988.

Fry, Roger. *Vision and Design*. New York: Brentano's, n.d.

Gadamer, Hans-Georg. "Aesthetics and Hermeneutics." In *Philosophical Hermeneutics*, translated and edited by David E. Linge, 95–104. Berkeley: University of California Press, 1976.

———. *Philosophical Hermeneutics*. Translated and edited by David E. Linge. Berkeley: University of California Press, 1976.

———. "The Play of Art." In *The Philosophy of Art, Readings Ancient and Modern*, edited by Alex Neill and Aaron Ridley, 75–81. New York: McGraw-Hill, 1995.

———. *Truth and Method*. 2nd ed. Translation revised by Joel Weinsheimer and Donald G. Marshall. New York: Continuum, 1999.

Gardner, Helen. *Art through the Ages*. 2nd ed. New York: Harcourt, Brace, 1936.

Gaunt, William. *The Aesthetic Adventure*. New York: Schocken Books, 1967.

Goldwater, Robert. *Primitivism in Modern Art*. New York: Vintage Books, 1967.

Gorys, Boris. "On the Ethics of the Avant-Garde." *Art in America* (May 1993): 110–13.

Greenberg, Clement. *Art and Culture*. Boston: Beacon Press, 1961.

Greenblatt, Stephen. "Resonance and Wonder." In *Exhibiting Cultures: The Poetics and Politics of Museum Display*, edited by Ivan Karp and Steven D. Lavine, 42–56. Washington, D.C.: Smithsonian Institution Press, 1991.

[Pope] Gregory I. "Letter to Bishop Serenus of Marseille." Reprinted in *Early Medieval Art, 300–1150: Sources and Documents*, edited by Caecilia Davis-Weyer, 47–49. Englewood Cliffs, N.J.: Prentice-Hall, 1971.

Hampshire, Stuart. "Logic and Appreciation." In *Aesthetics and Language*, edited with an introduction by William Elton, 161–69. Oxford: Basil Blackwell, 1967.

Hartt, Frederick. *History of Italian Renaissance Art: Painting, Sculpture, Architecture*. New York: Harry N. Abrams, 1974.

Harvey, John. *Mediaeval Craftsmen*. London: B. T. Batsford, 1975.

Hauser, Arnold. *The Social History of Art*, vol. 2: *Renaissance, Mannerism, Baroque*. Translated by Stanley Godman. New York: Vintage Books, 1985.

Hawkes, Terence. *Structuralism and Semiotics*. Berkeley: University of California Press, 1977.

Hegel, Georg Wilhelm Friedrich. *Introductory Lectures on Aesthetics*. Translated by Bernard Bosanquet and edited by Michael Wood. London: Penguin Books, 1993.

Heidegger, Martin. "Building Dwelling Thinking." In *Poetry, Language, Thought*, translated by Albert Hofstadter, 145–61. New York: Harper & Row, 1971.

———. "Memorial Address." In *Discourse on Thinking*, translated by John M. Anderson and E. Hans Freund with an introduction by John M. Anderson, 43–57. New York: Harper & Row, 1966.

———. "The Origin of the Work of Art." In *Poetry, Language, Thought*, translated by Albert Hofstadter, 17–87. New York: Harper & Row, 1971.

———. "The Thing." In *Poetry, Language, Thought*, translated by Albert Hofstadter, 165–86. New York: Harper & Row, 1971.

Heimann, Nora. "Rob Barnard." In *Inheritors of a Legacy: Charles Lang Freer and the Washington Avant-Garde*, 7. Washington, D.C.: Japanese Information and Culture Center Gallery, 1999. Exhibition catalog.

Heskett, John. *Industrial Design*. New York: Thames and Hudson, 1980.

Hickey, Dave. *The Invisible Dragon: Four Essays on Beauty*. Los Angeles: Art Issues Press, 1993.

Hill, Rosemary. "The 2001 Peter Dormer Lecture: The Eye of the Beholder: Criticism and Crafts." *Crafts: The Magazine of the Decorative and Applied Arts* (May/June 2002): 44–49.

Hixon, Kathryn, and Ann Weins. "Editorial." *New Art Examiner* (April 1994): 7.

Honour, Hugh. *The New Golden Land: European Images of America from the Discoveries to the Present Time*. New York: Pantheon, 1975.

Husserl, Edmund. *Logical Investigations*. 2 volumes. Translated by J. N. Findlay. London: Routledge, 1973.

Janson, H. W. *The History of Art*. Englewood Cliffs, N.J.: Prentice-Hall, 1962.

Jauss, Hans Robert. *Towards an Aesthetics of Reception*. Minneapolis: University of Minnesota Press, 1982.

Judd, Donald. "Specific Objects." *Arts Yearbook* 8 (1965). Reprinted in *Donald Judd: Complete Writings, 1959–1975*, 181–89. Halifax: The Press of the Nova Scotia College of Art and Design and New York University, 1975.

Kamuf, Peggy, ed. *A Derrida Reader: Between the Blinds*. New York: Columbia University Press, 1991.

Kangas, Matthew. "Comment: The Myth of the Neglected Ceramics Artist: A Brief History of Clay Criticism." *Ceramics Monthly* (October 2004): 107–12.

———. "The State of the Crafts." *New Art Examiner* (September 1990): 28–30.

Kant, Immanuel. *Analytic of the Beautiful*. Translated by Walter Cerf. New York: Bobbs-Merrill, 1963.

————. *Anthropology from a Pragmatic Viewpoint* (1798). Reprinted in *Analytic of the Beautiful*, edited by Walter Cerf, 59–98. New York: Bobbs-Merrill, 1963.

————. *Observations on the Feelings of the Beautiful and Sublime*. Translated by John T. Goldthwait. Berkeley: University of California Press, 1960.

Kemenov, Vladimir. "Aspects of Two Cultures." In *Theories of Modern Art: A Source Book for Artists and Critics*, edited by Herschel B. Chipp, 490–96. Berkeley: University of California Press, 1968.

Kirwan, James. *Beauty*. Manchester: Manchester University Press, 1999.

Koplos, Janet. "What Is This Thing Called Craft?" *American Ceramics* 11, no. 1 (1993): 12–13.

Kristeller, Paul O. "The Modern System of the Arts: A Study in the History of Aesthetics." *Journal of the History of Ideas*, 12, no. 4 (October 1951): 496–527; 13, no. 1 (January 1952): 17–46.

Kubler, George. *The Shape of Time: Remarks on the History of Things*. New Haven: Yale University Press, 1962.

Kuspit, Donald. "Crowding the Picture: Notes on American Activist Art Today," *Artforum* (May 1988). Reprinted in *Postmodern Perspectives: Issues in Contemporary Art*, 2nd ed., edited by Howard Risatti, 108–20. Upper Saddle River, N.J.: Prentice-Hall, 1998.

————. *The New Subjectivism: Art in the 1980s*. New York: Da Capo Press, 1993.

Lawal, Babatunde. "Aworal: Representing the Self and Its Metaphysical Other in Yoruba Art." *Art Bulletin* 83, no. 3 (September 2001): 498–526.

Lee, Rensselaer W. *Ut Pictura Poesis: The Humanistic Theory of Painting*. New York: W. W. Norton, 1967.

Loos, Adolf. *Die Form ohne Ornament*. Stuttgart: Deutsche Verlags Anstalt, 1924. Catalog for the exhibition staged by the Deutsche Werkbund.

————. *Ornament and Crime: Selected Essays*. Translated by Michael Mitchell and edited with an introduction by Adolf Opel. Riverside, Calif.: Ariadne Press, 1998.

Maclehose, Luisa S. *Vasari on Technique*. New York: Dover, 1960.

Mackenzie, Lynn. *Non-Western Art: A Brief Survey*. Upper Saddle River, N.J.: Prentice-Hall, 1995.

Mandelbaum, Maurice. "Family Resemblances and Generalizations Concerning the Art." *American Philosophical Quarterly* (1965). Reprinted in *The Philosophy of Art: Readings Ancient and Modern*, edited by Alex Neill and Aaron Ridley, 192–201. New York: McGraw-Hill, 1995.

Marchese, Pasquale. *L'invenzione della forchetta* (The Invention of the Fork). Soveria Mannelli, Catanzaro, Italy: Rubbettino Editore, 1989.

Martland, M. R. "Art and Craft: The Distinction." *British Journal of Aesthetics* 14, no. 3 (Summer 1974): 231–38.

Marx, Karl. *Capital*. vol 1. New York: Modern Library, n.d.

McCullough, Malcolm. *Abstracting Craft: The Practiced Digital Hand.* Cambridge, Mass.: MIT Press, 1996.

McDonald, Marcy. "Komar and Melamid." *New Art Examiner* (December 1983): 15.

McEvilley, Thomas. "Doctor, Lawyer, Indian Chief: 'Primitivism' at the Museum of Modern Art in 1984." *Artforum* (November 1984): 52–58. Reprinted in *Art and Otherness: Crisis in Cultural Identity*, 27–55. New York: McPherson, 1992.

———. "Letter in Response to Rubin." *Artforum* (February 1985): 46–51.

———. "Second Letter in Response to Rubin." *Artforum* (May 1985): 65–71.

Meikle, Jeffrey L. *Design in the USA.* Oxford: Oxford University Press, 2005.

———. *Twentieth Century Limited: Industrial Design in America, 1925–1939.* 2nd ed. Philadelphia: Temple University, 2001.

Melikian, Souren. "Contemporary Art: More Records Set in Hot Auction Weeks." *International Herald Tribune*, November 17, 2006, Culture & More, 10.

Montgomery, Charles F. *American Furniture: The Federal Period.* New York: Viking Press, 1966.

Morris, Robert. "Note on Sculpture, Part 2." *Artforum* (October 1966). Reprinted in *Minimal Art: A Critical Anthology*, edited by Gregory Battcock, 223–35. New York: E. P. Dutton, 1968.

Morris, William. "The Arts and Crafts Today." In *The Theory of the Decorative Arts: An Anthology of European and American Writings, 1750–1940*, edited by Isabelle Frank, 61–70. New Haven: Yale University Press, 2000.

Mounce, H. O. "Art and Craft." *British Journal of Aesthetics* 31, no. 3 (July 1991): 230–40.

Nochlin, Linda. "'Matisse' and Its Other." *Art in America* (May 1993): 88–97.

Osborne, Harold. "The Aesthetic Concept of Craftsmanship." *British Journal of Aesthetics* 17, no. 2 (Spring 1977): 138–48.

Owen, Paula. "Abstract Craft: The Non-Objective Object." In *Abstract Craft: The Non-Objective Object*. San Antonio: Southwest School of Art and Craft, 1999. Exhibition catalog.

———. "Labels, Lingo, and Legacy: Crafts at a Crossroads." In *Objects and Meaning: New Perspectives on Art and Craft*, edited by M. Anna Fariello and Paula Owen, 24–34. Lanham, Md.: Scarecrow Press, 2004.

Panofsky, Erwin. *Meaning in the Visual Arts.* Garden City, N.Y.: Doubleday, 1955.

Perlman, Hirsch. "A Wastrel's Progress and the Worm's Retreat." *Art Journal* 64, no. 4 (Winter 2005): 64–69.

Perreault, John. "Craft Is Not Sculpture." *Sculpture* (November–December 1993): 32–35.

Perry, Greyson. "A Refuge for Artists Who Play It Safe." *The Guardian*, March 5, 2005. <<http://www.guardian.co.uk>>.

Peterson, Susan. *Jun Kaneko*. Foreword by Arthur C. Danto. London: Laurence King, 2001.

Petroski, Henry. *The Evolution of Useful Things*. New York: Vintage Books, 1999.

Plagens, Peter. "The Good, the Bad, and the Beautiful." *New Art Examiner* (April 1994): 18–20.

Plato. "Art as Imitation: From 'The Republic,' Book 10." In *Aesthetics: Critical Essays*, edited by George Dickie and R. J. Sclafani, 9–12. New York: St. Martin's Press, 1977.

Pollitt, J. J. *The Art of Ancient Greece: Sources and Documents*. Cambridge: Cambridge University Press, 1990.

———. *Art and Experience in Classical Greece*. London: Cambridge University Press, 1972.

Pollock, Jackson. "My Painting." *Possibilities* 1, no. 1 (Winter 1947–48): 79.

Pye, David. *The Nature and Aesthetics of Design*. Bethel, Conn.: Cambium Press, 1982.

———. *The Nature and Art of Workmanship*. Rev. ed. Edited by James Pye and Elizabeth Balaam. Bethel, Conn.: Cambium Press, 1995.

Rebora, Giovanni. *Culture of the Fork: A Brief History of Food in Europe*. Translated by Albert Sonnenfeld. New York: Columbia University Press, 2001.

Rewald, John. *The History of Impressionism*. 4th rev. ed. New York: Museum of Modern Art, 1973.

Richards, M. C. *Centering in Pottery, Poetry, and the Person*. 25th anniversary edition. Hanover, N.H.: University Press of New England, 1989.

Ricoeur, Paul. *The Conflict of Interpretations*. Edited by Don Ihde. Evanston, Ill.: Northwestern University Press, 1974.

Risatti, Howard. "Crafts and Fine Art: An Argument in Favor of Boundaries." *Art Criticism* 16, no. 1 (2001): 62–70.

———. "Eccentric Abstractions." *Ceramics: Art and Perception*, no. 51 (2003): 57–59.

———. *Postmodern Perspectives: Issues in Contemporary Art*. 2nd ed. Upper Saddle River, N.J.: Prentice-Hall, 1998.

———. "The Subject Matters: Politics, Empathy, and the Visual Experience." *New Art Examiner* (April 1994): 30–35.

Robb, Peter. *Midnight in Sicily: On Art, Food, History, Travel, and La Cosa Nostra*. Boston: Faber and Faber, 1996.

Rubin, William. "Doctor, Lawyer, Indian Chief: Part Two." *Artforum* (May 1985): 63–65.

———. "On 'Doctor, Lawyer, Indian Chief.'" *Artforum* (February 1985): 42–45.

Rubinstein, Raphael. "Klimt Portrait Priciest Painting Ever Sold." *Art in America* (September 2006): 37.

Rutsky, R. L. *High Technē: Art and Technology from the Machine Aesthetic to the Posthuman.* Minneapolis: University of Minnesota Press, 1999.

Sartre, Jean-Paul. *Time and Nothingness.* New York: Philosophical Library, 1957.

Saussure, Ferdinand de. *Course in General Linguistics.* Translated with an introduction and notes by Wade Baskin and edited by Charles Bally and Albert Sechehaye in collaboration with Albert Riedlinger. New York: McGraw-Hill, 1966.

Schopenhauer, Arthur. *The World as Will and Idea.* In *The Works of Arthur Schopenhauer,* translated by R. H. Haldane and J. Kemp and edited by Will Durant, 118–19. Garden City, N.Y.: Garden City Publishing Co., 1928.

Schwabsky, Barry. "The Sublime, the Beautiful, the Gender of Painting: Confessions of a Male Gaze." *New Art Examiner* (April 1994): 21–24, 55.

Semper, Gottfried. *Science, Industry, and Art.* In *Art in Theory, 1815–1900: An Anthology of Changing Ideas,* translated by Nicholas Walker and edited by Charles Harrison and Paul Wood with Jason Gaiger, 331–36. Malden, Mass.: Blackwell, 1998.

Seneca, Lucius Annaeus. *De Otio: De Brevitate Vitae.* Edited by G. D. Williams. Cambridge: Cambridge University Press, 2003.

Shanken, Edward A. "Tele-Agency: Telematics, Telerobotics, and the Art of Meaning." *Art Journal* 59, no. 2 (Summer 2000): 64–77.

Simmel, Georg. *On Individuality and Social Forms.* Translated and edited with an introduction by D. Levine. Chicago: University of Chicago Press, 1971.

Slivka, Rose. "The New Ceramic Presence." *Craft Horizons* (May 1961): 31–37.

Soffer, O., J. M. Adovasio, and D. C. Hyland. "The 'Venus' Figurines: Textiles, Basketry, Gender, and Status in the Upper Paleolithic." *Current Anthropology* 41, no. 4 (August–October 2000): 511–37.

Sparke, Penny. *Ettore Sottsass Jnr.* London: Design Council, 1981.

———. *An Introduction to Design and Culture in the Twentieth Century.* New York: Harper & Row, 1986.

Steiner, Wendy. *Venus in Exile: The Rejection of Beauty in Twentieth Century Art.* New York: Free Press, 2001.

Stockholder, Jessica, and Joe Scanlan. "Dialogue: Art and Labor." *Art Journal* 64, no. 4 (Winter 2005): 50–63.

Stuckey, Charles. "Dada Lives." *Art in America* (June/July 2006): 142–51, 206–7.

Taylor, Michael R. "New York." In *Dada,* edited by Leah Dickerman, 275–95. Washington, D.C.: National Gallery of Art, 2006. Exhibition catalog.

Thompson, Clive. "Music of the Hemispheres." *New York Times,* December 31, 2006, sec. 2.

Tompkins, Jane P., ed. *Reader-Response Criticism: From Formalism to Post-Structuralism*. Baltimore: Johns Hopkins University Press, 1980.

Trapp, Kenneth, and Howard Risatti. *Skilled Work: American Craft in the Renwick Gallery, National Museum of American Art, Smithsonian Institution*. Washington, D.C.: Smithsonian Institution Press, 1998.

Varnedoe, Kirk. "Letter in Response to McEvilley." *Artforum* (February 1985): 45–46.

Velkley, Richard. "Edmund Husserl." In *History of Political Philosophy*, 3rd ed., edited by Leo Strauss and Joseph Cropsey, 870–87. Chicago: University of Chicago Press, 1987.

Vitruvius. *The Ten Books on Architecture*. Translated by Morris Hicky Morgan. New York: Dover, 1960.

White, Morton. *The Age of Analysis: 20th Century Philosophers*. New York: Mentor, The New American Library, 1955.

Whittick, Arnold. "Towards Precise Distinctions of Art and Craft." *British Journal of Aesthetics* 24, no. 1 (Winter 1984): 47.

Wills, Christopher. *The Runaway Brain: The Evolution of Human Uniqueness*. London: HarperCollins, 1994.

Wilson, Frank R. *The Hand: How Its Use Shapes the Brain, Language, and Human Culture*. New York: Pantheon Books, 1998.

Wittkower, Rudolf, and Margot Wittkower. *Born under Saturn: The Character and Conduct of Artists*. New York: W. W. Norton, 1962.

Wolff, Kurt H. *Essays on Sociology, Philosophy, and Aesthetics*. New York: Harper & Row, 1959.

INDEX

▪ ▪ ▪

86; *L.H.O.O.Q.*, 260; *Why Not Sneeze Rose Selavy?*, 141
Dufrenne, Mikel, 57, 182n2, 252n1
Dunnigan, John, 227, 232–33; *Slipper Chairs*, 227, 230 (ill.)
Dürer, Albrecht, 84–85, 104, 196, 197n3

Earl, Harvey, 237n8
Egyptian art, 68, 80, 107, 195–96; New Kingdom chair, 199, 227, 229 (ill.), 232–33; pottery, 243n9
Electricians, 160–61
Endell, August, 178
Etruscan art: *Apollo of Veii*, 7 (ill.), 68
Expression, 218, 220–21, 225–26, 232–33, 258; human, 223
Expressive act, 252
Expressive intention, 268
Expressive objects, 249

Facio ergo sum, 253
Fauvism, 224, 263
Feminism, 210n2, 262n2
Ferguson, Ken, 68
Fetishism of material, 106
Figurines, 5, 18, 125–26
"Fine art": origin of term, 210, 244, 246–47
Fine craft, 275, 279, 280, 303–6
Finkel, Doug, 289–90; *Sex Pistil*, 291 (ill.)
Flaubert, Gustave, 249
Flusser, Vilém, 50
Folk art, 104n7
"Fore-understanding": concept of, 277, 280, 303, 305–6
Form and content, 9, 268
"Formed-object stage," 44–45
"Form follows function," 236
Form giving, 27, 135, 182–83, 202, 224

Fountain. See Duchamp, Marcel
Franco-Prussian War, 76
Frankenthaler, Helen, 142
Fresco, 103
Freud, Sigmund, 106n13, 148n12
Fry, Roger, 233–34; and theory of "aesthetic unity," 233
Function: aerodynamic, 237; applied, 41–47, 54–55, 58, 60–65, 67, 183, 226, 277–78, 281; commercial, 249; communicative, 72–77, 79, 85, 127; metaphorical, 200, 284–86, 288, 306; social, 80, 230, 232, 234
Functionalism, 237
Function and nonfunction, 20–21, 67–69, 91, 149, 153, 207, 219, 220, 233, 237, 239, 240–42, 249, 271, 287, 302
Function-concept, 278n3
Funk Art, 6
Furniture making, 16, 29; chairs, 198
Futurism, 182n1

Gabo, Naum, 287
Gadamer, Hans-Georg, 84n6, 129, 258n9; on beauty in nature, 269nn15–16; on games, mimesis, and recognition, 5, 8–10, 14, 88–89, 252n1; and science, 187n5, 192–93, 221; on taste, 271n17; on understanding, 304
Games: concept of, 5, 8–9; "language games," 246n12
Gardner, Helen: *Art Through the Ages*, 210n2
Gautier, Theophile, 249
Gehry, Frank, 304
German art, 68; and expressionism, 263
Gestalt, 129
Giacometi, Alberto: *Hand*, 119n2

G. I. Bill (Servicemen's Readjustment Act), 282

Gilbert & George, 94, 145n8

Giotto, 144n5

Glass blowing, 16

Gobelins, 154–55

Gothic art, 75n9, 81–82, 83 (ill.), 113n7; Bamberg Cathedral, 84; Chartres Cathedral, 73, 81–82, 83 (ill.), 130, 137

Graves, Michael, 304

Gray, Myra Mimlitsch, 298; *Sugar Bowl and Creamer III*, 302 (ill.)

Greek art, 117, 130, 137; burials, 198n7; Classical, 72, 82, 113; Paestum, 84; sculpture, 207

Greenberg, Clement, 144n5, 233–34, 277n2; and formalist theory of art, 233, 254

Gropius, Walter, 178

Grotesque, 264

Guilds, 38, 47, 154, 159, 214–15, 282, 305; and medieval trade, 17,

Hals, Franz, 137

Hammersley, Bill, 286, 288; *C-Shell*, 288 (ill.)

Hampshire, Stuart, 266–67

Hand, The. See Wilson, Frank R.

"Hand-eye" coordination, 103, 105

Hand in craft, 108–15, 183–84, 186, 195–98

"Handmade-ness," 152–53, 159, 183, 189, 191–92, 195, 197, 255

"Hand-material" coordination, 103

Hands and body, 217

"Handsomeness," 110–11, 290

Hanson, Duane, 93, 125n10

Haptic, 148

Harris, John, 49

Harvey, John, 164–65

Haskett, John, 178

Hauser, Arnold, 154–55, 215n19

Hegel, Georg Wilhelm Friedrich, 207; on beauty and nature, 263–64, 269n16; and bodily senses, 148; *Introductory Lectures on Aesthetics*, 263

Heidegger, Martin: on appearance and reality, 190–91; on calculative and meditative thinking, 264–65; on "the jug," 46n5, 128–29, 140n1, 205; on material, 132, 135; on *technē*, 210–11n5; on tools, 42–43, 207; and "world-withdrawal," 84

Heizer, Michael: *Double Negative*, 94

Hellenistic art, 72, 212; *Old Market Woman*, 72, 262; *Venus de Milo*, 262

Heteronomous objects, 220, 224, 227, 233

"High art," 209, 249

Hindu Gods, 81

Hirshhorn Museum and Sculpture Garden, 260n15

History of Art, The. See Janson, H. W.

Hitler, Adolf, 256n7

Homo Faber, 78, 253, 275

Horace, 214n15

Hugo of Saint Victor, 211n6

Husserl, Edmund: on the body, 119, 123; on intentional object, 252, 276, 279; *Logical Investigations*, 222n5, 252; on signs and intentionality/meaning, 221–22, 226, 253n2

Hutter, Sidney R., 298; *Vase #65–78*, 299 (ill.)

Industrial production, 151–53, 155, 159–61, 167–68, 173, 177, 181, 185–86, 191–93, 199, 202, 214; ideology of, 204, 239n1; and mechano-techno-scientific culture, 112, 186–88

279; compound, 47; and material, 194–95, 197

"Magiciens de la Terre" exhibition, 256

Maloof, Sam, 199 (ill.)

Mandelbaum, Maurice, 130n7; "Family Resemblances," 246n12

Man Ray, 175

Manufacture Royale des Meubles de la Couronne (Gobelins), 154–55

Manus, 112

Marquis, Richard, 295; *Teapot Goblets*, 297 (ill.)

Marx, Karl, 50, 103n6, 158n2, 198n6

Mass production, 155, 165, 176–77

Material, 105–6; reuse of (*spoglie*), 195n2; technical knowledge of, 195

Mathematics, 212–13

Matisse, Henri, 224

McEvilley, Thomas, 86n10

Meaning: intention to, 221–22, 226, 230–31; intuitive, 223; naive, 223

Mechanical advantage, 49–52

Mediaeval Craftsmen. See Harvey, John

Medici government, 214

Meditative object, 261

Meditative thinking, 264–65

Medium versus material, 105–6

Memory: declarative, 99; motor/pro-cedural, 100

Meso-American Indians, 164

Michelangelo, 106, 214, 235; *Creation of Adam*, 280n6; *David*, 117, 118 (ill.), 123, 214; *Last Judgment*, 77, 148, 263; Sistine Ceiling, 274

Middle Ages, 68, 75n9, 82, 83 (ill.), 159, 211; and idolatry, 137

Mies van der Rohe, Ludwig, 188, 202, 204, 227, 303; *Barcelona Chair*, 174n4, 188, 202, 203 (ill.), 277

Mimesis, 8

Minimalism, 116, 145–46, 182n1, 284n5, 286

"Minor arts," 209, 217, 249

Misuse, 76–77, 136, 240

Mochica culture: *Stirrup Spout Vessel*, 289, 293 (ill.)

Modern art: Abstract Expression-ism, 102, 116; abstraction, 74, 80; Cubism, 182n1; *Fauvism*, 224, 263; Futurism, 182n1; German Expres-sionism, 263; Minimalism, 116, 145–46, 182n1, 284n5, 286; pro-cess art, 151n1; Soviet Realism, 74; Surrealism, 102, 182n1

Monet, Claude, 130–31, 188

Morris, Robert, 145

Morris, William, 19n4

Mosaic, 35, 103

Moscow "Show Trials," 256n7

Multiples, 173–76, 184, 193, 197, 202, 204

Museum of Arts and Design (MAD), 153, 169

Museum of Modern Art (MoMA), 86n10, 153, 168, 255

Mutt, R. *See* Duchamp, Marcel

National Endowment for the Arts, 81

Native American art, 84–86; *Stirrup Spout Vessel* (Mochica), 289, 293 (ill.)

Nature: and culture, 202, 224–25, 231, 253, 258, 269n16, 270, 279; man's confrontation with, 56–59; physical laws of, 78, 87, 98–99, 182

Necessity: physiological, 55–60, 69, 78; social, 79

Need versus desire, 23–24

Neo-Platonism, 214n16

"New Ceramic Presence, The." *See* Slivka, Rose

Purpose, 24–28, 46, 54–55, 59, 63–65, 67, 69, 233; communicative, 72–77, 139, 234, 236, 251; social, 79–80

"Purposive objects," 220, 224, 233, 236, 279

Puryear, Martin, 260n15

Pye, David, 162, 164–69, 172, 202, 218, 240–41

Quadrivium, 211n6

Quilts and quilting, 15–16, 29, 132–33, 260n14

Raphael, 14, 144n5

Rauschenberg, Robert, 132–34, 136; *Bed*, 133 (ill.), 260n14; combine, 133 (ill.)

Reader-Response criticism, 255–56, 275

Readymades, 260, 278n3, 285

Real objects, 86, 183, 213, 279

Reception aesthetics, 243

Recognition, 8–10, 246n12

Reformation, 148

Rembrandt, 14, 104

Renaissance, 82, 96, 113n7, 211–12, 218, 235, 282, 305

Repetition, 101–5, 170, 192–93, 197

Representations, 87, 92–93, 139–40, 146, 163n3, 284

Reproductions, 174–76, 184

Richards, M. C.: *Centering, In Pottery, Poetry, and the Person*, 102

Ricoeur, Paul: *Conflict of Interpretations*, 280n6

Riemenschneider, Tilman, 68n

Riemerschmid, Richard, 178

Rookwood, 77n11, 283

Rosenbaum, Allan: *Tale*, 6 (ill.), 298

Rossi, Aldo, 304

Roycroft, 155, 283

Rubin, William, 86n10

Rucellai Palace, 195n2

Runaway Brain, The. See Wills, Christopher

Ruskin, John, 215n20

Ryoan-ji Garden, 270 (ill.)

Saint Augustine, 148

Saint Gregory (Pope), 74

Saint Peter's Cathedral, 189

Sartre, Jean-Paul, 204n8

Saussure, Ferdinand de, 79, 89–90

Saxe, Adrian, 3

Schelling, F. W. J., 263n4

Schjeldahl, Peter, 3

Schopenhauer, Arthur, 136, 265–66; and "disinterested contemplation," 266–67

Schrader, Donald, 197n3

Science, 212–13

Scientific method, 192–93

Sculpture, 5, 18, 94–96, 285–86; Assyrian, 72; Chinese, 7, 68; Egyptian, 68, 117; Etruscan, 7 (ill.); German, 68; Japanese, 68; Pre-Columbian, 75, 84–85, 117, 196

Self-awareness/self-understanding, 196

Self-sufficiency/self-reliance, 36–39, 42–43, 46, 53

Semper, Gottfried, 107, 194–95

Seneca, 86n9

Senses: bodily, 148–49; distance, 148

Sensus Communis, 271n17

Seven Arts, 211–12

Shakespeare, 211

"Shape-matching stage," 27

Sheraton, Thomas, 153–54

Sherlock, Maureen, 106

Shostakovich, Dimitri, 256n7

Shroud of Turin, 120

Sign and sign theory, 79, 88–97, 132,

Tradesmen, 161, 212–14, 282

Transformative act, 252–54, 276

Transgressions of scale, 290

Tré, Howard Ben, 290; *First Vase,* 294 (ill.)

Trivium, 211n6

Trompe l'oeil, 93, 132–34, 137

Turning, 15–16, 99, 108

Understanding: challenge of, 271, 275, 279, 289, 304, 306

Use, 217, 243; and function, 24–28, 42–47, 218

Useful, 207; and nonuseful, 266–67

Utilitarian craft, 304

Utopian world, 204

Ut pictura poesis, 214n15

Van Eyck, Jan, 137; *Ghent Altarpiece,* 148

Varchi, Benedetto, 213n13

Vasari, Giorgio, 106, 116, 154, 213–15; *Lives of the Artists,* 106, 215

Velázquez, 137

Venus de Milo, 262

"Vintage": as term, 175–76

Visual art: fine, 248 (diagram), 265; utilitarian, 248 (diagram), 265

Visual Artists Rights Act, 245n11

Vitruvius: *Ten Books on Architecture,* 113n7; *The Vitruvian Man,* 120–21, 123 (ill.)

Vlaminck, Maurice de, 224

Voulkos, Peter, 256–57, 276, 277n2, 278n5, 282, 295; *Untitled Platter,* 257 (ill.)

Warhol, Andy, 142, 235

Washington Monument, 75

Waxworks, 136

Weaving, 15–16, 29, 61–62, 99, 108; baskets, 60–62, 64, 109, 134, 208, 226, 296

Weber, Max, 186n4

Wedgwood, Josiah, 177

"Well-made-ness," 14–15

Whistler, James Abbott McNeill, 215n20, 249

Wilde, Oscar, 249, 263n4

Wills, Christopher: *The Runaway Brain,* 45n4, 56n2, 65n6

Wilson, Frank R.: *The Hand,* 45n4, 56n2, 100n2, 147, 149n13

Wimsatt, W. K.: "The Intentional Fallacy," 254

Witchcraft, 17, 160

Wittgenstein, Ludwig, 130n7, 246n12

Wittkower, Rudolf and Margot: *Born under Saturn,* 212n12, 215n18

Wood, Beatrice, 258n10, 295

Wood working, 16, 29

Workmanship, xiv, 51, 157, 162–66, 177, 181, 215; of certainty, 165–67, 169, 202; process of, 173

World War I, 260

World War II, 282, 305

Yaeger, Charles, 226; *Untitled Chair,* 228 (ill.)

Yamaguchi Ryuun, 286, 298; *Tide Wave,* 287 (ill.)

Printed in Great Britain
by Amazon